CHRISTIE'S REVIEW
OF THE SEASON 1973

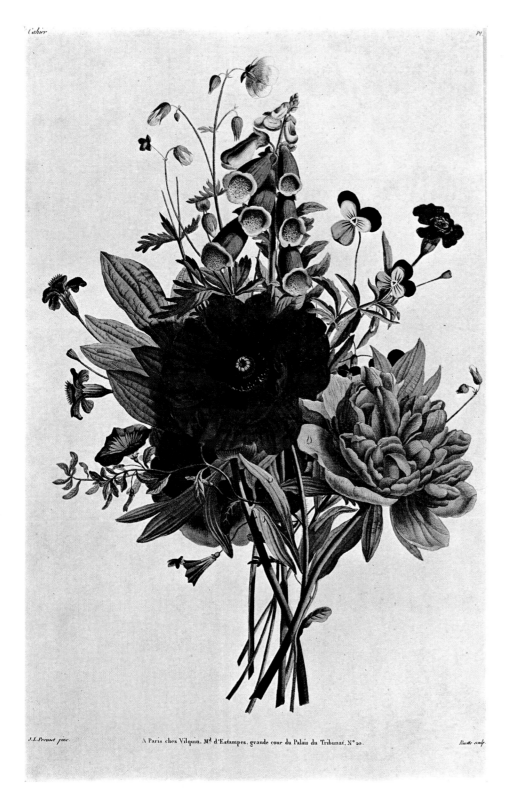

J.L.Prevost pinx. A Paris chez Vilquin. M.^d d'Estampes, grande cour du Palais du Tribunat, N° 20. Ruotte sculp.

JEAN-LOUIS PREVOST:
Collection des Fleurs et des Fruits
48 coloured plates, folio, Paris 1805
Sold 9.5.73 for £12,500 ($31,250)
Bought by the Trustees of the
Chatsworth Settlement

CHRISTIE'S REVIEW OF THE SEASON 1973

Edited by John Herbert

HUTCHINSON OF LONDON / ST MARTIN'S PRESS, NEW YORK

HUTCHINSON & CO (*Publishers*) LTD
3 Fitzroy Square, London W1
London Melbourne Sydney Auckland
Wellington Johannesburg Cape Town
and agencies throughout the world

ST. MARTIN'S PRESS, INC
175 Fifth Avenue, New York, NY 10010

First published 1973

*First published in the
United States of America in 1974*

© *Christie, Manson & Woods, 1973*

*This book was designed and produced for
Christie, Manson & Woods by Hutchinson Benham Ltd
It was set in 'Monotype' Baskerville 12 on 15 point,
and printed in England by The Anchor Press Ltd, Tiptree, Essex,
with colour letterpress by Benham & Co Ltd, Colchester, Essex,
and binding by Wm. Brendon & Son Ltd, Tiptree, Essex*

ISBN 0 09 118050 3 Library of Congress Catalog Number: 66–33358

CONTENTS

Mr Arthur Grimwade selling the superb pair of Queen Anne chandeliers which fetched £115,000 ($287,500) on 27th June – a record price for a single lot of English silver. See pages 228–30

Gilt bronze figure of
St John the Evangelist
c. 1200
3¼ in. (9.5 cm.) high
Sold 5.12.72 for
35,000 gns. ($88,200)
See pages 400–1

The Hon Patrick Lindsay, who is in charge of the picture department, selling Aelbert Cuyp's *Woody river landscape* for £609,000 ($1,522,500). It was in a sale of highly important Old Master pictures on 29th June which realized a total of £3,226,860 ($8,067,150). See pages 18–19

Foreword

DENYS SUTTON, Editor of *Apollo*

The extraordinary and varied changes marking the last decade or so—the ever-increasing speed of communications, the acceleration of inflation and the emergence of new centres of economic power—have made a strong impact on the art market. This is not surprising, for, throughout history, this market has proved a sensitive barometer registering not only changes in taste, but fluctuations in the economic and political situation.

Not so long ago, Christie's remained very much an Edwardian establishment, where life proceeded at a leisurely pace and where most of the habitués knew each other by sight, if not by name. Of recent years, the tempo has become brisker. This may be seen not only from the increase in the number of sales held by the firm, which have risen from about 200 in 1958 to around 300 in the last season, but in the sales total. Last season this amounted to £33,837,981 ($84,594,952), which, when compared with that of just under £20 million ($48 million) for the previous year, registers an increase of over seventy per cent. Visibly, too, business can be seen to flourish at Christie's, for the front counter often looks as if under siege. Yet growth has been at the expense of neither standards nor continuity; old hands still come across such seemingly perennial figures as Mr Leadbeater, unflappable and smiling and sporting a red rose in his buttonhole, season permitting.

At a time of change, in fact, it is agreeable to discover this sense of continuity at Christie's. The Chairman, Peter Chance, has spent his career in the service of the firm, not to forget the immensely important work he has done for the Georgian Group and his considerable role in the campaign to save Bath. Among the senior directors, Mr J. A. Floyd had a cousin and Mr Guy Hannen a father and grandfather at Christie's. The two last-mentioned have taken a large part in securing foreign business for Christie's. Mr Floyd, the deputy Chairman, is responsible for negotiating with important overseas clients, particularly in North America, and Mr Hannen is in charge not only of day-to-day administration in King Street, but of the complex organization required for sales held on the Continent and the efficient management of overseas offices.

Perhaps the most noticeable change at Christie's since the end of the last war is not only the polyglot nature of the clientele, but the way in which the firm has become the centre of an international network. Foreign buyers and sellers were customers before 1939, but there were few, if any, occasions when the firm held sales abroad, or even thought of the possibility of running offices in foreign cities. Christie's is now a world-wide business.

In accordance with this trend, Christie's recently opened a branch in Tokyo in order to service the

ever-growing number of Japanese collectors. This is run by Sir John Figgess, a former diplomat, a connoisseur of Oriental art and a fluent Japanese speaker.

The range of the firm's overseas business is attested to by the sales that are regularly held in Geneva, Düsseldorf, Melbourne, Montreal, Rome and Sydney. What is noticeable and, if one may say so, intelligent about the character of such sales is that they are designed to accord with local demand. An instance of this was the sale of Russian icons held in Düsseldorf in June: this city was chosen because the demand for works of this type is especially strong there. The former owner, Jean Herbette, built up his collection when serving as French Ambassador in Moscow shortly after the First World War. His last years, however, were spent in Switzerland which explains the reasons for the sale being arranged by the firm's Geneva office.

It makes sound sense for an auction house, like any other international business, to take advantage of local conditions. Furniture, for instance, is both difficult and expensive to transport. Geneva is easy of access to buyers (an hour by aeroplane from London, for instance), and in May Christie's staged, at the Hôtel Richemond, Geneva, an important sale of French 18th-century furniture, derived from houses around the Lake of Geneva.

Practical reasons also explain why many jewellery sales are held in Geneva. Ninety per cent of the pieces sold there are modern and if sent to London for disposal, they would attract considerable duty. The buoyancy of this particular market was confirmed when on 9th May a jewellery sale in Geneva achieved a total of £2,620,450. Many of the lots came from American owners.

The observer of the art scene is aware that the salerooms are more specialized than used to be the case. During the season described in this book, Christie's has extended its regular sales to include watches and clocks, musical instruments, oak furniture, continental marquetry other than French 18th-century furniture, pewter and photographica. In this connection, amateurs of the Edwardian era will be intrigued by the group photograph of Edward VII (when Prince of Wales) and others at Tranby Croft at the time of the famous gambling scandal (see illustration page 466).

One fascinating department opened at Christie's is devoted to the sale of modern literary manuscripts. An impetus has been given to this section by the appointment as adviser of Cyril Connolly, former editor of *Horizon* and a leading literary critic. One recent sale included a series of letters from Virginia Woolf to Saxon Sydney-Turner and documents concerning Oscar Wilde (see illustrations pages 296–97). The second group included the poignant visiting-card sent by the faithful Reggie Turner asking for a priest to baptize and administer extreme unction to Wilde in Paris.

Inevitably inflationary pressures and fears about the stability of currencies have driven prices upwards. As is only to be expected, the principal 19th- and 20th-century French painters have fared well during the past season. So have major Old Master paintings, as was proved when the Cuyp landscape, which once belonged to Boni de Castellane, and Georges de La Tour's *Beggars' brawl* fetched £609,000 ($1,522,500) and £399,000 ($957,600) respectively (see illustrations pages 19 and 37).

Yet it is as well to remember that the turnover in less important items remains very considerable and it is probably true to say that about fifty per cent of the lots sold at Christie's fetch under £100 ($250).

Mr Guy Hannen, managing director, taking the Geneva jewellery sale in May which achieved a world record total of Sw. fr. 20,963,000 (£2,620,450)

The saleroom once again provides a pointer to taste by reflecting the mounting interest in the British school which is paralleled by the research work undertaken by American, as well as British, scholars. Important portraits by Gainsborough or Reynolds may be expected to arouse stiff competition, but the strength of this particular market is shown more graphically when a picture by Thomas Hudson (see illustration page 47) sells for as much as £16,800 ($40,320). Richard Wilson, deservedly, has now achieved star status, as was shown when a landscape by him (page 53) fetched £63,000 ($157,500). However, buyers are selective and the condition of Hogarth's *Southwark Fair* was such that it did not arouse enthusiasm.

The Victorians have forged ahead, with the Pre-Raphaelites in the van, and painters such as William Deverell (page 57) have sold exceedingly well. The sharp change in the fortune of 19th-century British artists was revealed when Burne-Jones's paintings of the Seasons (pages 60–61) fetched £37,800 ($94,450). These made only £65 ($186) in 1956. The growing appreciation of Art Nouveau was illustrated by the 800 gns. ($2016) paid for two leather panels designed by H. Granville-Fell (page 463).

Each season the commentator is tempted to ask from where will emerge the new crop of major items. Obviously the plenitude of earlier days is a thing of the past. Yet it is astonishing how many works of quality come under the hammer. Last season, for instance, Christie's sold the Ducas collection of Far Eastern bronzes and Renaissance sculpture from the Weininger collection, to take just two examples. And a glance at the illustrations in this volume is evidence of how treasures have remained in private hands: the Tullio Lombardi sculpture (page 404), Terbrugghen's *Dice players* (page 16), Pieter Brueghel the Younger's *Village scene* (page 23), the Cuyp *Landscape* (page 19), and Canaletto's sparkling *View of the*

Piazza del Campidoglio, Rome (page 39). Discoveries have also been made such as the Gerard David *Crucifixion* (page 15) and the 14th-century Ming jar (page 337).

Paintings inevitably catch the limelight. However, one pleasure of the saleroom is to provide the visitor with a liberal education in the arts. Christie's have displayed works of art ranging from ancient Egypt to the twentieth century. One of the most appealing works sold was the small silver-gilt bronze figure of St John the Evangelist (page 401) of around 1200, an epitome of quality. The rooms also permit the visitor to gain knowledge about such less well-known subjects as Dutch and German cabinet-making, and two important examples from these countries were sold at Christie's (pages 382–83).

The hunger for works of art of all types, which is such a feature of our period, has received additional support from the injection into the market of fresh capital provided by certain merchant banks. This has given stability to the market, even if it has tended to make life difficult for the collector. Here, Christie's have made a novel departure by forming 'Christie's Contemporary Art' in order to sell limited editions (150 copies) of specially commissioned prints. The artists who have participated in this scheme include Salvador Dali, Barbara Hepworth, Patrick Procktor, John Piper, Sidney Nolan and William Scott. It is an imaginative example of patronage.

An example of the role played by Christie's in British life was shown early this year when the firm, together with Sotheby's, the British Antique Dealers' Association and the Society of London Art Dealers clubbed together to mount an exhibition in connection with the Fanfare for Europe celebrations. This was superbly staged and contained many works of the highest calibre. It was opened by Mr Edward Heath, and was a striking demonstration of the vitality of private enterprise. The Prime Minister paid tribute to the London art market as follows:

'One of the things we share with the other members of the Community is the whole cultural heritage of Western Europe in music, literature and the arts.

'In these fields, Britain has for centuries drawn inspiration and expertise from Europe. In return, we have made our contributions to the common treasury of European art.

'The British Art Market owes its origins to the fact that the British have, for the last three centuries at least, been great collectors of works of art from all over Europe.

'For a variety of reasons, London became, and has retained its status as, the main market place for objects of art, not only from Europe, but from all over the world.'

The currency equivalents given throughout the book are based on the rate of exchange ruling at the time of the sale. Any apparent contradictions are due to fluctuations in the exchange rates during the course of the season.

OLD MASTER
PICTURES

A newly discovered David Crucifixion

GREGORY MARTIN

Christ on the Cross between Saint John the Baptist and Saint Francis by Gerard David is one of the most important 'Flemish primitives' to have been sold at auction in the last decade, but was discovered by chance. The picture (see illustration opposite), the property of the Parish of All Hallows, Berkyngechirche by the Tower, was found by the present vicar, the Rev. Colin Cuttell, amongst some 'bric-à-brac' in the vestry. It had originally been given to the late Rev. Philip 'Tubby' Clayton, founder of Toc H and Vicar of All Hallows from 1922 to 1963. Mr Clayton, who died last December, was left the picture by Lady Troup in 1946 in his capacity as vicar of All Hallows. Mr Cuttell sought the advice of Mr Michael Tollemache who brought it to Christie's.

The discovery of this picture ranks in significance with that of Rogier van der Weyden's *Portrait of a man as Saint Ivo* (sold by private treaty by Christie's to the National Gallery two years ago) and makes a notable addition to the extant work of Gerard David – the last genius of the 15th-century Netherlandish school.

As with the other leading personalities of the school, little is known about Gerard David's life. He was born in the northern Netherlands, but made his career in Bruges where he is first recorded in 1484. There he achieved fame as he maintained and then extended the tradition established earlier in the century by Jan van Eyck.

David's vision combined an unrelenting astringency with a gentle, almost wistful, poetry; but there is a sad piquancy about his place in art history, for he brought renewed artistic glory to a city that was on the decline. During his career, trade, money and business shifted to Antwerp: this phenomenon was sufficiently disturbing for David to uproot himself towards the end of his life and enrol in the Antwerp guild of painters. The new environment, which breathed the spirit of the Italian Renaissance, proved uncongenial to the conversative-minded David. And four years later, in 1519, he is recorded as once again in Bruges, where he was to die in 1523.

The *Christ on the Cross* connects with the paintings generally accepted as early works – a fact recognized by Karel Boon, who was the first independent authority to attribute the painting to David. In this early phase, David can be seen experimenting with different styles. Here he develops an Eyckian theme evident both in the beauti-

GERARD DAVID: *Christ on the Cross between Saint John the Baptist and Saint Francis*
On panel
$26\frac{1}{2} \times 16\frac{3}{4}$ in. (67.2×42.6 cm.)
Sold 29.6.73 for 160,000 gns. ($420,000)
From the parish of All Hallows Berkyngechirche by the Tower

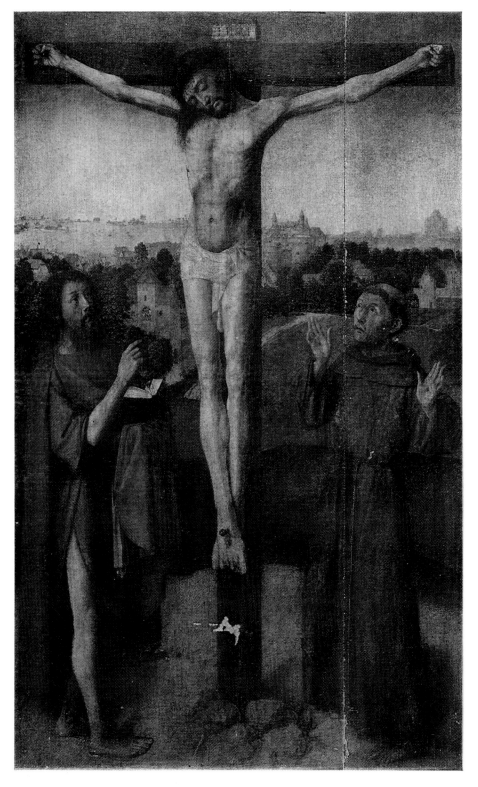

fully detailed townscape and in the pose of Christ whose limbs are cruelly – so tautly – stretched out and whose head hangs limp after the agony of crucifixion.

Several other depictions of Calvary by David are known, but this work differs in that here is not intended a simple rendering of the climax of Christ's Passion. Instead of a weeping John the Evangelist and (for instance) a Magdalen swooning at the foot of the Cross, there is a stern St John the Baptist, preaching the coming of the Messiah, and an ecstatic St Francis, whose eyes are lifted to heaven as he displays the stigmata. And in a distant casement can be made out the resurrected Christ taking leave of his Mother.

Thus this serene and beautifully executed work is not a re-telling of the story of the events on Calvary, but a movingly phrased advocacy of the triumph of faith in Christ's supreme sacrifice.

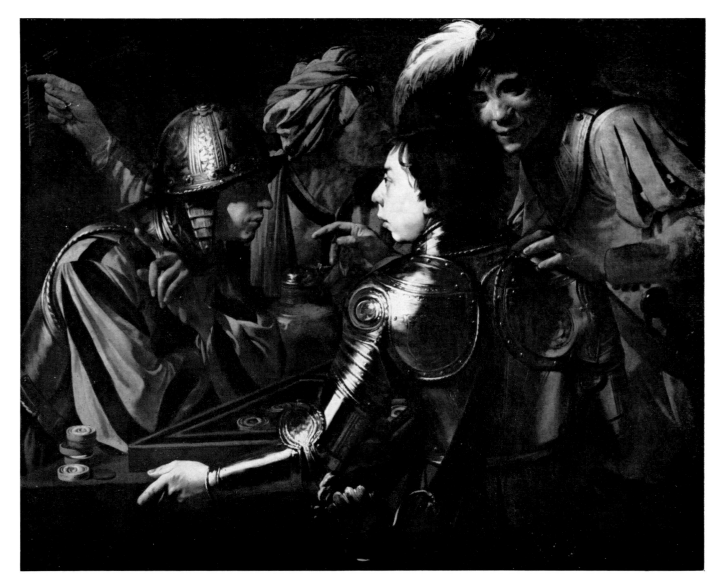

FREDRICK TERBRUGGHEN: *Backgammon players*
Signed and dated 1627, 46 × 60 in. (116.8 × 152.4 cm.)
Sold 8.12.72 for 190,000 gns. ($478,800)
From the collection of the late Madame Streletsky of Stockholm

SIR PETER PAUL
RUBENS: *Self portrait*
On panel
$24\frac{1}{4} \times 17\frac{3}{4}$ in.
(61.6×45.1 cm.)
Sold 8.12.72 for
130,000 gns. ($327,600)
From the collection of
Stavros Niarchos, Esq
Bought by the City of
Antwerp, and now on
exhibition in the Rubens
House

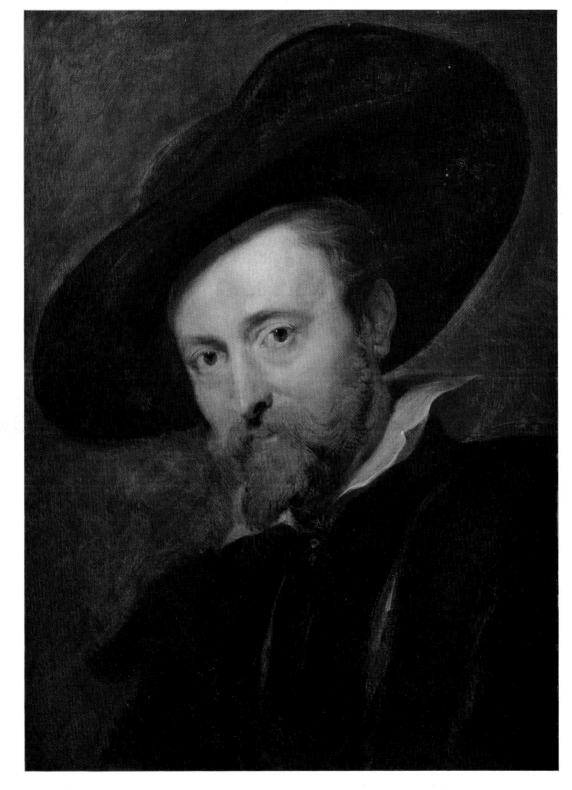

A Cuyp masterpiece

GREGORY MARTIN

Of all the Dutch masters of the 17th century who won the affection of later English connoisseurs and moulded their taste in the process, Aelbert Cuyp is pre-eminent. As a result, there is a fair number of great works by Cuyp in public and private collections in England. None has appeared in the saleroom in the last decades of the calibre of that sold on 29th June (see illustration opposite).

Although singled out for praise in the early years of this century by the leading Dutch connoisseur, Hofstede de Groot, the picture was not well known. Indeed, it had not been publicly exhibited since 1894. But its impact was such that the admiration of generations of English connoisseurs for the artist seemed completely justified.

Cuyp's unique contribution to the course of Dutch painting in the 17th century was his rejection of the cool, steely view of the countryside which emanated from Haarlem, and his moulding of an imported landscape tradition into a viable vehicle to express a new and grand vision of nature. With the Haarlem painters rain nearly always seems to threaten; with Cuyp, active for the whole of his career in his native Dordrecht, the sun usually shines.

Unlike many of his fellow Dutch landscape painters, Cuyp often worked on a large scale: and here only a large canvas was sufficient to express all he had to say. This signed masterpiece was painted probably during his early maturity – in the 1650s – with the youthful influence of van Goyen behind him and the counter lessons of Jan Both, fresh from Italy, already absorbed.

The landscape is both wild and idyllic, friendly and awesome – a fantasy that is nevertheless inspired by detailed observation and understanding of nature and of the play of light on foliage, water and stone.

But Cuyp was not content with describing and expressing the beauty of an imagined countryside, he had a human story to tell – the story of the traveller. Here travellers meet a shepherdess who directs them on their way. Nothing – not even the charms of the shepherdess – will deter them as they ride away from the sun-dappled, distant town. They seem to be men of destiny, who bring to mind the heroic urgency of Rembrandt's *Polish rider*.

AELBERT CUYP: *Woody river landscape*
Signed
$39\frac{1}{4} \times 62$ in. (99.3 × 157.5 cm.)
Sold 29.6.73 for 580,000 gns. ($1,522,500)

All Cuyp's particular genius finds expression in this picture: nothing seems out of place. The eye is held and fascinated by the assured fluency of the brushwork, and the mind is stirred by a sense of wonder and mystery. Here is poetry that rivals Claude's: we witness landscape in Cuyp's hands elevated to the realms of high art.

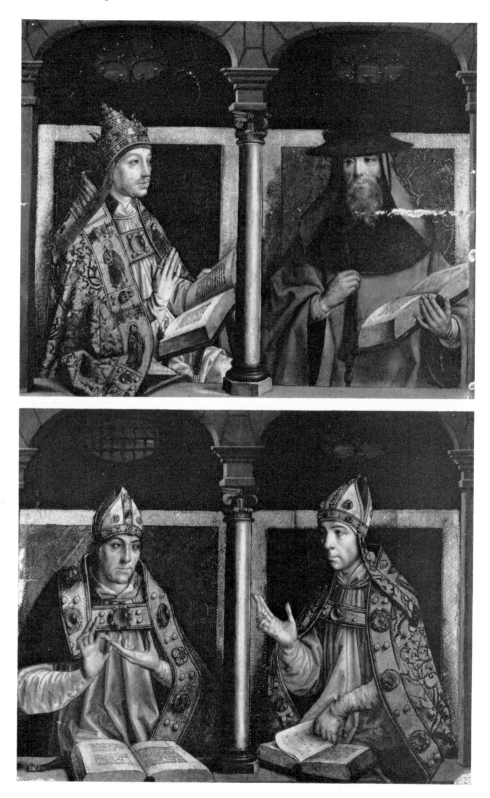

PEDRO BERRUGUETE: *The four Fathers of the Church: Saint Gregory and Saint Jerome;* and *Saint Ambrose and Saint Augustine*
On panel
23 × 28 in. (58.4 × 71.1 cm.) each
Sold 8.12.72 for 35,000 gns. ($88,200)

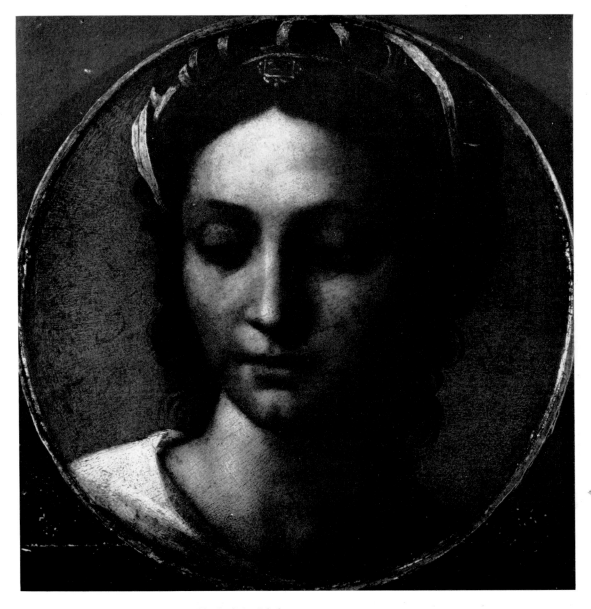

SEBASTIANO DEL PIOMBO: *Head of the Madonna*
On panel, circular
9½ in. (24.1 cm.) diam.
Sold 8.12.72 for 55,000 gns. ($138,600)
From the collection of the Hon Lady Salmond

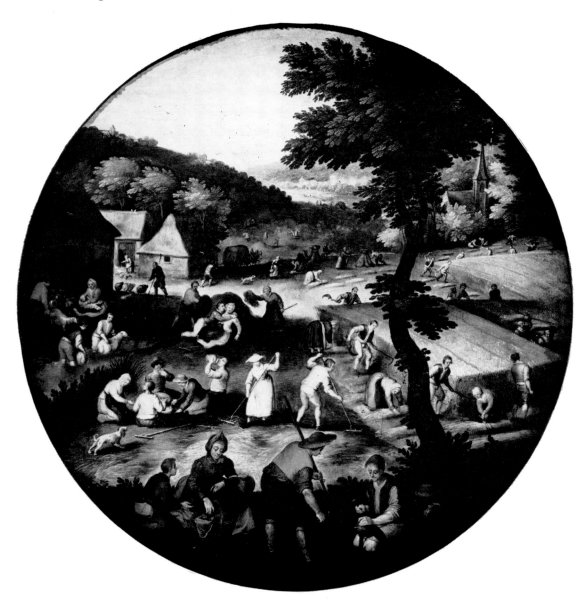

ABEL GRIMMER: *Summer: woody landscape with cottages and a church and numerous peasants*
On panel, circular
29¼ in. (74.3 cm.) diam.
Sold 8.12.72 for 30,000 gns. ($75,600)
From the Dayton Art Institute, Ohio

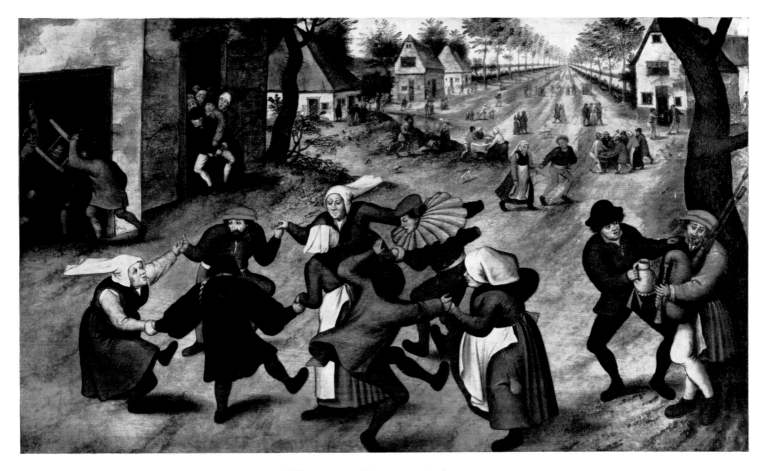

PIETER BRUEGHEL THE YOUNGER: *Village scene with peasants dancing*
Signed
16 × 28½ in. (40.6 × 72.4 cm.)
Sold 23.3.73 for 150,000 gns. ($378,000)

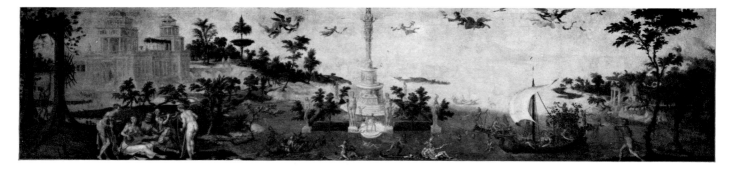

MARTEN VAN HEEMSKERK: *Natura*
Signed on an open scroll Martin van Hemskerck Fecit, inscribed Natura, and dated 1567 on the base of the column, on panel
14½ × 62½ in. (36.8 × 158.6 cm.)
Sold 29.6.73 for 70,000 gns. ($183,750)

An allegory by Marten van Heemskerk

The exact meaning of this allegory remains somewhat obscure. The statue presumably represents Artemis of the Ephesians. Whereas the Greek Artemis remained, above all, a goddess of chastity, her Ephesian counterpart was associated with various orgiastic activities. The flying figures above are bringing offerings to the goddess. The statues at the corners of the enclosed garden could represent the four elements of earth, water, fire and air. The two larger statues at the entrance to the garden appear to be those of Artemis holding a crescent moon and Pluto holding a mask. Between these two statues, on a circular platform, stand two figures which could be Adam and Eve. The five groups in the foreground, namely the musicians (see detail opposite), the man clutching a naked woman in a boat, the woman looking at herself in a mirror, the couple feasting and the figures in the ship with the vine bower, could be interpreted as the five senses.

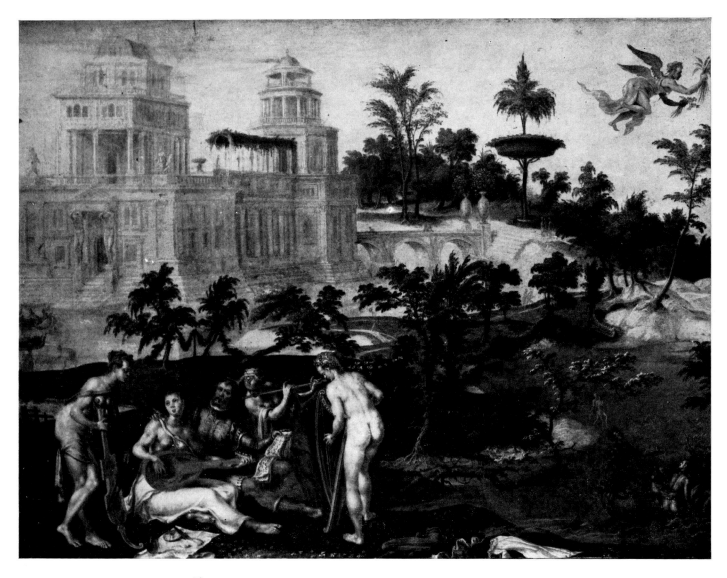

MARTEN VAN HEEMSKERK: *Natura*
Detail

JUSEPE DE RIBERA, LO SPAGNOLETTO: *Saint Bruno and another Carthusian in adoration before the infant Christ, with the Virgin and Saint Joseph*
$88\frac{1}{2} \times 75\frac{1}{2}$ in. (224 × 192 cm.)
Sold 8.12.72 for 70,000 gns. ($176,400)
From the collection of the late Oscar Falkman of Stockholm

PIETRO BERRETTINI, called PIETRO DA CORTONA: *The adultress before Christ*
58 × 89 in. (132 × 226 cm.)
Sold 8.12.72 for 30,000 gns. ($75,600)

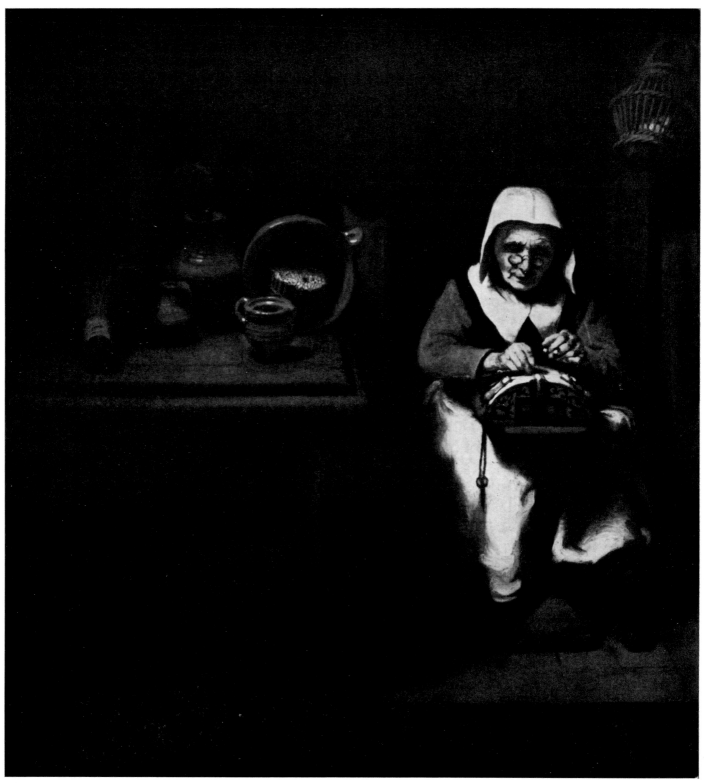

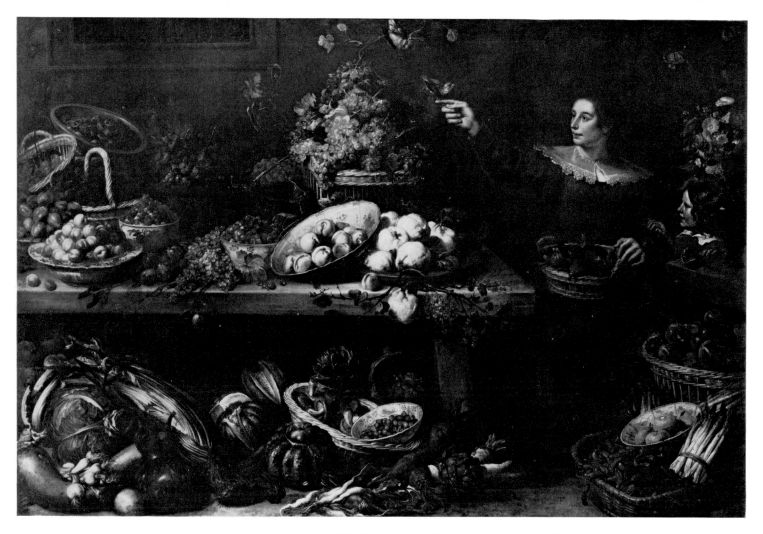

FRANS SNYDERS and CORNELIS DE VOS: *Still life of numerous bowls and baskets of fruit on a table*
Signed by Snyders
69 × 101 in. (175.1 × 256.4 cm.)
Sold 29.6.73 for 36,000 gns. ($94,500)

Opposite:
NICOLAES MAES: *Old lady making lace in a kitchen*
Signed, on panel
14½ × 13¼ in. (36.3 × 33.7 cm.)
Sold 29.6.73 for 100,000 gns. ($262,500)
From the collection of Mr and Mrs Stanley S. Wulc

JAN VAN GOYEN: *View of the Waal River near Hal Manor House*
Signed with monogram and dated 1652, on panel
$25\frac{1}{2} \times 38$ in. (64.8 × 96.5 cm.)
Sold 29.6.73 for 48,000 gns.
($126,000)

WILLEM VAN DE VELDE THE YOUNGER: *Coastal scene with Dutch fishing boats*
Signed, on panel
$14 \times 17\frac{1}{2}$ in. (35.5 × 44.4 cm.)
Sold 23.3.73 for 28,000 gns.
($70,560)
Record auction price for a work by this artist

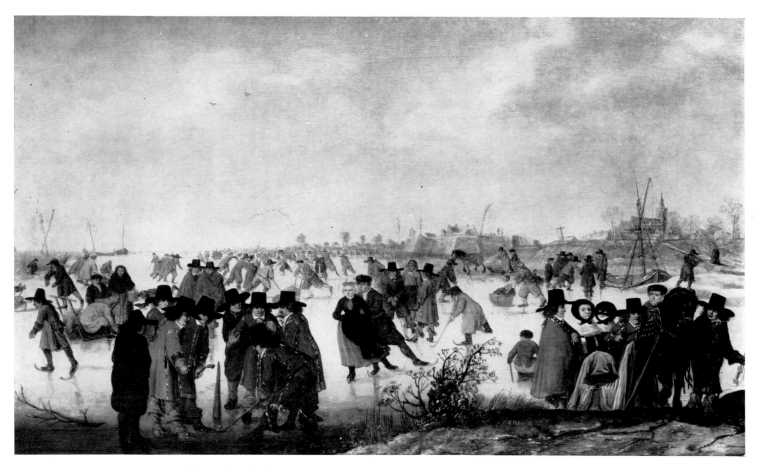

BARENT AVERCAMP: *Frozen river landscape*
Signed, on panel
$11\frac{1}{2} \times 20\frac{1}{2}$ in. (29.2 × 52 cm.)
Sold 8.12.72 for 48,000 gns. ($126,960)

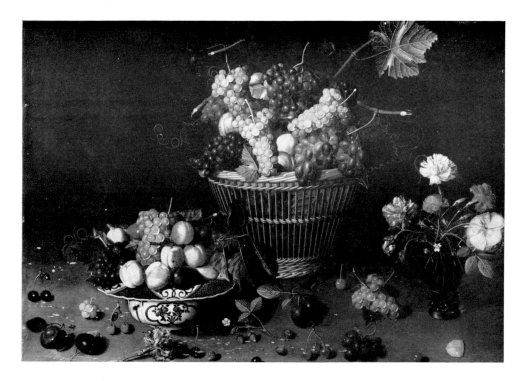

JAN SOREAU: *Basket of grapes and peaches, a bowl of plums, grapes and peaches, and a vase of flowers*
On panel
$29 \times 40\frac{1}{2}$ in. (73.6×102.8 cm.)
Sold 8.12.72 for 26,000 gns. ($65,520)
From the collection of
Mrs Norrie Wells

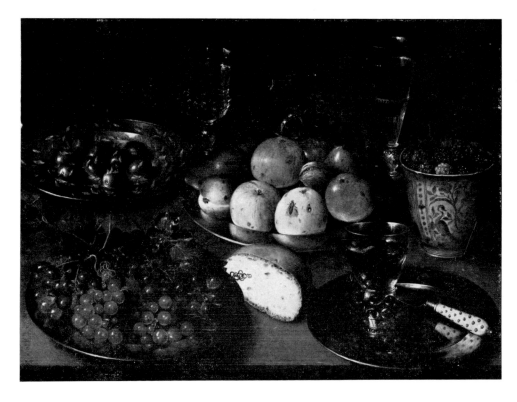

OSIAS BEERT THE ELDER: *Still life of blackberries in a Chinese Ming beaker, with grapes, apples and other fruit on pewter dishes, bread, a roehmer and two goblets on a table*
On copper
$17 \times 24\frac{1}{4}$ in. (43.2×61.5 cm.)
Sold 29.6.73 for 24,000 gns. ($63,000)
From the collection of Mr and
Mrs Stanley S. Wulc

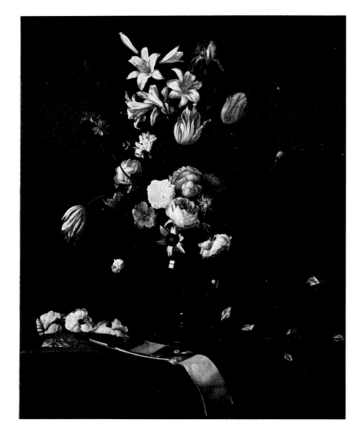

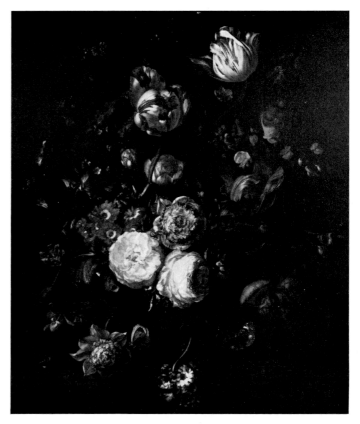

JEAN-MICHEL PICART: *Roses, tulips, a lily, an iris and other flowers in a glass jar*
$37\frac{1}{2} \times 30\frac{1}{2}$ in. $(95.3 \times 77.5$ cm.$)$
Sold 23.3.73 for 32,000 gns. ($80,640)

RACHEL RUYSCH: *Roses, tulips and other flowers in a vase on a ledge*
$24\frac{3}{4} \times 21\frac{1}{4}$ in. $(63 \times 54$ cm.$)$
Sold 23.3.73 for 30,000 gns. ($75,600)

JACOB VAN RUISDAEL: *Extensive woody landscape with cornfields*
Signed
18 × 21½ in. (45.7 × 54.6 cm.)
Sold 29.6.73 for 110,000 gns. ($288,750)

MEYNDERT HOBBEMA: *Woody landscape with a pool, cottages and peasants*
Signed, on panel
23 × 32 in. (58.4 × 81.2 cm.)
Sold 29.6.73 for 90,000 gns. ($236,250)

La Tour's 'Beggars' brawl'

WILLIAM MOSTYN-OWEN

The theme of the Blind Beggar is one that appeared in literature, painting and engraving in the Low Countries and in France during the 15th century. In particular, the blind beggar playing the hurdy-gurdy occurs in the paintings of Hieronymus Bosch and Pieter Brueghel and in such literary works as the *Chronique de Bertrand du Guesclin*:

> Ainsi vont li aveugles et li povres Truants . . .
> Car ils vont d'huis en huis leur instrument portant
> Et demandant leur pain. . . .

The theme seems to have been taken up in Lorraine and occurs frequently in the work of such artists as Callot and Bellange, due perhaps to Lorraine's geographical position as a kind of European cross-roads where many itinerant musicians and wandering beggars could be seen. Callot was to be followed by Georges de La Tour, a fellow artist from Lorraine whose work disappeared into oblivion in the 18th century and has only been re-discovered and re-assessed during the last forty years: an oblivion due in part to the small number of his works which have survived, in part to the lack of documentary information about his life, and in part to his working-class 'realism' which was unlikely to appeal to 18th-century courtly taste.

La Tour is perhaps best known for the nocturnal and candle-lit scenes from his later years. But in his earlier years he had produced a series of pictures of blind beggars and musicians depicted with almost distressing realism. One such painting (see illustration opposite) remained unknown in an English private collection until its re-discovery and publication in 1971 by Benedict Nicolson and Christopher Wright. Subsequently it was included in the exhibition of the artist's work at the Orangerie in Paris in the summer of 1972, and was then sent for sale by its owner on 8th December.

The intensity of despair and misery depicted in this picture is unforgettable. Probably dating from about 1630, and therefore ante-dating the spread of the Thirty Years' War into Lorraine by about five years, it is tempting, however, to read already in these faces the effects of that hideous and disastrous struggle, and to regard them possibly as refugees from Savoy or some other region of the war; and the tragic help-

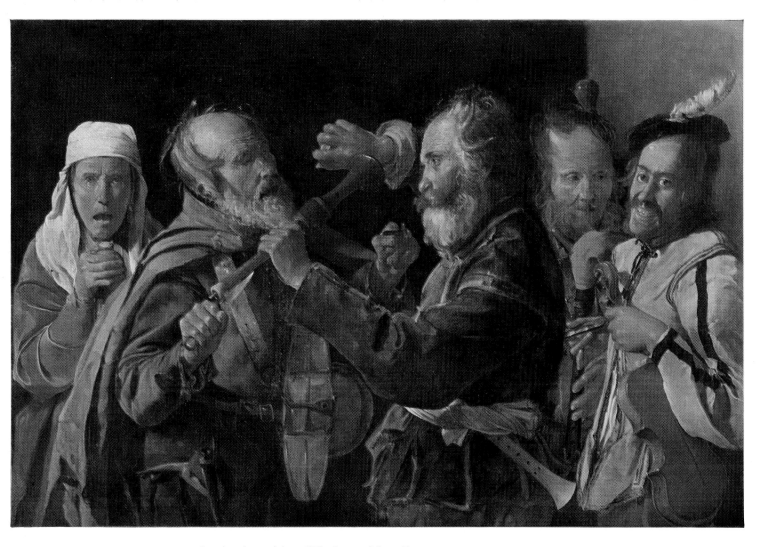

GEORGES DE LA TOUR: *La rixe de musiciens (The beggars' brawl)*
$37 \times 55\frac{1}{2}$ in. $(94 \times 141$ cm.$)$
Sold 8.12.72 for 380,000 gns. ($957,600)

lessness which scars the face of the old woman on the left is well summed up by a quotation from Dame Veronica Wedgwood's *Thirty Years' War*:

> Morally subversive, economically destructive, socially degrading, confused in its causes, devious in its course, futile in its result, it is the outstanding example in European history of meaningless conflict. The overwhelming majority in Europe . . . wanted no war; powerless and voiceless, there was no need even to persuade them that they did.

Canaletto's 'Campidoglio'

WILLIAM MOSTYN-OWEN

The choice of Canaletto's *View of the Piazza del Campidoglio* (see illustration opposite) to occupy an important place in the Fanfare for Europe exhibition held at Christie's by the London Fine Art Trade in January was particularly apt. The work of a Venetian artist depicting the former capitol of Rome, commissioned by an English collector and subsequently in private collections in Germany and Italy, it seemed the perfect choice for such an occasion. This was confirmed by its sale at a record price on 23rd March.

Canaletto is less well known for his Roman views, and indeed there is something of a mystery about his connection with Rome. He certainly visited the city as a young man, and some authorities think he paid a second visit in the 1740s. This is partly due to the fact that his best-known Roman pictures are a set of five views formerly in the collection of Consul Smith and now in the Royal Collection at Windsor, all of which are dated 1742.

Our picture came originally from a series of six commissioned by an English collector from Canaletto in 1754 to 1755 when the artist was in England. The collector in question was Thomas Hollis who, according to unconfirmed tradition, is depicted in the painting at the foot of the steps with his friend and eventual heir Thomas Brand, together with their servant and their dog. They had visited Venice in 1750 where they met Canaletto's patron Consul Smith and with whom Hollis subsequently kept up a correspondence after his return to England. Canaletto was not in Venice at that time, but it seems likely that he must have been recommended to Hollis by Smith.

Born in 1720, Hollis was a strong Radical and supported the cause of the American Colonies in their fight for independence. He was a rich man who travelled extensively and collected books, engravings and medals, a large number of which he gave to Harvard; indeed, one of the earliest Halls at Harvard is named Hollis Hall and was built in 1765. His fondness for 17th-century Republican literature and his habit of having engravings and the covers of his books depicted with daggers and caps of liberty led to his being labelled a Republican, but he only considered himself 'a true Whig' and adopted as his faith Lord Molesworth's preface to Hotomanus's *Franco-*

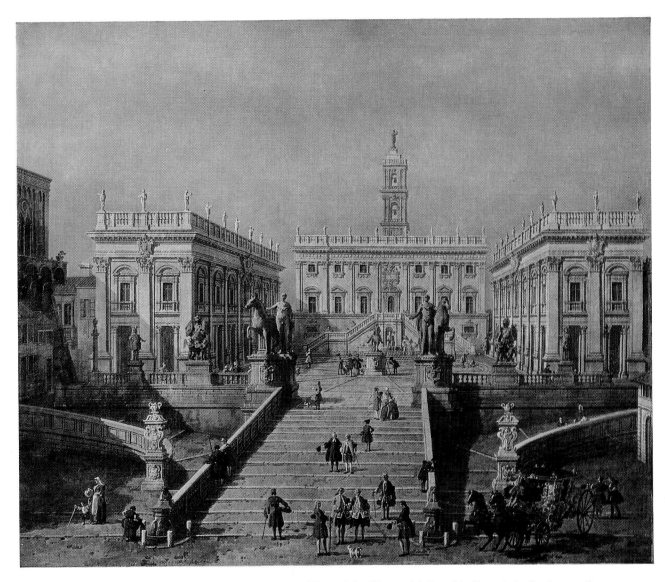

GIOVANNI ANTONIO CANAL, IL CANALETTO: *View of the Piazza del Campidoglio and the Cordonata, Rome*
20½ × 24 in. (52 × 60.9 cm.)
Sold 23.3.73 for 170,000 gns. ($428,400)

gallia. He attended no church and was consequently suspected of atheism, but his memoirs indicate that he was a man of unusual piety. He led the life of a recluse and abstained not only from intoxicating liquor, but also from butter, milk, sugar, spices and salt. In 1770 he left London and retired to a secluded farmhouse on his property at Corscombe in Dorset, where he died in 1774.

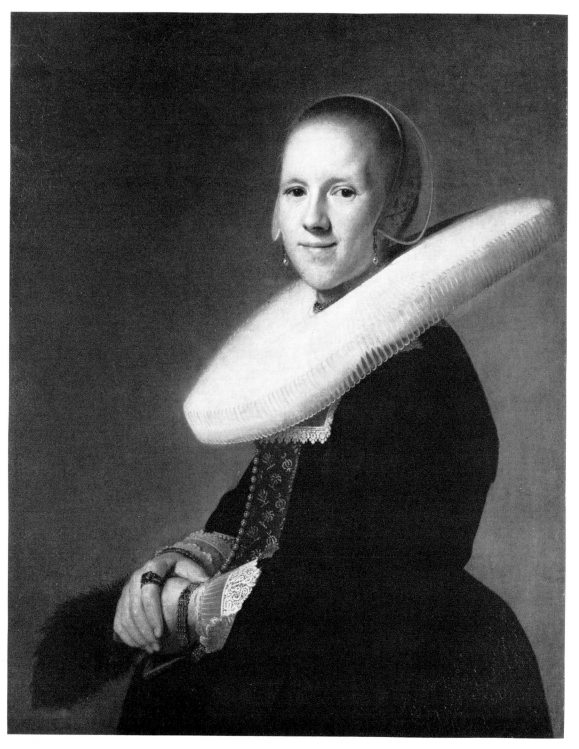

JOHANNES
CORNELISZ.
VERSPRONCK:
Portrait of a lady
Signed and dated
1641
$30\frac{1}{2} \times 25\frac{1}{2}$ in.
(76.8 × 57.1 cm.)
Sold 29.6.73 for
35,000 gns. ($91,875)

JEAN-BAPTISTE-
SIMEON CHARDIN:
Still life
Signed
$15\frac{1}{2} \times 13$ in.
(39.4×33 cm.)
Sold 29.6.73 for
38,000 gns. ($99,750)
From the collection
of the late Sydney
J. Lamon

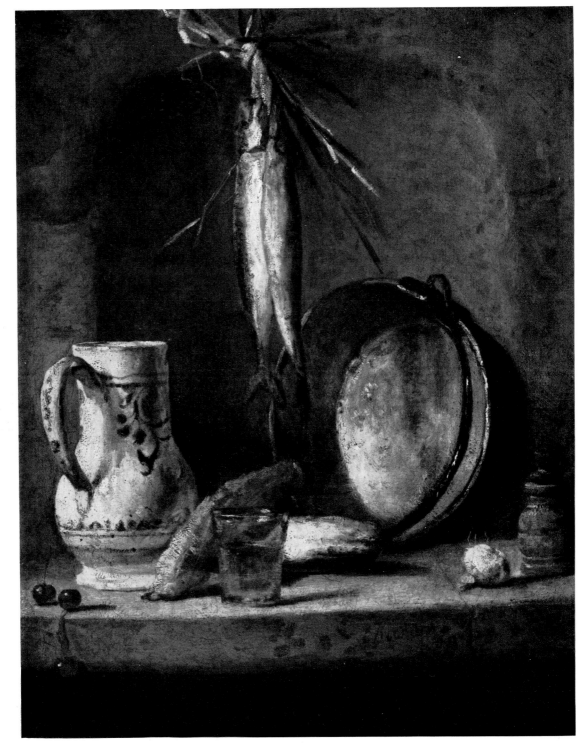

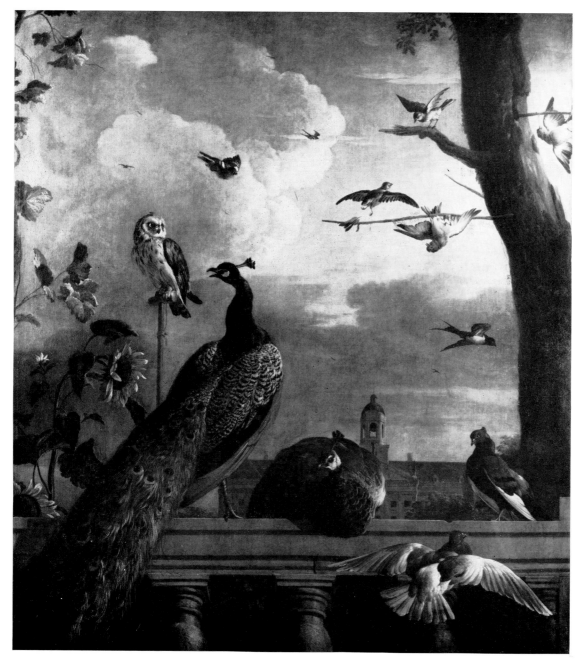

MELCHIOR D'HONDECOETER: *Peacocks on a balcony, pigeons, an owl, and other birds*
Signed and dated 1670
$71\frac{1}{2} \times 62\frac{1}{2}$ in. (181.5×158.6 cm.)
Sold 29.6.73 for 34,000 gns. ($89,250)

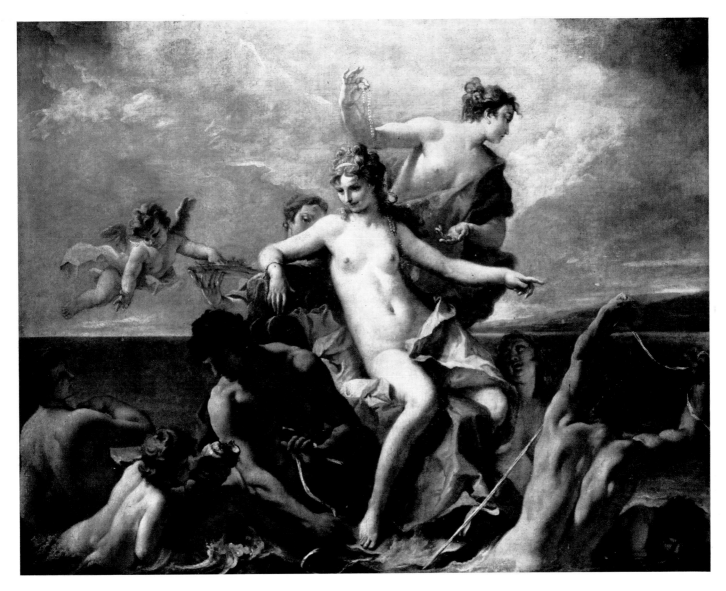

SEBASTIANO RICCI: *Triumph of the Marine Venus*
63 × 83 in. (159.9 × 210.7 cm.)
Sold 8.12.72 for 18,000 gns. ($45,760)
Now in the J. Paul Getty Museum, Malibu, California

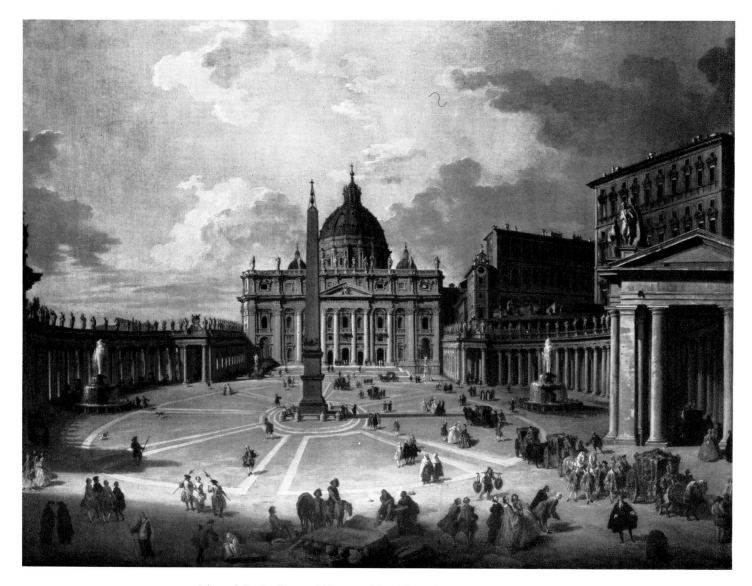

GIOVANNI PAOLO PANNINI: *View of the Basilica and Piazza of San Pietro, Rome*
Signed with initials and dated .754
$28\frac{1}{2} \times 38\frac{1}{2}$ in. (72.3 × 97.7 cm.)
Sold 23.3.73 for 45,000 gns. ($113,400)
From the collection of Cater Ryder & Co Ltd

ENGLISH AND CONTINENTAL PICTURES

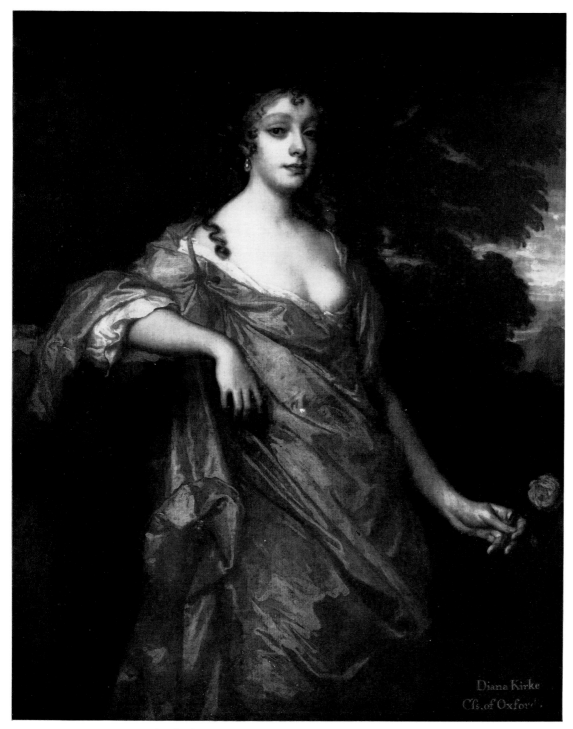

SIR PETER LELY: *Portrait of Diana Kirke, Countess of Oxford*
Inscribed, 52 × 41 in. (131.9 × 104.1 cm.)
Sold 6.4.73 for 15,000 gns. ($37,800)

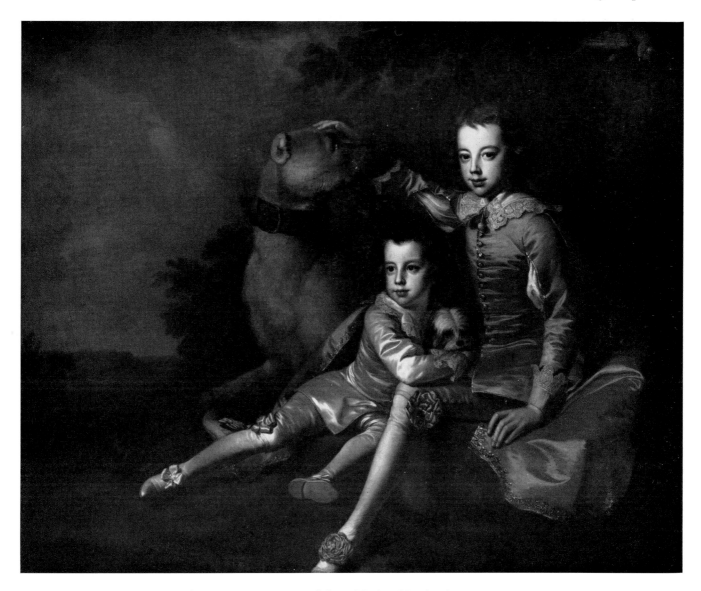

THOMAS HUDSON: *Portraits of John and Robert, sons of the 2nd Duke of Roxburgh*
Signed and dated 1752
53 × 65½ in. (134.5 × 166.2 cm.)
Sold 6.4.73 for 16,000 gns. ($40,320)
From the collection of Mrs Nancy Lancaster
Record auction price for a work by this artist

Two paintings of ship portraits and shipyards on the Thames in the 18th century

EDWARD H. H. ARCHIBALD

Once patronage of the fine arts spread from the aristocrats to the merchants, in the early part of the 18th century, it is possible for us to see for the first time, through the eyes of the painters they commissioned, something of their works and interests. In the case of London's ship-owners and ship-builders, two artists made a speciality of ship portraits and shipyard scenes on the Thames: John Cleveley and Francis Holman.

The Cleveley family lived at Deptford, where John Cleveley was a shipwright in the Royal Dockyard. He was born about 1712, which probably makes him ten or fifteen years Holman's senior. We have no dates of their births, but there are numerous Cleveleys dated in the late 1740s, while the earliest Holmans date from the 1760s.

The work of Francis Holman, especially in his shipyard scenes, bears so many resemblances to Cleveley's that it is tempting to believe that Holman was his pupil. Certainly Cleveley's studio was an art school for his sons Robert, John and James. When Holman was established he lived at Wapping and Shadwell, and was the master of Thomas Luny.

Much of what these two painters had to offer their customers can be seen in the two paintings illustrated opposite and on page 50.

First of all the Cleveley; here is an unusually uncompromising three-position ship portrait, set against a background of a private yard. The composition as regards the ship hardly avoids the appearance of a dressed-up builder's draught, and on the evidence of other similar paintings, a composition probably dictated by the ship's owner, rather than Cleveley's artistry.

The ship is a typical mid-18th-century Indiaman of about 700 tons, armed on the lines of a contemporary naval sixth rate. That is to say with only two guns in a tier on the gun-deck, set aft, and a loading port forward. The main battery is on the upper deck, probably 9 pounders, while since she is much bigger than a sixth rate, she can carry guns on her quarter-deck, and a coach or round-house aft, with the saloon for the passengers and officers. These ships were the finest merchantmen in the world, and Cleveley proudly portrayed them correct to the last rope, as well he could, and as well he must, for his patrons would notice a rope out of place.

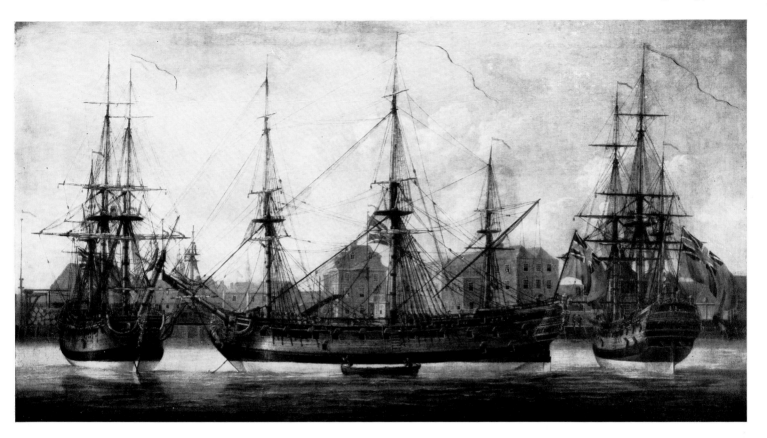

JOHN CLEVELEY: *East Indiaman in three positions in the Thames*
Signed, c. 1750
29 × 55 in. (73.7 × 139.6 cm.)
Sold 22.6.73 for 8500 gns. ($22,312)

Many of Cleveley's pictures are of occasions of the launch of naval ships at Deptford, and it is a measure of his meticulous observation that the tree beside the chief shipwright's house grows with the advancing dates of the paintings.

While it is easy to recognize the royal dockyards, the private ones present more, and often insuperable, difficulties of identification. In this particular painting two church towers can be seen through the ship's rigging, so perhaps this picture may give up its secrets.

In the shipyard scene by Holman, another private yard is seen, and here no notable spires protrude above the houses to give a clue to the location. Two of the ships in the picture are named, the *William and Elizabeth* on the right, and the *John* in the middle. The one on the left is not named, which is a pity, since she wears a Royal Naval jack and must be much better recorded than the two merchantmen.

The hats of the two ladies in the wherry indicate a date about 1770, and in Lloyd's

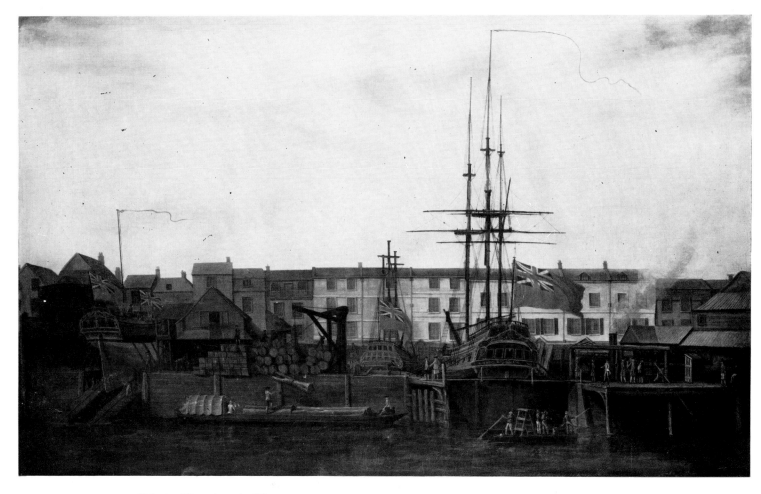

FRANCIS HOLMAN: *Private shipyard on the Thames*
c. 1770. $31\frac{1}{2} \times 50$ in. (80 × 126.9 cm.)
Sold 22.6.73 for 9000 gns. ($23,625)
Now in the Tate Gallery

Lists for that period there is a ship called the *William and Elizabeth* built by Maitland and Co., and the place of building 'River', which means the Thames. There is the name Morley, Sailmaker, on one of the houses, so this picture too may give up its secrets.

Altogether the wealth of information about the river left to us by these two artists is somewhat tempered by the lack of contemporary titles. They probably thought everybody knew.

There was a third artist working in the mid-18th century making equally valuable recordings. His name was John Hood and he specialized in large pen-and-wash drawings in monochrome.

WILLIAM and
HENRY BARRAUD:
Mr Samuel A. Reynell,
Master of the
West Meath hounds
$40\frac{1}{2} \times 65\frac{1}{2}$ in.
$(102.8 \times 166.8$ cm.)
Sold 24.11.72 for
8500 gns. ($21,420)

ARTHUR DEVIS:
Group portrait of
Mr Edward Holt and
two gentlemen seated
round a table in the
garden of Ince Hall,
nr. Wigan
18×29 in.
$(45.7 \times 73.7$ cm.)
Sold 24.11.72 for
9500 gns. ($23,940)

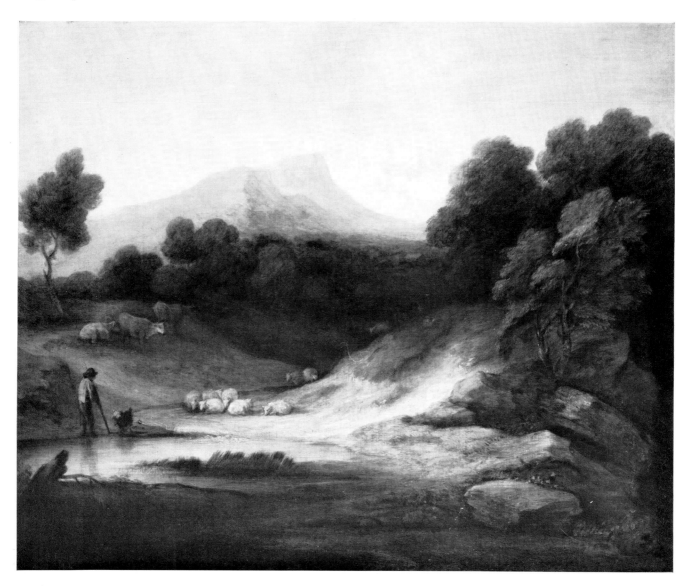

THOMAS GAINSBOROUGH, RA: *Wooded landscape in the Lake District*
Signed with initials and dated 1784
$46\frac{1}{2} \times 58\frac{1}{4}$ in. (118×148 cm.)
Sold 24.11.72 for 36,000 gns. ($90,720)
From the collection of Mr and Mrs Eugene Ferkauf of New York

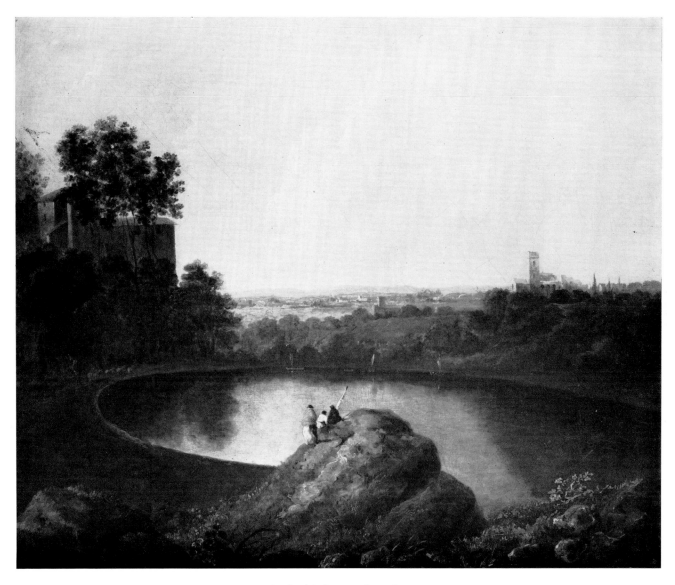

RICHARD WILSON: *View of the head of Lake Nemi with Gensano beyond*
24 × 29 in. (60.9 × 73.6 cm.)
Sold 22.6.73 for 60,000 gns. ($157,500)
Record auction price for a work by this artist

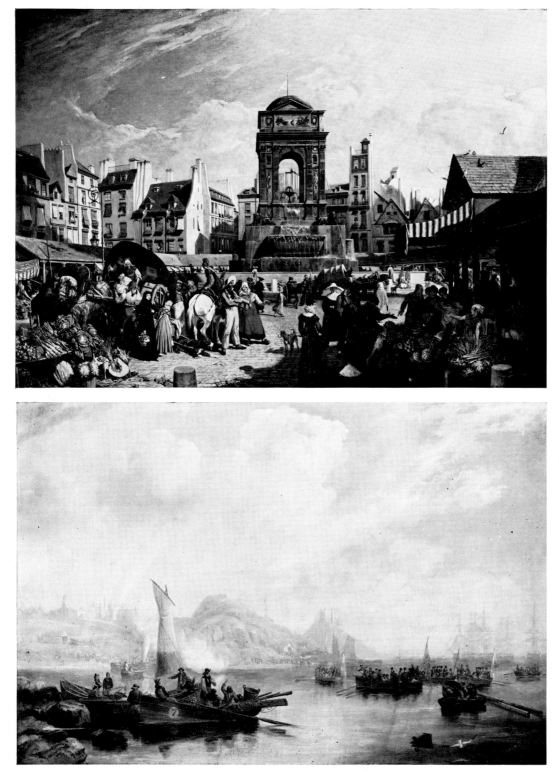

JOHN JAMES CHALON,
RA: *View of the market
and Fountain of the
Innocents, Paris*
Signed and dated 1822
41 × 59½ in.
(104.1 × 151.1 cm.)
Sold 15.12.72 for
10,000 gns. ($25,200)
Record auction price for a
work by this artist

JOHN WILSON
CARMICHAEL:
*Holy Island, Northumberland
October 22, 1839*
Signed and dated 1840
41½ × 62½ in.
(105.4 × 158.6 cm.)
Sold 16.3.73 for
7000 gns. ($17,640)
Record auction price for a
work by this artist

EDWARD LEAR:
*View of the Forest of
Bavella, Corsica*
Signed with
monogram
36 × 58 in.
(91.4 × 147.2 cm.)
Sold 16.3.73 for
7500 gns. ($18,900)
Record auction price
for a work by this
artist

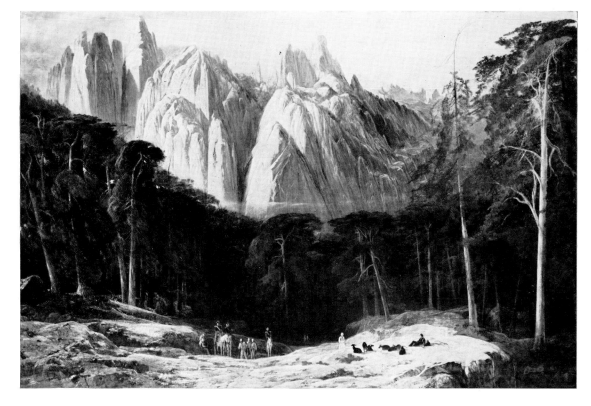

JOHN MARTIN:
*View near Pembroke
Lodge, Richmond Park*
Signed and dated 1850
20 × 36 in.
(50.8 × 91.4 cm.)
Sold 15.6.73 for
7000 gns. ($18,375)
From the collection
of P. E. Satchell, Esq

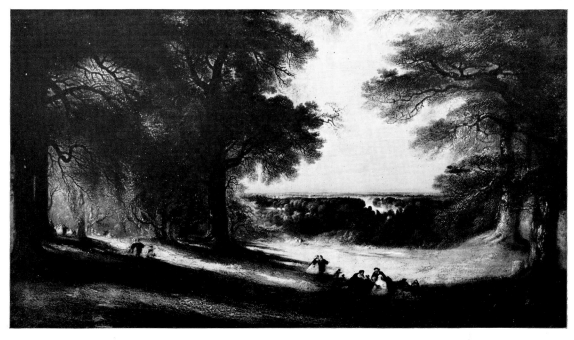

Walter Howell Deverell— the forgotten Pre-Raphaelite

CHRISTOPHER WOOD

Deverell's career is one of the minor tragedies of the Pre-Raphaelite story. He is forgotten today because he died in poverty at the age of only 26, leaving about eight finished paintings. One of the best known of these, a scene from *Twelfth Night* (see illustration opposite), was sold in our Victorian picture sale in December 1972 for £12,600 ($30,240). Painted in 1850, the picture and the circumstances surrounding it are part of the legend of the Pre-Raphaelite Brotherhood. Elizabeth Siddall posed for the figure of Viola on the left. It was the first picture in which she was used as a model by the Pre-Raphaelites, and it was Deverell who found her working in a shop in the Strand. Rossetti sat for the Jester, and Deverell himself for the Prince in the middle of the group. Deverell and Rossetti shared a studio for a time at 17 Red Lion Square – the same one later used by Morris and Burne-Jones – and so it may well have been Deverell who made the fateful introduction between Rossetti and Lizzie Siddall.

Deverell was born of English parents in Virginia, U.S.A., in 1827. By 1829 his family were back in London, and they later sent him to study at Sass's Drawing School, where he first met Rossetti. Together they discussed the idea of a sketching club, but in the end Deverell never became a member of the Brotherhood. He knew them, contributed to the *Germ*, and in 1850 was about to be elected a member in place of James Collinson. But the election never took place.

Some time after this Deverell's father must have died, because he was forced to support his mother and sisters. In doing so he completely overworked himself, and his health broke down. Rossetti, Millais, Ruskin and others visited him in his poverty-stricken lodgings, where he died in 1854, drawing and sketching in bed up to the last moment. He left two unfinished pictures, entitled ironically *The doctor's last visit* and *Children watching a funeral*. Millais bought another of his pictures *The pet* from Deverell's family. This is perhaps the only well-known picture by Deverell, and is now in the Tate Gallery. Rossetti was so moved by Deverell's death that he could not bring himself to go to the funeral. He wrote to Deverell's brother 'I have never yet had to bear a loss so great to me as that of your brother'.

In a way the death of Deverell was the final scene of the Pre-Raphaelite story. By 1854 Woolner was in Australia, Hunt in the Middle East, Millais had become an

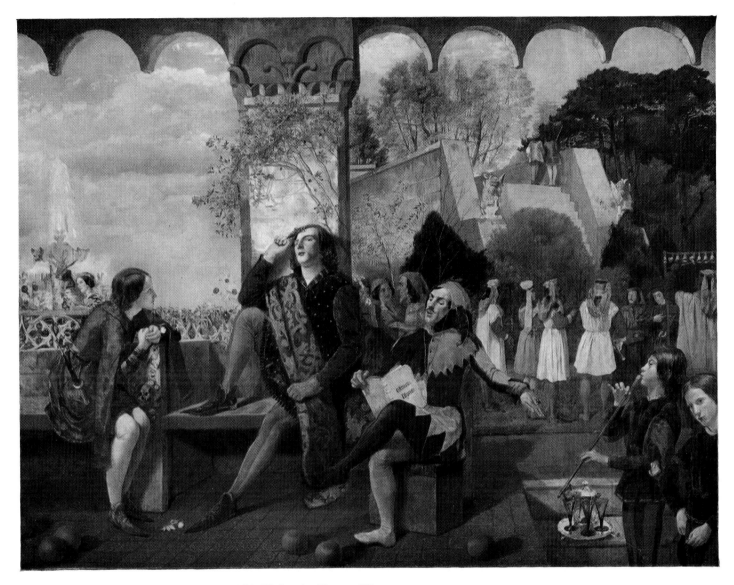

WALTER HOWELL DEVERELL: *Twelfth Night, Act II scene IV*
$40\frac{1}{4} \times 52\frac{1}{2}$ in. (102.3 × 133.4 cm.)
Sold 15.12.72 for 12,000 gns. ($30,240)
From the collection of the late William Edmondson, Esq

A.R.A., and Rossetti had written to his sister Christina 'So now the whole Round Table is dissolved'. Deverell's death must have seemed to Rossetti the end of an era, and he wrote to Woolner 'if I live even to middle age, his death will seem to me a grief of my youth'.

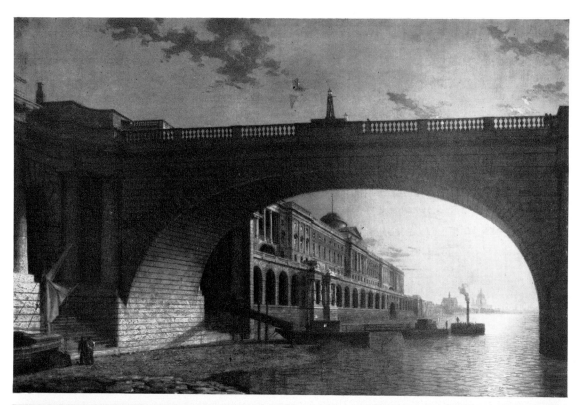

HENRY PETHER:
Moonlit view of Somerset House
Signed
$23\frac{1}{2} \times 35$ in.
(59.7 × 88.9 cm.)
Sold 16.3.73 for
7500 gns. ($18,900)
From the collection of
Paul Stobart, Esq
Record auction price
for a work by this
artist

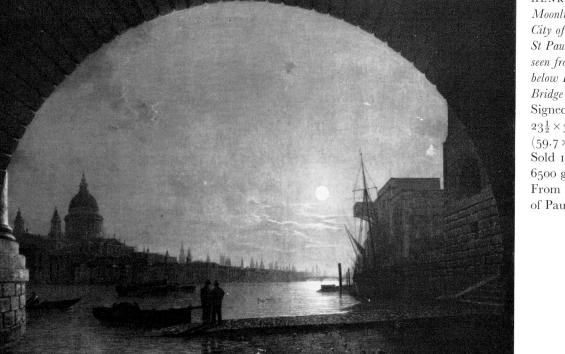

HENRY PETHER:
*Moonlit view of the
City of London and
St Paul's Cathedral,
seen from the foreshore
below Blackfriars
Bridge*
Signed
$23\frac{1}{2} \times 35$ in.
(59.7 × 88.9 cm.)
Sold 16.3.73 for
6500 gns. ($16,380)
From the collection
of Paul Stobart, Esq

ABRAHAM SOLOMON:
Waiting for the verdict
Signed and dated 1859
24 × 29½ in. (61 × 75 cm.)
Sold 15.12.72 for 2800 gns. ($7056)

ABRAHAM SOLOMON: *The acquittal*
Signed and dated 1859
24 × 29½ in. (61 × 75 cm.)
Sold 15.12.72 for 3000 gns. ($7560)

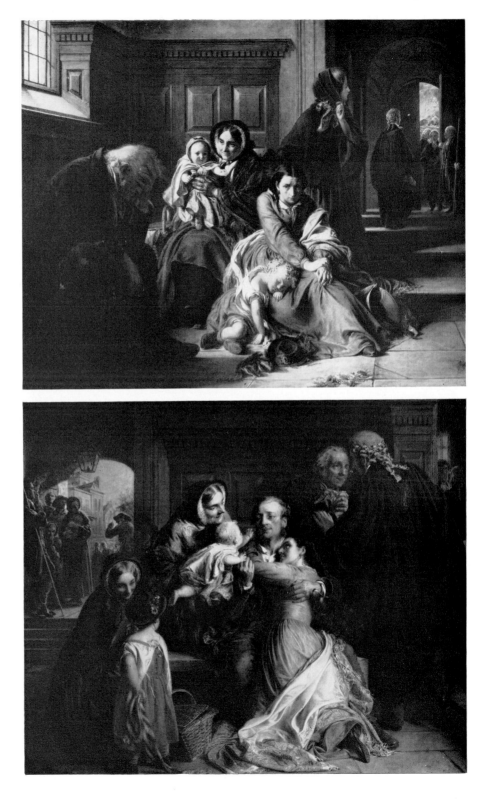

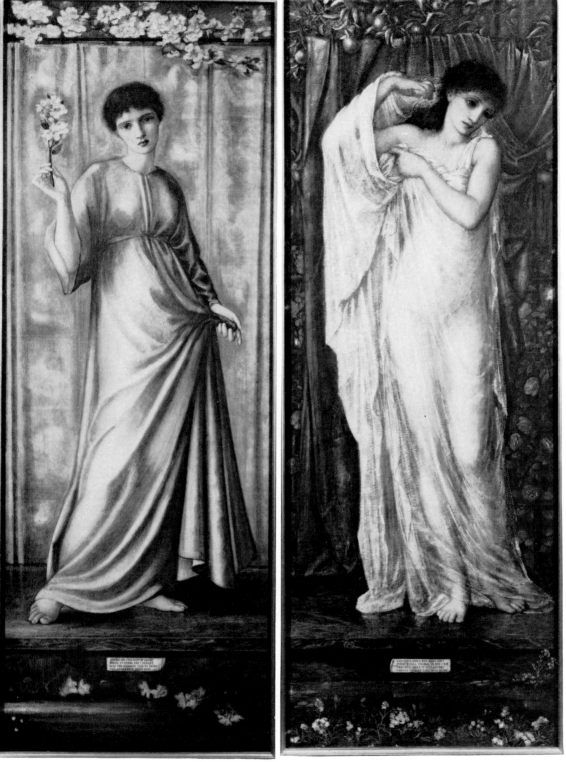

SIR EDWARD
COLEY BURNE-
JONES, BT, ARA:
Spring
Gouache
$48 \times 17\frac{1}{4}$ in.
(122×43.8 cm.)
Sold 15.6.73 for
7000 gns. ($18,375)

SIR EDWARD
COLEY BURNE-
JONES, BT, ARA:
Summer
Signed with initials
and dated
MDCCCLXX
Gouache
$48 \times 17\frac{1}{4}$ in.
(122×43.8 cm.)
Sold 15.6.73 for
11,000 gns. ($28,875)

SIR EDWARD
COLEY BURNE-
JONES, BT, ARA:
Autumn
Gouache
$48 \times 17\frac{1}{4}$ in.
(122×43.8 cm.)
Sold 15.6.73 for
6000 gns. ($15,700)

SIR EDWARD
COLEY BURNE-
JONES, BT, ARA:
Winter
Signed and dated
MDCCCLXX
Gouache
$48 \times 17\frac{1}{4}$ in.
(122×43.8 cm.)
Sold 15.6.73 for
12,000 gns. ($31,500)

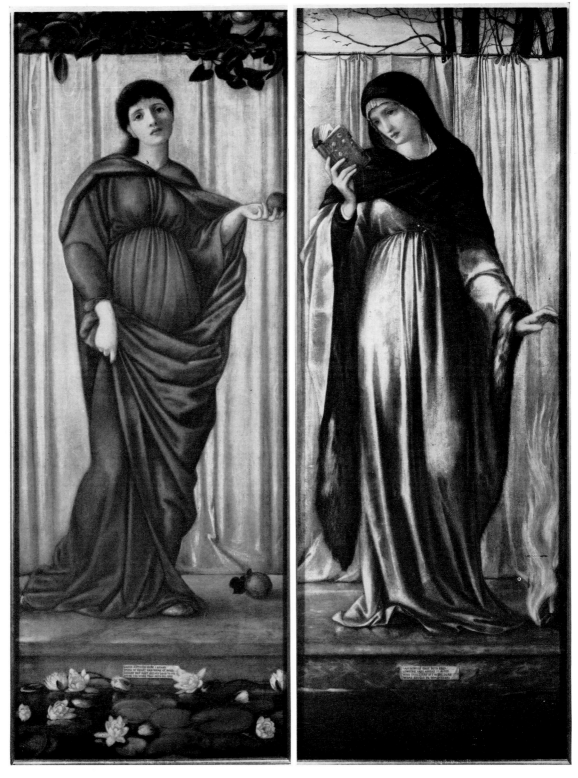

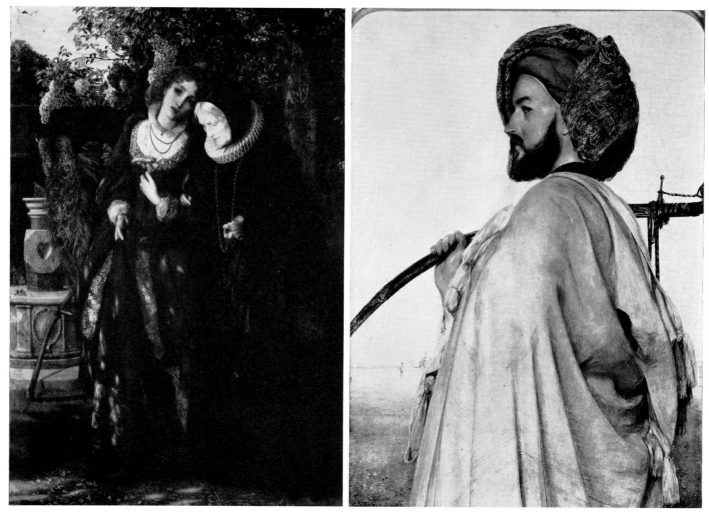

ARTHUR HUGHES: *Silver and gold*
Signed
39 × 26 in. (99 × 66 cm.)
Sold 15.12.72 for 6500 gns. ($16,380)
From the collection of Lt.-Colonel L. H. Trist, DSO

JOHN FREDERICK LEWIS, RA:
A Mameluke, Egypt
Signed and dated 1868, on board
13½ × 9½ in. (34.3 × 24.1 cm.)
Sold 15.6.73 for 6500 gns. ($17,062)

SIR JOHN EVERETT
MILLAIS, BT, PRA:
*Twa bairns—portrait of
Frederick and Mary
Phillips*
Signed with monogram
and dated 1888
52 × 39 in.
(131.9 × 99 cm.)
Sold 15.6.73 for
9000 gns. ($23,625)
From the collection of
E. G. Millais, Esq,
grandson of the artist

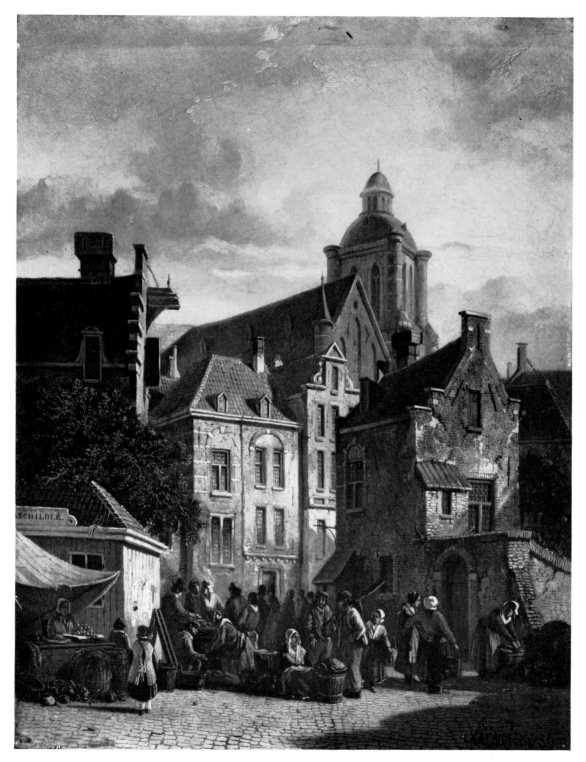

ADRIANUS
EVERSEN:
*Street scene in
Amsterdam on market
day*
Signed and dated '54,
on panel
16½ × 13½ in.
(41.9 × 34.3 cm.)
Sold 4.5.73 for
6500 gns. ($17,062)

JACQUES CARABAIN:
View of the River Moselle at Cochem
Signed; and signed, dated
16 Mars 1868, and inscribed
on an old label on the reverse
31 × 42½ in. (78.7 × 108 cm.)
Sold 4.5.73 for 8500 gns.
($22,302)

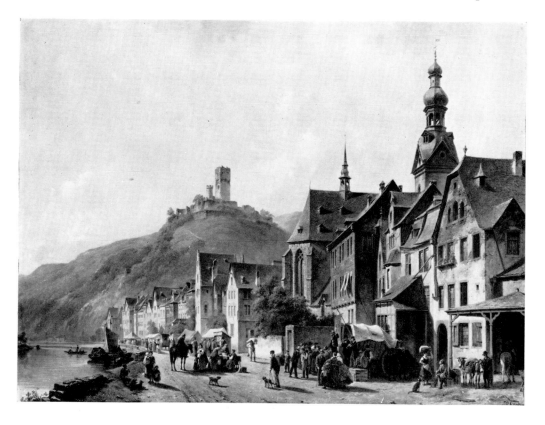

HERMAN TEN KATE:
The new recruit
Signed
16 × 26½ in.
(40.6 × 67.3 cm.)
Sold 4.5.73 for 6000 gns.
($15,750)
Record auction price for a
work by this artist

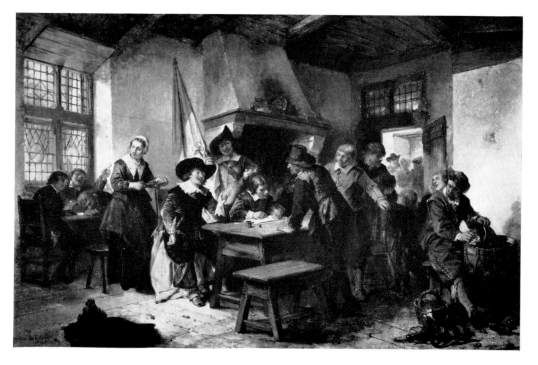

65

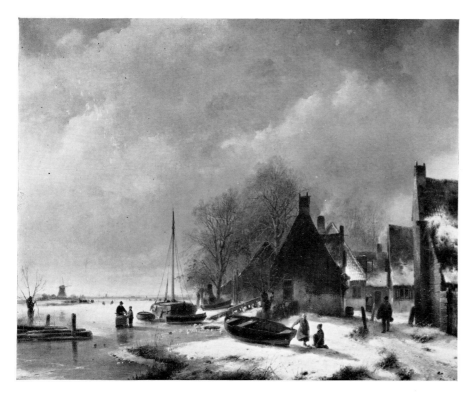

ANDREAS SCHELFHOUT:
Frozen river landscape
Signed
$25\frac{1}{2} \times 33$ in. (64.8 × 83.8 cm.)
Sold 4.5.73 for 24,000 gns. ($63,000)

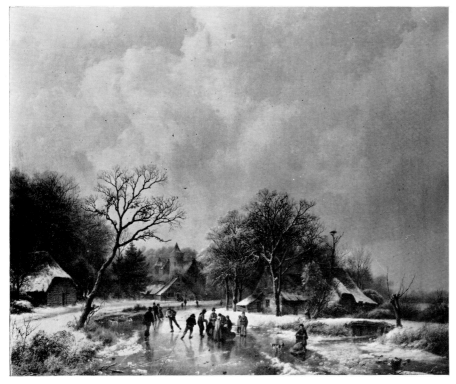

BAREND CORNELIS KOEKKOEK:
Wooded winter landscape
Signed and dated 1839
$26 \times 32\frac{1}{2}$ in. (66 × 82.6 cm.)
Sold 19.1.73 for 32,000 gns. ($80,640)
Record auction price for a work by a
member of the Koekkoek family

OLD MASTER AND
ENGLISH DRAWINGS
AND WATERCOLOURS

Drawings and the development of taste

FRANCIS RUSSELL

The history of drawings and their collection affords a fascinating microcosm of the changing climate of aesthetic taste. For drawings have been collected systematically since the time of Vasari in the 16th century and, as many of the great collectors have used marks or stamps of one kind or another to identify their possessions, the provenance of these is easily recognized. Many painters were avid collectors themselves, and Prosper Henry Lankrinck and Sir Peter Lely, Richard Gibson, Jonathan Richardson and Sir Joshua Reynolds, Nathaniel Hone, Paul Sandby, Richard Cosway and Sir Thomas Lawrence are but some of the artists who owned Old Master drawings sold in our last season. The role of amateurs whose collections were represented was equally impressive with Nicholas Lanière and Padre Resta, Crozat, Skippe and Udny, each in his way a remarkable connoisseur, not to mention such aristocratic figures as Somers, Warwick and Spencer.

Great collections of the past are represented in every drawings sale, but it is most unusual for an auction to throw so much light on the evolution of connoisseurship as that which was held in March. The sale began with a series of drawings from an album compiled for the Marchese del Carpio, one of the greatest Spanish administrators of the 17th century and an outstanding collector, whose drawings complemented a splendid gallery of pictures; these included Velazquez' *Rokeby Venus*, three El Grecos, among them *The Adoration of the Name of Jesus* – now in the National Gallery – and the companion *Espolio* at Upton, and the *Alba Madonna* of Raphael at Washington. Among the most impressive of the Carpio drawings we sold were seven views of Roman monuments which offer new evidence of the early development of the Genoese painter Giovanni Benedetto Castiglione. These may have been obtained at Rome, but the remarkable group of sheets by Neapolitan artists was clearly acquired while Carpio was Viceroy at Naples between 1682 and 1687. Notable among these were five sketches by Corenzio, one of the most wayward of Seicento draughtsmen, and an important group of studies by Aniello Falcone, best known for his pictures of battle scenes. As only three of his landscape drawings were previously known, the seven from the album were of particular interest. One, a view of the Roman baths at Pozzuoli (see illustration page 73) is Falcone's only known

SCHOOL OF
NUREMBERG:
*Christ on the Cross with
the Virgin, St John the
Evangelist and
Bishop Hugo von
Hohen-Landenberg
kneeling at the foot of
the Cross*
c. 1515
Bodycolour heightened
with gold on vellum
$16\frac{1}{8} \times 11\frac{3}{8}$ in.
(40.9 × 28.9 cm.)
Sold 20.3.73 for
24,000 gns. ($60,480)
From the collection of
The Lord Margadale of
Islay, TD

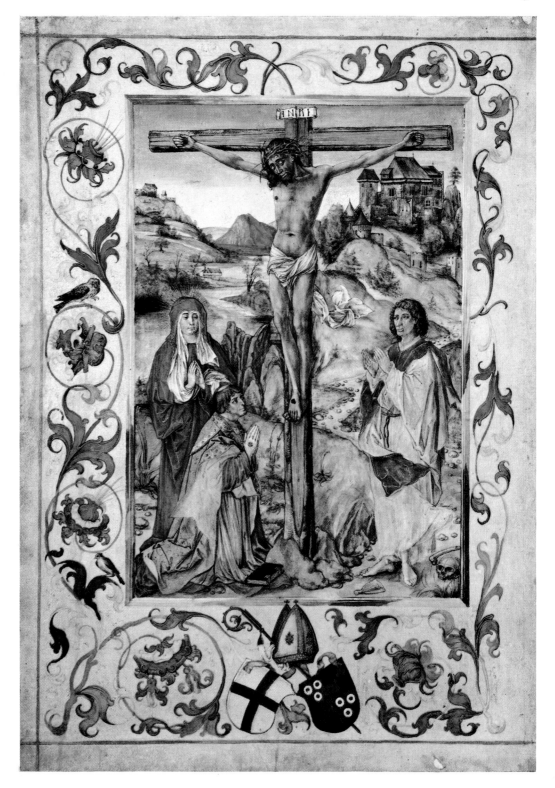

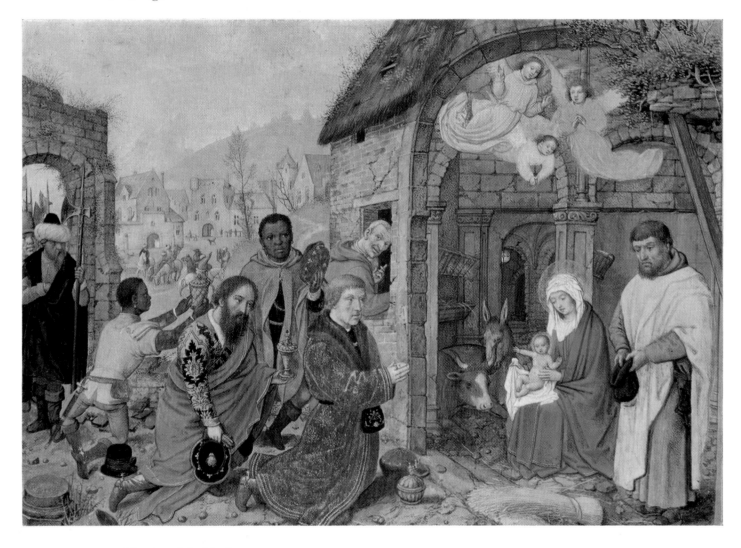

SIMON BENING: *Adoration of the Magi*
Bodycolour heightened with gold on vellum
$6\frac{1}{8} \times 8\frac{5}{8}$ in. (15.6 × 21.9 cm.)
Sold 20.3.73 for 19,000 gns. ($47,880)
From the collection of The Lord Margadale of Islay, TD

ANIELLO FALCONE: *Landscape with trees by a water wheel and a building behind*
With Carpio atttibution 'A. falcone' on the mount
Red chalk
$6\frac{1}{4} \times 8\frac{1}{2}$ in. (15.9 × 21.7 cm.)
Sold 20.3.73 for 1300 gns. ($3276)

venture of the kind in pen and ink, and implies some knowledge of Brill's drawings; his delicate impressions of classical ruins and cliffs in red chalk are also eloquent of the impact of the North on Neapolitan culture, while the beautifully informal yet strangely evocative study of a mill (see illustration above) places the painter as a southern ancestor of Watteau.

Despite a wealth of material of the period, collections of the 18th century were only represented by scattered sheets. These, however, included a drawing by Watteau that was owned by the younger Richardson. 19th-century taste was more fully documented, a number of Dutch and Flemish drawings illustrating the interests of an artist of modest means. These came from an album compiled by the painter Richard Buckner, whose own collector's mark, long misattributed, was securely identified for the first time in our catalogue.

Two exceptionally fine illuminations from the extraordinary assemblage of works of art of every kind formed by Alfred Morrison at Fonthill and now sent for sale by Lord Margadale, testified to the vigour of a great Victorian collector. Of the two, the more instant in appeal was the *Adoration of the Magi* by Simon Bening (see illustration opposite) which was a beautiful interpretation of the composition originally

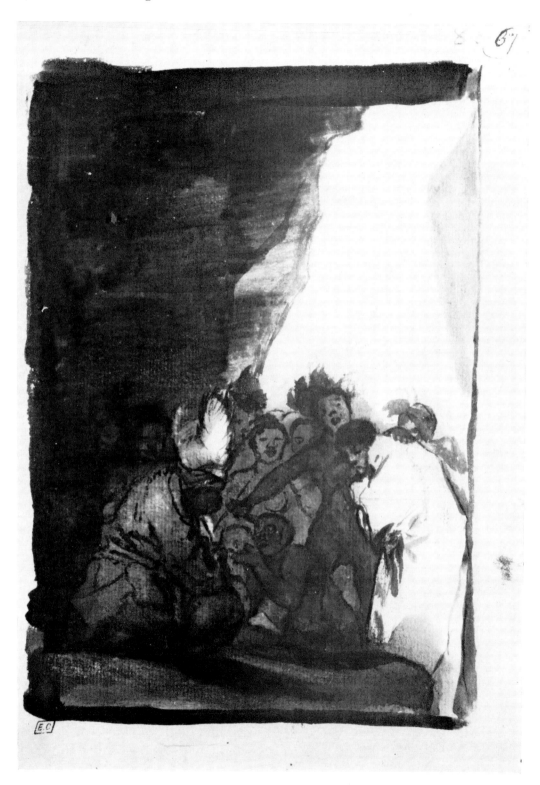

FRANCISCO GOYA
Y LUCIENTES:
*Monk brought to an
Indian chief at the
entrance of a cave*
Numbered 83 in brush
and brown ink by the
artist, and 67 by a
later hand
Brown wash
$8 \times 5\frac{1}{2}$ in. (20.4×14.1 cm.)
Sold 20.3.73 for
36,000 gns. ($90,720)

ANIELLO FALCONE: *View of the Roman ruins at Pozzuoli*
Inscribed 'A.F. a Pozzuolo' with Carpio attribution 'falcone' on the mount
Pen and brown ink, brown wash
$7\frac{1}{4} \times 10\frac{5}{8}$ in. (18.4 × 27 cm.)
Sold 20.3.73 for 750 gns. ($1890)

evolved by Hugo van der Goes and transmitted through the medium of a derivation at Munich ascribed to Gerard David; however, the Nuremberg School *Crucifixion* (see illustration page 69) was the more penetrating, with its tension of emotion fused against one of the loveliest of late Gothic landscapes. By an artist in Dürer's immediate circle and executed as a canonblatt of a missal for a prominent patron of the time, Bishop Hugo von Hohen-Landenberg, who himself kneels before the Cross, the *Crucifixion* is surely one of the noblest things of its kind to have appeared in the saleroom for many years.

The Morrison illuminations which illustrated so perfectly the Victorian rediscovery of the northern Renaissance were followed by drawings from two 19th-century French collections. That of the Parisian connoisseur Calando was represented by the wonderful Goya drawing of a *Monk brought to an Indian chief at the entrance of a cave* (see illustration opposite). Its strong brown wash inevitably evoked comparison with Rembrandt and the sketch was but one of a group of this kind which appeared at Calando's sale in Paris in 1899.

Two years earlier the great collection of the Goncourt brothers who did so much to revive interest in French art of the 18th century had been auctioned. Three drawings sold then were included in the March sale: the engaging Huet of an

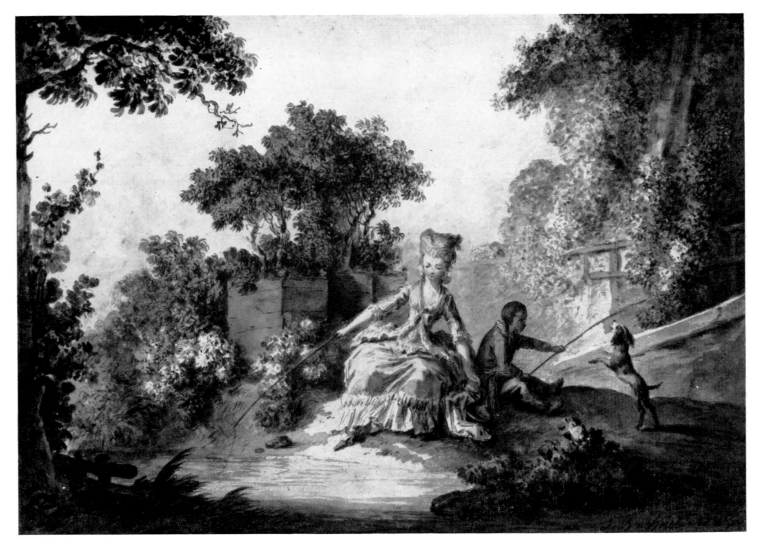

JEAN BAPTISTE HUET:
Elegant young lady angling
Signed and dated 1783
Pencil and watercolour on
paper watermarked C. & J.
Honig
$7\frac{7}{8} \times 11\frac{5}{8}$ in. (20 × 29.5 cm.)
Sold 20.3.73 for 2600 gns.
($7552)

Elegant young lady angling (see illustration above), a masterly Trinquesse (see illustration opposite) and a Hubert Robert landscape. These belonged to a fine group of 18th-century drawings all by French artists, with the exception of a late Guardi, and came from an anonymous collection formed in the 1930s. The quality of this group was a tribute to the best standards of pre-war connoisseurship. The prices realized for drawings of this kind, for example the enchanting Robert of children under an archway (see illustration opposite), marked yet another revival of interest in what had until recently been a flagging field. The success of the auction proved once again that the saleroom provides a fascinating commentary on the history of the evolution of taste and a unique forum for its continued development.

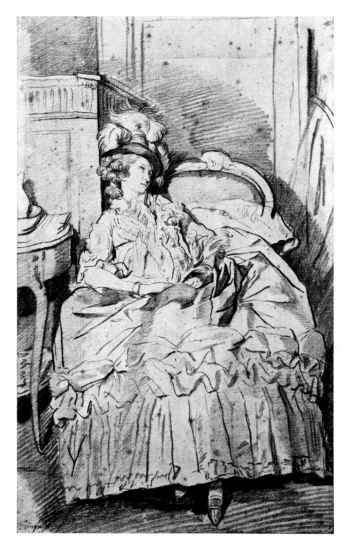

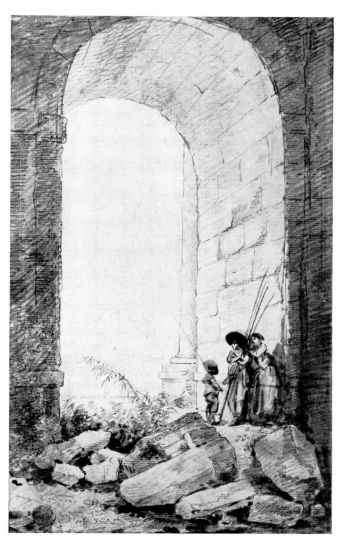

LOUIS ROLAND TRINQUESSE: *Elegant young lady,*
seated in a bergère
Signed or inscribed
Red chalk
$15\frac{1}{2} \times 9\frac{1}{2}$ in. (39.4 × 24.1 cm.)
Sold 20.3.73 for 800 gns. ($2016)

HUBERT ROBERT: *Three children near fallen masonry under*
a Roman arch
Black chalk, brown wash
$14\frac{3}{4} \times 9\frac{3}{8}$ in. (37.5 × 23.8 cm.)
Sold 20.3.73 for 1900 gns. ($4788)

FRANCESCO MAZZOLA, IL PARMIGIANINO:
Daniel in the lion's den
Red chalk, the subsidiary study in pen
and brown ink
$3\frac{1}{8} \times 3\frac{1}{8}$ in. (8.1 × 8.1 cm.)
Sold 10.7.73 for 2200 gns. ($5775)

TADDEO ZUCCARO:
Drunken Silenus with revelling attendants
Pen and brown ink, brown wash, the upper
left corner cut
$4\frac{7}{8} \times 6\frac{3}{8}$ in. (12.6 × 16.4 cm.)
Sold 10.7.73 for 2400 gns. ($6300)

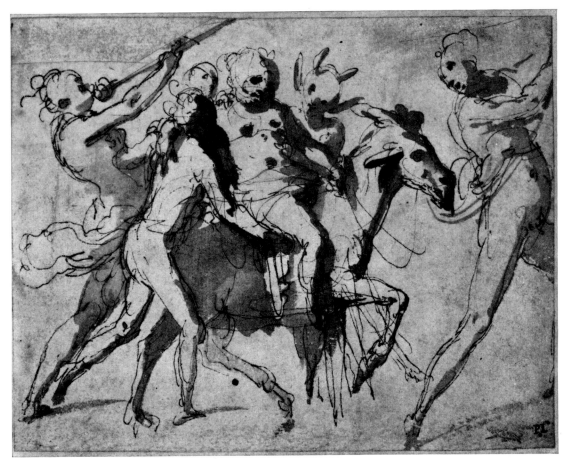

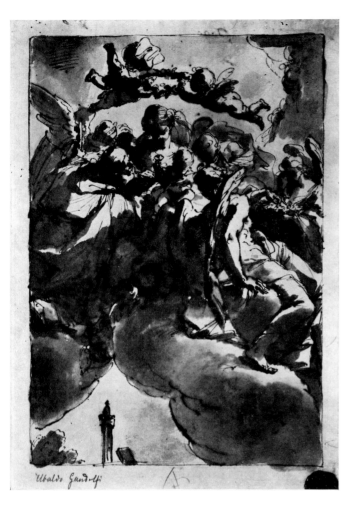

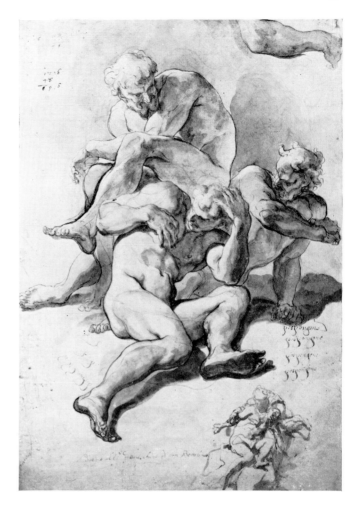

UBALDO GANDOLFI: *Madonna and Child in clouds crowned by angels and flying putti, and adored by a bishop saint, with the two towers of Bologna below*
Red chalk, pen and brown ink, brown wash
To borderline 10¼ × 7 in. (26.1 × 18 cm.)
Sold 10.7.73 for 1500 gns. ($3937)
From the collection of the late Edward Waldo Forbes

PAOLO PAGANI: *Studies of a group of three nude male figures, and a subsidiary study*
The larger study in black chalk, pen and brown ink, brown wash, the smaller in violet ink
16½ × 11½ in. (41.9 × 29.4 cm.)
Sold 6.12.72 for 950 gns. ($2394)

JACOPO PALMA, IL GIOVANE: *Coronation of the Virgin*
Black chalk, pen and brown ink, brown wash heightened with white on light brown paper
$11\frac{1}{2} \times 11$ in. (29.1 × 27.7 cm.)
Sold 6.12.72 for 800 gns. ($2016)
From the collection of the late H. W. de Zoete, Esq

MOSES TERBORCH: *Boy standing trailing a stick*
Inscribed with colour notes, black and white chalk, grey wash on blue paper
$7\frac{1}{4} \times 5\frac{1}{2}$ in. (18.5 × 14.1 cm.)
Sold 10.7.73 for 800 gns. ($2100)

PIETER PIETERSZ. LASTMAN: *Portrait of Nicolaes (Claes) Pietersz. Lastman*
Signed with initials and inscribed 'Nicolaes Pieter soon behoort dit tœ: Anno 1613 den 25 October'
Pen and brown ink
$1\frac{3}{4} \times 1\frac{3}{4}$ in. (4.5 × 4.5 cm.)
Sold 20.3.73 for 850 gns. ($2142)

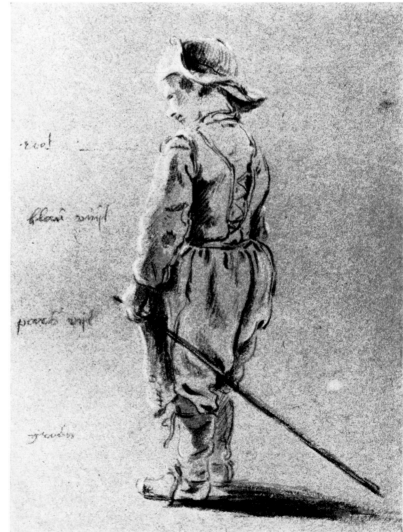

ABRAHAM BLOEMAERT:
Winter scene with travellers
approaching a gnarled tree
Inscribed 'Ab. Bloemart'
on the old mount
Traces of black chalk, pen
and brown ink, brown
wash
$6\frac{1}{4} \times 8\frac{1}{4}$ in. (15.9 × 21 cm.)
Sold 20.3.73 for 2800 gns.
($7056)

GIOVANNI BENEDETTO
CASTIGLIONE:
Jacob leading the flocks of Laban
With Carpio attribution
'Gio. Bened.' on the mount
Pen and brown ink
$7\frac{5}{8} \times 11\frac{1}{2}$ in. (19.4 × 29.2 cm.)
Sold 20.3.73 for
1300 gns. ($3276)

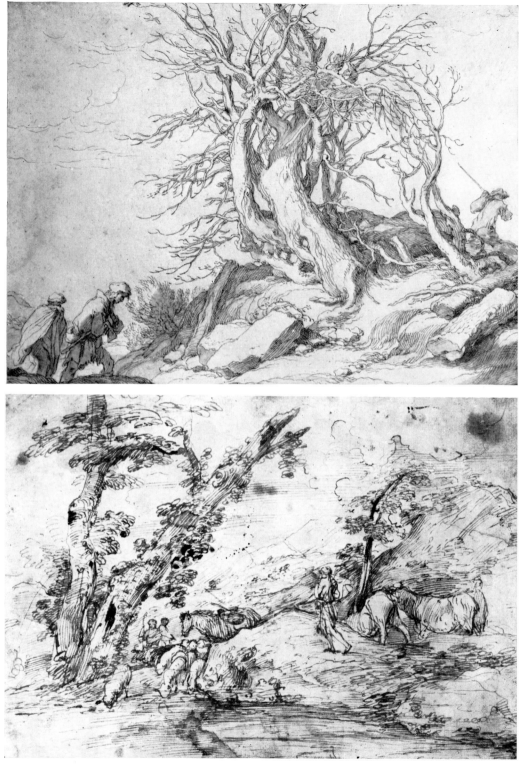

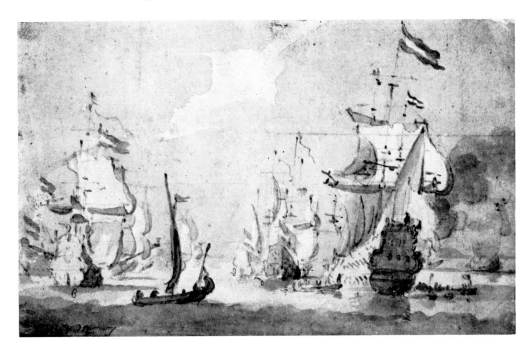

WILLEM VAN DE VELDE,
THE YOUNGER:
Dutch flagships under easy
sail in a light breeze
Signed with initials, five
of the ships identified
with letters
Black chalk, brown and grey
washes
$5\frac{1}{4} \times 8\frac{1}{8}$ in. (13.3 × 20.7 cm.)
Sold 6.12.72 for 1100 gns.
($2772)

PIETER MOLYN:
Open landscape with travellers
on a road
Signed lower right
Black chalk, pale grey wash
on paper with an eagle
watermark(?)
$5\frac{7}{8} \times 7\frac{7}{8}$ in. (14.9 × 19.9 cm.)
Sold 20.3.73 for 1000 gns.
($2520)

MARCO RICCI: *Italian landscape*
Bodycolour on vellum
$12 \times 17\frac{1}{2}$ in. (30.4 × 44.5 cm.)
Sold 10.7.73 for 4000 gns. ($10,500)
From the collection of the late Cicely, Marchioness of Zetland

GIUSEPPE GALLI BIBIENA:
*Design in cross-section for a
castrum doloris to the Holy Roman
Emperor Leopold Joseph*
Inscribed 'J . . . Elleinna' and
'terza parte' on the reverse
Pen and brown ink, grey and
brown wash
$20\frac{1}{4} \times 13\frac{1}{2}$ in. (51.4×34.3 cm.)
Sold 10.7.73 for 700 gns.
($1837)

C. ALLORI: *Study of a young girl in profile to the right*
Black and red chalk heightened with white on
grey paper
$5\frac{1}{2} \times 3\frac{7}{8}$ in. (14×10 cm.)
Sold 20.3.73 for 1000 gns. ($2520)

FRANÇOIS BOUCHER: *Head of a youth looking down to the left*
Black chalk heightened with white on greyish brown paper
$6\frac{1}{8} \times 5\frac{5}{8}$ in. (15.4×14.2 cm.)
Sold 6.12.72 for 900 gns. ($2268)

FRANCESCO GUARDI: *La Fenice, Venice*
Black chalk, pen and brown ink, brown wash
$10 \times 8\frac{3}{4}$ in. $(25.6 \times 22.2$ cm.)
Sold 20.3.73 for 7500 gns. ($18,900)

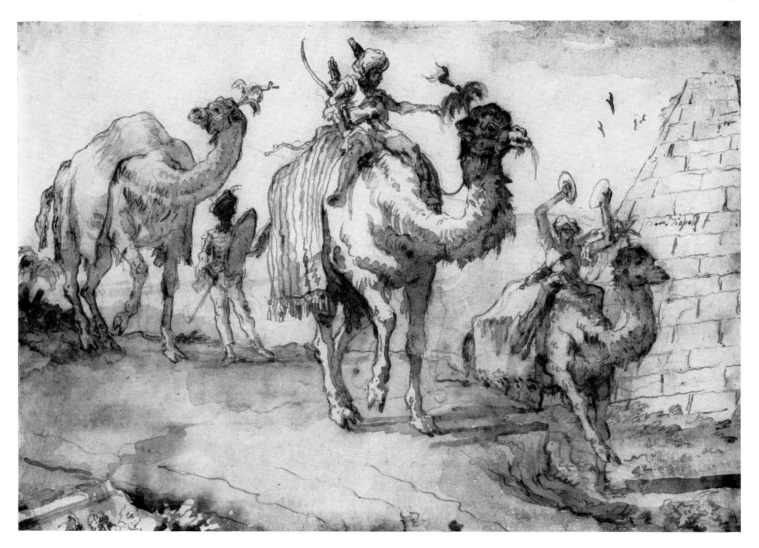

GIOVANNI DOMENICO TIEPOLO: *Three dromedaries passing a pyramid*
Signed
Black chalk, pen and brown ink, brown wash
$7\frac{1}{2} \times 11\frac{1}{4}$ in. (19.1 × 28.5 cm.)
Sold 20.3.73 for 5000 gns. ($12,600)

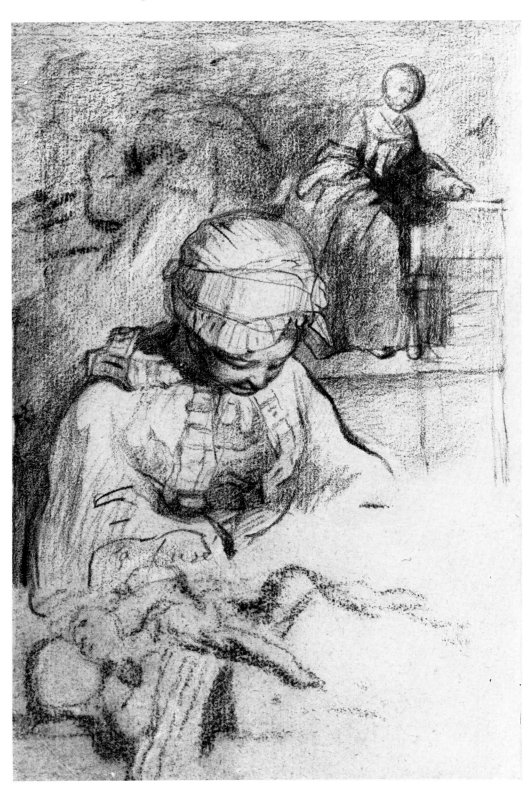

GABRIEL JACQUES
DE SAINT-AUBIN:
*Young woman bending over
her work*
Inscribed 'la fusé'
Black chalk heightened
with white
$7\frac{7}{8} \times 5\frac{1}{2}$ in.
(20 × 13.9 cm.)
Sold 10.7.73 for
3000 gns. ($7875)

LOUIS GABRIEL MOREAU
L'AINE: *Extensive landscape
with sportsmen*
Bodycolour
$9\frac{1}{8} \times 13\frac{1}{4}$ in. (23.1 × 33.6 cm.)
Sold 20.3.73 for 1300 gns.
($3276)

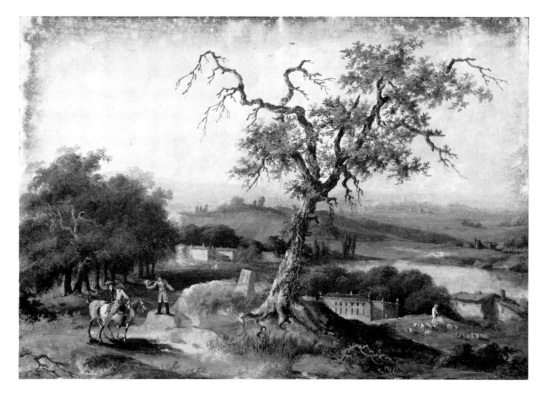

LOUIS JEAN DESPREZ:
*Piazza del Duomo at Palermo
during the Festival of
St Rosalia*
Signed and inscribed on
the reverse
Pen and black ink and
watercolour
$8\frac{3}{8} \times 13\frac{1}{2}$ in. (21.3 × 34.4 cm.)
Sold 20.3.73 for 1600 gns.
($4032)

Old Master drawings

HUBERT ROBERT: *Architectural capriccio*
Black chalk, pen and brown ink and watercolour
$7\frac{7}{8}$ in. (20 cm.) diam.
Sold 20.3.73 for 2000 gns. ($5040)

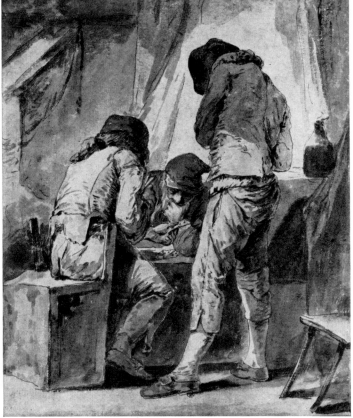

NICOLAS BERNARD LEPICIE: *Un coup difficile*
Pen and grey ink and watercolour, in carved Louis
XVI frame
$8\frac{5}{8} \times 7\frac{1}{4}$ in. (21.8 × 18.3 cm.)
Sold 20.3.73 for 1300 gns. ($3276)

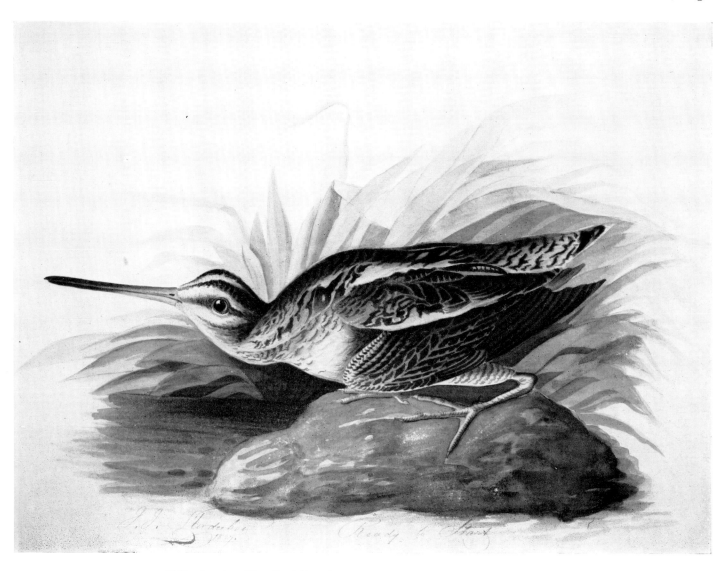

JOHN JAMES AUDUBON: *Wilson's snipe (Capella delicata)*
Signed and dated 1827 and inscribed 'Ready to Start'
Pencil and watercolour
$9 \times 14\frac{5}{8}$ in. (24.5 × 35.5 cm.)
Sold 6.12.72 for 3500 gns. ($8820)

WILLIAM PAYNE:
Dockyard at Devonport
Signed and inscribed
'Plymouth'
Pen and brown ink and
watercolour
$15\frac{1}{4} \times 22\frac{3}{4}$ in. (38.8 × 57.8 cm.)
Sold 6.3.73 for
2000 gns. ($5040)
From the collection of
Richard Walker, Esq

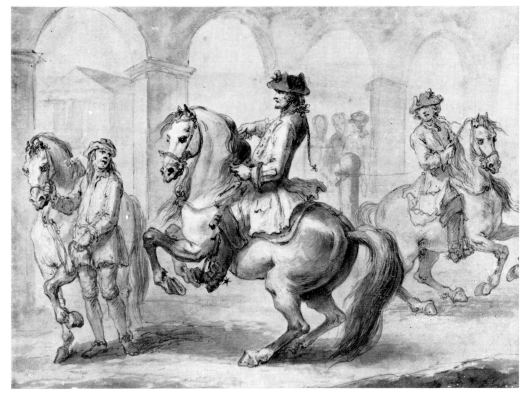

JOHN VANDERBANK:
Riding school
Signed and dated 1729
Pencil, pen and brown
ink, brown wash
heightened with white on
light brown paper
$9\frac{7}{8} \times 13\frac{7}{8}$ in.
(25.1 × 35.2 cm.)
Sold 5.6.73 for 1500 gns.
($3938)
From the collection of
Lord Richard Percy

JOHN DUNTHORNE, JUN.:
Musical entertainment
Pencil, pen and grey ink
and watercolour
$12\frac{5}{8} \times 19\frac{3}{8}$ in. (32.3×49.3 cm.)
Sold 6.3.73 for
1100 gns. ($2772)
From the collection of
S. P. St C. Raymond, Esq

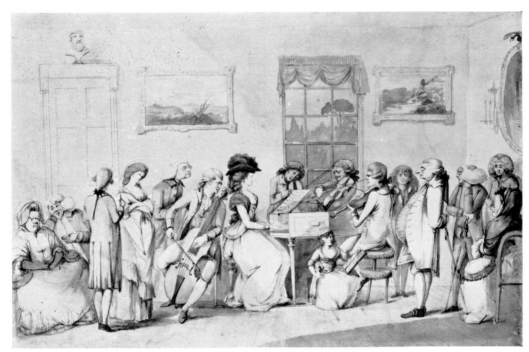

HENRY ALKEN: *Exercising
race-horses on Newmarket Heath*
Pencil and watercolour
$13\frac{1}{2} \times 18\frac{7}{8}$ in. (34.2×48 cm.)
Sold 14.11.72 for
1700 gns. ($4284)
From the collection of the late
Miss C. A. Moore

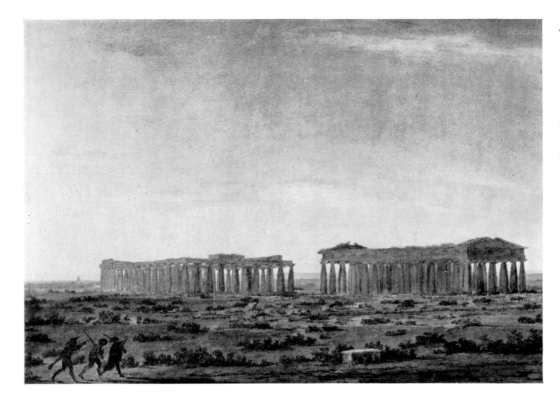

JOHN ROBERT COZENS:
Temples at Paestum
Inscribed on the reverse by
the artist 'Temples of
Pestum'
Pencil and watercolour
$9\frac{5}{8} \times 14\frac{1}{2}$ in.
(24.4 × 36.8 cm.)
Sold 6.3.73 for
7500 gns. ($18,900)
From the collection of
Mr and Mrs A. T. Vulliamy

HUGH WILLIAM
'GRECIAN' WILLIAMS:
*The Parthenon seen from the
Propylæa*
Signed and dated 1820
Pencil and watercolour
$15\frac{1}{2} \times 24$ in. (39.5 × 61 cm.)
Sold 6.3.73 for
1400 gns. ($3528)
From the collection of
Miss Irene Foley

JOHN ROBERT COZENS:
Monte Circeo from Terracina
between Rome and Naples
Signed on the mount
Pencil and watercolour
$12\frac{1}{8} \times 18$ in. $(30.8 \times 45.9$ cm.)
Sold 5.6.73 for 17,000 gns.
($44,625)
From the Mount Trust
Collection

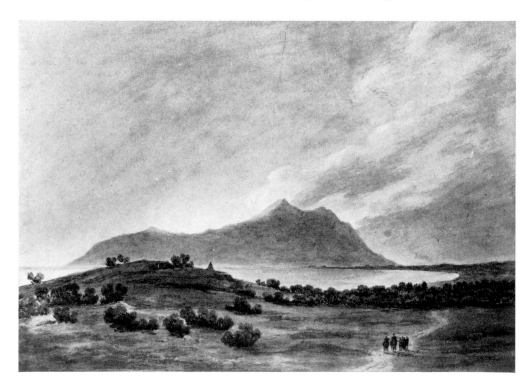

RICHARD WILSON, RA:
Circus of Flora, Rome
Signed with initials, inscribed
'Circus' and with a label
'Circus of Flora' superimposed,
and dated Romae 1754, no. 8
on the mount and numbered 51
on the reverse
Pencil heightened with white
chalk on grey paper
$11 \times 16\frac{5}{8}$ in. $(27.9 \times 42.3$ cm.)
Sold 5.6.73 for 4200 gns.
($11,025)
From the Mount Trust
Collection

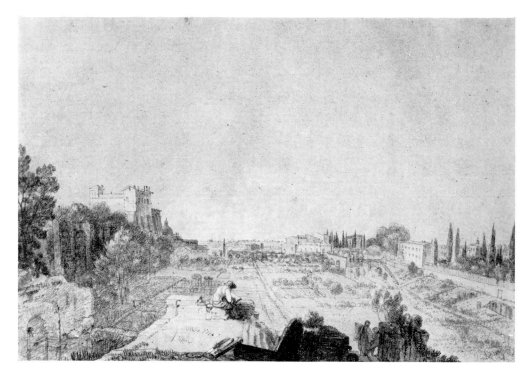

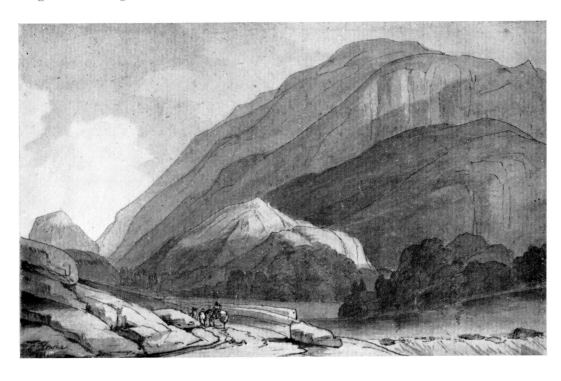

FRANCIS TOWNE:
Entrance into Borrowdale
Signed and indistinctly
dated 1786, inscribed and
numbered 2 on the back
of the original mount
Pen and brown ink and
watercolour
$3\frac{7}{8} \times 6\frac{1}{8}$ in. (9.8 × 15.7 cm.)
Sold 14.11.72 for
3800 gns. ($9576)
From the Mount Trust
Collection

FRANCIS TOWNE:
Houses at Ambleside
Signed and dated 1786,
inscribed on the back of
the mount
Pen and brown ink and
watercolour
$10\frac{3}{8} \times 15$ in.
(26.3 × 38.1 cm.)
Sold 14.11.72 for
4800 gns. ($12,096)
From the Mount Trust
Collection

JOHN ROBERT COZENS:
End of Ullswater
Watercolour
$23\frac{1}{2} \times 32\frac{1}{2}$ in. (59.5×82.3 cm.)
Sold 14.11.72 for 8000 gns.
($20,160)
From the collection of Capt. Sir
Everard Radcliffe, BT, MC

JOHN ROBERT COZENS:
Waterfall of Lodore, Cumberland
Pencil and watercolour
$14\frac{1}{4} \times 19\frac{3}{4}$ in. (36.2×50.2 cm.)
Sold 5.6.73 for 10,000 gns.
($26,250)

JAMES MILLER: *Westminster Abbey from Dean's Yard*
Pencil and watercolour
16 × 24⅜ in. (40.7 × 61.9 cm.)
Sold 5.6.73 for 9500 gns. ($24,938)
From the Mount Trust Collection

JULIUS CAESAR IBBETSON: *Skaters on the Serpentine near the Old Cheesecake House, Hyde Park*
Signed
Pen and grey ink and watercolour
$13\frac{7}{8} \times 23$ in. (35.3×58.4 cm.)
Sold 5.6.73 for 18,000 gns. ($47,250)
From the Mount Trust Collection

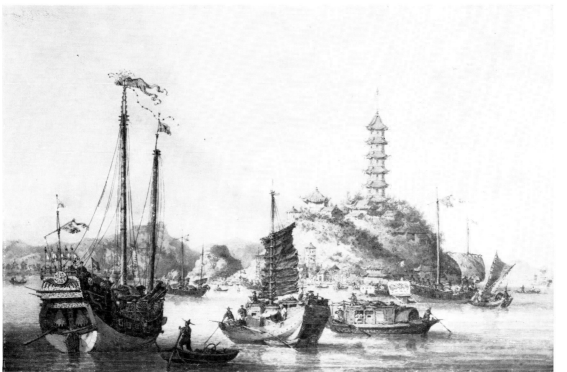

WILLIAM
ALEXANDER:
*View of the Tchin-Shan
or Golden Island in the
Yang-Tse-Kiang or
Great River of China*
Signed and dated '95
Pencil and
watercolour
$11\frac{7}{8} \times 17\frac{7}{8}$ in.
(30.3 × 45.5 cm.)
Sold 5.6.73 for
12,500 gns. ($32,813)
From the collection
of Louis Carus, Esq

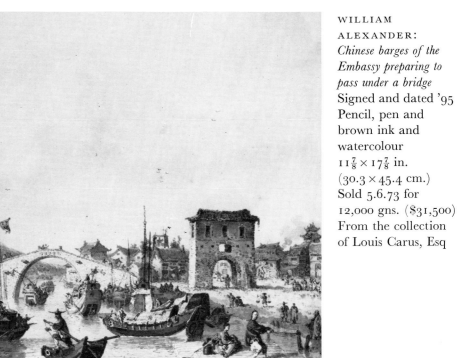

WILLIAM
ALEXANDER:
*Chinese barges of the
Embassy preparing to
pass under a bridge*
Signed and dated '95
Pencil, pen and
brown ink and
watercolour
$11\frac{7}{8} \times 17\frac{7}{8}$ in.
(30.3 × 45.4 cm.)
Sold 5.6.73 for
12,000 gns. ($31,500)
From the collection
of Louis Carus, Esq

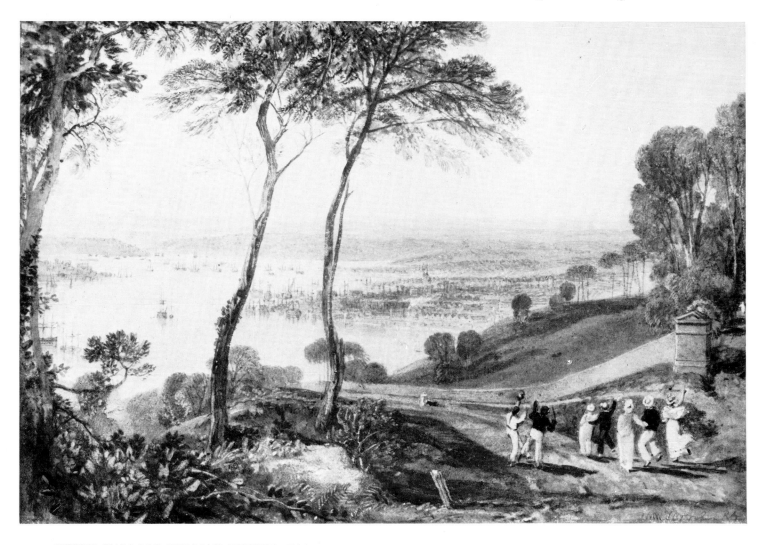

JOSEPH MALLORD WILLIAM TURNER, RA:
View of Devonport, Torpoint and Saltash from Mount Edgcumbe, with sailors merrymaking
Signed
Watercolour
$6\frac{1}{8} \times 9\frac{1}{2}$ in. (15.6 × 24 cm.)
Sold 6.3.73 for 14,500 gns. ($36,540)

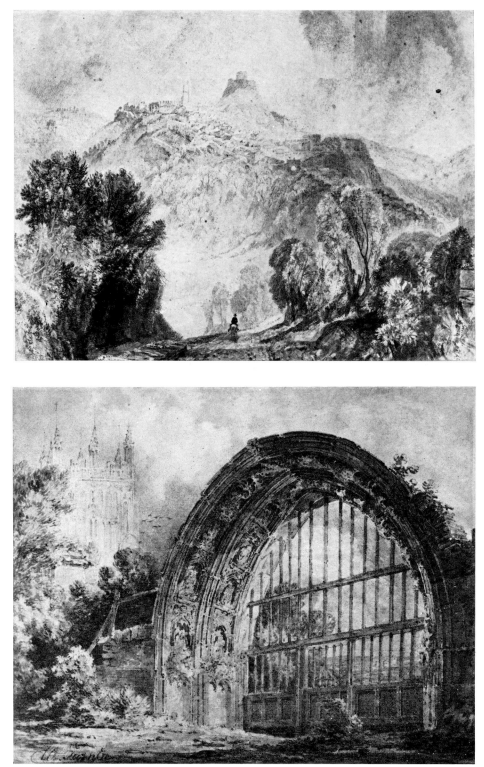

JOSEPH MALLORD
WILLIAM TURNER, RA:
Launceston
Watercolour
11 × 15⅜ in. (27.9 × 39 cm.)
Sold 5.6.73 for 11,000 gns. ($28,875)

JOSEPH MALLORD
WILLIAM TURNER, RA:
Old archway at Evesham Abbey
Signed
Pencil and watercolour
8⅜ × 10⅞ in. (21.2 × 27.6 cm.)
Sold 5.6.73 for 5000 gns. ($13,125)

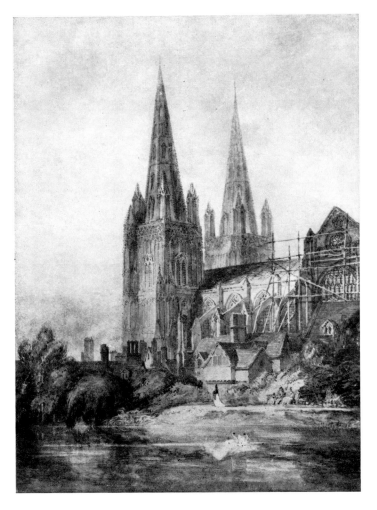

JOSEPH MALLORD WILLIAM TURNER, RA:
Lichfield Cathedral
Watercolour
$12\frac{1}{8} \times 8\frac{7}{8}$ in. (30.8 × 22.5 cm.)
Sold 5.6.73 for 4200 gns. ($10,500)
From the collection of George Goyder, Esq

JOHN CONSTABLE, RA:
Two children fishing from a barge at Flatford Mill
Pen and brown ink, brown wash on paper
Watermarked J. Whatman Turkey Mill 1824
13 × 8 in. (32.9 × 22.4 cm.)
Sold 5.6.73 for 7000 gns. ($18,375)

JOHN SELL COTMAN:
Thatched barn with cattle
by a pond
Pencil and watercolour
$9\frac{3}{8} \times 13$ in. (23.7 × 33.1 cm.)
Sold 5.6.73 for 6000 gns.
($15,750)

JOHN SELL COTMAN:
Llyn Ogwen
Signed and dated 1803
Watercolour
$11\frac{1}{4} \times 17\frac{3}{8}$ in.
(28.6 × 44.2 cm.)
Sold 5.6.73 for 3800 gns.
($9975)

DAVID COX:
Fishing boats off Antwerp
Signed and dated 1838
Watercolour
$7\frac{1}{4} \times 10\frac{1}{4}$ in. (18.6 × 26 cm.)
Sold 14.11.72 for 1500 gns. ($3780)
From the collection of
P. K. Collins, Esq

JOHN SELL COTMAN:
Postwick Grove, Norfolk
Signed, drawn 1837–9
Pencil and watercolour
$7\frac{1}{4} \times 10\frac{7}{8}$ in. (18.3 × 27.5 cm.)
Sold 14.11.72 for 7500 gns.
($18,900)

RICHARD PARKES BONINGTON:
Barges and coastal vessels near the shore
Signed
Watercolour
$7\frac{1}{2} \times 10\frac{1}{2}$ in. (19.1 × 26.8 cm.)
Sold 5.6.73 for 11,000 gns. ($28,875)

Opposite: EDWARD LEAR:
Italian peasants near a shrine in a wood in a Campagna landscape
Pen and brown ink and watercolour heightened with white
To borderline $4\frac{1}{2} \times 7\frac{1}{2}$ in. (11.5 × 19 cm.)
Sold 5.6.73 for 1900 gns. ($4988)

THOMAS SHOTTER
BOYS: *Harvest
landscape with a
church in the distance*
Signed with initials
and dated 1834
Watercolour
$2\frac{5}{8} \times 5\frac{7}{8}$ in.
(6.6 × 14.9 cm.)
Sold 6.3.73 for
1900 gns. ($4788)
From the collection of
L. H. Gilbert, Esq

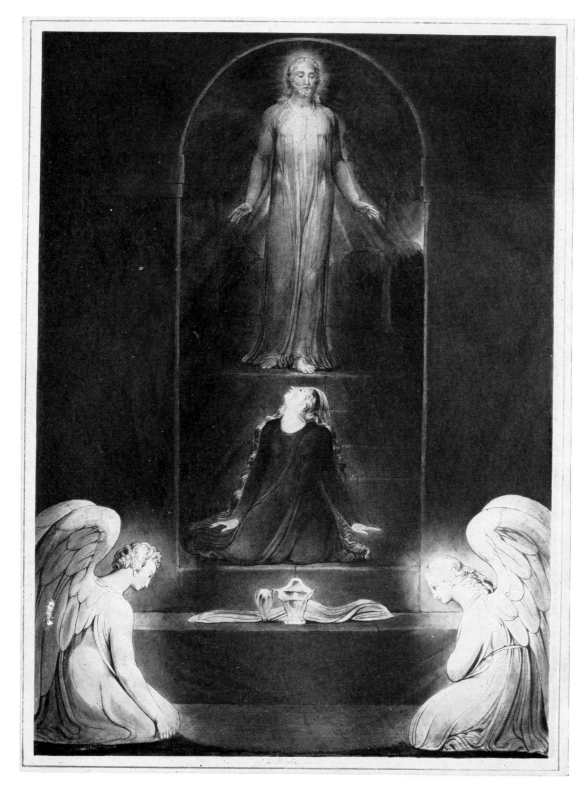

WILLIAM BLAKE:
*Mary Magdalen at the
sepulchre (St John XX,
11–16)*: 'She turned
herself back, and saw
Jesus standing, and
knew not that it was
Jesus'
Signed with
monogram
Pen and black ink
and watercolour
$16\frac{3}{4} \times 12$ in.
(42.6 × 30.5 cm.)
Sold 5.6.73 for
22,000 gns. ($57,750)
From the Mount
Trust Collection

HENRY FUSELI, RA: *Standing male figure*
Pencil, pen and brown ink and watercolour
11 × 8 in. (27.9 × 20.5 cm.)
Sold 6.3.73 for 4000 gns. ($10,800)
From the collection of Anthony Heath, Esq

SIR JOHN EVERETT MILLAIS, BT, PRA: *Married for money*
Signed
Pen and black and brown ink, brown wash
8¼ × 6 in. (21 × 15.2 cm.)
Sold 12.12.72 for 2800 gns. ($7056)

WILLIAM WESTALL, ARA:
Entrance to Newmarket, with horses and trainers
Pencil and watercolour
$3\frac{3}{4} \times 5\frac{5}{8}$ in. (9.6 × 14.4 cm.)
Sold 5.6.73 for 1300 gns.
($3413)
From the collection of
J. E. Dennell, Esq

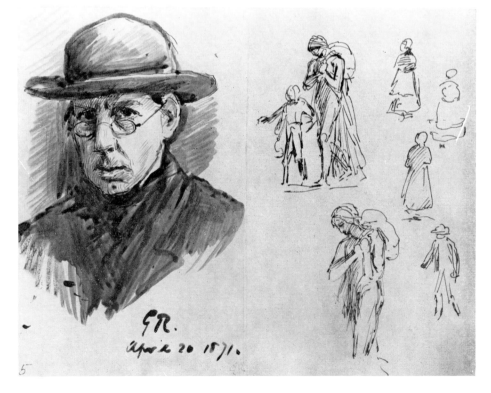

GEORGE RICHMOND, RA:
Portrait of the artist in hat and spectacles, with subsidiary figure studies on the right half of the sheet
Signed with initials and dated April 20 1871
Pen and brown ink, brown wash
7×9 in. (17.8 × 23 cm.)
Sold 12.6.73 for 680 gns. ($1785)

WILLIAM JOY: *British man-o'-war and other shipping on the Solent*
Watercolour
$7\frac{3}{4} \times 11\frac{1}{8}$ in. (19.7×28.2 cm.)
Sold 12.12.72 for
1000 gns. ($2520)

Below:
JOHN MARTIN:
Leith Hill, Surrey
Signed and dated 1842
Watercolour with touches
of varnish
$10\frac{1}{4} \times 26\frac{1}{2}$ in. (25.8×67.3 cm.)
Sold 5.6.73 for 5000 gns.
($13,125)

JAMES SMETHAM: *Eventide*
Signed twice and dated 1865
Watercolour heightened with white
$4 \times 8\frac{1}{8}$ in. (10.2 × 20.6 cm.)
Sold 13.3.73 for 2200 gns. ($5544)

JOHN RODDAM SPENCER STANHOPE:
Rispah the daughter of Aiah
Signed with initials. Watercolour
$12\frac{5}{8} \times 7\frac{1}{2}$ in. (32 × 19 cm.)
Sold 12.6.73 for 2200 gns. ($5775)

DANTE GABRIEL ROSSETTI: *Joan of Arc*
Signed with monogram and dated 1864
Watercolour heightened with white. In the original frame
$12\frac{1}{4} \times 11\frac{3}{4}$ in. (31 × 29.8 cm.)
Sold 13.3.73 for 6500 gns. ($16,380)

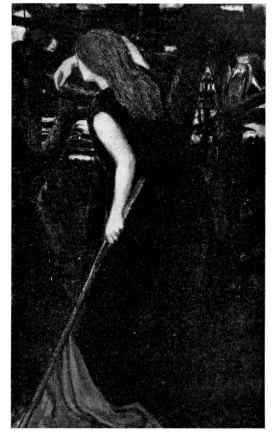

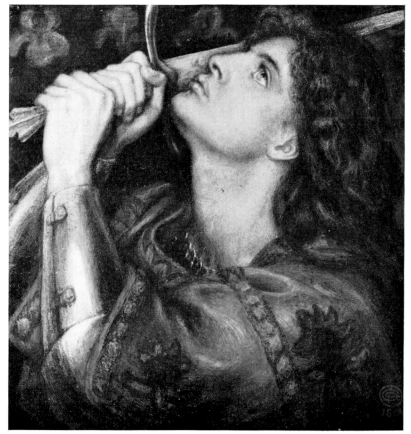

JOHN FREDERICK LEWIS, RA:
Highland hospitality
Watercolour heightened with white
$21\frac{5}{8} \times 29\frac{1}{2}$ in. $(54.9 \times 74.9$ cm.$)$
Sold 13.3.73 for 2400 gns. ($6048)

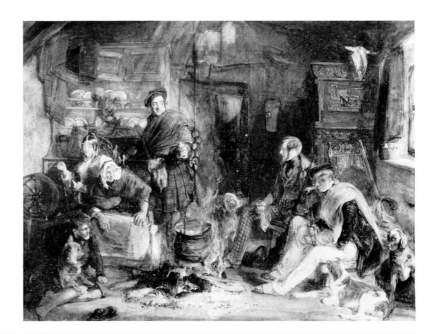

FREDERICK WALKER, ARA: *Harbour of refuge*
1872
Signed with initials
Watercolour
$22\frac{1}{4} \times 36\frac{1}{4}$ in. $(56.4 \times 92.1$ cm.$)$
Sold 13.3.73 for 1200 gns. ($3024)
From the collection of the Misses E. and L.
Glen-Coats

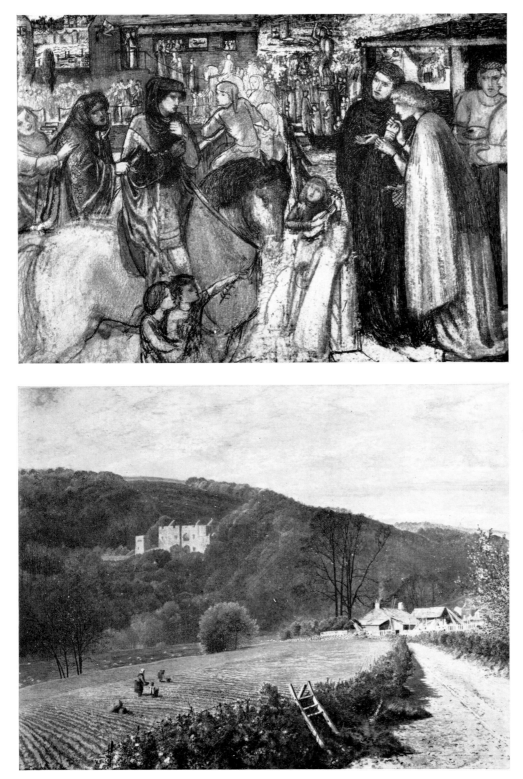

SIR EDWARD COLEY
BURNE-JONES, BT, ARA:
Buondelmonte's wedding
Pencil, pen and black ink
$9\frac{1}{2} \times 14\frac{1}{8}$ in. (24.3 × 35.9 cm.)
Sold 13.3.73 for 3400 gns. ($8568)
From the collection of
The Wallis Estate

JOHN ATKINSON GRIMSHAW:
*Barden Tower, Yorkshire, with
peasants in the foreground*
Signed and dated 1864
Bodycolour
$15\frac{5}{8} \times 21\frac{1}{4}$ in. (39.7 × 54.1 cm.)
Sold 12.12.72 for 1300 gns.
($3276)

OLD MASTER
AND
MODERN PRINTS

MARTIN SCHONGAUER:
Nativity (B. VI, 4; Lehrs 5)
Engraving
Sold 30.11.72 for
3800 gns. ($9576)

After PIETER BRUEGHEL THE ELDER: *Skaters before the gate of St George at Antwerp*, by Frans Huys (Holl. 205)
Engraving, first state with the address of Cock
Sold 30.11.72 for 1600 gns. ($4032)

ALBRECHT DÜRER: *The Apocalypse:*
martyrdom of Saint John (B. 61; M., Holl. 164)
Woodcut
Sold 6.7.73 for 2200 gns. ($5775)

ANDREA ANDREANI:
Triumph of Julius Caesar, after Mantegna (B. XII, 101, 11)
Chiaroscuro woodcuts, printed from three blocks in black and
two shades of olive green, nine plates
Sold 6.7.73 for 1600 gns. ($4200)
From The Wallis Trust Collection

LUCAS CRANACH:
Saint George on horseback slaying the dragon (B. 64; Holl. 82)
Woodcut
Sold 6.7.73 for 1500 gns. ($3937)

LUCAS CRANACH:
Beheading of Saint John the Baptist (B. 62; Holl. 87)
Woodcut
Sold 6.7.73 for 2500 gns. ($6562)

REMBRANDT HARMENSZ. VAN RIJN:
David and Goliath (B., Holl. 36; H. 284)
Etching, Hollstein's state C/4 (of five)
Sold 6.7.73 for 1400 gns. ($3675)

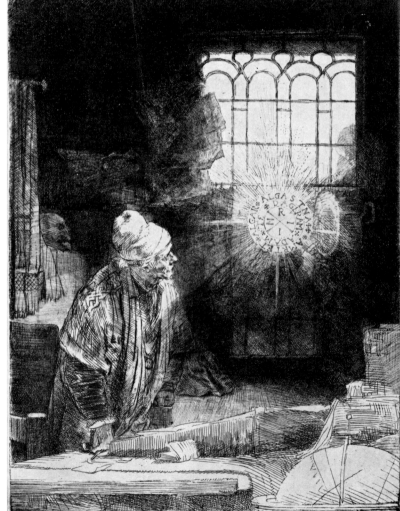

REMBRANDT HARMENSZ. VAN RIJN:
Faust (B., Holl. 270; H. 260)
Etching, first state (of three)
Sold 6.7.73 for 3500 gns. ($9187)

PIERRE BONNARD:
La petite blanchisseuse
(R-M. 42)
Lithograph, 1896, printed
in five colours
Signed in pencil and
numbered 68
Sold 5.7.73 for 3000 gns.
($7875)
From the collection of
K. E. Bond, Esq, FRCS

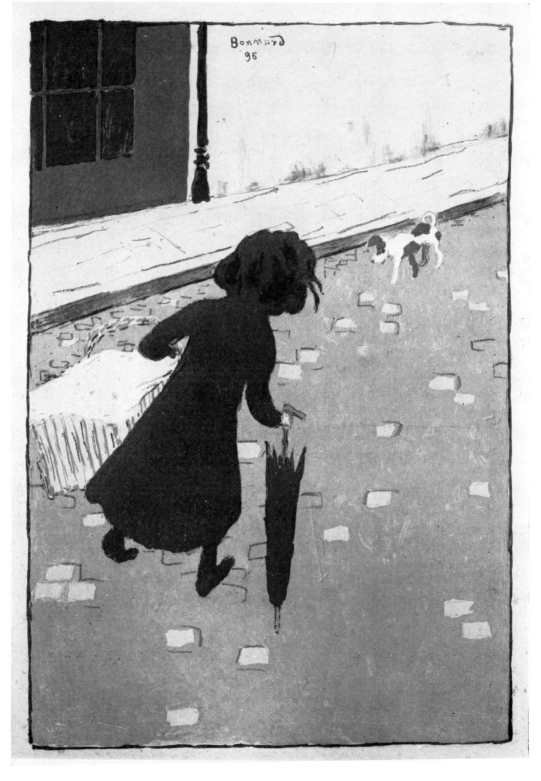

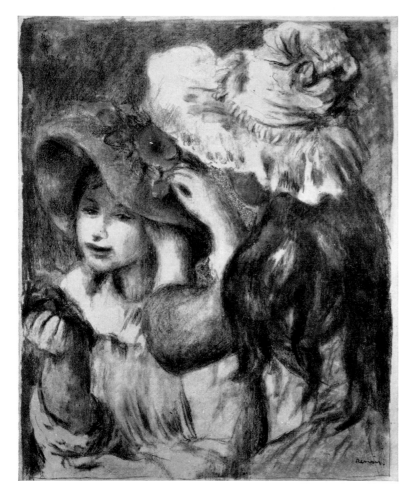

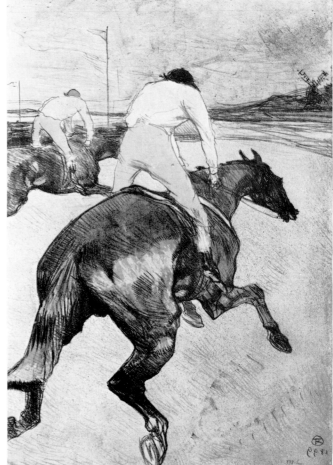

PIERRE-AUGUSTE RENOIR:
Le chapeau épinglé : deuxième planche (L.D. 30)
Lithograph, 1898, printed in colours
Signed in pencil
Sold 5.7.73 for 5800 gns. ($15,225)
From the collection of Mrs C. G. Lancaster

HENRI DE TOULOUSE-LAUTREC: *Le jockey* (L.D. 279)
Lithograph, 1899, printed in black, brown, green, blue,
red and fawn on Chine
One of the edition of 100
Sold 30.11.72 for 5000 gns. ($12,600)
From the collection of Dr Robert Ducroquet

EDVARD MUNCH:
Das kranke Mädchen (Sch. 59;
Timm 43)
Lithograph, 1896, printed in
black, grey, lemon-yellow and
dark red on Chine
Signed in pencil
Sold 5.7.73 for 11,700 gns.
($30,712)
From the collection of Kenneth
Lewin, Esq

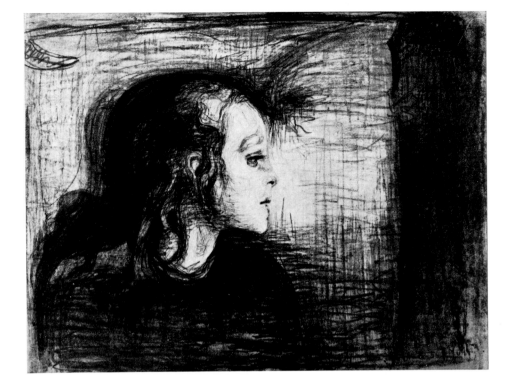

EDVARD MUNCH:
Der Tag danach (Sch. 15; Timm 16)
Drypoint, first state (of four)
Signed in pencil
Sold 5.7.73 for 3800 gns. ($9975)

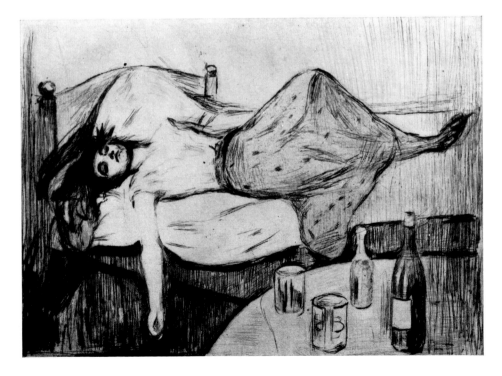

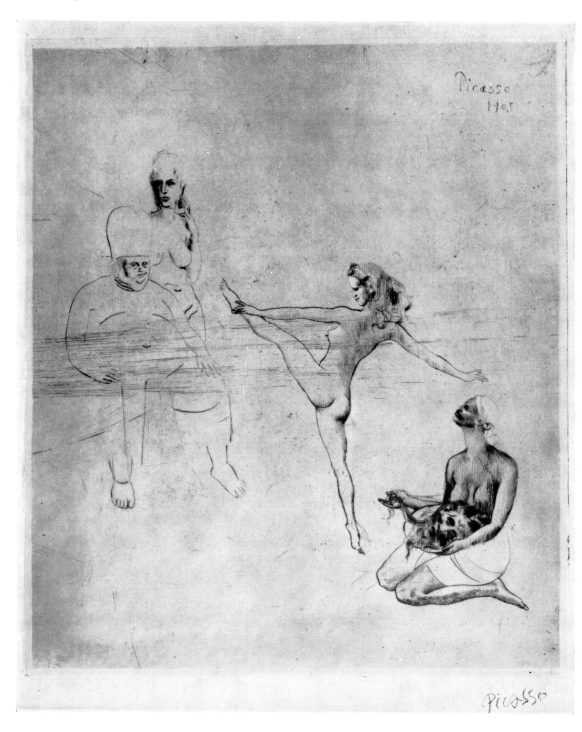

PABLO PICASSO:
Salome
(Bl. 14; G. 17a)
Drypoint, 1905,
before the steel facing
Signed in black chalk
Sold 30.11.72 for
6000 gns. ($15,120)

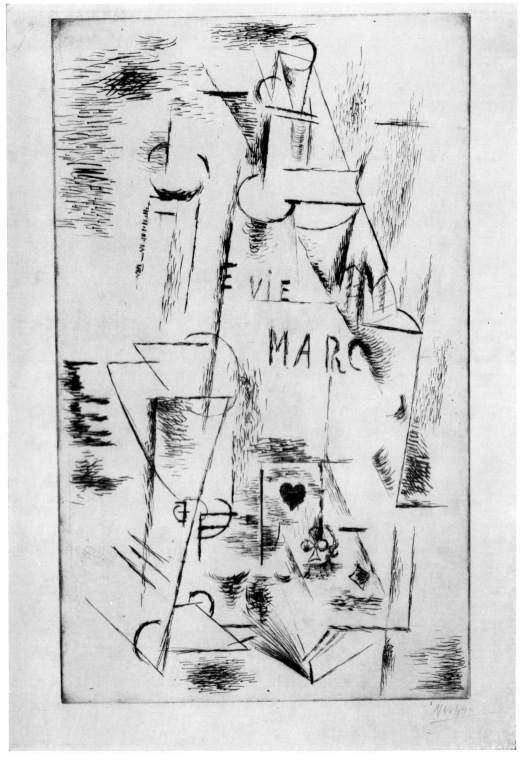

PABLO PICASSO:
Nature morte, bouteille
(B. 24; G. 33b)
Drypoint, 1912, on Arches
Signed in pencil and
numbered 81
Sold 5.7.73 for 10,000 gns.
($26,250)

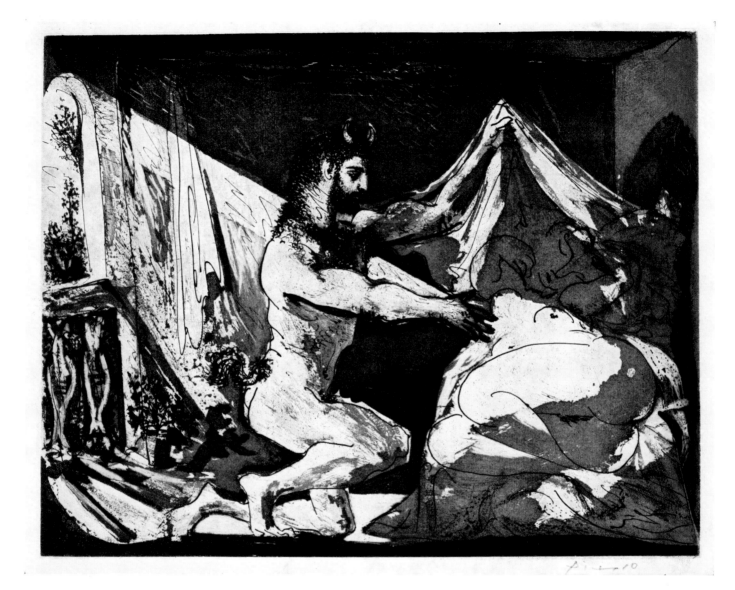

PABLO PICASSO: *The Vollard Suite*
(Bl. 134–233)
The complete set of 100 etchings
All signed in pencil
Sold 30.11.72 for 90,000 gns. ($226,800)

PABLO PICASSO:
Le départ (B. 686; M. 201)
Lithograph, 1951, printed in colours
on Arches
Signed in pencil and numbered 42/50
Sold 5.7.73 for 3500 gns. ($9187)
From the collection of Mr Arild
Wahlstrom

PABLO PICASSO:
Le picador blessé (B. 693)
Aquatint, 1952
Signed in pencil and numbered 40/50
with margins
Sold 5.7.73 for 2800 gns. ($7350)
From the collection of Mr Arild
Wahlstrom

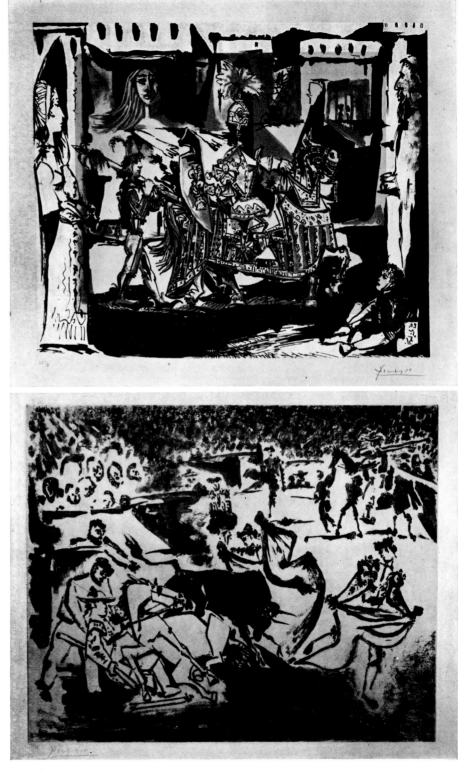

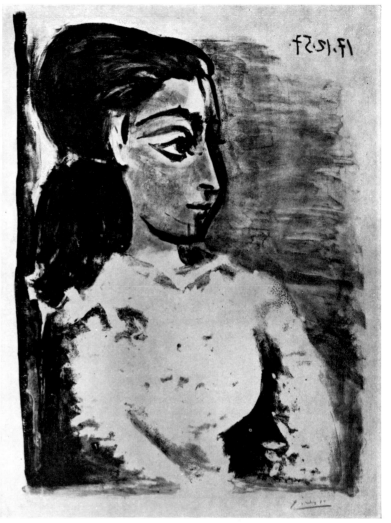

PABLO PICASSO: *La femme à la fenêtre* (Bl. 695)
Aquatint, 1952, printed on Arches
Signed in pencil and numbered 26/50
Sold 30.11.72 for 6500 gns. ($16,380)

PABLO PICASSO: *Buste de femme au corsage blanc* (B.848; M.311)
Lithograph, 1957, on Arches
Signed in blue chalk and numbered 20/50
Sold 5.7.73 for 2400 gns. ($6300)

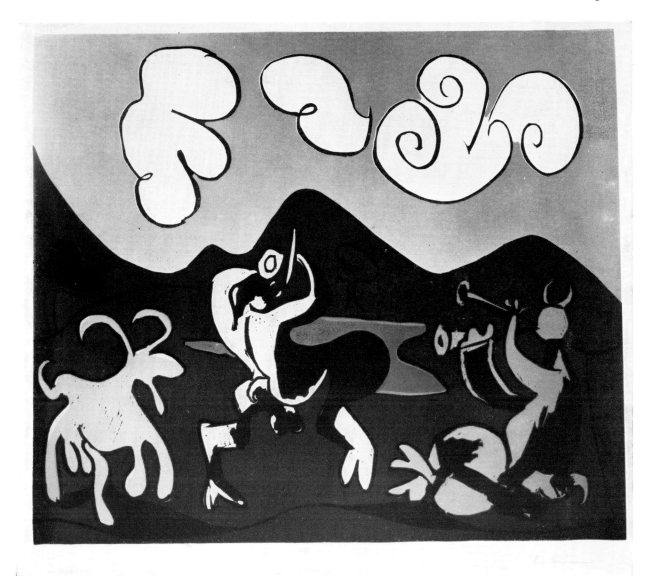

PABLO PICASSO: *Faunes et chèvre* (B.934)
Linocut, 1959, printed in colours on Arches
Signed in pencil and numbered 43/50
Sold 5.7.73 for 2800 gns. ($7350)

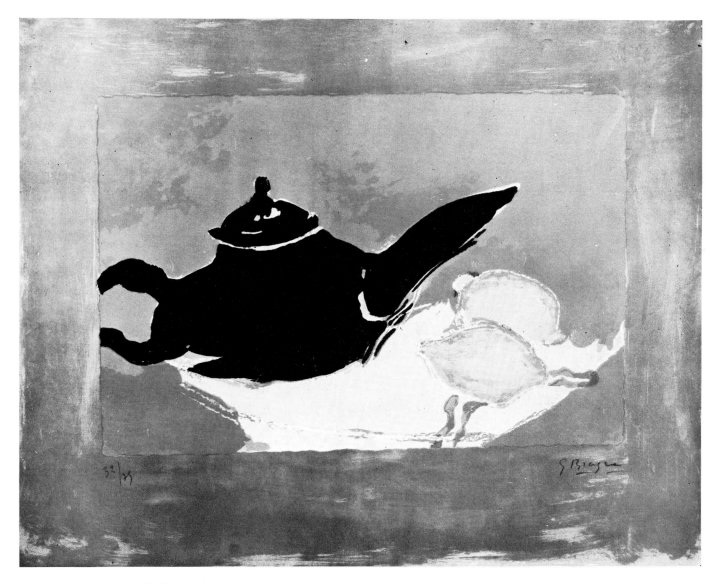

GEORGES BRAQUE: *Théière et citrons* (M.21)
Lithograph, 1949, printed in colours on Arches
Signed in pencil and numbered 32/75
Sold 5.7.73 for 2500 gns. ($6562)

GEORGES ROUAULT:
Le Christ en croix
Aquatint, 1936
Printed in colours
Sold 5.7.73 for
1400 gns. ($3675)

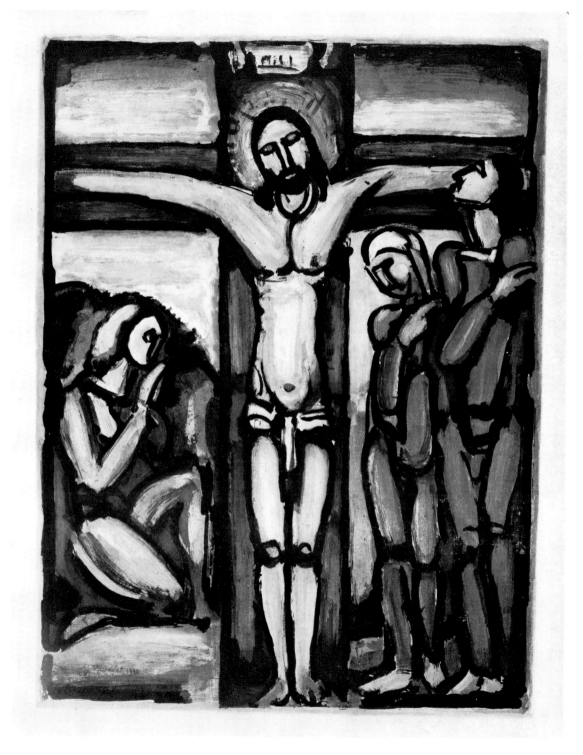

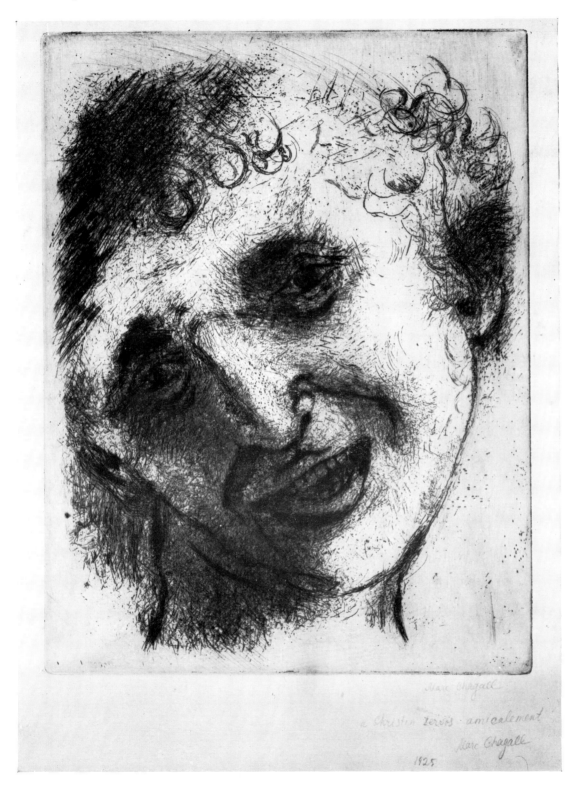

MARC CHAGALL:
Autoportrait au sourire (K. 42)
Etching, 1925
Signed, and inscribed 'a Christin [*sic*] Zervos amicalement Marc Chagall 1925'
Sold 5.7.73 for 1100 gns. ($2887)

PAUL KLEE: *Was lauft er?* (K. 109)
Etching, 1932
Signed in pencil
Sold 5.7.73 for 1300 gns. ($3412)

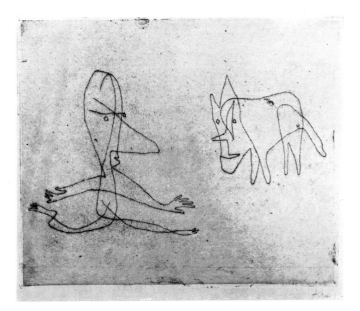

MARC CHAGALL: *Le songe du capitaine Bryaxis*
(M. 328)
Lithograph, 1960, Plate XXI from Daphnis
et Chloé, printed in colours on Arches
Signed in pencil and numbered
31/60
Sold 30.11.72 for 1400 gns. ($3528)

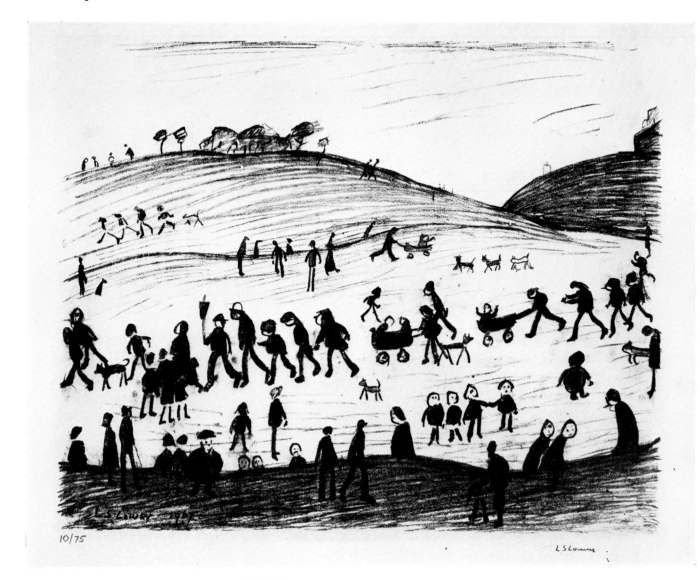

LAURENCE STEPHEN LOWRY, RA: *A hillside*
One of a set of fourteen lithographs, 1967–72
All signed in crayon, numbered 10/75
Sold 5.7.73 for 1700 gns. ($4462)

IMPRESSIONIST AND TWENTIETH-CENTURY PICTURES AND SCULPTURE

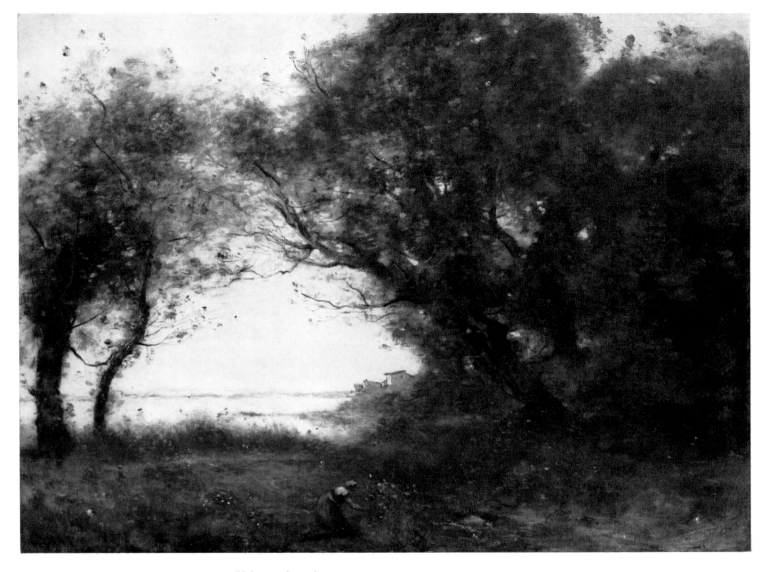

JEAN BAPTISTE CAMILLE COROT: *L'Arceau de verdure*
Signed and dated 1872
21¾ × 30¾ in. (55 × 78 cm.)
Sold 27.3.73 for 32,000 gns. ($80,600)

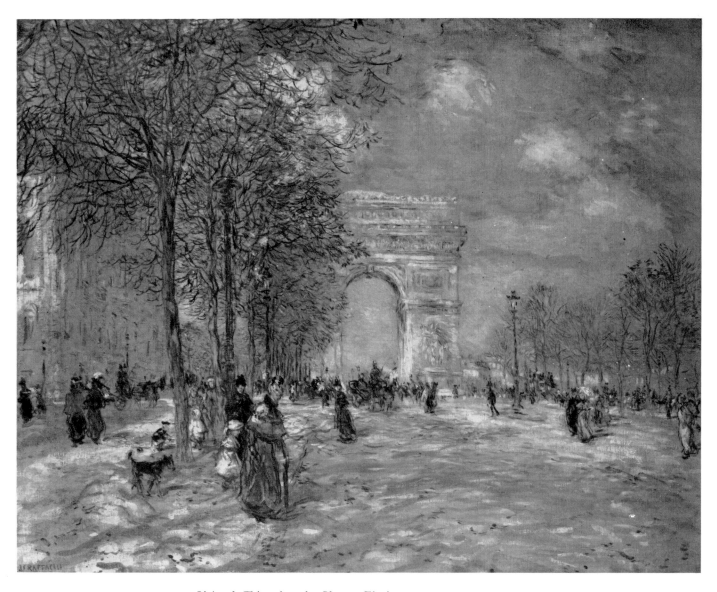

JEAN FRANÇOIS RAFFAELLI: *L'Arc de Triomphe et les Champs Elysées en automne*
Signed
$25\frac{1}{2} \times 32$ in. (65 × 81 cm.)
Sold 27.3.73 for 17,000 gns. ($42,840)
From the collection of the late Howard Young
Record auction price for a work by this artist

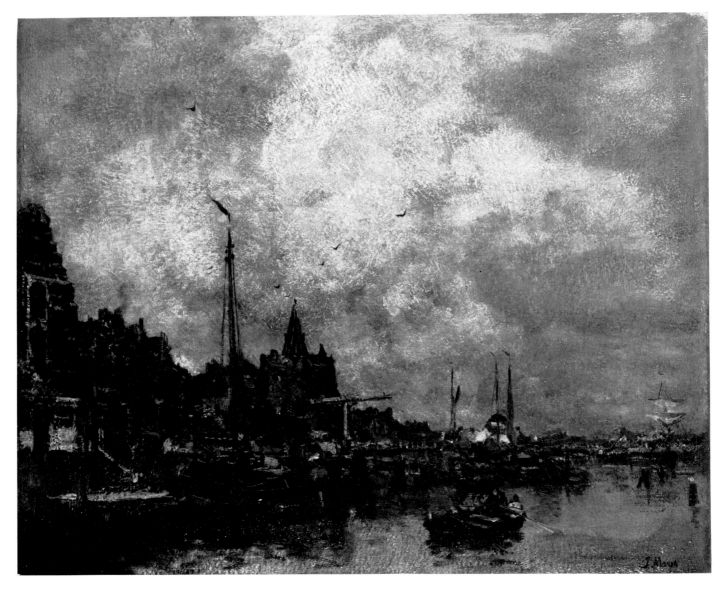

JACOB MARIS: *The Schreierstoren on the IJ at Amsterdam*
Signed
20 × 26 in. (51 × 66 cm.)
Sold 6.7.73 for 19,000 gns. ($49,875)
From the collection of the late Mrs Reine Pitman
Record auction price for a work by this artist

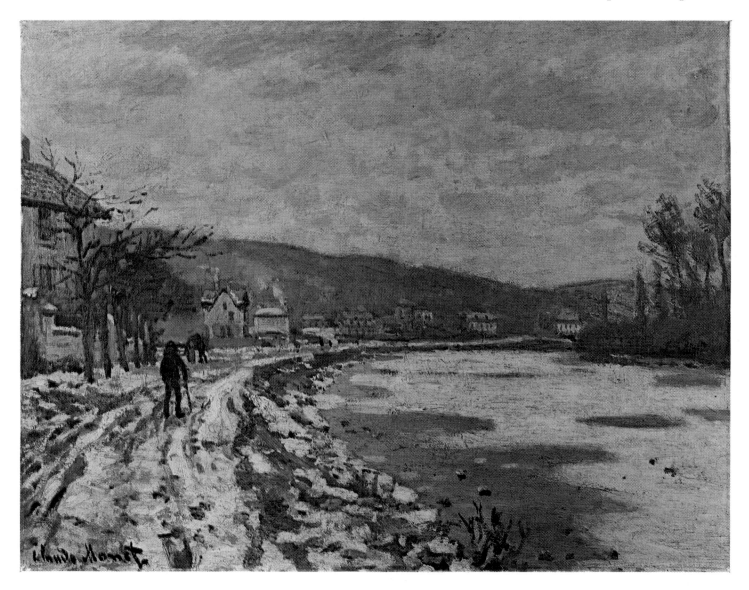

CLAUDE MONET: *Embacle de la Seine à Bougival*
Signed, painted c. 1873
$19\frac{3}{4} \times 25\frac{3}{4}$ in. (50 × 65.5 cm.)
Sold 28.11.72 for 92,000 gns. ($231,840)
From the collection of Mrs Rosemary Peto

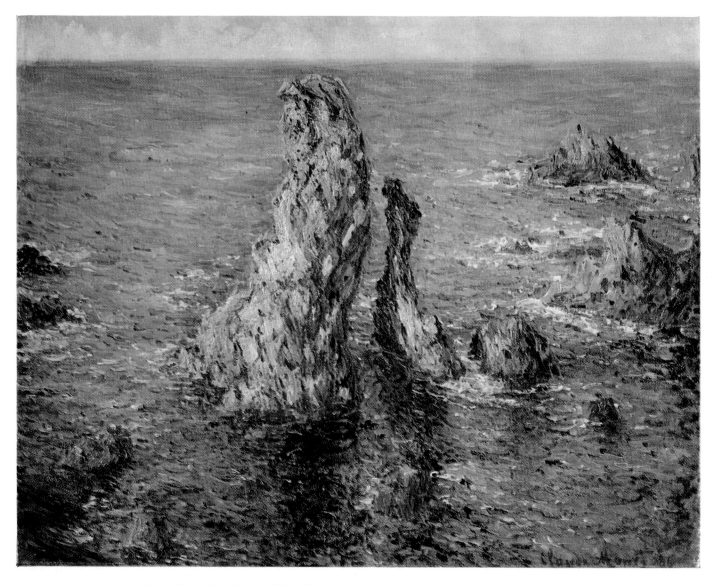

CLAUDE MONET: *Les Pyramides à Port-Coton (Belle-Isle)*
Signed and dated '86
$25\frac{1}{2} \times 32$ in. (65×81 cm.)
Sold 27.3.73 for 68,000 gns. ($171,360)

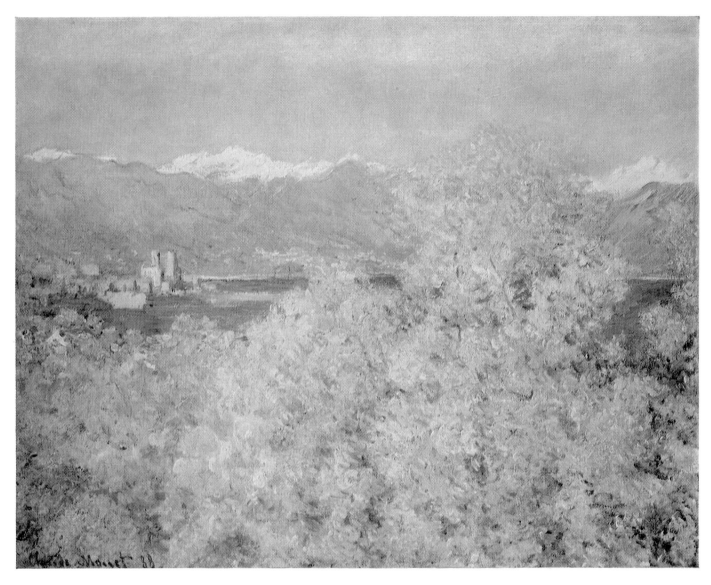

CLAUDE MONET: *Antibes, vue des Jardins de la Salis*
Signed and dated '88
$29\frac{1}{4} \times 36\frac{1}{2}$ in. (74×93 cm.)
Sold 27.3.73 for 95,000 gns. ($239,400)
From the collection of the late Howard Young

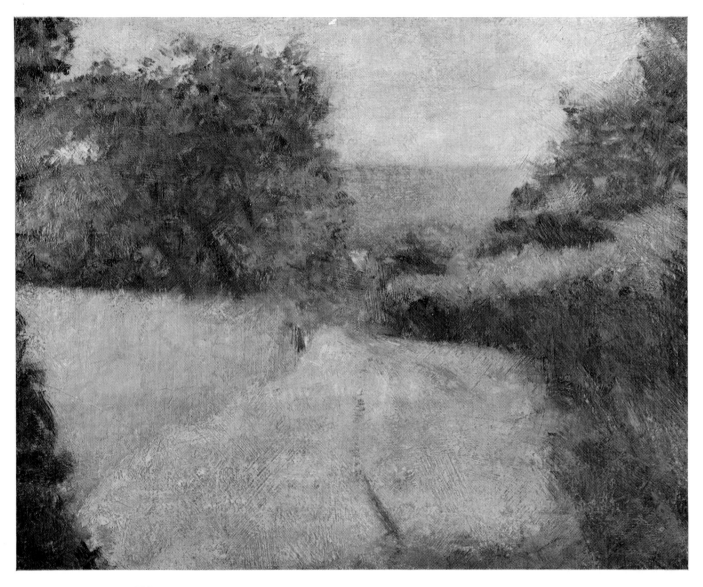

GEORGES SEURAT: *Eté*
Oil on canvas laid down on panel, painted c. 1882
12¾ × 16 in. (32.5 × 40.5 cm.)
Sold 28.11.72 for 65,000 gns. ($163,800)
From the collection of Mrs Rosemary Peto

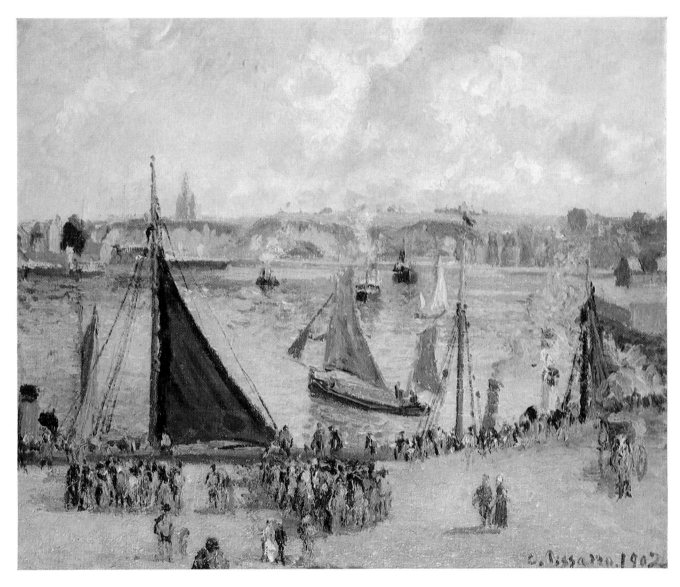

CAMILLE PISSARRO: *Avant-port de Dieppe*
Signed and dated 1902
$21\frac{1}{4} \times 25\frac{1}{2}$ in. $(54 \times 65$ cm.$)$
Sold 27.3.73 for 90,000 gns. ($226,800)
From the collection of the late Howard Young

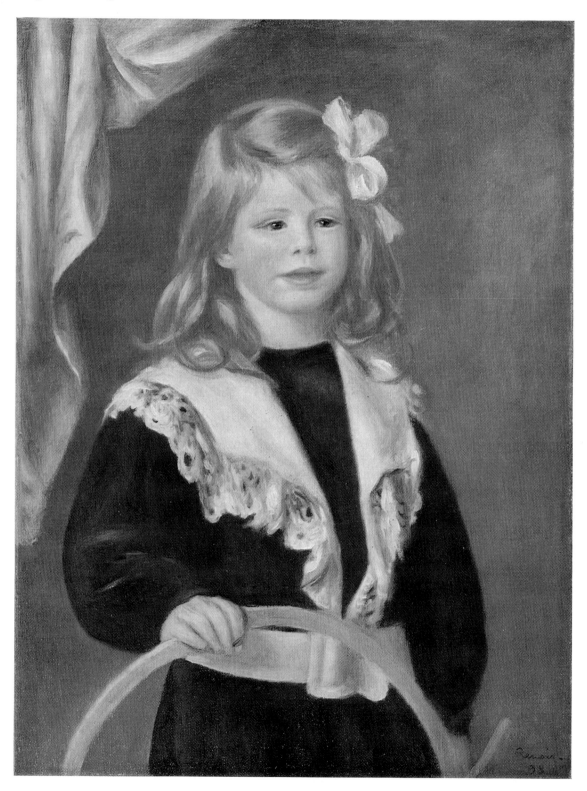

PIERRE AUGUSTE
RENOIR: *Portrait de
Jean Renoir tenant un
cerceau*
Signed, painted
in 1898–9
26 × 20 in.
(66 × 50 cm.)
Sold 3.7.73 for
185,000 gns.
($485,625)

PIERRE AUGUSTE
RENOIR: *Portrait de
Madame Mithouard*
Signed and dated '02
$32 \times 25\frac{3}{4}$ in.
(81 × 65.5 cm.)
Sold 27.3.73 for
150,000 gns.
($378,000)
From the collection
of the late
Howard Young

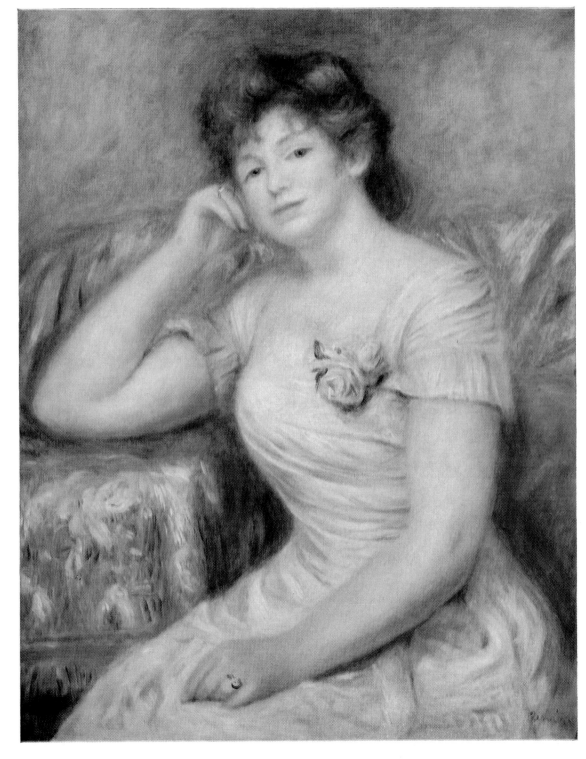

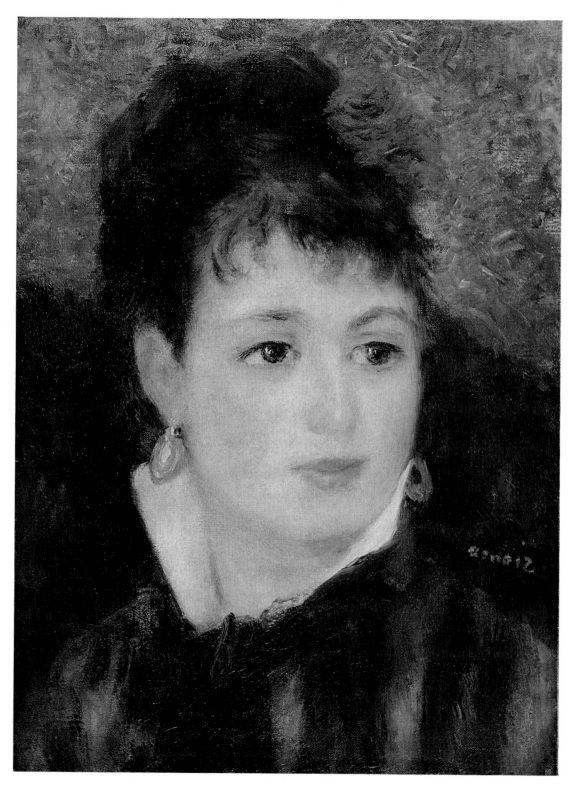

PIERRE AUGUSTE
RENOIR: *Femme
à la rose*
Signed
$13 \times 10\frac{1}{2}$ in.
(33×27 cm.)
Sold 3.7.73 for
150,000 gns.
($393,750)

GEORGES ROUAULT:
L'accusé
Signed and dated
1908, on paper laid
down on board
$38\frac{1}{2} \times 28$ in.
(98×71 cm.)
Sold 3.7.73 for
60,000 gns.
($157,500)
Record auction price
for a work by this
artist

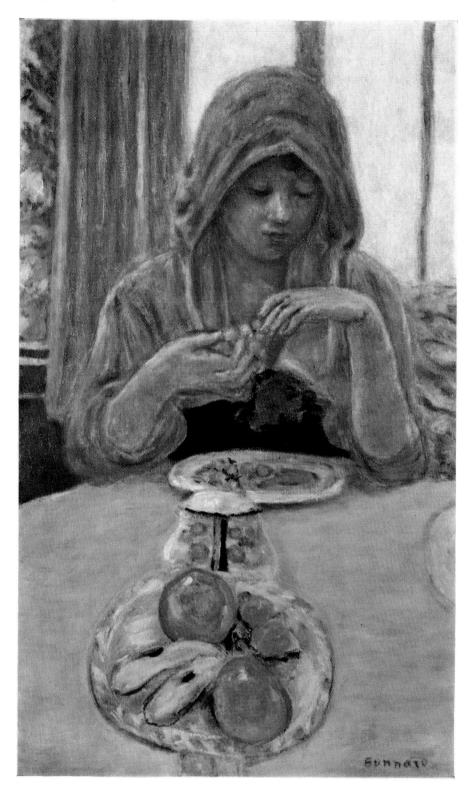

PIERRE BONNARD: *Femme à la nature morte*
Signed
$29\frac{1}{2} \times 18\frac{1}{2}$ in. $(75 \times 47$ cm.)
Sold 27.3.73 for 80,000 gns. ($201,600)
From the collection of the late
Howard Young

EDOUARD VUILLARD:
Le tennis
Signed and dated 1907
65 × 60 in. (165 × 152.5 cm.)
Sold 27.3.73 for
34,000 gns. ($85,680)
From the collection of the
late Howard Young
Record auction price for a
work by this artist

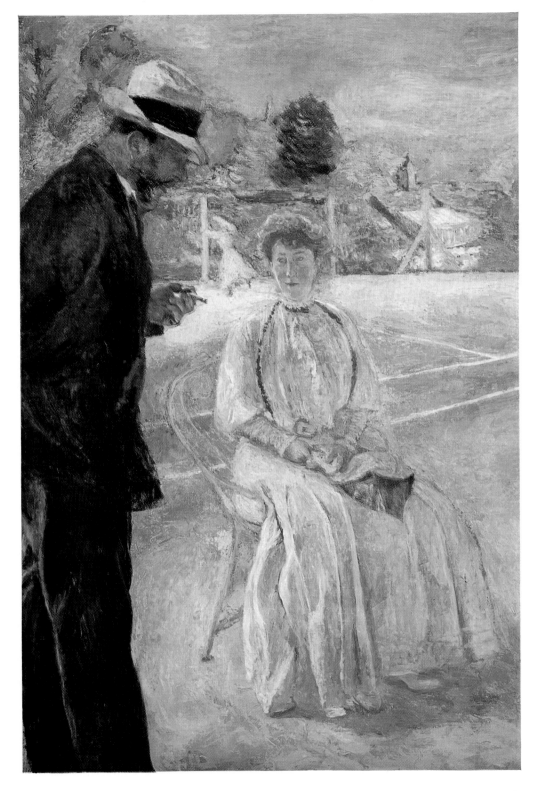

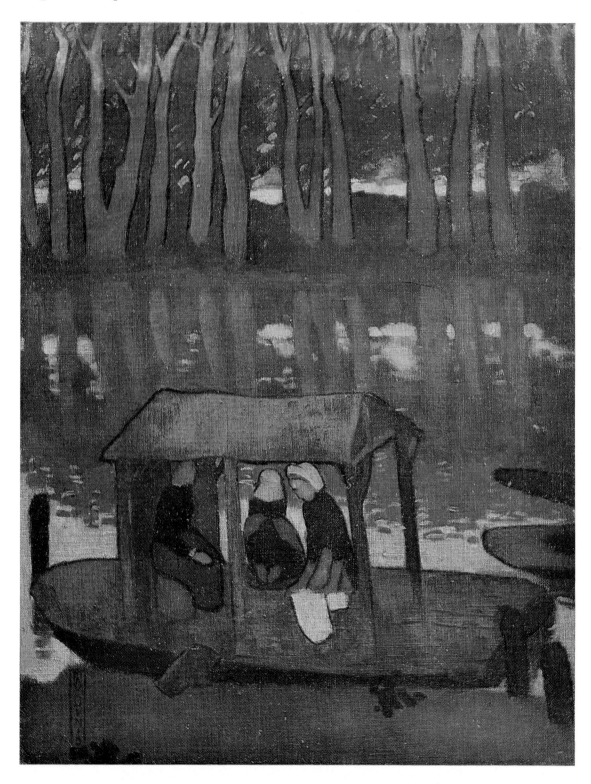

MAURICE DENIS:
Les lavandeuses
Signed and dated
Avril 90
22 × 18¼ in.
(56 × 46.5 cm.)
Sold 27.3.73 for
13,000 gns. ($32,760)

JUAN GRIS: *L'intransigeant*
Painted in 1915
$25\frac{1}{2} \times 18\frac{1}{4}$ in. (65×46 cm.)
Sold 28.11.72 for
65,000 gns. ($163,800)
From the collection of
L. A. Basmadjieff, Esq

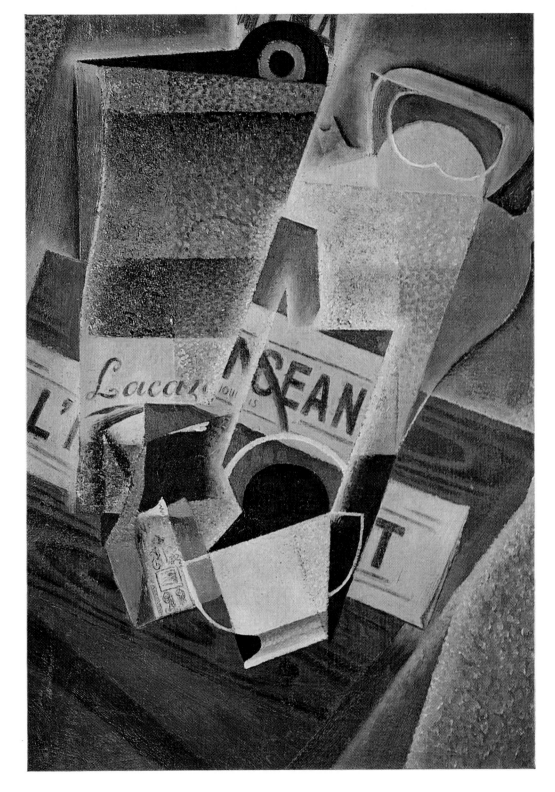

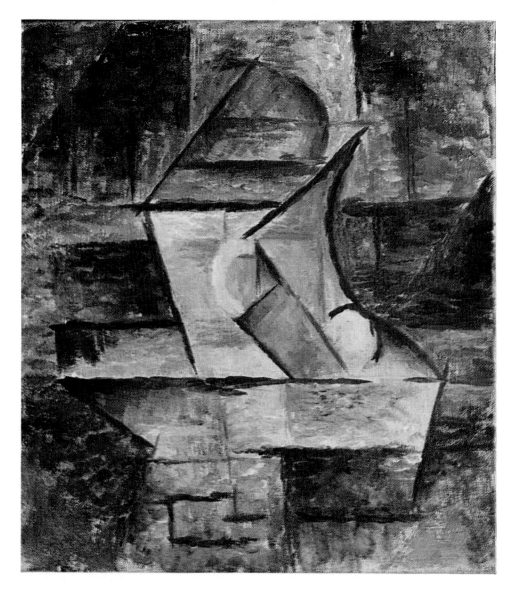

PABLO PICASSO: *Table*
Signed on the reverse
$8\frac{1}{4} \times 7\frac{1}{2}$ in. (21×19 cm.)
Sold 3.7.73 for 46,000 gns. ($120,750)

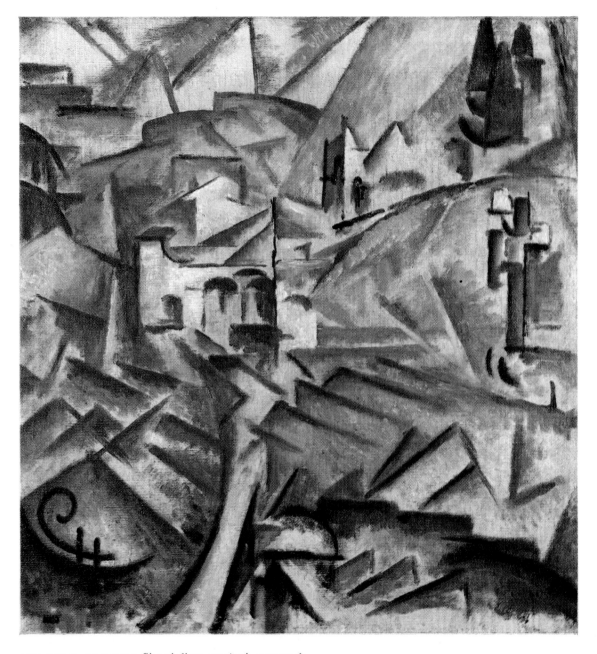

ARDENGO SOFFICI: *Sintesi di un paesàggio autumnale*
Signed and dated 1912 on reverse
18 × 17 in. (45.5 × 43 cm.)
Sold 28.11.72 for 16,000 gns. ($40,320)

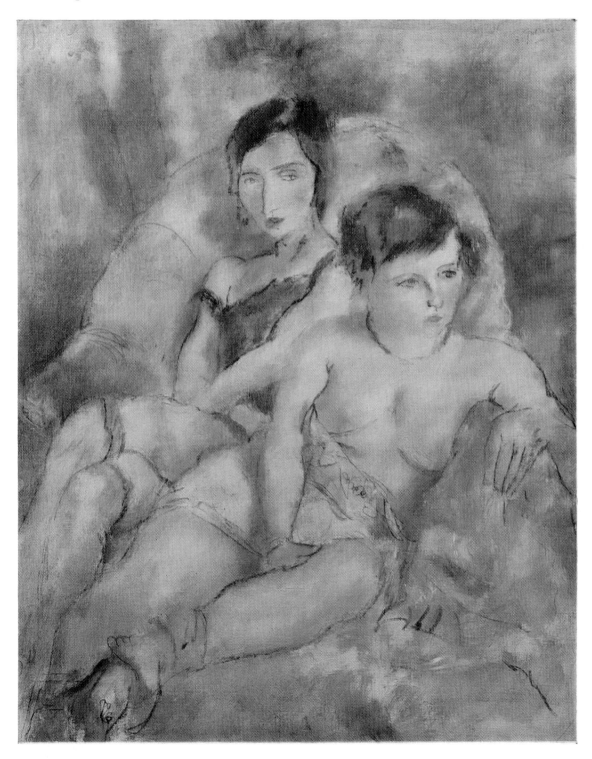

JULES PASCIN:
Les deux amies
Signed, painted
c. 1924
$31\frac{3}{4} \times 25\frac{1}{2}$ in.
(81 × 65 cm.)
Sold 28.11.72 for
23,000 gns. ($57,960)
From the collection of
Dr Robert Ducroquet

JOAN MIRO: *Vase de fleurs et papillon*
Signed and dated
1922–23, tempera on
panel, painted in
Montroig and Paris
$32 \times 25\frac{1}{4}$ in.
(81×64 cm.)
Sold 28.11.72 for
55,000 gns. ($138,000)
From the collection of
L. A. Basmadjieff, Esq

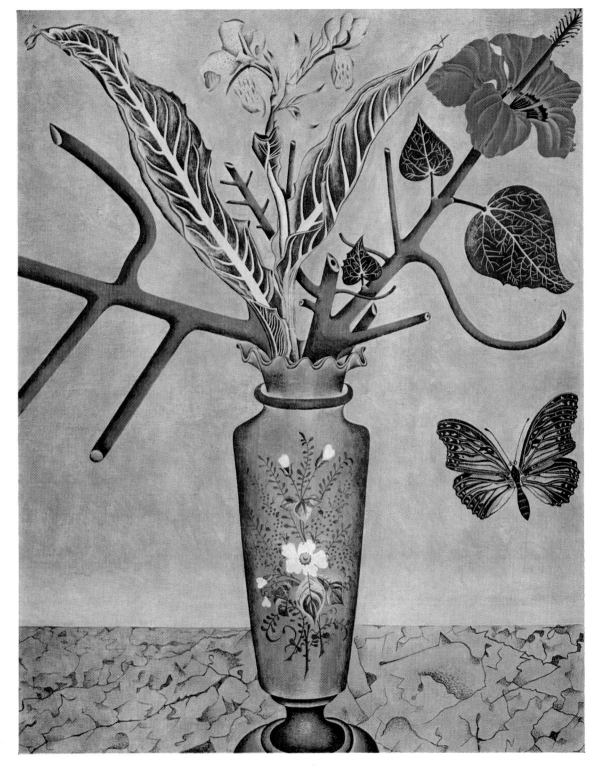

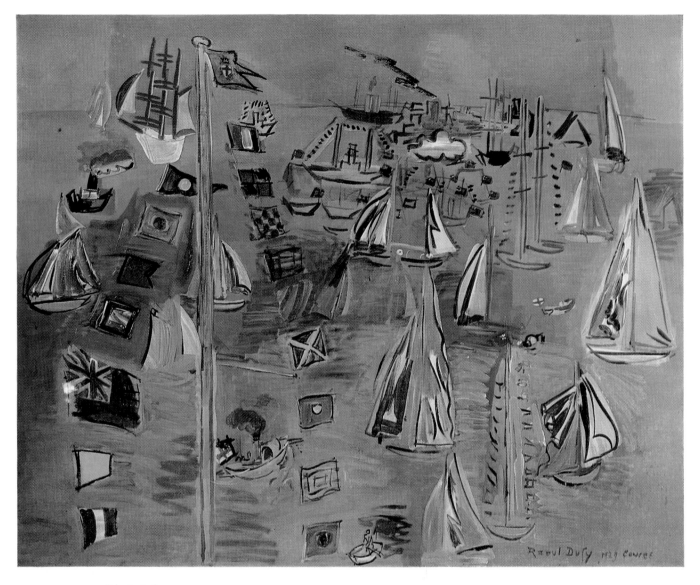

RAOUL DUFY: *Régate à Cowes*
Signed and dated Cowes 1929
52 × 64 in. (132 × 162.5 cm.)
Sold 28.11.72 for 38,000 gns. ($95,760)

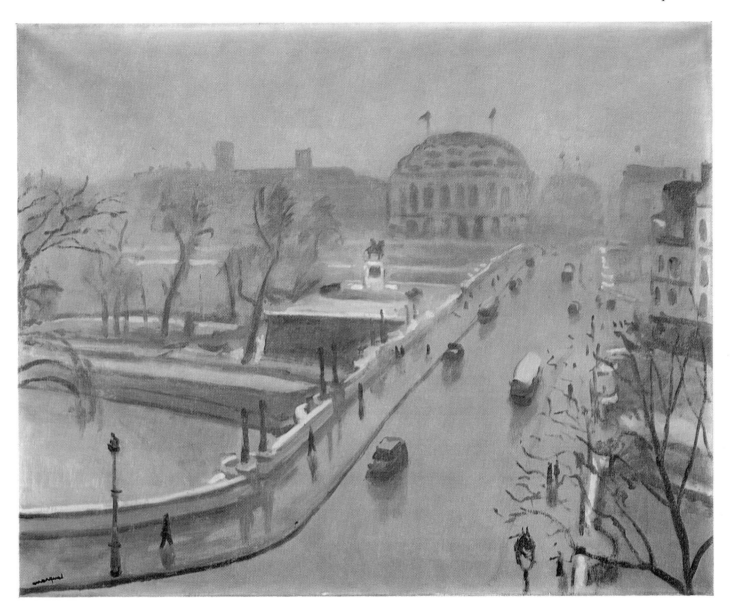

ALBERT MARQUET: *Le Pont Neuf et la Samaritaine*
Signed
$25\frac{3}{4} \times 32\frac{1}{4}$ in. (65×82 cm.)
Sold 28.11.72 for 24,000 gns. ($60,480)
From the collection of Dr Robert Ducroquet
Record auction price for a work by this artist

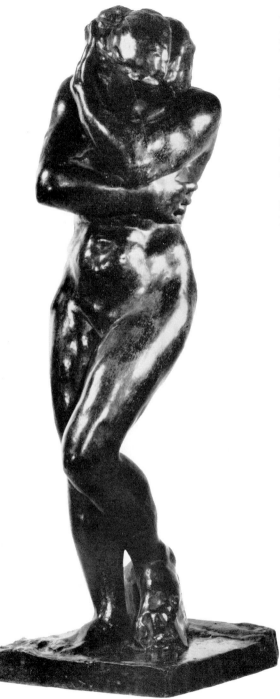

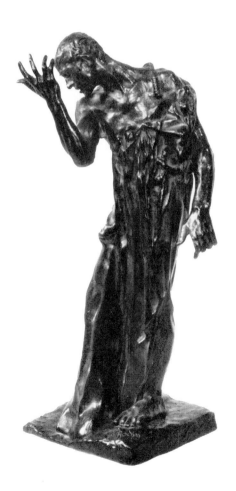

Left: AUGUSTE RODIN: *Eve*
Signed and marked '2ème épreuve' and 'Alexis Rudier, Fondeur, Paris'
Bronze with dark green patina, executed in 1881
29¾ in. (75.5 cm.) high
Sold 27.3.73 for 13,000 gns. ($32,760)
From the collection of the late Howard Young

Below: AUGUSTE RODIN: *Pierre de Wiessant*
Signed and marked 'Alexis Rudier, Fondeur, Paris' and with the
artist's signature in relief on the underside of the base, bronze with
dark patina, executed in 1889
17½ in. (44.5 cm.) high
Sold 3.7.73 for 7000 gns. ($18,375)
From the collection of Lady Cottesloe

WALTER RICHARD
SICKERT, ARA:
Une rue à Dieppe
Signed, inscribed and dated
1898 on the reverse
21¾ × 15 in. (55.3 × 38 cm.)
Sold 11.5.73 for 15,000 gns.
($39,375)

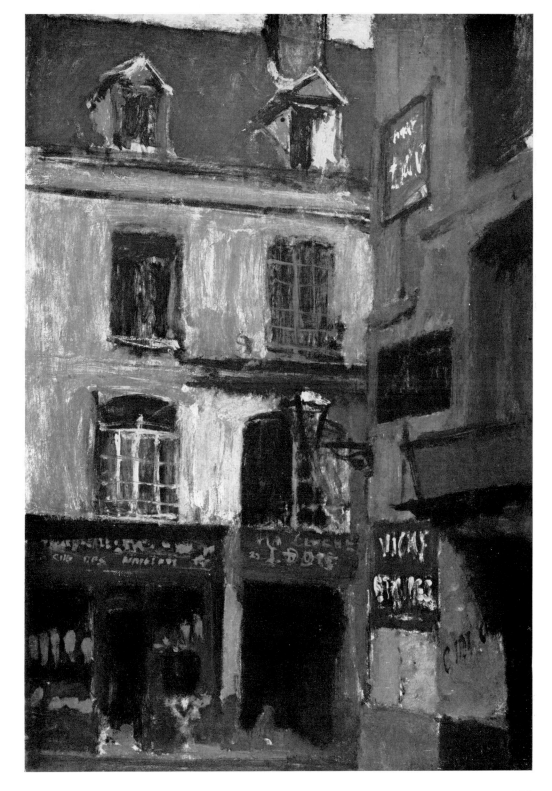

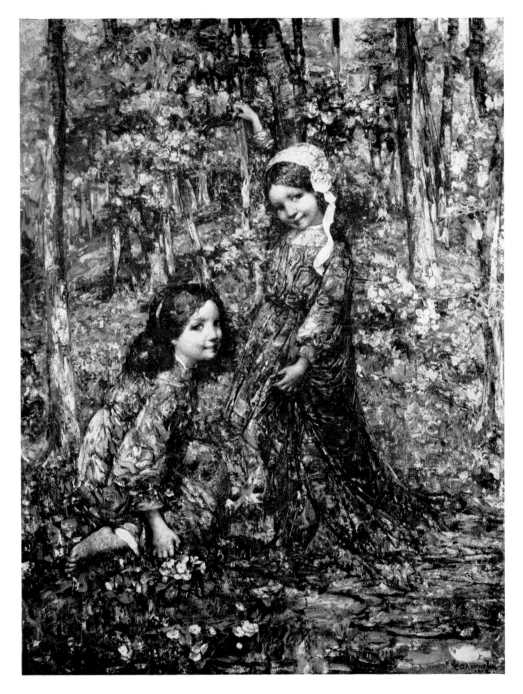

EDWARD ATKINSON HORNEL: *Young coquettes*
Signed and dated 1912
40 × 30 in. (101.6 × 76.2 cm.)
Sold 19.12.72 for 3800 gns. ($9576)
From the collection of Mrs Kathleen Harmer

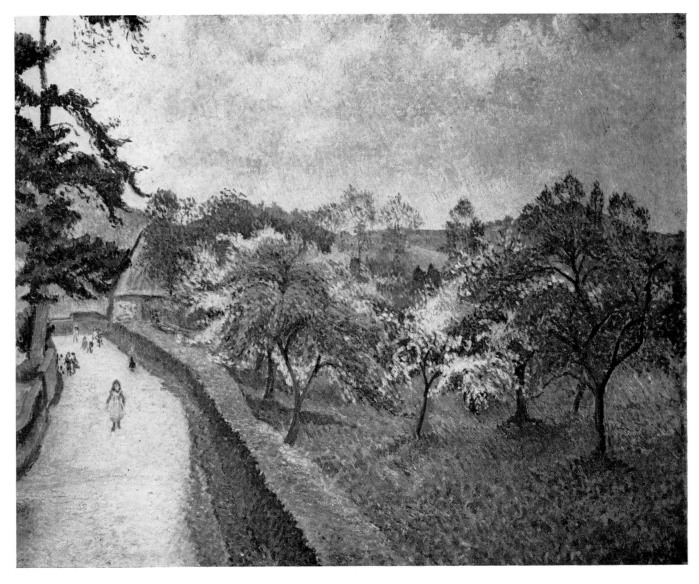

LUCIEN PISSARRO: *Apple blossom, East Knoyle*
Signed with monogram and dated 1917
21 × 25½ in. (53.3 × 64.7 cm.)
Sold 13.7.73 for 3800 gns. ($9975)
Record auction price for a work by this artist

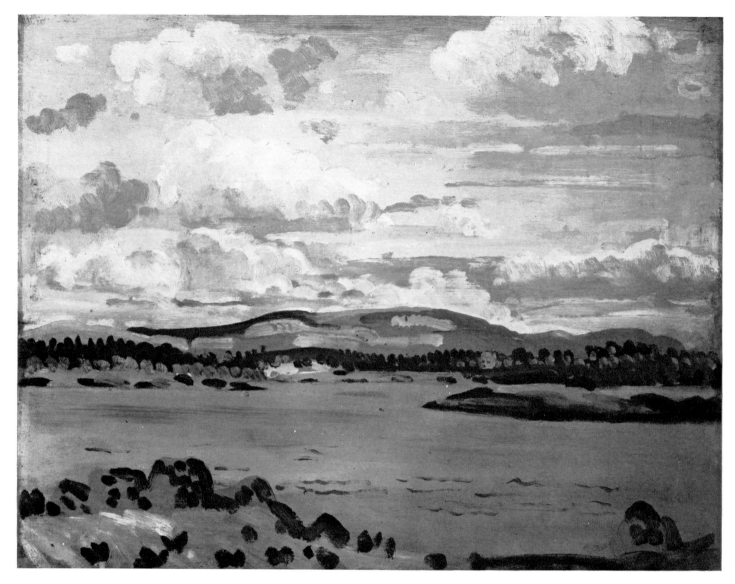

JAMES DICKSON INNES: *Lake at Coole Park, co. Galway*
On panel
12 × 16 in. (30.5 × 40.7 cm.)
Sold 13.7.73 for 5000 gns. ($13,125)

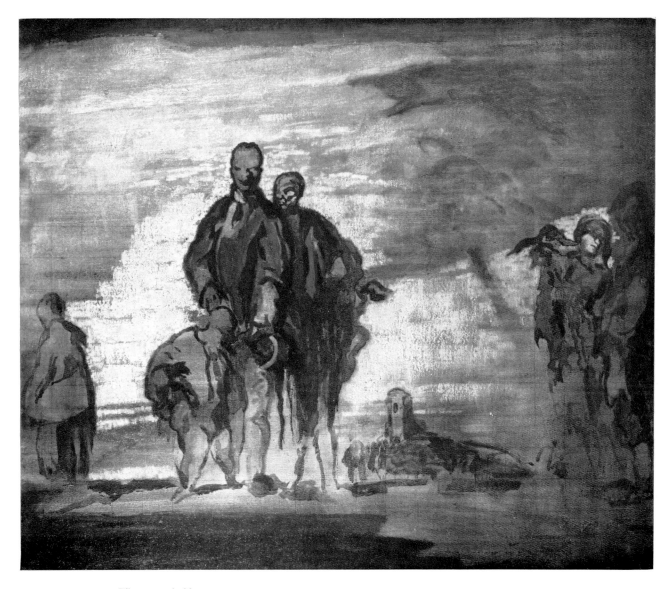

JAMES PRYDE: *The untouchables*
37 × 44 in. (94 × 111.7 cm.)
Sold 13.7.73 for 2400 gns. ($6300)
Record auction price for a work by this artist
The picture made 8 gns. ($40) when sold at Christie's in 1948

SIR WILLIAM ROTHENSTEIN: *Farm in Burgundy*
Signed with initials and dated 1906
23 × 31 in. (58.3 × 78.7 cm.)
Sold 13.7.73 for 3100 gns. ($8137)
Record auction price for a work by this artist

PAUL NASH:
*Lavrengo and Isopel in
the dingle*
Signed
Pen and black ink
with pencil and grey
washes, drawn in 1912
$17\frac{1}{2} \times 14$ in.
(44.3 × 35.7 cm.)
Sold 13.7.73 for
1850 gns. ($4856)
Record auction price
for a drawing by this
artist

SIR ALFRED MUNNINGS, PRA: *Suffolk horse fair*
Signed and dated 1901
50 × 80 in. (127 × 203.3 cm.)
Sold 11.5.73 for 33,000 gns. ($86,625)
Acquired by The Munnings Trust, Dedham
Record auction price for a work by this artist

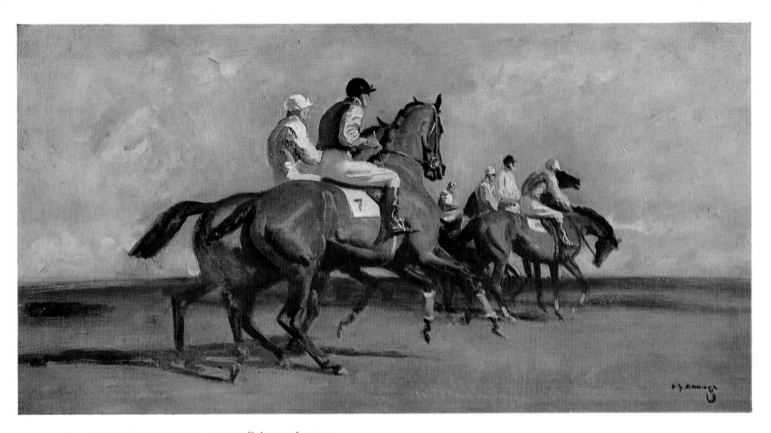

SIR ALFRED MUNNINGS, PRA: *Going to the start*
Signed, on board
11 × 21½ in. (28 × 54.7 cm.)
Sold 11.5.73 for 24,000 gns. ($63,000)

DAME BARBARA HEPWORTH:
Fenestration (*the magnifying glass, stage 2*)
Signed and dated 4/48, signed and inscribed and
dated again on the reverse, oil and pencil on board
15 × 10¾ in. (38 × 27.3 cm.)
One of a series of six pictures done at the London
Clinic of Fenestration, an operation on the ear to
help otosclerotic deafness
Sold 13.7.73 for 3200 gns. ($8400)
Record auction price for a drawing by this artist

DAME BARBARA HEPWORTH:
Two studies of a seated nude
Signed and dated 11/47, oil and pencil on board
11¼ × 9¼ in. (28.7 × 23.5 cm.)
Sold 11.5.73 for 3100 gns. ($8040)

GRAHAM SUTHERLAND, OM:
*Study for 'The origins of the
land'*
Gouache with black and
coloured chalks, painted in
1951
32 × 21 in. (81.3 × 53.3 cm.)
Sold 13.7.73 for 5800 gns.
($15,225)
Study for the large picture
commissioned for the Festival
of Britain and now in the
Tate Gallery

PERCY WYNDHAM LEWIS:
The patrol
Signed and dated 1918
Watercolour with pen and
black ink
10 × 13¾ in. (25.3 × 35 cm.)
Sold 11.5.73 for 2000 gns.
($5250)
From the Mount Trust
Collection

JOHN ARMSTRONG, ARA:
Battle of religion
Signed and dated '53
30 × 40 in. (76.3 × 101.7 cm.)
This is one of three pictures
painted at the same period and
inspired by the uselessness of all
political and religious activity.
The other two are called
Battle of propaganda and
Battle of nothing (both private
collections)
Sold 11.5.73 for 1100 gns.
($2887)

WILLIAM SCOTT: *Frying pan and blue fish*
Signed, painted in 1947
20 × 24 in. (50.5 × 61 cm.)
Sold 11.5.73 for 2900 gns. ($7612)

WILLIAM SCOTT: *Hare and candle*
Signed, painted c. 1948
26½ × 32¼ in. (67.3 × 82 cm.)
Sold 13.7.73 for 4400 gns. ($11,500)
Record auction price for a work by
this artist

LAURENCE STEPHEN LOWRY, RA: *Canal and factories*
Signed and dated 1955
24 × 30 in. (61 × 76.3 cm.)
Sold 11.5.73 for 14,000 gns. ($36,750)

SIR WILLIAM RUSSELL
FLINT, RA: *The green skirt*
Signed, signed again and
inscribed on the backboard
Watercolour
$10\frac{1}{2} \times 14\frac{1}{2}$ in. $(26.7 \times 36.9$ cm.)
Sold 11.5.73 for 5000 gns.
($13,125)

DAVID SHEPHERD:
Buffalo disturbed
Signed and dated '62
24×36 in. $(61 \times 91$ cm.)
Sold 11.5.73 for 3800 gns.
($9975)
From the collection of Ernest
Kleinwort, Esq, and sold on
behalf of the World Wildlife
Fund

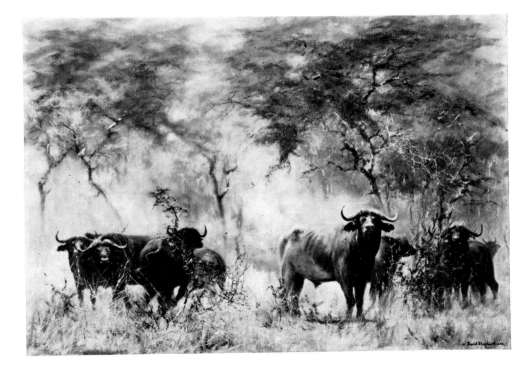

Japanese connoisseurship reflected in the saleroom

SIR JOHN FIGGESS

The bold advance of dealers and collectors from Japan into certain areas of the art market, which has been such a feature of the London saleroom in recent years, has drawn some perplexed comment in the press and caused no little puzzlement among Western collectors and dealers. The Japanese, it is safe to say, are today among the most discriminating collectors of art and antiques in the world and if the eclectic nature of their purchasing sometimes seems hard to understand it is worth remembering that it reflects a tradition of collecting works of art that goes back for upwards of a thousand years. Longer than that, indeed, since one can point to the Shōsō-in, an Imperial repository dating from the 8th century crammed full of treasures, including objects of exquisite craftsmanship brought as gifts to the court from far-away Persia and India as well as China. In the 13th century the Japanese were importing fine Chinese celadon in large quantities and in the 14th and 15th centuries the feudal rulers of the country eagerly promoted trade with China with a view to importing the superb Sung and Yüan paintings, porcelains and lacquer which they sought to embellish their palaces and furnish the Buddhist temples of the time. Later, in the

Shakudo nanako fuchi-kashira
Signed Hosono Sozayemon Masamori
Sold 13.3.73 for 200 gns. ($504)

PABLO PICASSO: *Petite tête de femme* (Bl. 1068)
Linocut, 1962, printed in black and three shades of
brown on Arches
Signed in pencil and numbered 43/50
Sold 30.11.72 for 1200 gns. ($3024)

EDGAR DEGAS: *Deux cavaliers*
Stamped (L. 658), pastel
12 × 9 in. (30.5 × 23 cm.)
Sold 3.7.73 for 16,000 gns. ($42,000)

16th and 17th centuries, the rising merchant class continued the tradition and, since the works acquired in this way have generally been treated in Japan with a care amounting almost to reverence, a considerable part of all the treasures accumulated over the centuries still survives in public and private collections, forming a standard by which new acquisitions tend to be judged. It is against this background that recent Japanese purchases of Oriental art in the West must be viewed.

In the realm of Western painting the Japanese are of course relative newcomers, but they are rapidly gaining experience and making their presence felt. The demand manifests itself at present mainly in the field of Impressionist and modern pictures where there is a passionate interest on the part of collectors and a growing number of well-informed dealers. But in the future they are unlikely to confine their purchases to such a narrow area. As the Japanese become more affluent and more familiar with the international art market it may be expected that their broadly based aestheticism will lead them into other avenues of art collecting and appreciation of Western art forms. There are signs of this already; for example there have been important Japanese purchases recently of Antiquities, modern British sculpture, and even vintage motorcars, a trend which is likely to continue.

Opposite:

AUGUSTE RODIN: *Le frère et la sœur*
Signed and inscribed 'à mon ami, Pierre Mael'
Bronze with green patina
15¼ in. (38 cm.) high
Sold 27.3.73 for 4600 gns. ($11,572)

Rare Ming blue and white mei p'ing
17½ in. (44 cm.) high
Sold 4.6.73 for 6000 gns. ($15,750)

Australian sales

JOHN HENSHAW

Some of the unexpected imagery, energy and feeling of the best Australian painting of the last eighty years finds expression also in the tastes of its more colourful collectors. Prominent among these in the season under review was Major Harold de Vahl Rubin, Queensland pastoralist and philanthropist, whose short, brilliant burst of collecting between 1958 and the year of his death, 1964, brought together one of the finest collections of Australian paintings in existence.

Major Rubin had a delightful habit of descending on a gallery showing the work of a young artist and, to the astonishment of everyone, buying every picture on view. Whether or not this turned out to be the wisest decision at the time is entirely beside the point, but in retrospect he did manage to secure panels by artists at the top of their form and no one seems to have succeeded to his particular flair.

His enthusiasm for the work of William Dobell was supreme. From the time of his spectacular purchases from the Norman Schureck collection in 1962, a whole new era of appreciation as well as speculation had developed. An important group of 25 works by Dobell was included in the first part of the sale in Sydney of the Rubin collection on the evening of October 4th. A 1934 study for *The Cypriot* (see illustration opposite) realised $A14,000 (£7000); *Girls under pandanus tree*, c. 1949, $A7000 (£3500); *Portrait of Norman Schureck*, $A11,000 (£5500); *Donkey and cabbage cart*, $A6000 (£3000); *Girl with a hat*, $A7000 (£3500) and a tiny study for what has proved to be perhaps the most popular of all Dobells, *Wangi boy*, fetched $A6800 (£3400). A small *Study of a young aboriginal stockman in a landscape* by Russell Drysdale reached $A9000 (£4500). The Rubin sale totalled $A180,190 (£90,095). Apart from the Dobells, it included Impressionist and modern works from the '50s and '60s. On the day before and on the morning of October 4th no fewer than 381 paintings of Australian interest were sold for $A256,720 (£128,360).

Quite another facet, that of Melbourne taste, was shown in the collections of the late Sir Charles Booth, CBE, Mrs Rosa Sacks and Family and Ronald Sharpe, Esq, which were offered in March. The Booth collection included rare selections of works by Frederick McCubbin, Walter Withers and David Davies. Prices were at a record for McCubbins: an early, strongly realistic, study of *The Yarra, Studley Park*, 1886

SIR WILLIAM DOBELL: *Study for the Cypriot (Aegeus Gabriell Ides)* *1934*
Signed, on wood panel, 30 × 30 in. (76.2 × 76.2 cm.)
Sold 4.10.72 for £7000 ($A14,000)
From the Harold De Vahl Rubin Collection

DAVID DAVIES: *Evening*
Signed and dated '97, $17\frac{1}{4} \times 22$ in. $(43.8 \times 55.8$ cm.)
Sold 1.3.73 for £8000 ($A16,000)

SIR GEORGE RUSSELL DRYSDALE:
Young immigrants
Signed and dated 1967 on the reverse
20×16 in. $(50.8 \times 40.6$ cm.)
Sold 1.3.73 for £8000 ($A16,000)

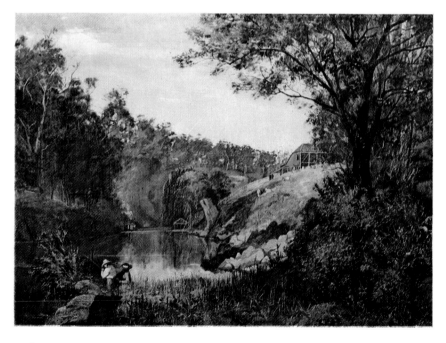

FREDERICK MCCUBBIN: *The Yarra,*
Studley Park
Signed and dated 1886
$31\frac{1}{4} \times 43\frac{1}{8}$ in. $(79.3 \times 109.5$ cm.)
Sold 1.3.73 for £11,000 ($A22,000)

(see illustration opposite) reached $A22,000 (£11,000) and a late *Edge of the Bush, Macedon*, 1911, $A13,000 (£6500); Walter Withers' *Saltwater Creek, Heidelberg*, 1898, a breezy glimpse of an informal, humble, yet typically Victorian dairy farm, fetched $A6500 (£3250) and a fine, poetic David Davies moonrise (*Evening*) of 1897 (see illustration opposite), $A16,000 (£8000).

The collection was fascinating in its concentration on the works of painters active before and around the turn of the century and included many fine examples by lesser known artists whose merit had not been fully appreciated – a solidly romantic, but shrewdly gathered, group of pictures.

Smaller, modern, but equal in the care with which they were brought together, were the collections of Mrs Rosa Sacks and Family, and Ronald Sharpe, Esq. The former produced a beautiful study of a woman and child entitled *Young mother*, by Sir William Dobell, 1942, which sold at $A13,000 (£6500), and the latter a John Perceval, *Arthur's Creek Road, with vintage car*, which reached $A7800 (£3900). Other important works included: *Young immigrants* by Sir Russell Drysdale (see illustration opposite) at $A16,000 (£8000) and the *Boundary rider* at $A12,500 (£6250); a Sidney Nolan, *Abandoned mine*, $A11,500 (£5750), and, to balance, a panel of rare early water-colours of Sydney and Port Piper as seen across the harbour ($A4200 [£2100] and $A4500 [£2250] respectively) by Joseph Lycett, the convict artist. Nicholas Chevalier, another colonial artist whose *Swiss landscape in Sovoie*, 1861, fetched $A6500 (£3250) and William Pignenit, whose *View of Lane Cove, Sydney* sold at $A7000 (£3500), indicated firm support for genuinely historical and topographic talent. The sale total of $A372,820 (£186,410) was a record for Christie's in Melbourne.

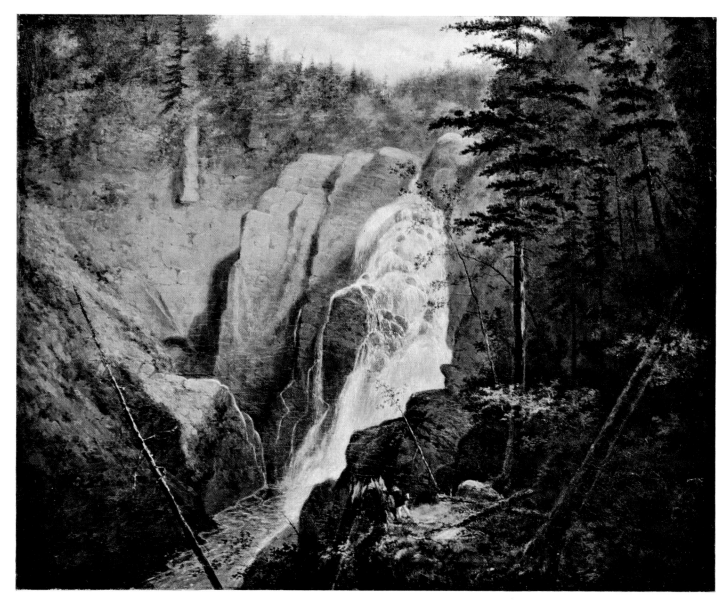

CORNELIUS KRIEGHOFF: *St Anne's Falls*
Signed and dated 1859
20 × 24½ in. (50.8 × 62.2 cm.)
Sold 2.5.73 at the Ritz Carlton Hotel, Montreal, for £12,000 ($30,000)
From the collection of the late R. B. Angus, Esq, of Montreal

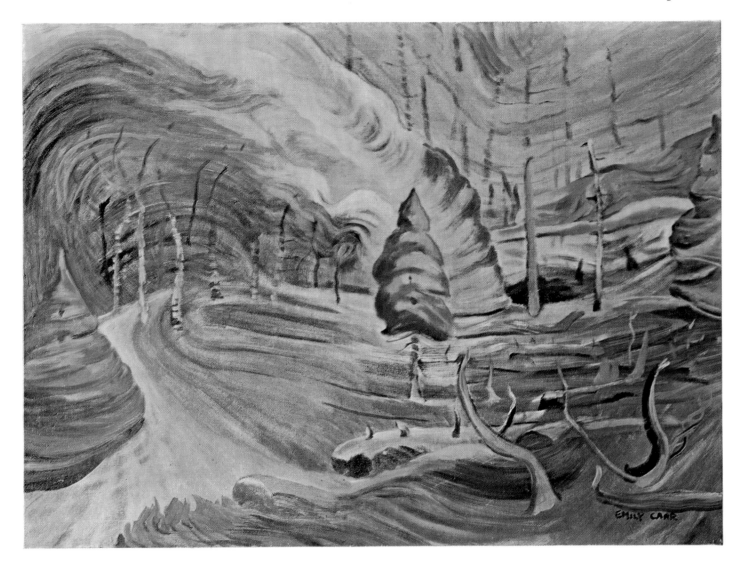

M. EMILY CARR: *Surge of spring*
Signed
24 × 33 in. (61 × 84 cm.)
Sold 2.5.73 at the Ritz Carlton Hotel, Montreal, for £13,600 ($34,000)

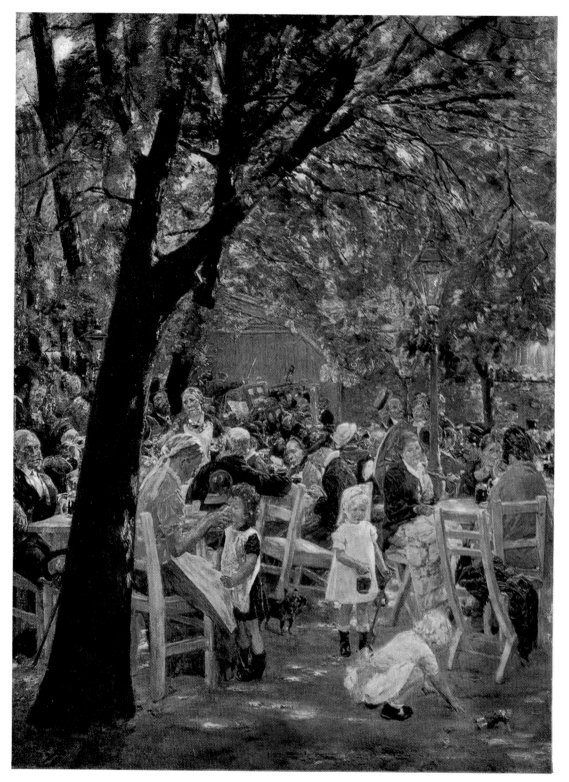

MAX LIEBERMANN:
Münchner Biergarten
Signed, oil on board
Painted in 1884
$37\frac{3}{8} \times 27$ in.
(95 × 68.5 cm.)
Sold 20.6.73 at Der
Malkasten, Düsseldorf,
for £39,393
(DM 260,000)
From the collection of
Mr Gerald Oliven

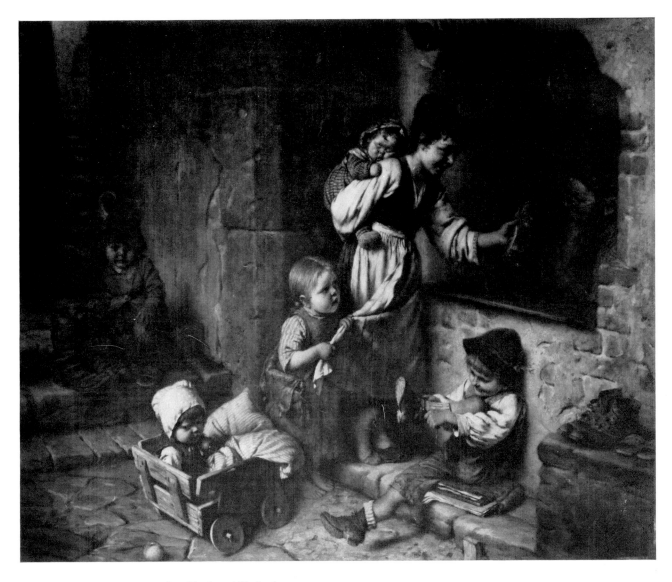

HERMANN KAULBACH: *Outside the cobbler's shop*
Signed, oil on panel
$21\frac{1}{2} \times 26\frac{3}{4}$ in. (55×68 cm.)
Sold 20.6.73 at Der Malkasten, Düsseldorf, for £16,666 (DM 110,000)
Record auction price for a work by this artist

Friedrich's symbolism

MICHAEL VOGGENAUER

It is very rare that a work of the German painter Caspar David Friedrich should be offered for sale at auction as was *Easter morning* which Christie's sold for £57,750 ($144,375) and which had been last recorded in 1859 (see illustration opposite). Incidentally, a month later in Düsseldorf Christie's sold another picture by Friedrich, *Die Nacht* from the cycle of *Times of day*, which was also thought to have been destroyed.

Friedrich is one of the most complex and symbolic artists of the 19th century and an interpretation of his work is not possible without an intimate knowledge of the political and spiritual tendencies in Germany in his lifetime.

He was born in 1774 in the harbour town of Greifswald in the part of Pomerania which then belonged to Sweden and was ceded to Prussia in 1815. The son of a prosperous soap boiler and candlemaker, Friedrich was brought up in the austere atmosphere of Pietism which, combined with the Romantic vision of an entity of God and Nature, was to underlie all his artistic creation.

Friedrich studied first with Quistorp, a drawing master in Greifswald, and it was probably on his advice that he went in 1794 to continue his studies at the Academy in Copenhagen. His teachers there were such distinguished painters as Jens Juel, the landscape painter Christian August Lorentzen and the history painter Nicolai Abilgaard.

In 1798 Friedrich moved to Dresden, then the centre of artistic life in Germany, where, except for visits to Bohemia, the island of Rügen, and his native Greifswald, he was to remain until his death in 1840. Friedrich's first ten years in Dresden were characterized by an intensive searching for form and symbol. It was first as a sepia painter that he gained recognition when he was awarded a prize by Goethe for two paintings exhibited at Weimar in 1805. These two sepia paintings *Summer landscape with a dead oak tree* and *Procession at dawn*, both in the Schlossmuseum at Weimar, foreshadow in their subjects and composition Friedrich's first attempt in oil *Cross in the mountains*, also called the *Tetschen Altar* (Gemäldegalerie Neue Meister, Dresden). In this exceptional painting where the frame is part of its symbolic meaning Friedrich realizes the synthesis of Paganism and Christian religion, expressed by the sunset which represents the passing of the old order of the world before Christ.

CASPAR DAVID
FRIEDRICH:
Easter morning
$17\frac{1}{2} \times 14$ in.
(44.4 × 35.6 cm.)
Sold 4.5.73 for
55,000 gns. ($144,375)
Record auction price
for a work by this
artist

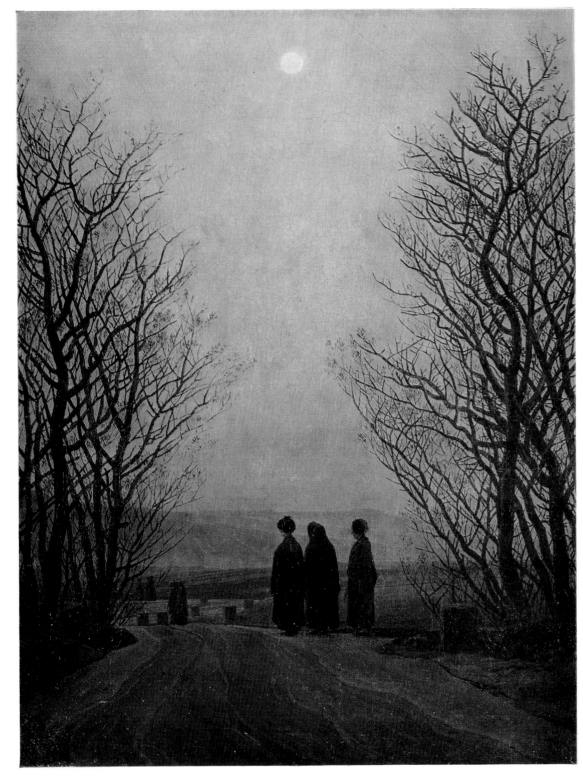

In 1810 he was exhibiting in Berlin *Monk by the sea*, which remains his most poignant and modern picture, and its pendant, *Abbey in the oakwood* (both now in Schloss Charlottenburg, Berlin), which despite its burial scene is an allusion to eternal life.

Patriot at heart, Friedrich was deeply concerned with the Wars of Liberation (1813-15) and the political changes in Germany. During the occupation of Dresden by French troops in 1813–14 he painted *'Chasseur' in the woods* (Private Collection, Bielefeld) in which he gave political overtones to his earlier religious symbolism. The subject was described in the Vossische Zeitung as 'A raven perched on an old branch singing the death song of a French Chasseur who is wandering alone through the snow-covered evergreen forest'. During this time he made also several designs for war monuments and gravestones, but of these only a few were executed. It is in *Ulrich von Hutten's grave* (Schlossmuseum, Weimar), probably dating from 1823, that he erected a spiritual monument of a more lasting kind, honouring not only the memory of a German patriot who had died in exile three hundred years before but also of those patriots like Jahn, Arndt, Stein and Görres, who played a leading part in the uprising of 1813 and who were now suffering from Prussian reactionism, by inscribing their names on the sarcophagus.

After 1816 Friedrich's pictorial language of symbols underwent a change, becoming less evident in its esoteric meaning. To some extent these developments are due to his marriage in 1818 to the young Caroline Bommer and the influence of younger artists, the most important being the Norwegian Johann Christian Dahl (1788–1857). Under Dahl's influence Friedrich's colour becomes more luminous and intense, the visionary buildings and misty atmosphere give way to a more human and everyday outlook on life. *Woman at the window* (Nationalgalerie, Berlin West) painted in 1822 and, dating from the same time, *Flat country landscape* and *Landscape with windmills* (both Schloss Charlottenburg, Berlin) express a peace of mind for which one searches in vain in his earlier pictures and which one will no more find after 1826, when he suffered a severe illness.

Easter morning places itself between the happy interlude and his darker and pain-stricken last years when he was to create such powerful evocations of the transience of life as *Large enclosure near Dresden* (Gemäldegalerie Neue Meister, Dresden) and *Stages of life* (Museum der bildenden Künste, Leipzig) painted about 1835.

Easter morning was recorded in 1859 in the collection of Wilhelm Wegener, the painter. In an article on Friedrich he wrote: 'In addition to this picture [*Early snow*, now Kunsthalle, Hamburg] I also possess a pendant an "Easter Morning". Three women, one in mourning, walk quietly to the graveyard in the early morning; the sun has not yet risen and the moon although still high in the sky throws no shadows.

The alders on either side of the path bear young buds and in the fields one can see the young green corn which has survived the winter, Nature also celebrates her awakening.' There is, however, no evidence that the painting sold at Christie's was intended by the artist as a pendant to *Early snow*, painted in 1828. One is more inclined to date it from its style and composition some four or five years earlier.

It is interesting to note that a sketchbook dated 1818, now in the Nasjonalgalleriet, Oslo, contains a very similar study of the two women who accompany the one in black in *Easter morning*. One first finds these two women in a painting in *Moonrise over the sea* (Nationalgalerie, Berlin West) which is believed to have been painted between 1820-26 and would be a further proof of the earlier date for *Easter morning*.

In his excellent introduction to the Friedrich exhibition held last year at the Tate Gallery, William Vaughan pointed out that 'those pictures in which a visionary intimation of the life beyond appear are, on the whole, those in which a symmetrical balance is established'. In this one a total symmetry is achieved by the full moon placed centrally in the sky and the alders on each side of the road. Although every symbol in the painting leads one to believe that Friedrich intended to illustrate with his own pictorial language the Easter morning, there is no evidence which proves this conclusively. One may only suppose that the three women are an allusion to the three Marys, the path on which they walk the path of life, marked by the milestones which are its stages. However, in this painting which reveals so much of Friedrich's faith, as he once expressed it in a poem: '. . . In order to live one day eternally, one must submit oneself to death many times', Christ is symbolized by the full moon and the Resurrection by the young buds on the trees and the new green corn in the fields.

BIBLIOGRAPHY

H. v. Einem, *Caspar David Friedrich*, Berlin 1938

Werner Sumowski, *Caspar David Friedrich-Studien*, Wiesbaden 1970

William Vaughan, Helmut Börsch-Supan, Hans Joachim Neidhardt, Catalogue of the Exhibition, *Caspar David Friedrich*, Tate Gallery, 1972

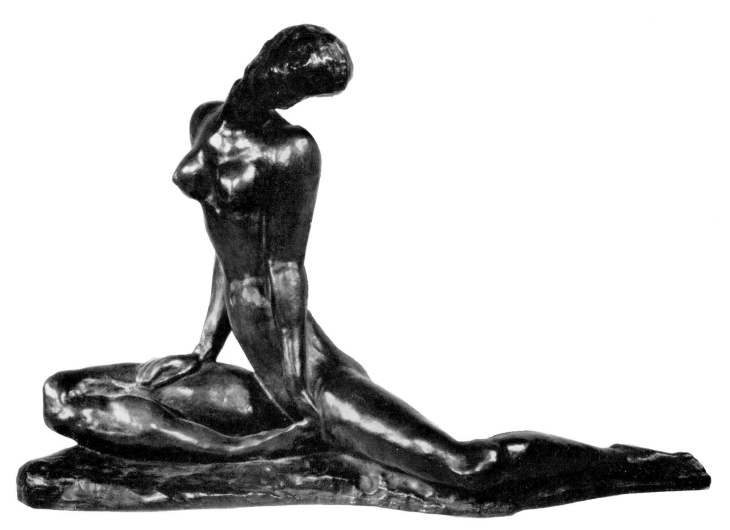

WILHELM LEHMBRUCK: *Sitting girl*
Signed and stamped 'H. Noack, Berlin Friedenau'
Bronze with dark brown patina, c. 1913
$11\frac{1}{4}$ in. (28.5 cm.) high
Sold 20.6.73 at Der Malkasten, Düsseldorf, for £10,606 (DM 70,000)

JEWELLERY

Magnificent diamond ring set with a navette diamond of approx. 20.89 ct. Sold 15.11.72 at the Hôtel Richemond, Geneva, for £68,156 (Sw. fr. 610,000)

Magnificent unmounted pear-shaped diamond of approx. 55.91 ct. Sold 15.11.72 at the Hôtel Richemond, Geneva, for £335,196 (Sw. fr. 3,000,000) World record price per carat

Magnificent diamond ring set with an emerald cut diamond of approx. 28.19 ct. By Cartier, New York Sold 15.11.72 at the Hôtel Richemond, Geneva, for £98,323 (Sw. fr. 880,000)

Superb ruby and
diamond parure
By Bulgari, Rome
Sold 9.5.73 at the
Hôtel Richemond,
Geneva, for £62,500
(Sw. fr. 500,000)

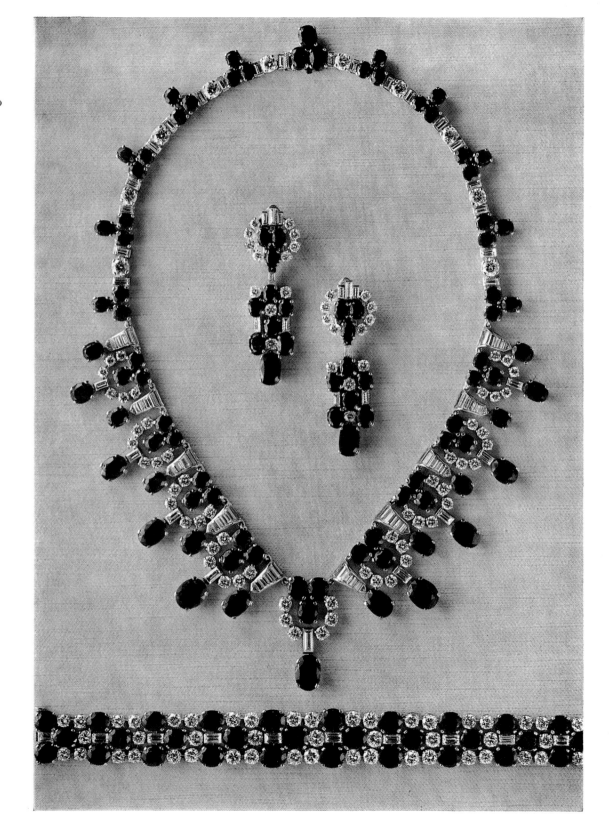

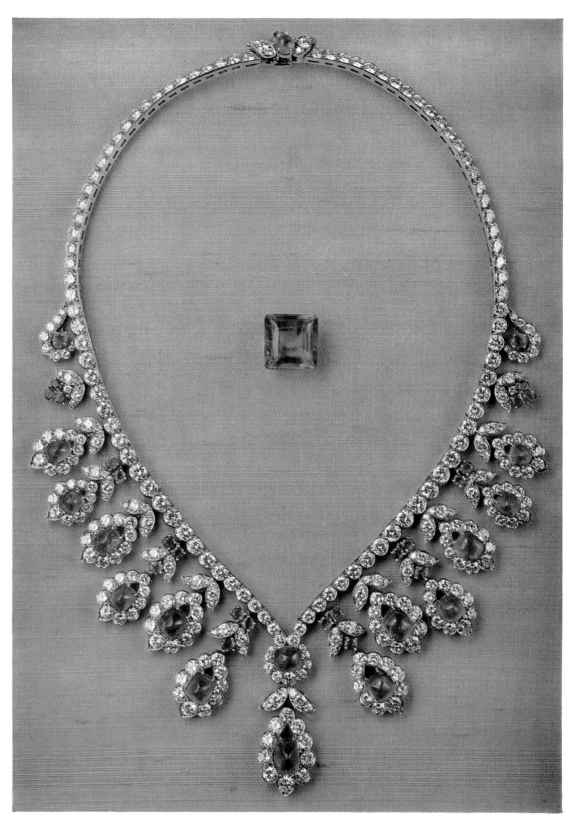

Important unmounted
square-cut emerald
of approx. 13.7 ct.
Sold 9.5.73 at the
Hôtel Richemond,
Geneva, for £23,750
(Sw. fr. 190,000)

Emerald and diamond
necklace
Signed by Van Cleef
& Arpels, New York
Sold 9.5.73 at the
Hôtel Richemond,
Geneva, for £21,250
(Sw. fr. 170,000)

Highly important
diamond necklace of
festoon design
By Van Cleef &
Arpels, New York
Sold 15.11.72 at the
Hôtel Richemond,
Geneva, for £39,106
(Sw. fr. 350,000)

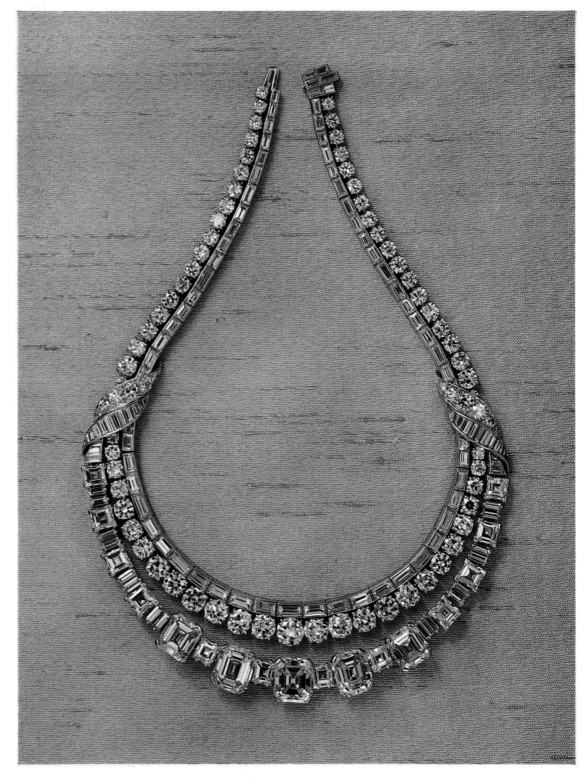

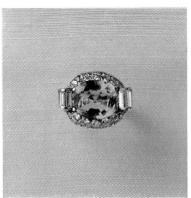

Important emerald and diamond ring set with a rectangular emerald
Sold 9.5.73 at the Hôtel Richemond, Geneva, for £10,000 (Sw. fr. 80,000)

Important emerald and diamond ring set with an oval emerald of approx. 4.06 ct.
Sold 9.5.73 at the Hôtel Richemond, Geneva, for £10,000 (Sw. fr. 80,000)

Important emerald and diamond ring set with a rectangular-cut emerald of approx. 6.53 ct.
Sold 9.5.73 at the Hôtel Richemond, Geneva, for £15,000 (Sw. fr. 120,000)

Highly important emerald and diamond ring set with a rectangular emerald
Sold 9.5.73 at the Hôtel Richemond, Geneva, for £12,500 (Sw. fr. 90,000)

Superb cabochon emerald and diamond ring, the fancy-cut cabochon emerald of approx. 13.66 ct.
Sold 9.5.73 at the Hôtel Richemond, Geneva, for £50,000 (Sw. fr. 400,000)

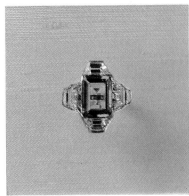

Superb imperial
jade necklace of
31 graduated
jade beads
Sold 9.5.73 at the
Hôtel Richemond,
Geneva, for £156,250
(Sw. fr. 1,250,000)

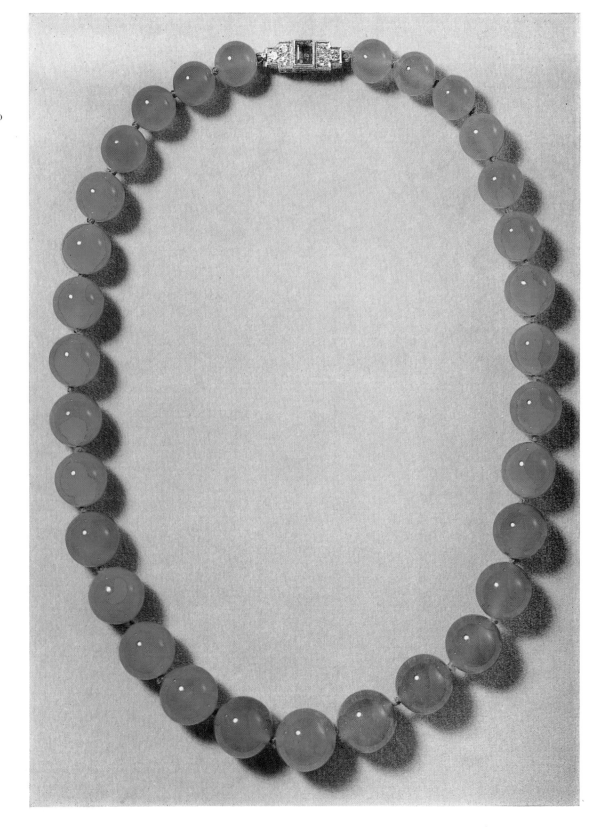

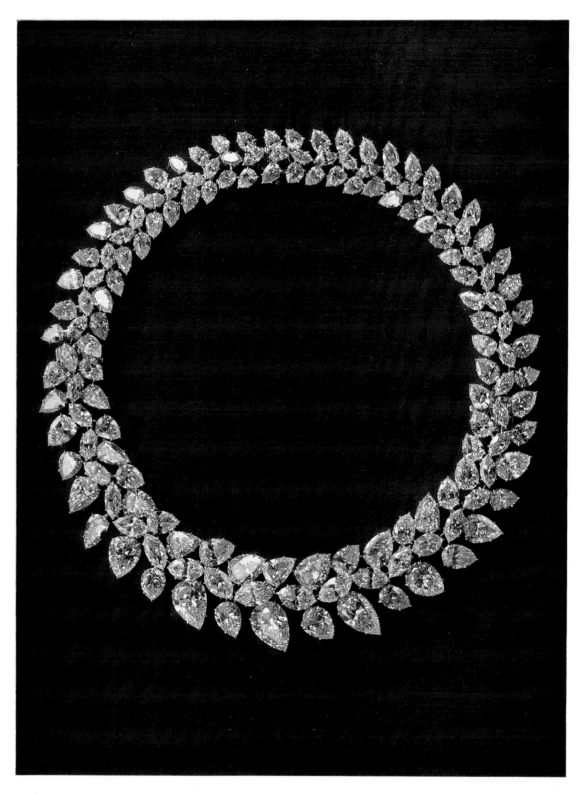

Magnificent diamond
necklace. 98 pear-
shaped diamonds:
approx. 110.58 ct.;
49 navette-diamonds:
approx. 31.12 ct.
By Harry Winston,
New York
Sold 9.5.73 at the
Hôtel Richemond,
Geneva, for £81,250
(Sw. fr. 650,000)

Superb diamond
necklace
Sold 9.5.73 at the
Hôtel Richemond,
Geneva, for £87,500
(Sw. fr. 700,000)

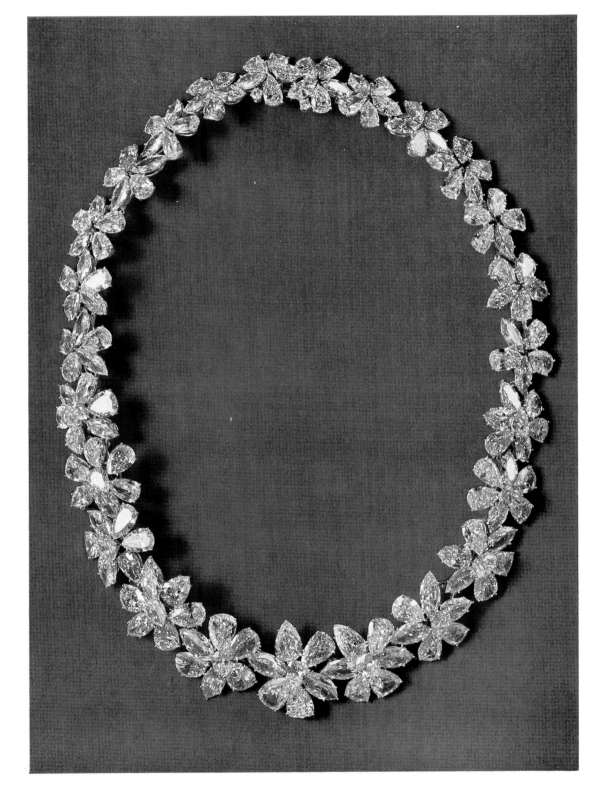

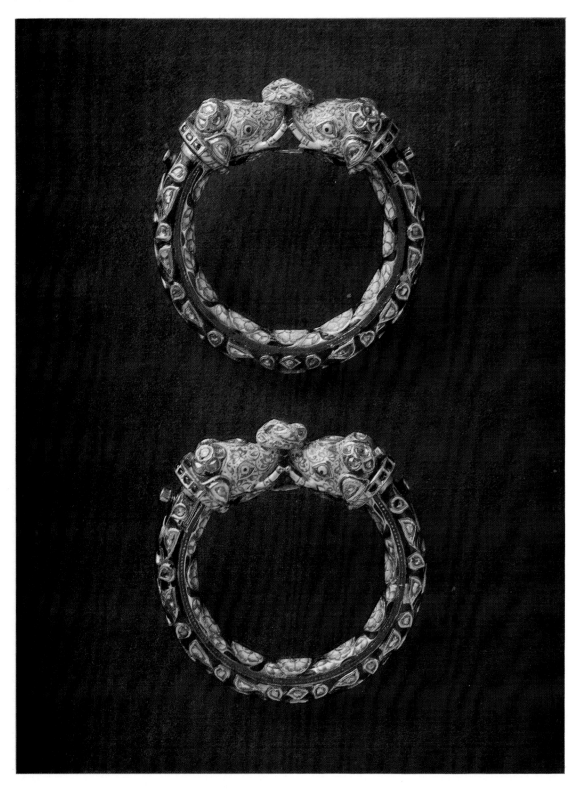

Important pair of
elephant Balā
(bangles)
Benares, late 18th or
early 19th century
Sold 9.5.73 at the
Hôtel Richemond,
Geneva, for £3500
(Sw. fr. 28,000)

Enamelled gold
octagonal box
$2\frac{1}{4} \times 2$ in. (5.8 × 5 cm.)
Delhi, early
19th century
Sold for £1750
(Sw. fr. 14,000)

Enamelled gold
octagonal box
$1\frac{3}{4} \times 1\frac{5}{8}$ in.
(4.5 × 4 cm.)
Delhi, early
19th century
Sold for £875
(Sw. fr. 7000)

Enamelled gold
octagonal box
$1\frac{5}{8} \times 1\frac{3}{8}$ in.
(4.2 × 3.5 cm.)
Delhi, early
19th century
Sold for £1062
(Sw. fr. 8500)

Oval jade plaque
$1\frac{5}{8} \times 1\frac{1}{8}$ in.
(4.2 × 2.7 cm.)
Delhi, early
19th century
Sold for £500
(Sw. fr. 4000)

All sold 9.5.73 at the
Hôtel Richemond,
Geneva

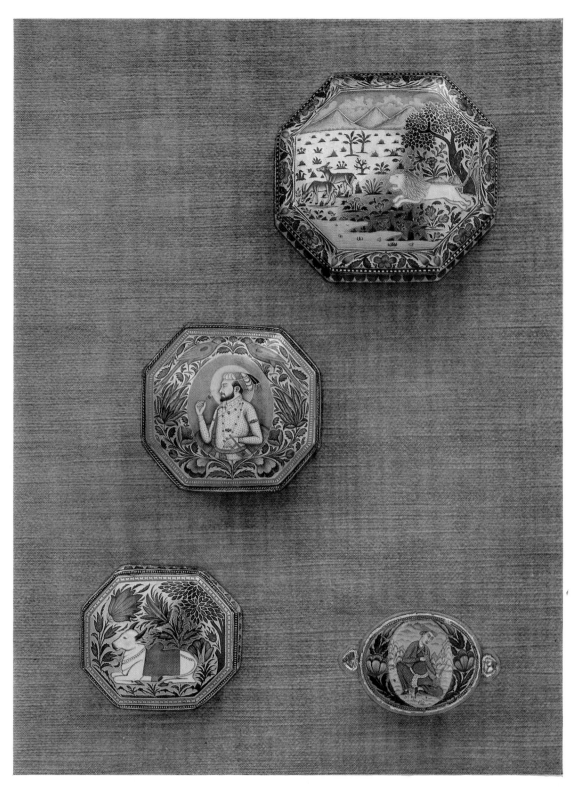

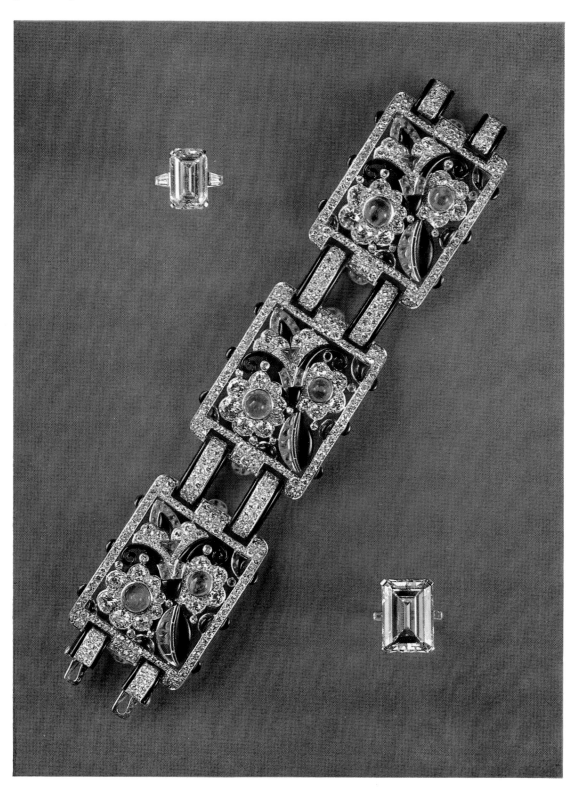

Important diamond ring set with a rectangular-cut diamond of approx. 10.15 ct. Sold 9.5.73 at the Hôtel Richemond, Geneva, for £17,500 (Sw. fr. 140,000)

Rare Art Deco bracelet set with cabochon and calibre emeralds, amethysts, black enamel and diamonds French, c. 1925 Sold 9.5.73 at the Hôtel Richemond, Geneva, for £5500 (Sw. fr. 44,000)

Diamond ring set with a rectangular diamond of approx. 20.51 ct. Sold 9.5.73 at the Hôtel Richemond, Geneva, for £11,250 (Sw. fr. 90,000)

Highly important
black pearl necklace
set with 67 graduated
black pearls
Sold 9.5.73 at the
Hôtel Richemond,
Geneva, for £7250
(Sw. fr. 58,000)

Superb antique
butterfly brooch
Sold 9.5.73 at the
Hôtel Richemond,
Geneva, for £5500
(Sw. fr. 44,000)

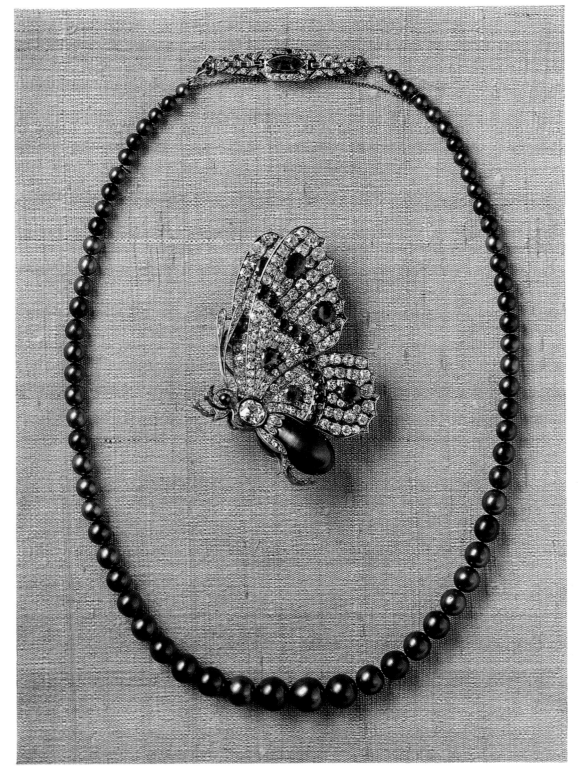

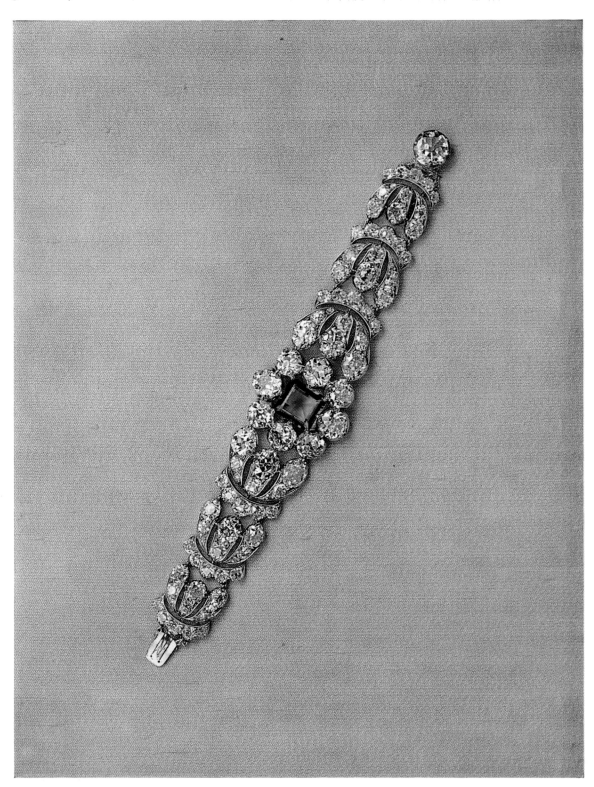

Magnificent antique emerald and diamond bracelet, the rectangular-cut emerald approx. 9.28 ct.
First half 19th century
Sold 15.11.72 at the Hôtel Richemond, Geneva, for £73,742 (Sw. fr. 660,000)

Important emerald
and diamond ring
set with a square-cut
emerald of approx.
10.12 ct.
By Boucheron, Paris
Sold 15.11.72 at the
Hôtel Richemond,
Geneva, for £33,520
(Sw. fr. 300,000)

Important emerald
and diamond bracelet
By Van Cleef &
Arpels, Paris
Sold 15.11.72 at the
Hôtel Richemond,
Geneva, for £20,111
(Sw. fr. 180,000)
From the collection
of H.H. Princess
Ibrahim

Pair of highly
important unmounted
drop-shaped emeralds
weighing approx.
6.46 and 6.55 ct.
Sold 15.11.72 at the
Hôtel Richemond,
Geneva, for £53,631
(Sw. fr. 480,000)

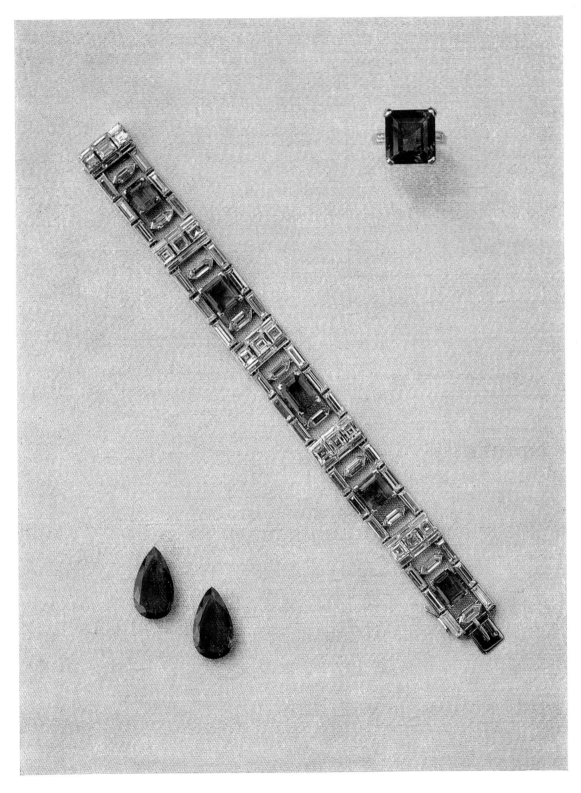

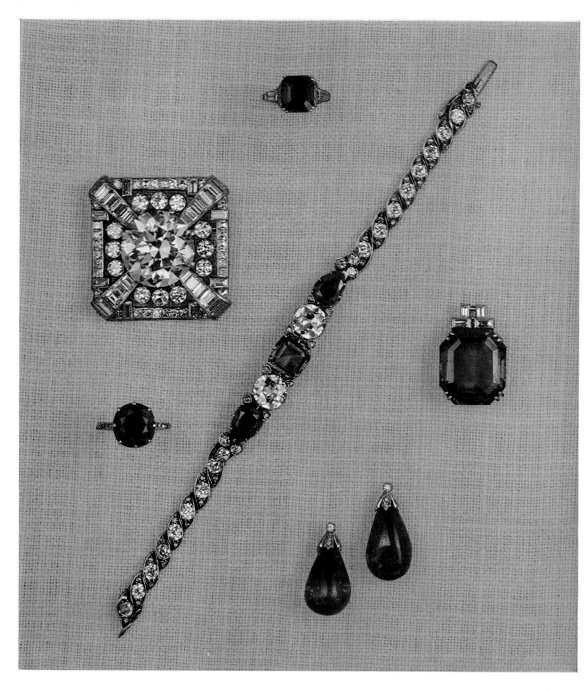

Important ruby ring, 3.67 ct. Sold 20.6.73 for £10,500 ($26,250)

Fancy yellow diamond, 31.71 ct., mounted in a diamond brooch Sold 20.6.73 for £13,000 ($32,500)

Important antique emerald, ruby and diamond bracelet Sold 20.6.73 for £17,500 ($43,750)

Magnificent emerald pendant, 26.93 ct. Sold 20.6.73 for £90,000 ($225,000)

Important sapphire ring, 9.25 ct. Sold 20.6.73 for £13,000 ($32,500)

Pair of important cabochon emerald drops, gross weight 43.96 ct. Sold 20.6.73 for £15,000 ($37,500)

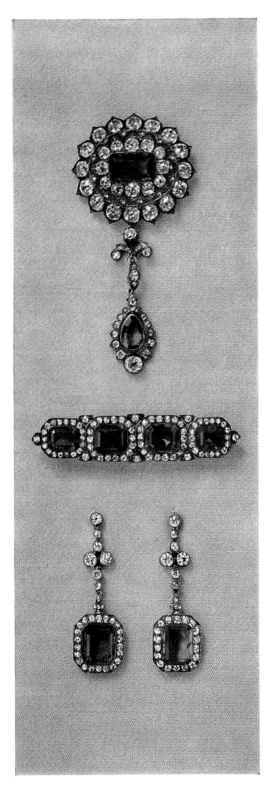

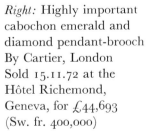

Left: Important antique emerald and diamond pendant brooch
Sold 15.11.72 at the Hôtel Richemond, Geneva, for £12,848
(Sw. fr. 115,000)

Important antique emerald and diamond bar brooch
Sold 15.11.72 at the Hôtel Richemond, Geneva, for £17,877
(Sw. fr. 160,000)

Pair of important antique emerald and diamond ear-pendants
Sold 15.11.72 at the Hôtel Richemond, Geneva, for £14,525
(Sw. fr. 130,000)

Right: Highly important cabochon emerald and diamond pendant-brooch
By Cartier, London
Sold 15.11.72 at the Hôtel Richemond, Geneva, for £44,693
(Sw. fr. 400,000)

Castellani and Giuliano in the context of their time

HANS NADELHOFFER
of Christie's Geneva Office

We have become used to regarding jewels as anonymous products of their time. This is due to the fact that, unlike the work of goldsmiths and silversmiths, they were not legally required to be stamped with a hallmark nor were they signed by the artist, and it is only very rarely, therefore, that their creators emerge as recognizable personalities. Not only was jewellery unsigned, but, as times changed and fashions altered, and occasionally due to financial stress, it was frequently altered or even destroyed. This is the reason why only a few pieces have come down to us in their original form. Sometimes, when striving to reconstruct the jewellery of past centuries, our only references are contemporary portraits or the original sketches of the pieces, frequently made by independent designers, as for example Holbein's creations for Henry VIII. These sketches, with their linear abstract outlines, and with no concession yet made to the material to be worked, often express the artist's intention more clearly than the finished piece of jewellery.

The much despised 19th century produced original jewellery of artistic value, in complete distinction to the average, machine-made factory output. This is proved by the work of the two jewellers Pio Fortunato Castellani (1793–1865) and Carlo Giuliano (d. 1912). Independent of their patrons, they made full use of the current technical advances in work methods of their time. The work of both these artists presents a most interesting contribution to the essential aesthetics of the 19th century, or to be precise, from 1820, when the predominance of French taste, which had ruled from the 18th century, was overthrown, until the turn of the century, when the originators of Art Nouveau found new, independent art forms.

The origins of the various 'isms' of the 19th century, Castellani and Giuliano being representative of this time, can be traced back to the middle of the 18th century. The determining factors were a renewed admiration for the art of classical antiquity, systematic theories concerning it, and excavations (Pompeii) which owed their success to calculation and to chance, which gave new impetus to artists. The possibility of teaching art was stressed and academies were founded. Their rigid, canonical rules often threatened to stifle the independent artistic spirit. Not only their rigid categorization, but even the unfortunate division into major or fine arts

206

Gold pendant set with mosaic panel with Christian symbol of two dolphins below an anchor
Sold for £200
(Sw. fr. 1800)

Gold brooch set with mosaic in the Byzantine style depicting a hand within an ornamented circle, pearl border
Sold for £212
(Sw. fr. 1900)

Lozenge-shaped gold brooch set with mosaic inscribed 'Vita Tibi'
Sold for £145
(Sw. fr. 1500)

Filigree gold pendant set with mosaic portrait of Dante on a gold ground
Sold for £536
(Sw. fr. 4800)

Gold brooch set with mosaic of a lion's head of Pompeian inspiration
Sold for £581
(Sw. fr. 5200)

Gold brooch set with mosaic of a spaniel in a classical landscape within lapis-lazuli border
Sold for £1005
(Sw. fr. 9000)

All by Fortunato Pio Castellani & Sons
All sold 15.11.72 at the Hôtel Richemond, Geneva

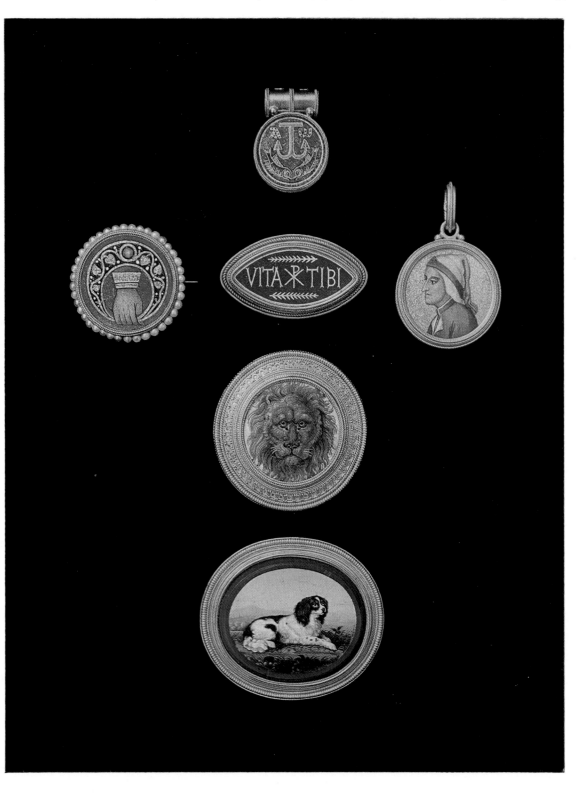

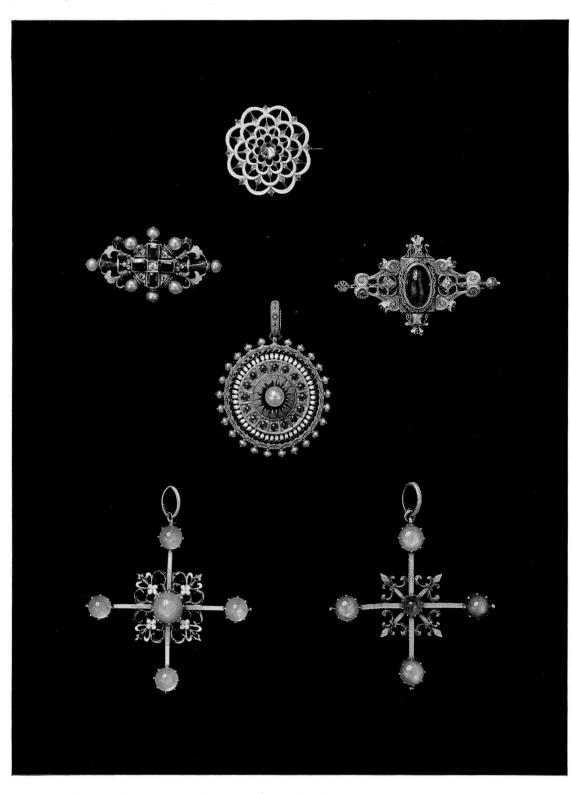

Circular gold brooch
with central
moonstone
Signed C & AG
Sold for £313
(Sw. fr. 2800)

Gold and enamel
brooch set with four
tourmalines, a
diamond, rose-
diamonds and pearls
Signed C.G.
Sold for £313
(Sw. fr. 2800)

Gold and enamel
brooch set with a
cabochon ruby and
diamonds
Signed C.G.
Sold for £670
(Sw. fr. 6000)

Circular gold and
enamel pendant set
with a pearl within a
circle of cabochon
rubies
Signed C.G.
Sold for £357
(Sw. fr. 3200)

Gold and enamel
cruciform pendant
set with round
star-sapphires
Signed C & AG
Sold for £625
(Sw. fr. 5600)

Gold and enamel
cruciform pendant set
with a cabochon ruby
Signed C & AG
Sold for £469
(Sw. fr. 4200)

All sold 15.11.72
at the Hôtel
Richemond, Geneva

and decorative or minor arts, jewellery coming under the latter, had serious consequences. The most varied of historical styles were taught and applied to painting, architecture and the decorative arts. Motif selection was based on scholarship, aesthetics and literature.

Apart from the Frenchman Froment-Meurice, it would be difficult to find a purer representative of the 'isms' of the 19th century in the world of jewellery than Castellani. His creations, which in the course of the fifty years when he was so productively active in his profession reinterpreted the styles of the past in the light of rapidly changing fashions, could be seen in all their variety at the auction which Christie's held in Geneva on 15th November. This may have been the last complete private collection to come on the market, as all others of significance are now in museums.

Trained in academic 'scholarship', Castellani very early on turned to a theoretical study of the styles of classical antiquity; he admired particularly Etruscan art, many examples of which were being unearthed in Italy at that time, leading to a somewhat superficial admiration for them. Castellani particularly studied the technical assumptions of the Etruscan goldsmiths. He was fascinated by filigree and granular works. He brought back into fashion ornaments such as these, which had been in continuous use for centuries in Italian provinces (St Angelo in Vado). He also succeeded in copying the antique gold colour and the soft surface of the gold by means of an electro-chemical process. Backed by his indefatigable patron Michael Angelo Caetani, Duke of Sermoneta, Castellani became the most significant goldsmith and jeweller of his time. When in 1852 Castellani retired from business, his two sons, Augusto and Alessandro, who had been exiled from Italy on political grounds, continued their father's work. The Great Exhibition, which had been held in London the year before, had made the public more familiar with exotic historical styles, and the two brothers extended his style by including Egyptian, Byzantine, Merovingian and Gothic elements and it was deemed permissible to raise adaptations in style to the level of exact copies. Thus a brooch with ear-clips, representing Greek winged Victories, has its prototype in a piece which was part of the remarkable collection of antique jewellery owned by Castellani himself and which is today in the British Museum.

The proud signature of the intertwined X on Castellani's jewellery is not only the sign of a confident personality but also the earliest trade mark of a creation which stood out from the flat, manufactured products of the time. The use of coloured mosaics, ranging from the strictly stylized Byzantine examples to representations of romantic and genre subjects, is of great interest (see illustration page 207). We may note the recurrence of the Dante motif, especially on the jewellery in the style of the Middle Ages. In Castellani's time Dante was hailed as the prophet of the emergent Italian National State, and a sentimental idealized portrait of him on a rich golden

mosaic background was very popular. Castellani creations were widely copied as they became successful.

Another jeweller, the Neapolitan Carlo Giuliano, started his career in Castellani's archaeological style. Like Castellani's sons, he made his second home in London, and here in the north he created the gracious openwork jewellery which became his speciality. As he gradually mastered the art he deviated more and more from Castellani's Roman grandeur, gave up sculptural effects and confined himself to linear drawings in the shape of tendrils, palm leaves and spiral scrolls based on the Italian Renaissance of the 16th century. Giuliano was a master at exploiting colour effects. He used enamel painted in pastel colours, his favourites being white, black and light blue, and lavishly applied it to Castellani's gold in combination with coloured stones, often cabochons. He included anything he could draw on from history and transformed it into his delicate, romantic pieces of jewellery to suit the taste of the mid-Victorian period (see illustration page 208). Giuliano died in 1912 and left a thriving business to his sons. Although his importance in the area of historical development is not as great as Castellani's, he excels from a purely artistic point of view.

Giuliano could hold his own even against the strong personality of Peter Carl Fabergé from St Petersburg, who became of increasing importance towards the end of the century. Among his works there are faint-hearted attempts to adapt to Art Nouveau, but his stylized design could never find a place within the style of this new generation of artists.

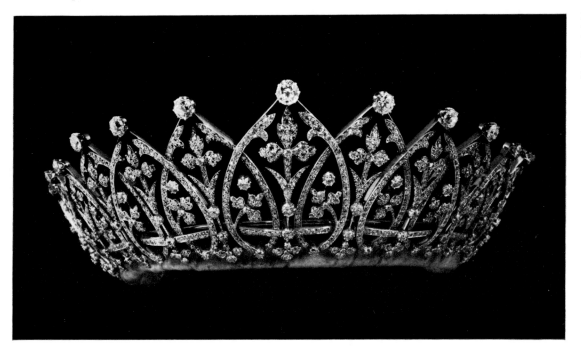

Important diamond tiara
Sold 4.10.72 for
£5200 ($12,480)

Highly important
diamond bracelet
Signed by Van Cleef
& Arpels, Paris
Sold 9.5.73 at the
Hôtel Richemond,
Geneva, for £30,000
(Sw. fr. 240,000)

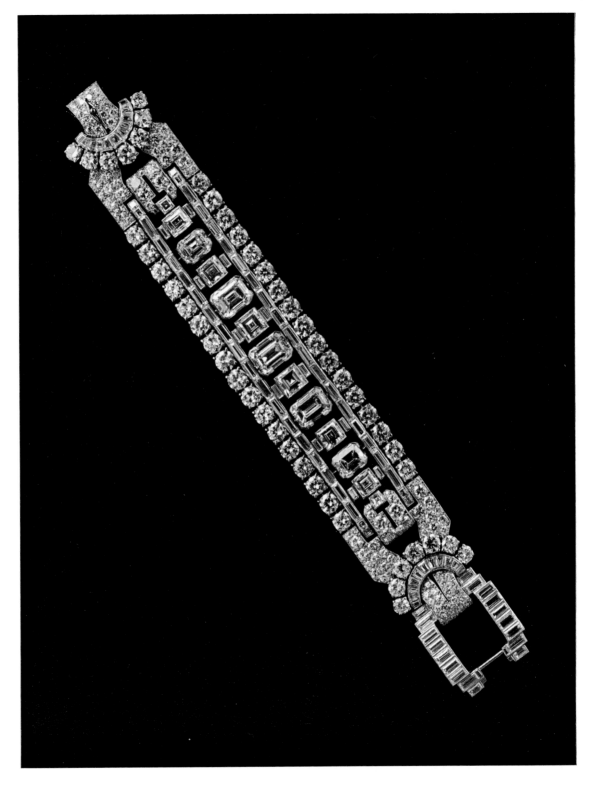

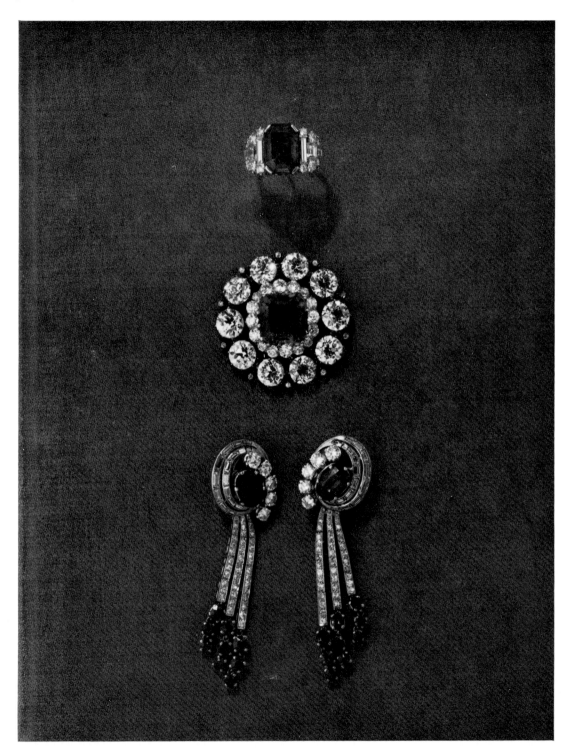

Important emerald and diamond ring, weight of emerald approx. 5.34 ct. Sold 4.10.72 for £14,000 ($33,600)

Highly important emerald and diamond brooch pendant Sold 4.10.72 for £21,000 ($50,400)

Pair of sapphire and diamond ear-clips Sold 4.10.72 for £2100 ($5040)

Sold by order of the Trustees of the late The 7th Duke of Newcastle

Important antique
diamond brooch,
weight of large
diamond approx.
12 ct.
Sold 4.10.72 for
£20,000 ($48,000)

Suite of four antique
diamond brooches
Sold 4.10.72 for
£3200 ($7680)

Sold by order of the
Trustees of the late
The 7th Duke of
Newcastle

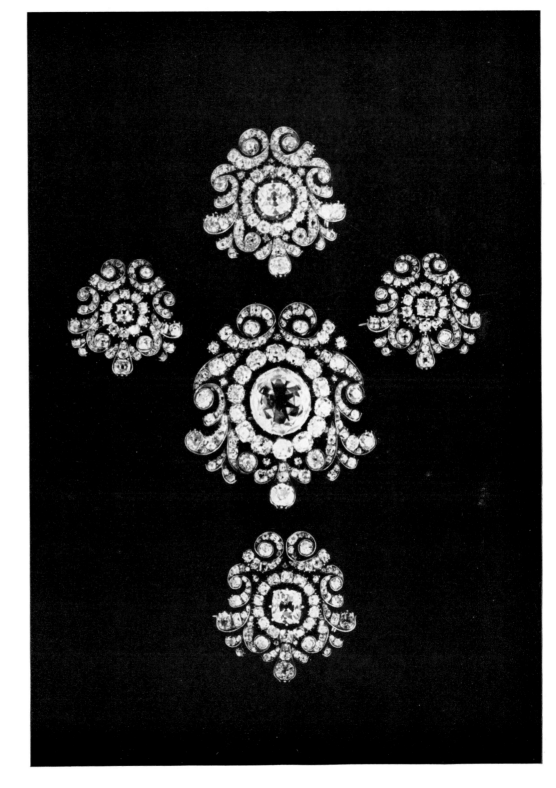

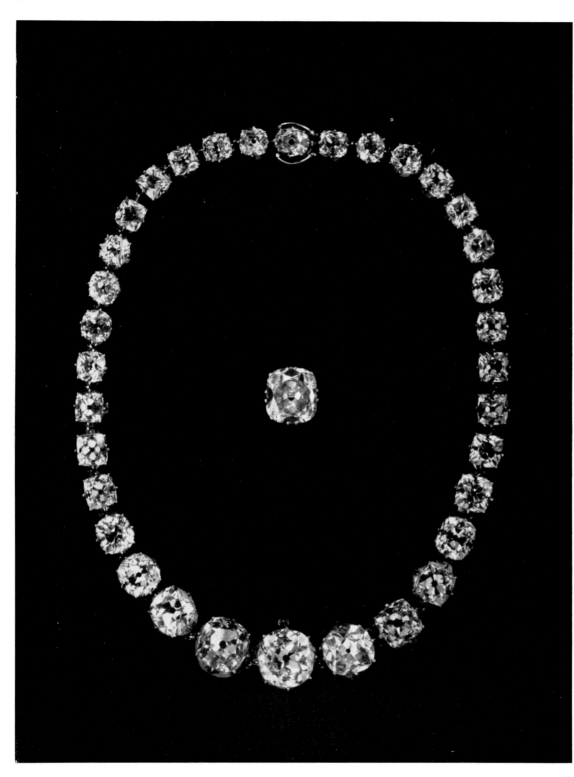

Highly important
antique diamond
riviere
Sold 4.10.72 for
£32,000 ($76,800)

Important
cushion-shaped
diamond single-stone
ring, weight of
diamond approx. 8 ct.
Sold 4.10.72 for
£4200 ($10,080)

Sold by order of the
Trustees of the late
The 7th Duke of
Newcastle

Antique diamond
necklace
Sold 13.7.73 for
£3800 ($9500)

Highly important
antique emerald and
diamond brooch
pendant
Sold 13.7.73 for
£31,000 ($77,500)

From the collection
of Sir Hugh
Arbuthnot, BT

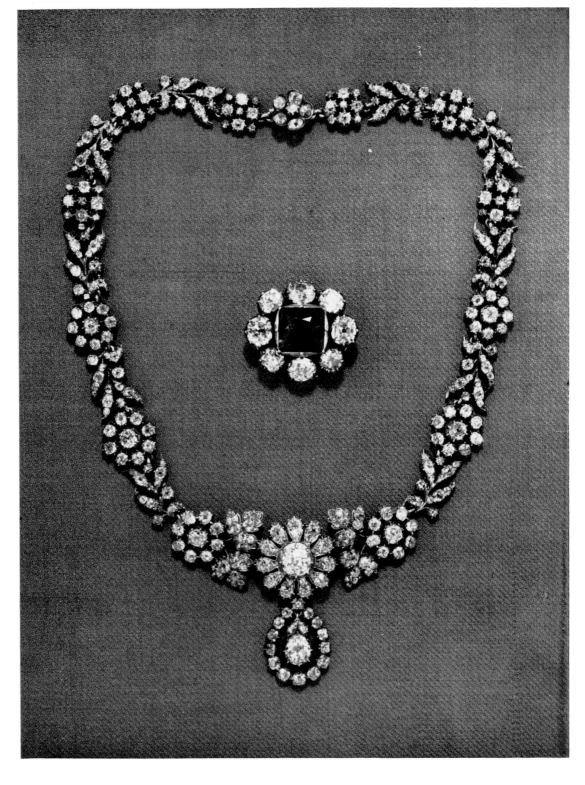

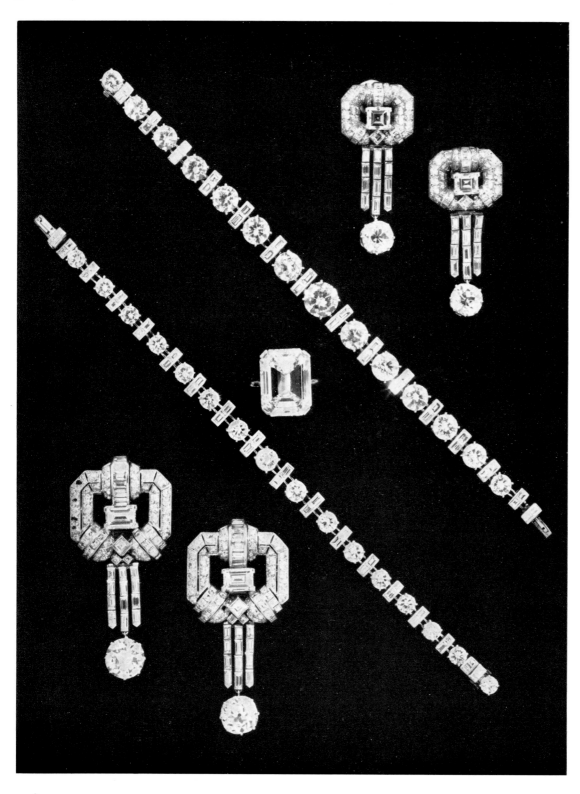

Two diamond
bracelets, forming a
necklace, pair of
important diamond
brooches and
earclips en suite
Sold 11.4.73 for
£10,000 ($24,000)

Important emerald-
cut diamond
single-stone ring,
approx. 16.11 ct.
Sold 11.4.73 for
£22,000 ($52,800)

SILVER

The St Agnes Tazza. An important Elizabeth I parcel-gilt tazza
4¾ in. (12.1 cm.) high, 6 in. (15.3 cm.) diam.
Maker's mark possibly a lizard, 1579
Sold 29.11.72 for £9000 ($21,600)
From the Parochial Church Council of St Agnes, Cornwall

Important Commonwealth silver-gilt two-handled porringer, cover and stand
Porringer 7½ in. (19.1 cm.) high, stand 11¼ in. (28.8 cm.) diam.
By Arthur Manwaring, 1655
Sold 14.11.72 at the Hôtel Richemond, Geneva for £7262 (Sw. fr. 65,000)
From the collection of M. Luben Basmadjieff

Spherical pommander
2¼ in. (5.7 cm.) high
Unmarked, c. 1580
English or German
Sold 27.6.73 for £2200 ($5500)

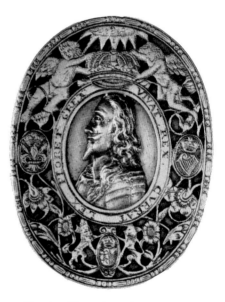

Charles II oval snuff-box
3⅛ in. (7.9 cm.) long
Unmarked, c. 1670
Sold 27.6.73 for £800 ($2000)

One of a pair of Charles II circular
toilet-boxes
3 in. (7.6 cm.) diam.
Maker's mark AC cinquefoil below in
shaped cartouche, 1676
Sold 27.6.73 for £1250 ($3125)

Charles I large plain wine-cup
7¼ in. (18.4 cm.) high
Maker's mark WS conjoined, 1640
Sold 29.11.72 for £4200 ($10,080)

Charles II teapot
6¼ in. (15.9 cm.) high
Maker's mark only S crowned for Charles Shelley or
Robert Smythier, c. 1675
Sold 29.11.72 for £6000 ($14,400)

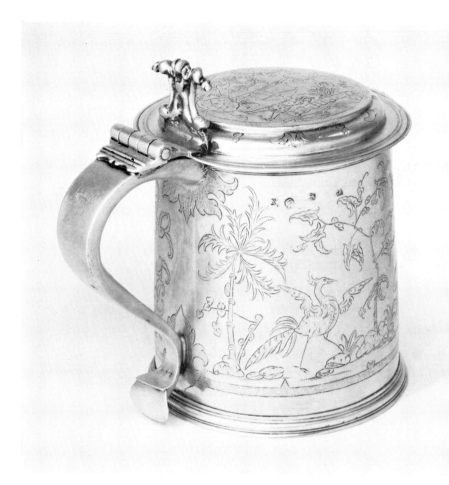

Charles II large cylindrical tankard and cover
7 in. (17.9 cm.) high
Maker's mark EG cinquefoil above and below, 1683
Sold 28.3.73 for £7500 ($18,000)
From the collection of Mr James Moseley

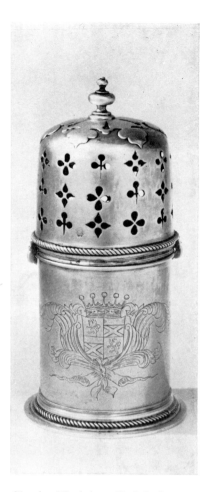

Charles II plain cylindrical
castor
7 in. (17.8 cm.) high
Maker's mark W.C., a
crown above, a pierced
mullet below, 1672
Sold 27.6.73 for £6,200
($15,500)

George I large plain silver-gilt cup and cover
12¾ in. (32.4 cm.) high
By Edmund Pearce, 1718
Sold 29.11.72 for £1500 ($3600)
From the collection of The Worshipful Company of
Coachmakers and Coach Harness Makers

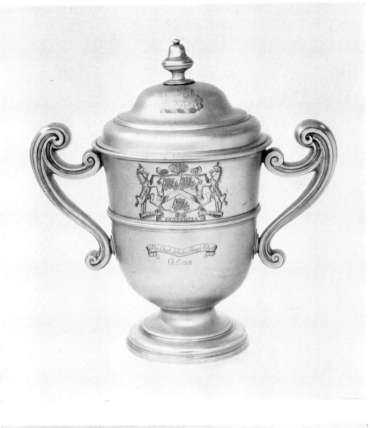

Pair of fine William and Mary table-candlesticks
10 in. (25.4 cm.) high
Maker's mark RS mullet above fleur-de-lys below
1690
Sold 29.11.72 for £4500 ($10,800)

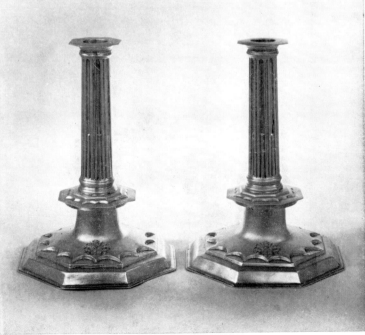

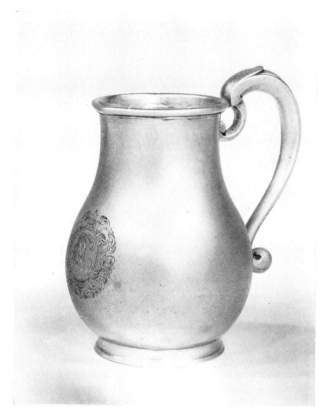

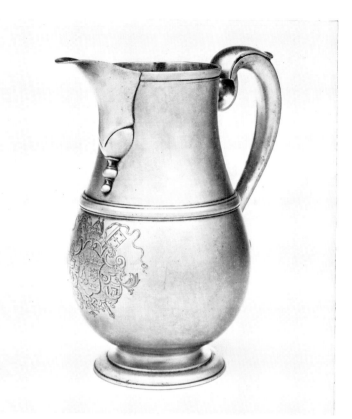

Fine George I beer-jug
6¼ in. (15.9 cm.) high
By Thomas Farren, 1721
Sold 29.11.72 for £6000 ($14,400)

George I plain pear-shaped jug
8 in. (20.3 cm.) high
By John Hamilton, Dublin, 1721
Sold 28.3.73 for £3000 ($7200)

George I large plain circular salver
15 in. (38 cm.) diam.
By Thomas Bolton, Dublin, 1725
Sold 28.3.73 for £3300 ($7920)

George I oblong tray
18¾ in. (47.6 cm.) long
By Louis Mettayer, 1720
Sold 29.11.72 for £5000 ($12,000)

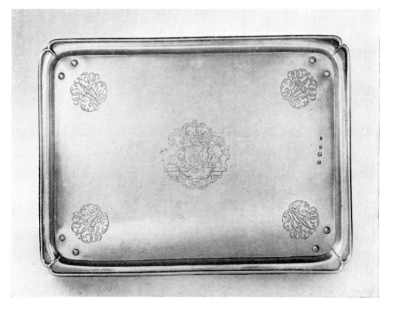

George I plain sugar-bowl and cover
3⅝ in. (9.2 cm.) diam.
By John Seatoune, Edinburgh, 1718
With the mark of Edward Penman as
Assay Master
Sold 29.11.72 for £3200 ($7680)

Pair of George I large plain sauceboats
By George Boothby, 1726, one with maker's
mark only struck four times
Sold 27.6.73 for £3600 ($9000)
From the collection of the Hon Mrs Collins

One of a set of four
silver-gilt George II
circular dishes
10 in. (25.4 cm.) diam.
By George Wickes
1739
Sold 28.3.73 for
£7000 ($16,800)

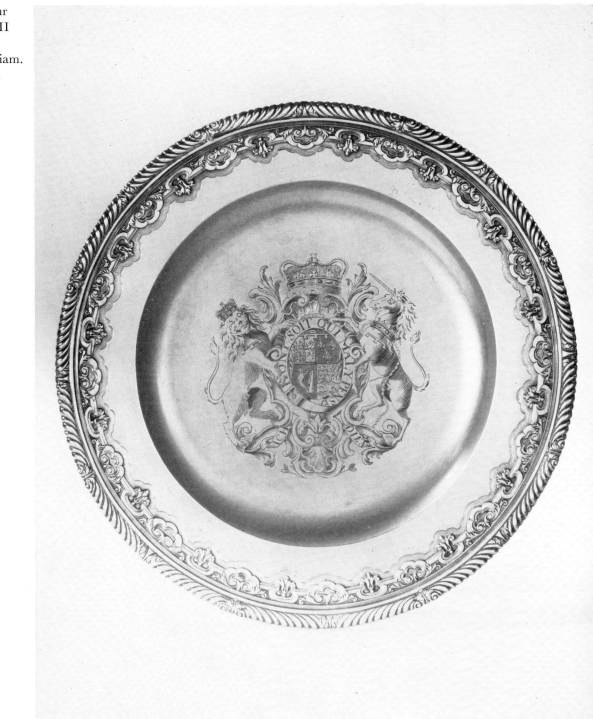

Silver in suspension

ARTHUR GRIMWADE

English silver chandeliers are the rarest of all objects of this precious metal to have survived, since they were always, it would seem, made only for the monarch or his wealthiest subjects. But they have a long history. There is, for example, a reference to them as found in a room in the Tower of London in 1325, while Elizabeth I owned at least one set of ten 'hanging Candelsticks with XXX sockettes and chaines all guilt' – i.e. with three branches each – weighing 1046 ounces. But, like prehistoric monsters, the unwieldiness of these striking objects must often have caused their disappearance and the earliest example to have survived is that of the Charles II period which belongs to the Duke of Buccleuch and hangs over the staircase at Drumlanrig Castle. Of massive baluster form chased with acanthus foliage, it weighs over 2000 ounces and has two tiers of branches which begin as boldly modelled dolphins from whose mouths spring elegantly curved mermaids holding the wax-pans and sockets above their heads. Next in date come two of about the same time, 1695, one by Daniel Garnier, now in Colonial Williamsburg, which originally came from the sale of the Sneyd Heirlooms at Christie's in 1924 and can be identified with an entry in the Royal inventory of 1721 as 'one 10 nozzled Branch' (the old name for such pieces) weighing 730 ounces 'at St James's in the Lodgings'. The branches of this are composed of no less than four reversed scrolls dipping downwards from the central vase. The other example of about the same date is at Chatsworth, but being unmarked cannot finally be established as English and might perhaps be of Dutch origin. This has ten branches on each of which perches a seated amorino while another seated on a globe holds up the ducal coronet overall.

The fine chandelier at Hampton Court by Francis Garthorne, goldsmith to William III is next in order of date, This is surmounted by cartouches chased with the national emblems and has two tiers of fluted S-scroll branches, while the baluster has bands of scalework and foliage not dissimilar to the de Grey pair, which in fact follow next in date. For these our colour plate (opposite) speaks. It must, to the purist, be a matter for regret that the original candle sockets which rose from the heads of the wyverns were replaced in 1847 by double branches to increase the candle power and it is tempting to consider the possibility of a restoration to the original appearance

228

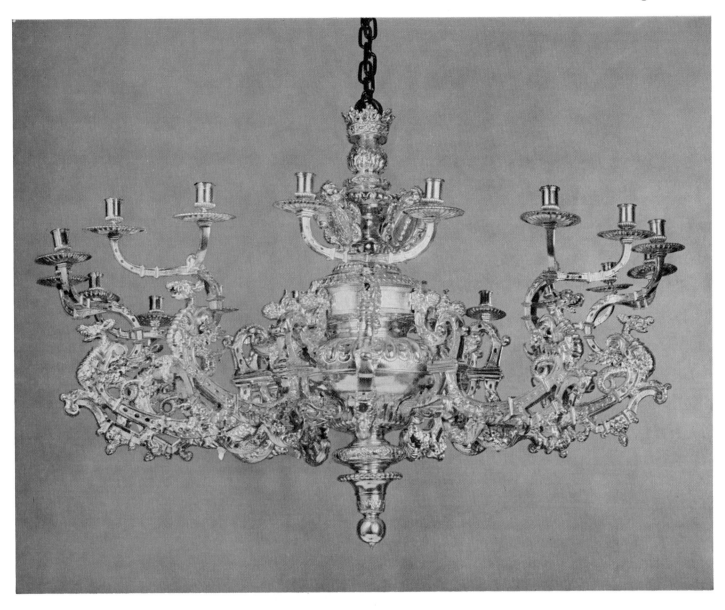

One of a pair of superb and unique Queen Anne chandeliers
31¼ in. (79.3 cm.) high, 45½ in. (111.5 cm.) diam.
By John Bodington, 1703 and 1704, the bifurcated branches by J. S. Hunt, 1847
Sold 27.6.73 for £115,000 ($287,500)
From the collection of Julian Salmond, Esq

of these magnificent creations. There is by a curious chance a giltwood chandelier of about 1710 in the Chapel of Kirkleatham Hospital, Yorkshire, which has wyvern's head crests above the scroll branches from which the wax-pans and sockets rise to give an interesting impression of what the de Grey chandeliers must originally have looked like.

After these, which are incidentally the only surviving pair of English silver chandeliers, we come next in date to the two examples by Paul de Lamerie of 1734 in the Kremlin, Moscow, each with sixteen branches but arranged one in a single row, the other in two tiers. In these the outer ends of the branches spring in foliage scrolls from the mouths of the grotesque male masks, recalling the use of the dolphins in the Drumlanrig specimen and suggesting the possibility of a common source of design. Finally the remaining 18th-century silver chandelier is the magnificent dolphin-entwined rococo example of the Fishmongers' Company of 1752 bearing the mark of William Alexander, recorded as the leading maker of brass chandeliers in London at the time but known in silver only by this example, although he had entered his mark at Goldsmiths' Hall nine years earlier in presumed anticipation of being commissioned to work in silver. In fact we know from the Company's minutes that the actual maker was William Gould, the well-known silver candlestick maker, since Alexander refunded the Company a sum in lieu of 'certain frauds' found in the chandelier by 'William Gould the workman'. This completes the roll call of English chandeliers before 1800, though we should perhaps mention as a tailpiece the important pair made by Behrens, the Court goldsmith at Hanover, for George II to the design of William Kent, which came to this country some fifty years ago with a large quantity of English silver from the Duke of Cumberland's collection. These hang in the library at Anglesey Abbey, Cambridgeshire, part of the collection formed by Lord Fairhaven and now one among many of the rare possessions of the National Trust.

It will be appreciated, therefore, that the de Grey chandeliers, which set a new record for a single lot of English silver on June 27th last, are unique both as a pair and also for the period of their production and so a most important link in the history of these rare and beautiful objects.

Pair of fine George II two-handled double-lipped sauceboats
By Peter Archambo, 1728
Sold 27.6.73 for £8000 ($20,000)
From the collection of Oliver May, Esq

Rare James II toy fire-grate, fire-dog, fender, shovel, fire-tongs and trivet
Length of grate 4 in. (10.1 cm.), width $1\frac{7}{8}$ in. (4.8 cm.), height of fire-dog $2\frac{3}{8}$ in. (6 cm.), length of fender
$3\frac{1}{4}$ in. (8.2 cm.), length of shovel $3\frac{7}{8}$ in. (9.8 cm.), length of fire-tongs $3\frac{3}{8}$ in. (8.6 cm.), length of trivet
$2\frac{1}{8}$ in. (5.4 cm.)
By George Manjoy, 1688, fully marked
Sold 11.10.72 for £1150 ($2760)

Queen Anne toy
silver tea and coffee
service
By George Manjoy
and David Clayton
1713
Sold 11.10.73 for
£1690 ($4225)
Purchased for the
Assheton-Bennett
Collection on loan
exhibition at
Manchester City
Art Gallery
The table specially
made to display the
service

A fine trophy for a 'Great Match'

ANTHONY PHILLIPS

The Sport of Kings has left a legacy of major pieces of 18th-century silver and gold plate unrivalled by any other field of sporting activity. With the relatively copious records that exist, it has not been too difficult to uncover interesting contemporary documentary evidence of the race, but it is rare indeed to be able to identify the engraver of horse-racing scenes and inscriptions on plate. However, as a result of research, it has been possible to identify perhaps the only known engraver of Irish 18th-century plate. The inscription on the bowl (see illustration opposite) reads 'The Great Match Run on the Curragh of Kildare Sepr. 5th 1751 for a 1000 Guineas by Black and all Black the property of Sir Ralph Gore Bart and Bajezet ye property of ye Rt. Honble y Earl of March won with ease by ye former'.

Our attention was drawn to the fact that there was another representation of the Great Match on Noble and Keenan's Map of the County of Kildare of 1752. A cursory glance at the map showed the group of figures on the left to be identical and those in the foreground to be similar to those on the bowl. Added interest was provided by the fact that the map engraving was signed by Daniel Pomarede of Dublin, but at this stage it was still not really possible to state categorically that the two were by the same hand. The final piece of the jig-saw fell into place when a search through the transactions of the Huguenot Society revealed that Daniel Pomarede was recorded as quarter or 'foreign' goldsmith in the Dublin assay office between 1744 and 1761.

There can be no doubt as to the love of the turf of both participants in the race. Douglas William, third Earl of March and fourth Duke of Queensberry, was born in 1724 and began his racing career by winning a wager against Count Taaffe that he would travel in a four-wheeled machine for a distance of 19 miles in one hour. It is said of him in the *Dictionary of National Biography* that 'besides acquiring by purchase and careful breeding an unsurpassed stud of racehorses, he bestowed special attention on his stablemen and jockeys whom he dressed in scarlet jackets, velvet caps and buckskin breeches. In 1756 he won a match in person dressed in his own colours'.

In a long obituary in the *Gentleman's Magazine* of 1802 he is said to have ridden himself 'in all his principal races, and was the rival in that branch of equitation, of the most professional jockeys'.

Important Irish racing trophy. George II large punch-bowl 13⅞ in. (35.3 cm.) diam., 8½ in. (21.6 cm.) high
By William Williamson, Dublin, 1751, the engraving by Daniel Pomarede
Sold 27.6.73 for £22,000 ($55,000)
From the collection of the Hon Mrs Collins

Far less is known of his rival and almost exact contemporary. Sir Ralph Gore was born in 1725 and died in the same year as the Earl of March, 1802. During a distinguished military career, he reached the rank of General by 1796. Between 1756 and 1760 he held the post of Ranger of the Curragh, and in 1772 was created Earl of Ross, Co. Fermanagh. Seriously wounded at the Battle of Fontenoy in 1746, he nevertheless seems to have been a fine horseman and indeed his ability is celebrated by at least one other extant engraved piece of silver – a two-handled cup.

It is interesting to note that the bowl was at one time in the collection of Lord Wavertree who celebrated his racing victories by engraving the details on so many pieces of plate, now in the Walker Art Gallery, Liverpool – a habit which Sir Ralph Gore anticipated by over a century and a half.

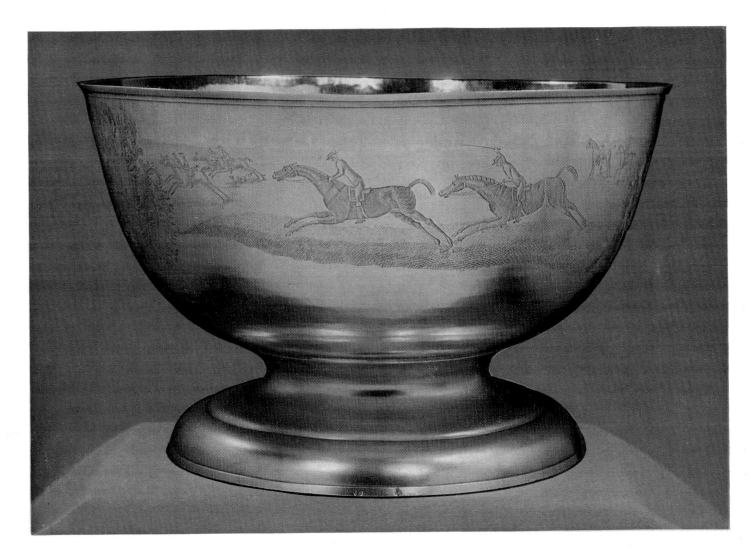

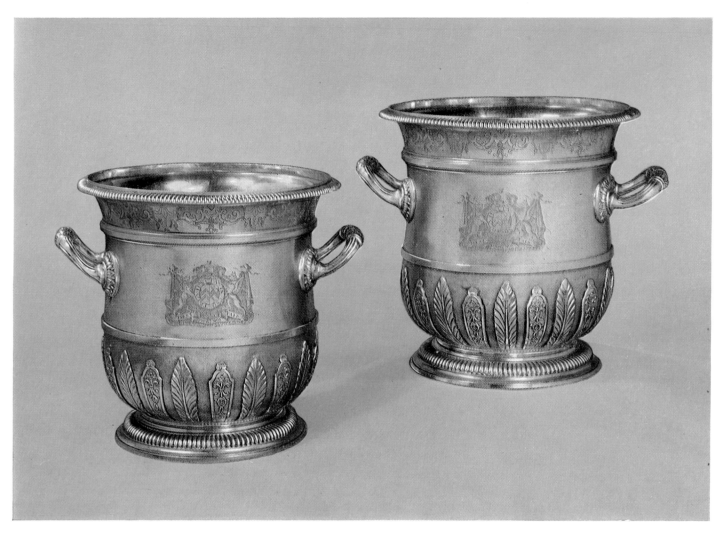

Pair of important George II wine-coolers
9 in. (22.8 cm.) high
By Thomas Farrer, 1727
Sold 27.6.73 for £13,000 ($32,500)
From the collection of David Rutherston, Esq

George II plain wall-sconce
11 in. (28 cm.) high
By William Gould, 1740
Sold 23.5.73 for £1650
($4125)

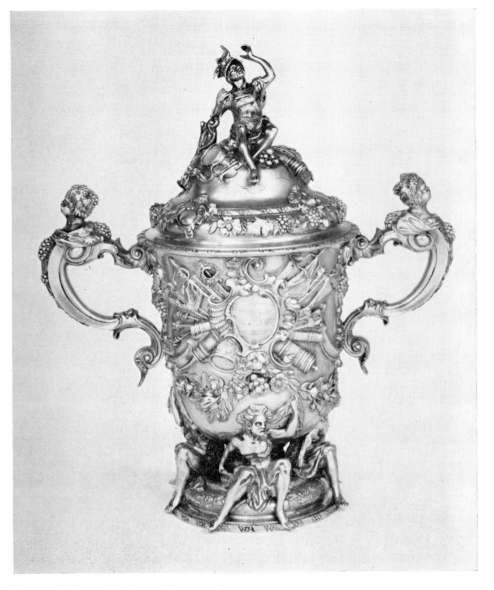

Unusual George II silver-gilt cup and cover
17 in. (43.3 cm.) high
By William Grundy, 1749
Sold 29.11.72 for £4000 ($9600)

Pair of George II chinoiserie tea-caddies
5⅜ in. (13.8 cm.) high
By Paul de Lamerie, 1744
Sold 14.11.72 at the Hôtel Richemond, Geneva, for £6257 (Sw. fr. 56,000)

One of a pair of Victorian nine-light candelabra
42 in. (115.2 cm.) high
By Robert Garrard, 1836 and 1842
Sold 23.5.73 for £11,000 ($27,500)
Record auction price for Victorian silver

One of a pair of early Victorian large vases
21½ in. (54.5 cm.) high
By Paul Storr, 1838
Sold 23.5.73 for £6000 ($15,000)

Unusual Victorian tea and coffee-service
Length of tray 20½ in. (52.1 cm.)
By D. and C. Hands, 1878
Sold 28.2.73 for 2200 gns. ($5544)

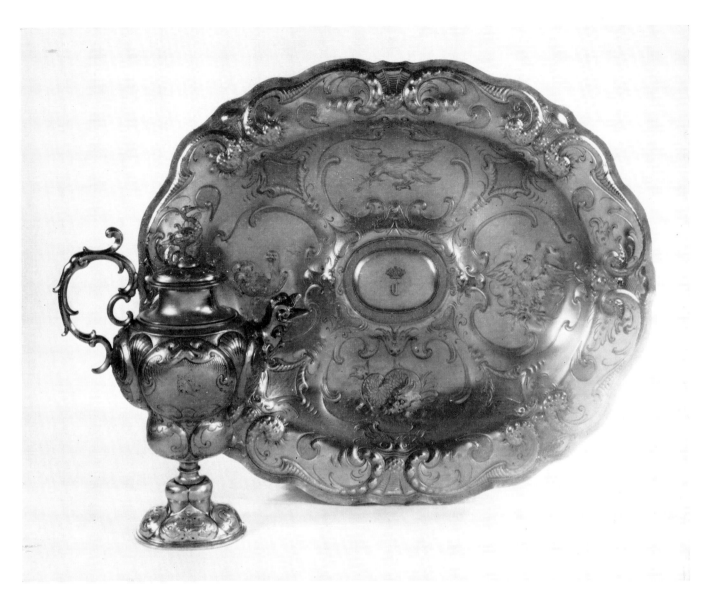

Important German silver-gilt covered ewer and basin
Height of ewer 11 in. (27.9 cm.), length of dish 18¾ in. (47.6 cm.)
By Johan Baptist Weinet, Augsburg, c. 1630
Sold 29.11.72 for £5200 ($12,480)

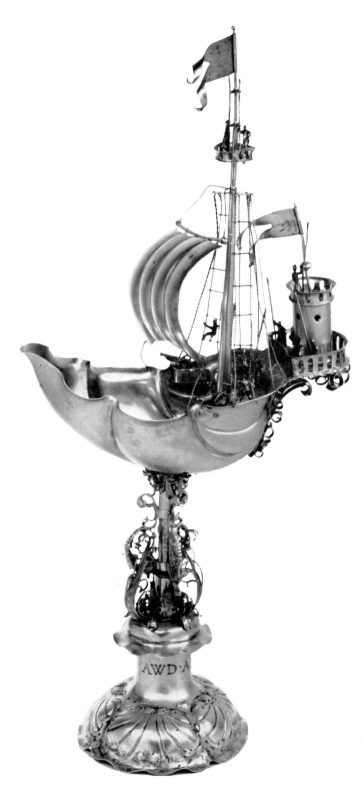

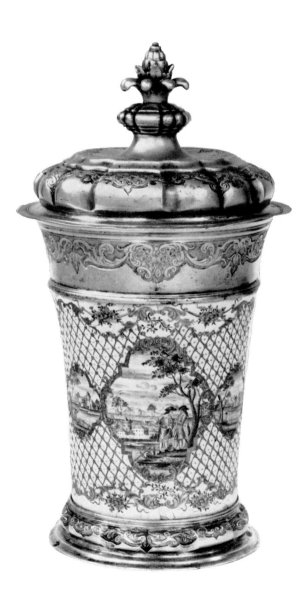

Left: German parcel-gilt single-masted nef
20¾ in. (52.7 cm.) high
By Pietre Hentz, Ulm, c. 1680
Sold 28.3.73 for £4400 ($10,560)

Below: Rare German silver-gilt and
Dresden enamelled covered beaker
8¾ in. (22.2 cm.) high
By Elias Adam, Augsburg, 1723/35
Sold 14.11.72 at the Hôtel Richemond, Geneva,
for £6927 (Sw. fr. 62,000)

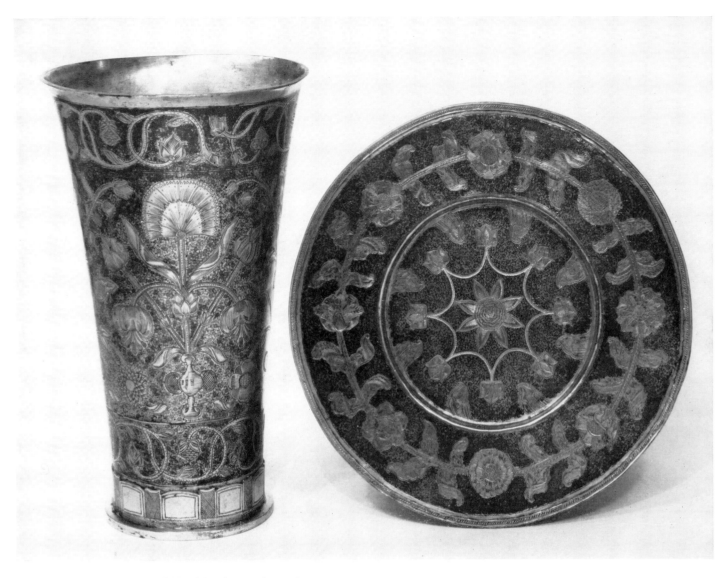

Russian large parcel-gilt nielloed beaker and stand
Beaker 10 in. (25.4 cm.) high, stand 9½ in. (24.1 cm.) diam.
Unmarked, c. 1680
Sold 28.3.73 for £2600 ($6240)

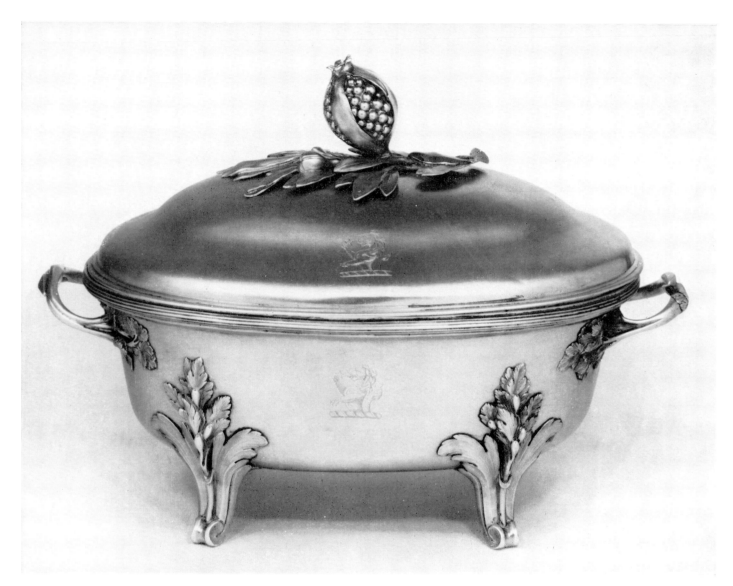

Louis XVI plain two-handled oval soup-tureen and cover
12 in. (30.5 cm.) long
By Claude-Isaac Bourgoin, Paris, 1780
Sold 29.11.72 for £3000 ($7200)
From the collection of P. O. R. Bridgeman, Esq

OBJECTS OF ART AND VERTU, ICONS, COINS, ETHNOGRAPHICA AND ANTIQUITIES

Top left: Fine jewelled gold pendant
set with a portrait of Charles I
1¾ in. (4.5 cm.) high, c. 1670
Sold 20.2.73 for 700 gns. ($1764)
From the collection of
the Hon Mrs E. V. Rhys

Top right: Rare drop-shaped gold pendant
set with a peach-stone portrait of Charles I
(enlarged)
1¼ in. (3.3 cm.) high, c. 1640
Sold 20.2.73 for 3400 gns. ($8568)
From the collection of
the Hon Mrs E. V. Rhys

Centre left: Oval gold pendant
Reverse showing with an agate cameo
cut with St George and the Dragon
2½ in. (6 cm.) high, c. 1650
Sold 20.2.73 for 1000 gns. ($2520)
From the collection of
the Hon Mrs E. V. Rhys

Bottom right: Reliquary pendant in the form
of a book of copper silvered and gilt
containing a silver-gilt portrait of
Charles I and a piece of blood-stained cloth
2½ in. (6.4 cm.) high, mid-17th century
Sold 20.2.73 for 700 gns. ($1764)

Bottom left: Gold-mounted pink jasper
oval pendant with a portrait of Charles I
2⅜ in. (6 cm.) high, c. 1640
Sold 20.2.73 for 900 gns. ($2268)
From the collection of
the Hon Mrs E. V. Rhys

SUSAN PENELOPE ROSSE:
Eleanor Gwynne, 'Nell Gwyn'
1⅝ in. (4.1 cm.) high
Sold 20.2.73 for 2300 gns.
($5796)

SAMUEL COOPER:
Charles II
Signed with monogram
and dated 1661
3⅜ in. (8.5 cm.) high
Sold 20.2.73 for
10,500 gns. ($26,460)
Record price for a
miniature by this artist

FRANCISZEK SMIADECKI:
Major-General John Desborough
Signed with monogram
Oil on copper
2⅝ in. (6.7 cm.) high
Sold 22.5.73 for 1200 gns.
($3150)

Top left:
RICHARD COSWAY:
George Drummond
2¼ in. (5.8 cm.) high
Sold 20.2.73 for
1900 gns. ($4788)

Top right·
JEREMIAH MEYER:
*Gentleman of the Seymour of
Westminster families*
2¼ in. (5.7 cm.) high
Sold 19.6.73 for 1000 gns.
($2625)

Centre:
JEAN BAPTISTE JACQUES
AUGUSTIN: *Gentleman*
Signed and dated 1830
1¾ in. (4.5 cm.) high
Sold 27.3.73 for
700 gns. ($1764)

Bottom left:
JOHN SMART: *An officer*
Signed with initials and
dated 1791 with the I for India
2¾ in. (6.5 cm.) high
Sold 3.10.72 for
2800 gns. ($7056)

Bottom right:
ROSALBA CARRIERA:
A lady
3¼ in. (8.2 cm.) high
Silver-gilt frame, perhaps
by Seamer
Sold 19.6.73 for 1150 gns.
($3018)

Top left:
WALTER ROBERTSON:
George Washington
3½ in. (9 cm.) high
Sold 20.2.73 for
1600 gns. ($4032)
From the collection of
Kammerherre Gregers
Juel

Top right:
HENRY BONE:
Horatio, Viscount Nelson
after Hoppner
Signed on the reverse
and obverse
Enamel
5¼ in. (13.4 cm.) high
Sold 22.5.73 for
1700 gns. ($4462)

Bottom left:
GEORGE ENGLEHEART:
Lt. Col. Thomas Hanmer
Signed with initial
3½ in. (8.8 cm.) high
Sold 27.3.73 for
1400 gns. ($3528)

Bottom right:
CHRISTIAN
HORNEMANN:
A lady
Signed and dated 1818
2⅞ in. (7.2 cm.) high
Gilt frame
Sold 19.6.73 for 500 gns.
($1312)

249

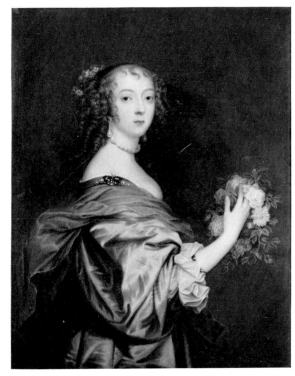

Top left:
Maria Theresa of Austria-Este, Duchess of Aosta
Later Queen of Sardinia
Perhaps by Veronica Telli (née Stern)
6 in. (15.3 cm.) high
Sold 20.2.73 for 1700 gns. ($4284)
From the collection of Boleyn Investments Ltd

Above:
Carl Emmanuel IV, as Prince of Piedmont
Perhaps by Veronica Telli (née Stern)
$5\frac{7}{8}$ in. (15 cm.) high
Sold 20.2.73 for 1700 gns. ($4284)
From the collection of Boleyn Investments Ltd

HENRY BONE:
Catherine Howard, Countess of Newburgh
Signed on obverse, also on reverse in full
$7\frac{1}{4}$ in. (18.5 cm.) high
Sold 19.12.72 for 1300 gns. ($3276)

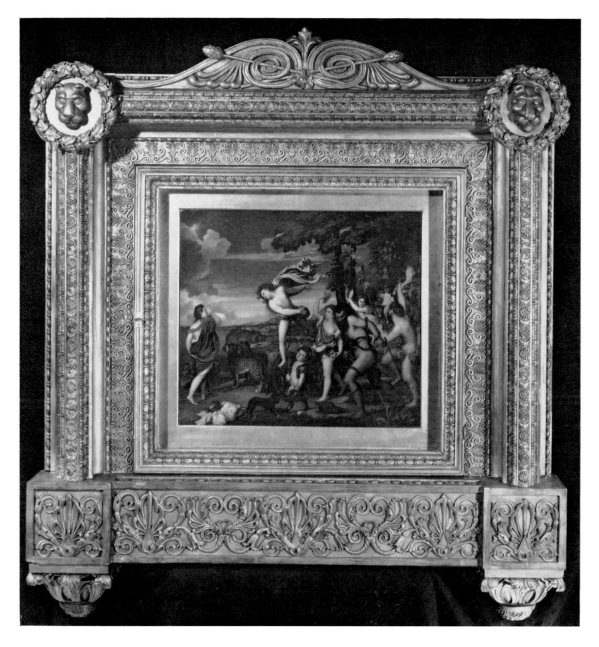

HENRY BONE: *Bacchus and Ariadne* (after Titian)
Signed on the reverse and dated 1808 until 1811, enamel
17½ in. (44.5 cm) wide
The picture by Titian is in the National Gallery, London
Sold 20.2.73 for 5000 gns. ($12,600)
Record price for a work by this artist

Boîtes d'or

ARTHUR GRIMWADE

As Sir Francis Watson writes in his introduction to the forthcoming Catalogue of the Ortiz-Patiño Collection – 'The craft of making gold boxes . . . was carried to a point of technical excellence in 18th-century Paris which has never been surpassed'.

Proof positive of this forthright statement, if it were needed, could be found without argument in the beautiful group of these *objets d'art* forming the first part of the Ortiz-Patiño Collection which appeared on the market in June. This group, of which we illustrate seven on these pages, clearly reflects the 'wide variety of techniques and materials' mentioned by Sir Francis 'to heighten their decorative character'. These included the various types of enamel, as for example the exquisite translucent blue chinoiserie scenes *en basse-taille*, that is, sunk in the gold surface over the engraved figures in gardens, exemplified so splendidly by the box of 1753 by Noël Hardivilliers (page 255 bottom); the *en plein* enamel of the jewel-like colours of the Teniers style scenes of Tiron's box of 1755–6 (page 254 top), or the very feminine fantasy of the Génard box of 1763 with its dogs in domestic settings (page 255 top). An unusual combination of opaque and translucent enamel also occurs in the delightful box of 1747 with its trellis pattern of flowers with gold leaves on dark green *guilloché* ground (see illustration opposite).

Other techniques used were Oriental lacquer and *piqué* work employed together in one example, the extremely chic oval box by Nicolas-Antoine Vallière, c. 1765, with its gold *piqué* flowers in black panels on coral red ground adorned with the finest quality chased and pierced gold mounts (page 255 centre).

Sir Francis's list of techniques includes the use of semi-precious stones and mother-of-pearl seen together in the important box by Filassier of 1746 with its encrustation of pastoral and bird subjects in a manner somewhat reminiscent of the Dresden school of workers in hardstones (page 254 centre). Indeed there is some evidence to suggest that, just as the *orfèvres bijoutiers* specializing in boxes employed so many techniques, they may in the process at times have imported foreign craftsmen to carry out the work, or, as in the case of the use of Oriental lacquer, ordered it to their requirements from the East.

One of the rarest of all the boxes in this sale was that by Claude Perron, of 1769,

Important Louis XV enamelled rectangular
snuff-box
$2\frac{7}{8}$ in. (7.3 cm.) long, $2\frac{1}{8}$ in. (5.5 cm.) wide
Paris 1747
Bearing the poinçons of Antoine Leschaudel,
Fermier 1744–1750
Sold 27.6.73 for 27,000 gns. ($70,875)
From the Ortiz-Patiño Collection

with its *lac burgauté* decoration on a leather ground – otherwise unknown in the records of these extravaganzas, a remarkable evocation of Oriental mannerism, although undoubtedly a 'home product' (page 254 bottom). The mind boggles at the infinite patience which was needed to compose these scenes out of minute particles of metal and tinted mother-of-pearl, a process which surely no craftsman today could bring himself to contemplate attempting.

Other boxes in the Ortiz-Patiño Collection, which limitations of space prevent us illustrating, were mounted with a *Conus textile* shell from Eastern seas, lapis-lazuli, and a cameo of **Philip of Spain** on cornelian panel, while gold boxes with chased vari-coloured subjects and the remarkable 'Droits de l'Homme et du Citoyen' engraving in minuscule letters in full on the double box of 1789 must close this brief survey of a remarkable auction event.

Important Louis XV gold and enamel rectangular
snuff-box
$3\frac{1}{4}$ in. (8.3 cm.) long, $2\frac{3}{8}$ in. (6 cm.) wide
By Jean-Marie Tiron, Paris 1755 and 1756
Sold 27.6.73 for 33,000 gns. ($86,625)
From the Ortiz-Patiño Collection

Important Louis XV encrusted rectangular snuff-box
$3\frac{1}{4}$ in. (8.2 cm.) long, $2\frac{1}{2}$ in. (6.4 cm.) wide
By Antoine-Philippe Filassier, Paris, 1746
Bearing the poinçons of Antoine Leschaudel,
Fermier 1744–1750
Sold 27.6.73 for 28,000 gns. ($73,500)
From the Ortiz-Patiño Collection

Rare and important Louis XV gold-mounted leather
oblong snuff-box
$3\frac{1}{4}$ in. (8.3 cm.) long, $2\frac{1}{8}$ in. (5.4 cm.) wide
By Claude Perron, Paris 1769
Bearing the poinçons of Julien Alaterre,
Fermier 1768–1774
Sold 27.6.73 for 26,000 gns. ($68,250)
From the Ortiz-Patiño Collection

Rare and important Louis XV enamelled oval snuff-box
2¾ in. (7 cm.) long, 2⅛ in. (5.4 cm.) wide
By François-Nicolas Génard, Paris 1763
Bearing the poinçons of Jean-Jacques Prevost,
Fermier 1762–1768
Sold 27.6.73 for 20,000 gns. ($52,500)
From the Ortiz-Patiño Collection

Fine Louis XV gold-mounted lacquer oval snuff-box
3½ in. (8.9 cm.) long, 1¾ in. (4.5 cm.) wide
By Nicolas-Antoine Vallière, Paris, c. 1765
Bearing the poinçons of Jean-Jacques Prevost,
Fermier 1763–1768
Sold 27.6.73 for 23,000 gns. ($60,375)
From the Ortiz-Patiño Collection

Important early Louis XV enamelled oval snuff-box
3⅜ in. (8.5 cm.) long, 2½ in. (6.4 cm.) wide
By Noël Hardivilliers, Paris 1753
Sold 27.6.73 for 38,000 gns. ($99,750)
From the Ortiz-Patiño Collection

Russian rectangular gold and enamel snuff-box
3⅝ in. (9·2 cm.) wide
By A. I. Yasinoff, St Petersburg, 1800
Sold 21.11.72 for 1600 gns. ($4032)

Extremely rare
Herrengrund model
of a mine
7¼ in. (18.5 cm.) long
c. 1740
Sold 14.11.72 at the
Hôtel Richemond,
Geneva, for £6703
(Sw. fr. 60,000)

Superb Swiss enamelled-gold oblong
automaton snuff-box with watch
$3\frac{3}{8}$ in. (8·5 cm.) wide
Maker's mark R &(?) C, Geneva, c. 1800
Sold 21.11.72 for 6200 gns. ($15,624)

Russian silver model of the 'Tsar's' cannon
$7\frac{1}{2}$ in. (19 cm.) wide
By P. Sazikov, Moscow, 1851
Sold 21.11.72 for 1000 gns. ($2520)

257

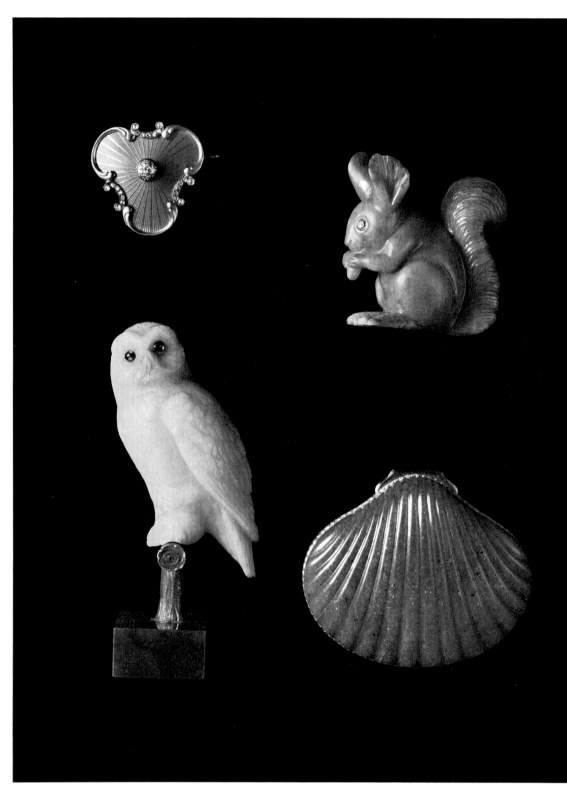

Russian jewelled gold brooch
1¼ in. (3.2 cm.) wide
By Carl Fabergé
Sold 9.5.73 at the Hôtel Richemond, Geneva, for £1250
(Sw. fr. 10,000)

Russian agate squirrel
1¾ in. (4.6 cm.) high
By Carl Fabergé
Sold 9.5.73 at the Hôtel Richemond, Geneva, for £375
(Sw. fr. 3000)

Russian chalcedony owl
3½ in. (8.9 cm.) high
By Carl Fabergé, the owl probably carved by Woerffel, the base by Henrik Wigström
Sold 9.5.73 at the Hôtel Richemond, Geneva, for £5250
(Sw. fr. 42,000)

Gold-mounted aventurine quartz shell-shaped snuff box
2½ in. (6.2 cm.) wide
By Carl Fabergé
Workmaster Henrik Wigström
Sold 9.5.73 at the Hôtel Richemond, Geneva, for £1625
(Sw. fr. 13,000)

Jaipur jewelled, enamelled gold horse
2¼ in. (5.7 cm.) high
18th/19th century
Sold 19.6.73 for 1300 gns. ($3412)

Below: Bengal ivory chess set
Kings 4 in. (10.1 cm.) high, pawns 2¼ in. (5.8 cm.) high
Early 19th century
Sold 22.5.73 for 780 gns. ($1047)

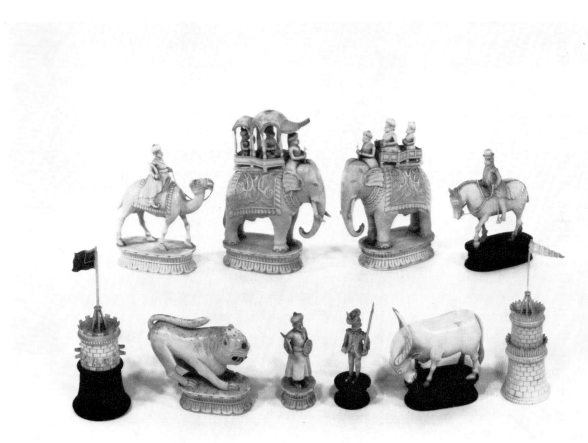

The Herbette Collection of Russian icons

ELVIRA COOPER

Of all the various icon sales held by the major auction houses throughout 1973, it was undoubtedly the dispersal of the Herbette collection of Russian icons, sold in Düsseldorf on 20th June, which aroused the greatest interest amongst the international clientele of buyers. For a market which is still considered by some to be highly specialized and esoteric, the public response was quite startling, bids still being received up to half an hour before the sale was due to commence, a great number coming from those of Christie's discerning English buyers who were unable to be present in Düsseldorf.

The Herbette collection was the largest private collection of Russian icons ever to appear at public auction, comprising over 120 icons whose authenticity and provenance were beyond dispute. Another important private collection of icons entrusted to Christie's for dispersal was the much smaller but superb collection belonging to the late Professor Bertel Hintze of Helsinki which was sold in 1971 for £48,846 ($121,662), and which is still remembered by connoisseurs as the outstanding icon sale of that year.

Jean Herbette, deceased, was appointed French Ambassador in Moscow following the resumption of diplomatic relations between France and the Soviet Union in December 1924. His collection was acquired during his stay there lasting six years, formed at the precise moment when the West first became aware of the icon as an art form.

In Russia itself, though icon scholarship had already begun towards the end of the 19th century, concentrating mainly on iconography, museum trustees, art-critics and connoisseurs only came to realize the full value of the icon around 1905-15. From the later 17th century onwards, the Russian intelligentsia had increasingly turned to the West for its cultural aspirations, tending to prefer baroque icons in the 'Frankish' manner to the 'primitive' mediaeval icons which were frequently overpainted in the newer style. Throughout this period, however, they had always been collected and saved from destruction, mainly for religious purposes, by the schismatic sect of Old Believers, persecuted by the State for their stubborn resistance to the cultural and ecclesiastical innovations ordained under Peter the Great and other

Important icon of
St Nicholas
$21\frac{1}{4}$ in. (54 cm.) high
Novgorod School
15th century
Sold 20.6.73 at Der
Malkasten, Düsseldorf, for
£7575 (DM 50,000)

rulers. The efforts of the Old Believers contributed much towards the appreciation of the icon at the beginning of the 20th century. After 1917 the Russian Government decreed that icons should be collected from all over Russia for scientific cleaning, conservation, and art-historical study. Russian society in general was

Far left: Important icon of the Archangel Michael 24 in. (62 cm.) high Novgorod or Pskov School 15th century Sold 20.6.73 at Der Malkasten, Düsseldorf, for £3030 (DM 20,000)

Top right: Fine icon of the Pokrov 11 in. (28 cm.) high Moscow School Second half of the 16th century Sold 20.6.73 at Der Malkasten, Düsseldorf, for £1060 (DM 7000)

Bottom right: The New Testament Trinity 13$\frac{1}{4}$ in. (34$\frac{1}{2}$ cm.) high Stroganov School 17th century Sold 20.6.73 at Der Malkasten, Düsseldorf, for £1666 (DM 11,000)

first made aware of the importance of the icon as an art form through a large exhibition held in Moscow in 1913.

The first great exhibition of Russian icons in the West was held from 1929 to 1930, arranged by the icon scholars Grabar and Anisimov. The icons were exhibited in Berlin, Frankfurt, Cologne, Hamburg, Vienna, London, Boston and New York, and were received with warm interest.

Anisimov conveys the sense of excitement at the discovery of a new type of aesthetics in an article published at the time of this exhibition:

> The line in Russian icon painting can be rivalled, indeed, only by the line in the Japanese print and in the bas-relief of the classical East. . . . Owing to the comparatively limited number of the principles of construction the artist was forced to make the most of the possibilities offered by the colouring, and actually did make the most of them. In power and intensity of colour, in the general depth of tone, icon painting may almost be said to surpass every other branch of the art of painting. The painters of the early Russian icon disclose the true nature and fundamental properties of every colour, and achieve their purposes by the most daring colouristic combinations. The lover of the elemental power of painting, i.e. colour, cannot but love icon-painting, for its achievements are chiefly based on that very power.*

It is therefore not surprising that a Russophile such as Jean Herbette should have formed his collection at this particular period. Around this time also the Soviet Government released for sale selected objects from those gathered together after the Revolution, to which the Diplomatic Corps was granted access. Western museums too were presented with the opportunity to purchase mediaeval icons in an attempt by Lenin's government to raise foreign currency, but the response was slight.

With such a large collection, the range of items was wide, including several fine early pieces, such as the 15th-century St Michael, Novgorod or Pskov School (see illustration opposite) which made DM 20,000 (£3030); the Communion of the Apostles, 16th-century Moscow School (see illustration page 264), which sold for DM 42,000 (£6363); and some very rare iconographical subjects, decorative silver oklad icons, and many festival icons celebrating the saints and feasts of the church calendar.

A particularly interesting discovery was that of the Grusinskaja Virgin (see illustration page 265). This at first sight appeared rather sombre against the brilliant colour contrast of the others, all the more so as it had never been cleaned. However, its almost awkwardly heavy archaic outlines emanated a strangely expressive power not found in later icons, and inspection under brilliant lighting disclosed the green flesh tones of an early icon. Subsequent cleaning revealed an important icon in an excellent state of preservation, the colouring and style most closely related to icons of the Novgorod School, though having certain unusual stylistic features that set it apart. One feels that it has its place in Russian icon-history, and that future icon-scholars will find it of sufficient interest to produce further comments as new discoveries are brought constantly to light and interrelated with present knowledge.

* *Masterpieces of Russian Painting*, edited by M. Farbman, London, Europa Publications Ltd, 1930, p 61

Icon of the Communion
of the Apostles
$17\frac{1}{2}$ in. ($44\frac{3}{4}$ cm.) high
Moscow School
Second half of the
16th century
Sold 20.6.73 at
Der Malkasten,
Düsseldorf, for £6363
(DM 42,000)

The highest price ever paid for an icon at Christie's was attained for the superb
15th-century St Nicholas, an important and classic example of the Novgorod School
(see illustration page 261), which was sold for DM 50,000 (£7575), the third highest
price ever paid at public auction. The bidding for this was keen, and it is appropriate

Superb Swiss enamelled-gold oblong
automaton snuff-box with watch
$3\frac{3}{8}$ in. (8·5 cm.) wide
Maker's mark R &(?) C, Geneva, c. 1800
Sold 21.11.72 for 6200 gns. ($15,624)

Russian silver model of the 'Tsar's' cannon
$7\frac{1}{2}$ in. (19 cm.) wide
By P. Sazikov, Moscow, 1851
Sold 21.11.72 for 1000 gns. ($2520)

Russian jewelled gold
brooch
1¼ in. (3.2 cm.) wide
By Carl Fabergé
Sold 9.5.73 at the
Hôtel Richemond,
Geneva, for £1250
(Sw. fr. 10,000)

Russian agate
squirrel
1¾ in. (4.6 cm.) high
By Carl Fabergé
Sold 9.5.73 at the
Hôtel Richemond,
Geneva, for £375
(Sw. fr. 3000)

Russian chalcedony
owl
3½ in. (8.9 cm.) high
By Carl Fabergé, the
owl probably carved
by Woerffel, the base
by Henrik Wigström
Sold 9.5.73 at the
Hôtel Richemond,
Geneva, for £5250
(Sw. fr. 42,000)

Gold-mounted
aventurine quartz
shell-shaped snuff
box
2½ in. (6.2 cm.) wide
By Carl Fabergé
Workmaster
Henrik Wigström
Sold 9.5.73 at the
Hôtel Richemond,
Geneva, for £1625
(Sw. fr. 13,000)

Jaipur jewelled, enamelled gold horse
2¼ in. (5.7 cm.) high
18th/19th century
Sold 19.6.73 for 1300 gns. ($3412)

Below: Bengal ivory chess set
Kings 4 in. (10.1 cm.) high, pawns 2¼ in. (5.8 cm.) high
Early 19th century
Sold 22.5.73 for 780 gns. ($1047)

The Herbette Collection of Russian icons

ELVIRA COOPER

Of all the various icon sales held by the major auction houses throughout 1973, it was undoubtedly the dispersal of the Herbette collection of Russian icons, sold in Düsseldorf on 20th June, which aroused the greatest interest amongst the international clientele of buyers. For a market which is still considered by some to be highly specialized and esoteric, the public response was quite startling, bids still being received up to half an hour before the sale was due to commence, a great number coming from those of Christie's discerning English buyers who were unable to be present in Düsseldorf.

The Herbette collection was the largest private collection of Russian icons ever to appear at public auction, comprising over 120 icons whose authenticity and provenance were beyond dispute. Another important private collection of icons entrusted to Christie's for dispersal was the much smaller but superb collection belonging to the late Professor Bertel Hintze of Helsinki which was sold in 1971 for £48,846 ($121,662), and which is still remembered by connoisseurs as the outstanding icon sale of that year.

Jean Herbette, deceased, was appointed French Ambassador in Moscow following the resumption of diplomatic relations between France and the Soviet Union in December 1924. His collection was acquired during his stay there lasting six years, formed at the precise moment when the West first became aware of the icon as an art form.

In Russia itself, though icon scholarship had already begun towards the end of the 19th century, concentrating mainly on iconography, museum trustees, art-critics and connoisseurs only came to realize the full value of the icon around 1905-15. From the later 17th century onwards, the Russian intelligentsia had increasingly turned to the West for its cultural aspirations, tending to prefer baroque icons in the 'Frankish' manner to the 'primitive' mediaeval icons which were frequently overpainted in the newer style. Throughout this period, however, they had always been collected and saved from destruction, mainly for religious purposes, by the schismatic sect of Old Believers, persecuted by the State for their stubborn resistance to the cultural and ecclesiastical innovations ordained under Peter the Great and other

Important icon of
St Nicholas
21¼ in. (54 cm.) high
Novgorod School
15th century
Sold 20.6.73 at Der
Malkasten, Düsseldorf, for
£7575 (DM 50,000)

rulers. The efforts of the Old Believers contributed much towards the appreciation of the icon at the beginning of the 20th century. After 1917 the Russian Government decreed that icons should be collected from all over Russia for scientific cleaning, conservation, and art-historical study. Russian society in general was

261

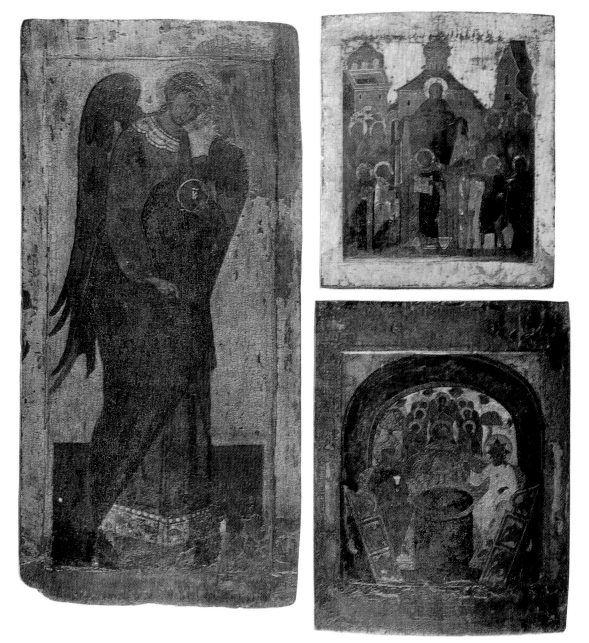

Far left: Important
icon of the Archangel
Michael
24 in. (62 cm.) high
Novgorod or Pskov
School
15th century
Sold 20.6.73 at
Der Malkasten,
Düsseldorf, for
£3030 (DM 20,000)

Top right: Fine icon
of the Pokrov
11 in. (28 cm.) high
Moscow School
Second half of the
16th century
Sold 20.6.73 at
Der Malkasten,
Düsseldorf, for £1060
(DM 7000)

Bottom right: The New
Testament Trinity
13¼ in. (34½ cm.) high
Stroganov School
17th century
Sold 20.6.73 at
Der Malkasten,
Düsseldorf, for £1666
(DM 11,000)

first made aware of the importance of the icon as an art form through a large exhibition held in Moscow in 1913.

The first great exhibition of Russian icons in the West was held from 1929 to 1930, arranged by the icon scholars Grabar and Anisimov. The icons were exhibited in Berlin, Frankfurt, Cologne, Hamburg, Vienna, London, Boston and New York, and were received with warm interest.

Anisimov conveys the sense of excitement at the discovery of a new type of aesthetics in an article published at the time of this exhibition:

> The line in Russian icon painting can be rivalled, indeed, only by the line in the Japanese print and in the bas-relief of the classical East. . . . Owing to the comparatively limited number of the principles of construction the artist was forced to make the most of the possibilities offered by the colouring, and actually did make the most of them. In power and intensity of colour, in the general depth of tone, icon painting may almost be said to surpass every other branch of the art of painting. The painters of the early Russian icon disclose the true nature and fundamental properties of every colour, and achieve their purposes by the most daring colouristic combinations. The lover of the elemental power of painting, i.e. colour, cannot but love icon-painting, for its achievements are chiefly based on that very power.*

It is therefore not surprising that a Russophile such as Jean Herbette should have formed his collection at this particular period. Around this time also the Soviet Government released for sale selected objects from those gathered together after the Revolution, to which the Diplomatic Corps was granted access. Western museums too were presented with the opportunity to purchase mediaeval icons in an attempt by Lenin's government to raise foreign currency, but the response was slight.

With such a large collection, the range of items was wide, including several fine early pieces, such as the 15th-century St Michael, Novgorod or Pskov School (see illustration opposite) which made DM 20,000 (£3030); the Communion of the Apostles, 16th-century Moscow School (see illustration page 264), which sold for DM 42,000 (£6363); and some very rare iconographical subjects, decorative silver oklad icons, and many festival icons celebrating the saints and feasts of the church calendar.

A particularly interesting discovery was that of the Grusinskaja Virgin (see illustration page 265). This at first sight appeared rather sombre against the brilliant colour contrast of the others, all the more so as it had never been cleaned. However, its almost awkwardly heavy archaic outlines emanated a strangely expressive power not found in later icons, and inspection under brilliant lighting disclosed the green flesh tones of an early icon. Subsequent cleaning revealed an important icon in an excellent state of preservation, the colouring and style most closely related to icons of the Novgorod School, though having certain unusual stylistic features that set it apart. One feels that it has its place in Russian icon-history, and that future icon-scholars will find it of sufficient interest to produce further comments as new discoveries are brought constantly to light and interrelated with present knowledge.

* *Masterpieces of Russian Painting*, edited by M. Farbman, London, Europa Publications Ltd, 1930, p 61

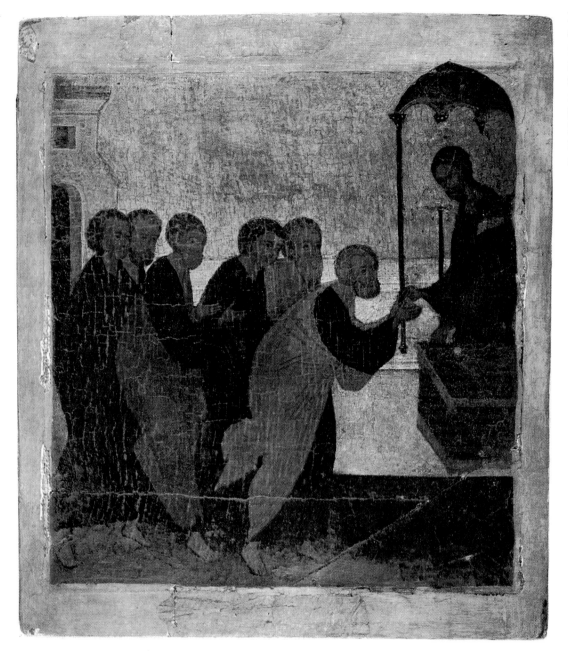

Icon of the Communion
of the Apostles
$17\frac{1}{2}$ in. ($44\frac{3}{4}$ cm.) high
Moscow School
Second half of the
16th century
Sold 20.6.73 at
Der Malkasten,
Düsseldorf, for £6363
(DM 42,000)

The highest price ever paid for an icon at Christie's was attained for the superb
15th-century St Nicholas, an important and classic example of the Novgorod School
(see illustration page 261), which was sold for DM 50,000 (£7575), the third highest
price ever paid at public auction. The bidding for this was keen, and it is appropriate

Important icon of the
Georgian Virgin
(Grusinskaja)
$28\frac{1}{4}$ in. (72 cm.) high
Regional school of
Novgorod
c. 1500
Sold 20.6.73 at
Der Malkasten,
Düsseldorf, for £6363
(DM 42,000)

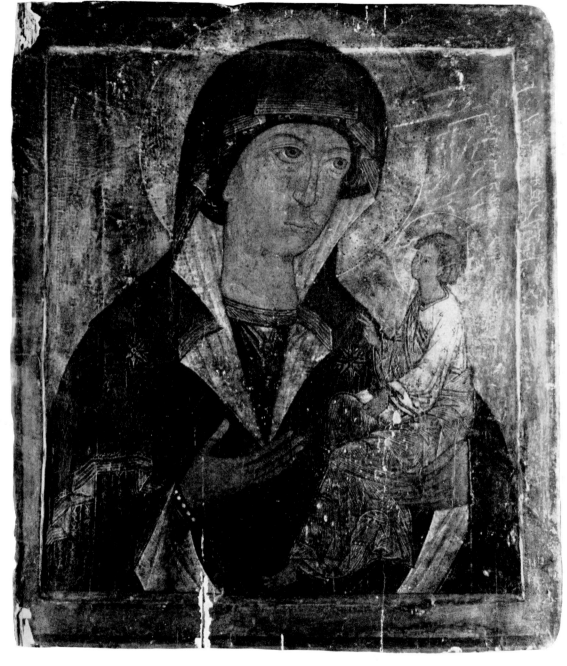

that it went to one of the most distinguished European private collections, bought
by a connoisseur not as an 'investment' but for its beauty.

The whole icon sale, totalling 161 lots, realized DM 594,170 (£90,253)— the
highest figure ever attained in any icon sale throughout the entire world.

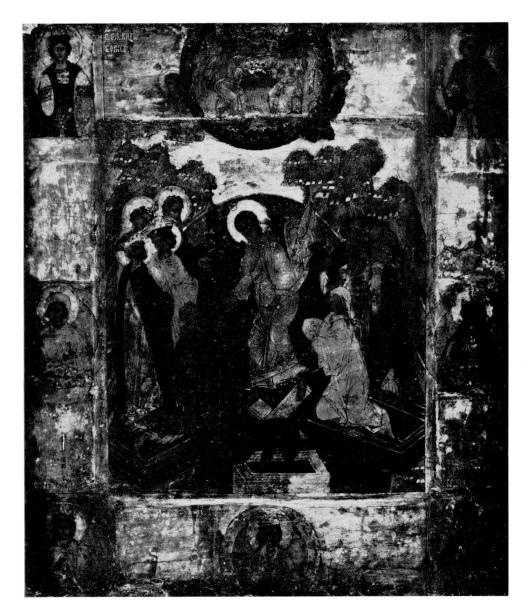

The Descent into Hell
13½ in. (34.9 cm.) high
Moscow School, 16th century
Sold 4.12.72 for 1200 gns.
($3024)

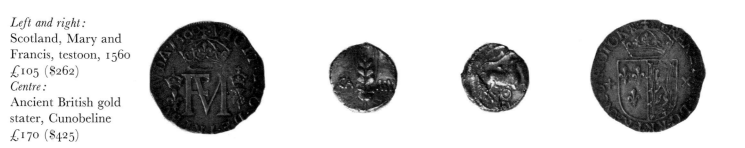

Left and right:
Scotland, Mary and
Francis, testoon, 1560
£105 ($262)
Centre:
Ancient British gold
stater, Cunobeline
£170 ($425)

The Oman Collection of British coins

The last portion of the fine collection of coins that was formed by the late Sir Charles
Oman, K.B.E., D.C.L., F.B.A., and his son, C. C. Oman, was sold on 31st October 1972
for £33,962 ($81,508). This was the British part of the collection and included
many fine and rare pieces. The first lot in the sale was a gold stater of the ancient
British tribe Cunobeline, found at Beckley, near Oxford (above centre).

Much valuable information can be gleaned from coins that are excavated or just
casually found, as it is one of the very few sure ways by which an archaeological site
can be dated with any accuracy. Among the Anglo-Saxon coins was a rare portrait
penny of King Alfred, A.D. 871–899, with a monogram for London on the reverse
(below centre). There was also a very rare penny of the last Anglo-Saxon king,
Harold II, which was struck at Colchester in 1066.

The coinage of Charles I (1625–1649) was well represented with a particularly
fine half-crown minted at Weymouth in 1643 or 1644, and for its type it is con-
sidered to be one of the finest known specimens (below left and right.)

The sale concluded with an interesting section of Scottish and Irish coins which
are rapidly gaining in popularity as they are much scarcer than their English
counterparts (above left and right).

Left and right:
Charles I, half-
crown, Weymouth,
1643-44
£400 ($1000)
Centre:
Alfred, penny
(A.D. 871–899)
£450 ($1125)

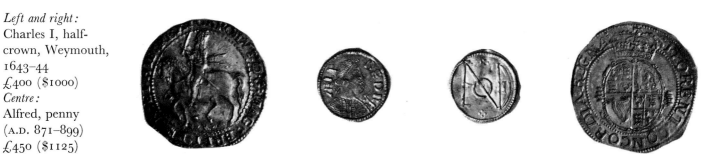

Richard III, groat
London, m. m. sun and
rose
£70 ($175)

Gold medal of the Supremacy of the Church, 1545, £2400 ($6000)

Anne, proof shilling
1707, £250 ($625)

Peru, Charles III, 8-escudos, 1762, Lima, £700 ($1750)

Brazil, John V, 20,000-reis, 1727, Minas, £800 ($2000)

Mary, sovereign, 1553, £1500 ($3750)

Henry VIII, sovereign, Southwark mint, 1544-47, £1300 ($3250)

Calabria, Tarentum
(c. 334–330 B.C.)
stater, £400 ($1000)

Sicily, Gela
(c. 490–480 B.C.)
stater, £850 ($2125)

Augustus
(27 B.C.–A.D. 14)
denarius, £100
($250)

Claudius I
(A.D. 41–54)
denarius, £300
($750)

Galba (A.D. 68–69)
denarius, £170
($425)

Vitellius (A.D. 69)
denarius, £130
($325)

Edward the Elder (A.D. 899–924)
penny, portrait type, £170 ($425)

Edward the Elder, penny, two line
type, £50 ($125)

Eadred (A.D. 946–955), penny
two line type, £50 ($125)

Henry VI (1422–1461)
salute d'or, St. Lo
£340 ($850)

Elizabeth I
(1558–1603)
half-pound, milled
issue, £1050 ($2625)

Henry VII
(1485–1509), angel
£280 ($700)

Edward VI
(1547–1553)
half-sovereign, Tower
mint, £180 ($450)

Cromwell, broad, 1656
£850 ($2125)

Northwest coast argellite
carving of seven figures
in a boat
12 in. (30.5 cm.) long
Haida, Queen Charlotte Islands
Sold 3.4.73 for
1500 gns. ($3780)

The figure in the stern of the boat is a
shaman. The one wearing a pelt and
facing out of the photograph appears to
be the 'bear woman', a subject of many
popular fables of the Haida. She is
alleged to have been taken into the forest
by a bear, by whom she had two
children.

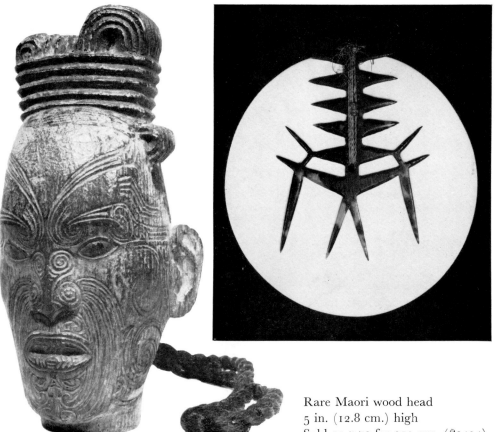

Santa Cruz pectoral ornament
(kap kap)
$4\frac{7}{8}$ in. (12.2 cm.) diam.
Sold 11.7.73 for 500 gns.
($1312)

Rare Maori wood head
5 in. (12.8 cm.) high
Sold 11.7.73 for 950 gns. ($2494)

Five Eskimo walrus ivory
gaming pieces
Each about $1\frac{1}{2}$ in. (3.8 cm.) long
Western Eskimo
Sold 3.4.73 for 260 gns. ($655)

Very little appears to be known about
these gaming pieces used in the game of
tingmiujang (or *tingmiujaq*), literally
'images of birds'. The Central Eskimo
tossed about fifteen such carvings in the
air and the player collected those which
landed upright and facing him. This
continued until all the pieces had been
collected and the player with the most
won.

Western Eskimo ivory
handle
4 in. (10.3 cm.) long
Sold 3.4.73 for 520 gns. ($1310)
From the collection of the late
Captain Raymond Johnes

Left: Eskimo ivory
standing female figure
2 in. (5.1 cm.) long
Sold 3.4.73 for 340 gns. ($856)

Right:
Marquesas bone toggle
$1\frac{3}{4}$ in. (4.4 cm.) high
Sold 11.7.73 for 160 gns. ($420)

Extremely fine Hellenistic marble portrait head of a man called
Euthydemos II, king of Bactria, c. 190 B.C.
$12\frac{1}{2}$ in. (31.8 cm.) high
Early 2nd century B.C.
Sold 11.7.73 for 6500 gns. ($17,062)
From the collection of Sir Ashley Clarke, GCMG, GCVO

Extremely fine Hellenistic bronze figure of
Herakles
$9\frac{3}{4}$ in. (24.8 cm.) high
c. 300 B.C.
Sold 11.7.73 for 7500 gns. ($19,687)

Extremely fine Celtic bronze
figure of a deer
4 in. (10.2 cm.) long
5 in. (12.7 cm.) high
1st century B.C. or earlier
Sold 11.7.73 for 20,000 gns.
($52,500)

This is among the largest Iron Age bronze animals known, and there are no close parallels, although stylistically it resembles the material from the Hounslow Hoard in the British Museum. The figure was washed out of the soil after a heavy rainfall on Coomb Moor, near Prestaign on the Welsh border. There were no associated finds. This is not unusual, for such objects are thought to have been votive in character, and are often discovered as isolated deposits.

It must be noted that the style of this figure links it with the Iron Age of Hallstatt rather than with La Tène. Since there is now evidence for a flourishing hill-fort community in Herefordshire with strong continental influences already established by the 6th century B.C., the possibility exists that the object was an ancient import into the Welsh Marches.

Important Irish side-blow horn of the
late Bronze Age
24½ in. (61.5 cm.) long through the
centre with a bell diameter of
2⅝ in. (6.8 cm.)
8th–7th century B.C.
Sold 11.7.73 for 10,000 gns. ($26,250)
From the collection of Eden Minns, Esq

The ancient Egyptian sculpture
from the Temple of Mut in Asher

ELIZABETH-ANNE NAYLOR-LEYLAND

It has become increasingly evident in the last two years that fine and well-provenanced works of art will always find willing buyers, even if medium quality material is more critically received. This was brought home very forcibly by the high prices realized for the six statues from the Temple of Mut in Asher at Karnak sold immediately before the important Mediaeval and Renaissance Works of Art on 5th December 1972. The antiquity market has always presented problems of authentication due to the very nature of the objects concerned. They belong to ancient civilizations with no written records about the production of what are now regarded as works of artistic importance, but which at the time of manufacture had a functional rather than artistic value in that they played a vital role in the religious beliefs of their creators or those who commissioned them. The recent awareness of the importance of a nation's ancient heritage has not made these difficulties any less, and there are relatively few private collections remaining which were formed in the days when it was considered permissible and respectable to carry off antique works of art from travel or excavation in a foreign land.

Just such a collection was the ancient Egyptian sculpture under discussion. In the year 1895 Miss Margaret Benson and Miss Janet Gourlay, two English ladies on a visit to Egypt, were struck while at Luxor by the romantic appearance of the ruined temple of the goddess Mut which lies to the south of the Great Temple of Amun at Karnak. They decided to ask permission to clear it, and finally M. Naville used his good offices with M. de Morgan, and the latter 'with the liberality which characterized all his dealings in this respect, immediately gave permission'. The work was carried out between 1895 and 1897 (financed by the devoted families of the ladies), and although the methods would strike despair in the heart of a modern archaeologist resulted in the discovery of a rich hoard of statues and inscribed blocks, the excavations being published in 1899 (Margaret Benson and Janet Gourlay, *The Temple of Mut in Asher*, London 1899).

Among the many statues unearthed was an inscribed votive statue of Senmut, the favourite of Queen Hatshepsut of the XVIIIth Dynasty, and others of important officials of that Dynasty and those following. One of the treasures of the Cairo Museum is

Standing statue of the god's father
and priest of Amun in Karnak
Ser son of II(?)
26 in. (66 cm.) high
Grey-green granite with a light
orange diagonal flaw
Dynasty XXVI, c. 610 B.C.
Sold 5.12.72 for 44,000 gns. ($110,880)

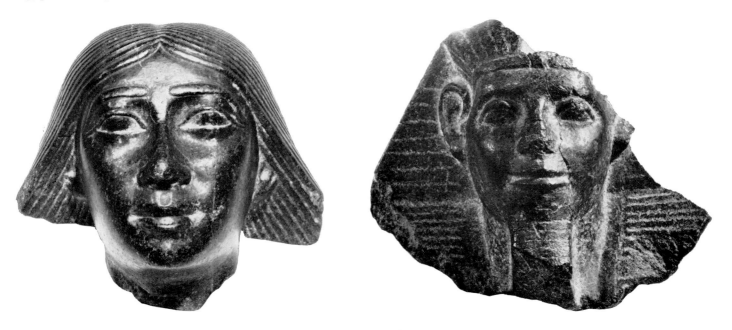

the remarkable portrait of Menthuemhet, who although the holder of only a modest office in the hierarchy of Amun, was also Prince of the City of Thebes and dominated the Thebaid at the end of the XXVth and the beginning of the XXVIth Dynasty; this statue also came from the excavations of Miss Benson and Miss Gourlay.

After one câche of sculpture had been discovered the ladies relate that M. Legrain appeared disturbed that they had transported some of the statues to their hotel, and he 'was very urgent with us to let the statues be taken to his storehouse at Karnak'. Pending a final decision from M. de Morgan, he allowed them temporarily to remove certain statues to their hotel for purposes of study, stipulating that they should in future 'accurately report all finds which from ignorance of what was required we had previously omitted to do'!

As a reward for their labours, Miss Benson and Miss Gourlay were permitted by the Department of Antiquities to keep such statues as were considered then of little importance. Six of these descended to a relative of Miss Benson, who, for lack of space, lent five of them to Winchester College where they remained on exhibition from the end of the Second World War until their removal to Christie's last year. Each is photographed and described in the 1899 publication, and the trench number of each one given.

The statues were of various dates, demonstrating the manner in which Egyptian temples grew up over the centuries, with every generation leaving its mark. The rose-coloured granite Osirid figure of Ramesses II (see illustration page 278) was on a

Opposite left: Head
from a statue of a
man
7½ in. (18.9 cm.) high
Black granite,
Dynasty XXVI
c. 650 B.C.
Sold 5.12.72 for
32,000 gns. ($80,640)

Opposite right: Part of
the head from a small
sphinx of Ramesses III
7½ in. (18.9 cm.) high
Dark grey granite
Dynasty XX
c. 1198 B.C.
Sold 5.12.72 for 1300
gns. ($3276)

scale that one would expect of a ruler who became known as 'the Great'. Although lacking fine detail, the statue had never been intended to be viewed in other than an architectural context and as such it had great majesty. The king had been seated, but unfortunately the knees and part of the throne were mislaid at Winchester.

The fragmentary head which the excavators alleged to have come from a sphinx bearing the cartouche of Ramesses III (see illustration opposite) was in its way extremely haunting. Certain aspects of the battered face suggested the possibility that it might be dateable to the XIIIth Dynasty and represent one of the kings of the period, named Sebekhotep, but since a suggestion of this nature would have presupposed a Middle Kingdom foundation for the Temple of Mut, it seemed wiser to adhere to the attribution of Benson and Gourlay rather than to provoke an Egyptological storm.

The dark grey polished granite head of Amun (page 278) had a serenity and a quality of workmanship that made it a desirable acquisition for any collector, even if he had never before invested in Egyptian art. The late Saite or Persian period statue of a priest of Amun holding an image of the goddess Sekhmet was less impressive, but still of better quality than is usually to be seen in the saleroom.

The standing figure of the God's Father and Priest of Amun in Karnak Ser (page 275), was a superb example of the finest work of the Late Period. The belt and back pillar were fully inscribed, the latter with a fine sunk relief of Ser's wife, the sistrum player of Amun Nai-nub, and the statue was further embellished by a dramatic orange flaw in the granite running diagonally across the torso, a feature peculiar to the Late Period when it was regarded as an ornament rather than a blemish.

Perhaps the most interesting and poignant of all the sculptures was the portrait head of a man wearing a wig whose form was fashionable in the Vth Dynasty, but with the expression and the features and planes of the face treated in such a way that it was clear that the head was related to a relatively rare group of sculpture dating from about 650 B.C. – a group to which the great Cairo Menthuemhet also belongs (see illustration opposite). The head had been exhibited at Burlington House in the 1962 Exhibition *5000 Years of Egyptian Art*, and it is good to know that it has now found its way back there, to take its place in what can be assumed to be its permanent home in the Fifth Room of the Egyptian Galleries in the British Museum.

Weeds and grass have healed the wounds that may have been left in the Temple of Mut by the excavations of Miss Benson and Miss Gourlay. The air is very still, the horseshoe-shaped Sacred Lake almost unruffled – the appearance of the site much as it must have been before 1895. Tourists seldom visit it, for they find their strength already overtaxed by the gruelling trek around the Great Temple of Amun.

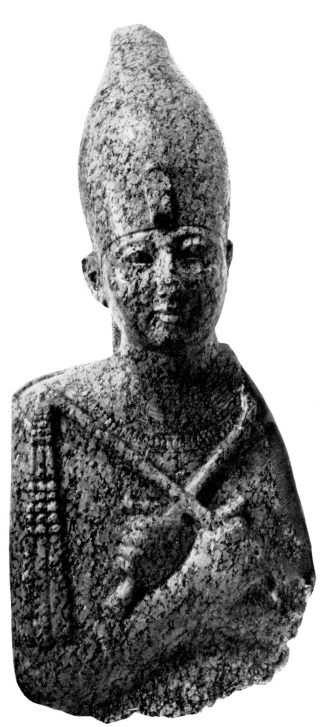

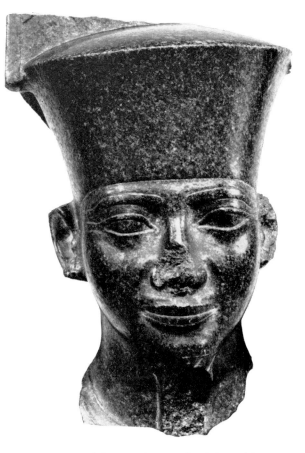

Head from a figure of a deity with
the aspects of Amun or Min-Amun
10½ in. (26.8 cm.) high
Dark grey granite, Dynasty XXV
c. 680 B.C.
Sold 5.12.72 for 17,000 gns. ($42,840)

Upper part of a seated Osirid figure of Ramesses II
41½ in. (105.5 cm.) high
Pink Aswan granite
Dynasty XIX, c. 1290 B.C.
Sold 5.12.72 for 13,000 gns. ($32,760)

BOOKS AND
MANUSCRIPTS

Natural History books

STEPHEN MASSEY

On 9th May, just over seven years since Christie's first held specialized sales of Natural History books, a group of these realized £309,234 ($742,161), a world record for a single session of printed books at auction.

Starting with a small collection of books on horsemanship, followed by atlases, travel books and Americana, the catalogue was arranged in three groups: zoology, ornithology and botany. In comparison with previous sales, all these categories showed spectacular increases in prices. Of the zoological books, Marcus Bloch's six-volume *Ichtyologie*, Berlin, 1785–97 (see illustration page 288), bound for the Duchesse de Berry, made the highest price, £6800 ($16,320). Daniel Giraud Elliot's *Monograph of the Felidae*, 1883, with its exciting lithographs of cats by Josef Wolf, fetched £1900 ($4560), while in 1967 it made £430 ($1290). In our June sale that year we sold three books by Thomas Martyn, the brilliant draughtsman of shells and insects, *The English Entomologist*, 1792, bound by Staggemeier & Welcher, *Aranei, or a Natural History of Spiders*, 1793 (see illustration page 286), and a unique copy of his rarest work, *Psyche*, 1797, printed on vellum. They then sold for £885 ($2655), whereas last May when the same copies reappeared they fetched £2800 ($7000).

Ornithological books had an English slant in our April sale last year but this time there were some fine European examples as well. Jean Baptiste Audebert and Louis Jean Pierre Vieillot: *Oiseaux Dorés*, Paris, 1802, was one of a very few books to use gold as part of the coloured engraving process. Originally coming from the collection of the Belgian Royal Family, it made £2800 ($7000). The work of the celebrated French ornithologist François Levaillant was represented by one of his works printed on Large Paper, in the original quarter morocco binding, *Histoire Naturelle d'une Partie d'Oiseaux . . . de l'Amérique*, Paris, 1801–2, which fetched £2300 ($5750). The Goulds sold by Mr James Williams were not as comprehensive as Jacob Bell's bequest to the Royal Institution which we sold last year, but individual prices continued their perennial increase. In spite of Gould's enthusiastic letter to George Williams in 1873 the collection was left incomplete at the latter's death and the family did not continue with the subscription. Nevertheless, prior to our sale, no work by Gould had fetched over £10,000 ($25,000) at auction, and new records were set when *The Birds of*

JOSEPH JAKOB
PLENCK:
*Icones Plantarum
Medicinalium Secundum
Systema Linnaei
Digestarum, Centuria
I to VIII Fasc. I and II*
758 coloured plates,
8 vols. folio, Vienna
1788–1812
Sold 9.5.73 for
£16,000 ($40,000)
Bought by the
Trustees of the
Chatsworth
Settlement

MAGNOLIA GLAUCA L.
Die Eisengraue Magnolie.

JOHANN WILHELM
WEINMANN:
Phytanthoza Iconographia
1025 coloured plates, 8 vols.
folio, contemporary red morocco
gilt with the arms of Antoine
Nicolas Gavinet, Regensburg,
Lenz [1735–]1745
Sold 9.5.73 for £9000
($22,500)
Bought by the Trustees of the
Chatsworth Settlement

GIORGIO GALLESIO:
Pomona Italiana
161 coloured plates, 3 vols.
folio, Pisa 1817–1839
Sold 9.5.73 for £5500 ($13,750)

Fico Petifero o Fico dell' Osso

Liliam Superbum Lis Superbo

PIERRE JOSEPH REDOUTE:
Les Liliacées
486 coloured plates, 8 vols. folio,
Paris 1802–1816
Sold 9.5.73 for £17,000 ($42,500)
Bought by the Trustees of the
Chatsworth Settlement

PIERRE JOSEPH REDOUTE:
Choix des Plus Belles Fleurs
Large Paper copy, 144 coloured plates, folio, Paris
1829[–1833]
Sold 9.5.73 for £8000 ($20,000)

MLLE G. FONTAINE:
Collection de Cent Espèces ou Variétés du Genre Camellia
100 coloured plates, 4to, Brussels 1845
Sold 9.5.73 for £6500 ($16,250)

Australia, 1848–69, made £11,000 ($27,500), and Sir William Seeds's copy of *A Monograph of the Trochilidae, or Family of Humming Birds*, [1849]–1887 (see illustration page 286), fetched £10,400 ($26,000). One of the author's rarer works, *Icones Avium*, 1837–8, bound with *A Monograph of . . . Kangaroos*, 1841–2, made £3200 ($8000). However, in our Australian sale of October 1972 the most prized item appeared. This was parts 1 and 2 of *The Birds of Australia*, published in 1837 and then abandoned prior to the author's expedition to Australia. It fetched $A11,200 (£5233). As well as being the rarest of Gould's works, this copy had belonged to the greatest bird-painter of all, the American, John James Audubon.

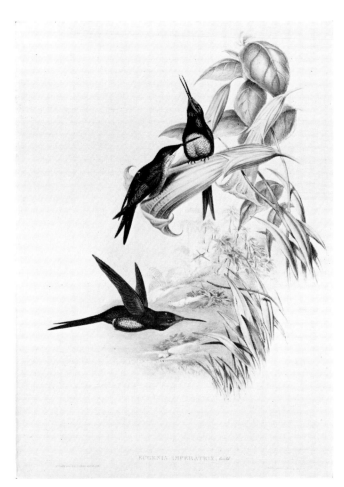

JOHN GOULD:
A Monograph of the Trochilidae, or Family of
Humming Birds
418 coloured plates, 6 vols. folio, [1849]–1887
Sold 9.5.73 for £10,400 ($26,000)
From the collection of Sir William Seeds, KCMG,
British Ambassador to Brazil 1930–5

THOMAS MARTYN:
Aranei, or a Natural History of Spiders
Coloured frontispiece and 28 plates, 4to, 1793
One of a collection of four books by Thomas Martyn
Sold 9.5.73 for a total of £2800 ($7000)

The high point of our sale was the exceptional range of botanical books. In 1971 the emphasis in our catalogue of the Knowsley Hall flower books was towards England, but on this occasion European publications led the field. From Belgium came one of the scarcest books on camellias, Mlle G. Fontaine, *Collection de Cent Espèces . . . du Genre Camellia*, Brussels, 1845 (see illustration page 285), also originating from the Belgian Royal library, fetching £6500 ($16,250). The work of the great German artist Georg Dionysius Ehret was well represented. His *Plantae et Papiliones*

Rariores, 1748–59, a mere 15 plates, made £1800 ($4500) and a more famous book produced in collaboration with Christoph Jakob Trew and Johann Jakob Haid, *Plantae Selectae*, Augsburg, 1750–3 went for £2000 ($5000). One of his first works was a commission to illustrate Johann Wilhelm Weinmann's *Phytanthoza Iconographia*, Regensburg, 1735–45 (page 282). One of the largest of the 18th-century collections of flower engravings, with 1025 plates, this copy was in a magnificent contemporary red morocco binding which helped to justify its record price of £9000 ($22,500). The Italian contribution to Natural History books was not large, but Giorgio Gallesio's *Pomona Italiana* Pisa, 1817–39 with its engravings of succulent fruit (page 283), has always been prized by collectors for its beauty and scarcity. It fetched £5500 ($13,750), three times higher than at Christie's in 1966.

During the second half of the 18th century royal patronage for flower books reached its height in Vienna with the restocking of the imperial gardens at Schönbrunn. Nikolaus Josef von Jacquin, one of the directors, was the author of several great flower books and is responsible in many ways for the importance of Vienna as a city of botanical publishing. One of his followers, Joseph Jakob Plenck, was the author of a book on medicinal plants: *Icones Plantarum Medicinalium*, Vienna, 1788–1812 (see illustration page 281). Owing to his death in 1807 the work remained unfinished with 758 plates. It is a book of the utmost rarity, no copy having appeared at auction since the turn of the century, and ours was in superb condition. It fetched £16,000 ($40,000). Published later and apparently complementary to it is Daniel Wagner's *Pharmaceutisch-Medicinische Botanik . . .*, Vienna, 827–30, which made £7000 ($17,500).

A book which owes more to art than botany is Jean-Louis Prevost's *Collection des Fleurs et des Fruits*, Paris, 1805 (see frontispiece). From its introduction one learns that the illustrations were to be used for arts and manufacturing, as a source for designers. Its forty-eight still-life engravings of great beauty in one collection do not seem enormously expensive amongst other prices of today at £12,500 ($31,250).

Finally the catalogue could boast the presence of four of the major works of the most celebrated of all flower painters, Pierre Joseph Redouté. Under the patronage of the Empress Josephine and later the Duchesse de Berry, he set standards of coloured engravings of flowers by which all others are judged. In 1968 we sold a copy of *Les Roses*, Paris, 1817–24, on Large Paper with the plates in two states for £10,000 ($25,000), then a world auction record for a flower book. A fine copy of an earlier but larger work *Les Liliacées*, Paris, 1802–16 (page 284), fetched £17,000 ($42,500), a new world record, while a Large Paper copy of his *Choix des Plus Belles Fleurs*, Paris, 1829–33 (page 285), made £8000 ($20,000). A posthumous work, *Le Bouquet Royal*, 1844, with only four plates and an ordinary paper copy of *Les Roses* fetched £850 ($2125) and £7500 ($18,750) respectively.

JOHANN JAKOB DILLENIUS:
Hortus Elthamensio
Special copy coloured by the author, 325 plates, 2 vols. folio,
contemporary English red morocco, Brownlow arms on sides, 1732
Sold 9.5.73 for £6700 ($16,750)

MARCUS ELIESER BLOCH:
*Ichtyologie, ou Histoire
Naturelle Générale . . . des
Poissons*
432 coloured plates, 12 parts
in 6 vols. folio
Contemporary calf gilt with
the arms of Caroline
Duchesse de Berry, Berlin
1785–97
Sold 9.5.73 for £6800
($17,000)

288

ROBERT BOYLE: Collection of first and early editions in contemporary bindings 1664–8
Sold 29.11.72 for £3545 ($8508)

ANDREA PALLADIO: *I Quattro Libri Dell'Architettura, First Edition*, Venice 1570, interleaved with a fine
calligraphic manuscript English translation
Sold 29.11.72 for £5000 ($12,000)
From the collection of Geoffrey Dutton, Esq

The Pricke of Conscience
Illuminated manuscript on
vellum, England, probably
West Midlands, third quarter
of the 14th century
Sold 28.6.73 for £4200 ($10,500)

Portrait of Sultan Mehmet Fatih
(i.e. the conqueror)
Turkish, early 18th century
Sold 28.6.73 for £1700 ($4250)

Dear Sir July 18. 1744

At my arrival in London, which was Yesterday, I immediately
perused the Act of the Oratorio with which You favour'd me,
and, the little time only I had it, gives me great Pleasure.
Your reasons for the Lenght of the first act are intirely
satisfactory to me, and it is likewise my Opinion to
have the following Acts short. I shall be very
glad and much obliged to You, if You will favour
me with the remaining Acts. Be pleased
to point out these passages in the Messiah
which You think require altering.

I desire my humble Respects and thanks to
My Lord Guernsey for his many Civility's
to me. and believe me to be with the greatest Respect

Your
most obedient and most humble
Servant
George Frideric Handel

One of the nine
surviving autograph
letters of George
Frideric Handel to
Charles Jennens, his
librettist
Sold 4.7.73 for
£35,000 ($87,500)
From the collection
of The Earl Howe,
CBE

Handel and his librettist

Autograph letters of George Frideric Handel are among the rarest of all composers' letters. On 4th July the nine surviving Handel letters to his librettist, Charles Jennens, were sold (see illustration opposite). As far as is known only 32 letters of Handel survive and the nine to Jennens are the largest number to any one correspondent; they are the only letters which refer to his compositions. The most important letter, written from Dublin on 29th December 1741, refers to Messiah, 'It was with the greatest pleasure I saw the continuation of your kindness by the lines you was pleased to send me, in order to be prefixed to your oratorio Messiah which I set to music before I left England.' Messiah, composed in 23 days, was first performed in Dublin in April 1742. The nine letters, dated from 1735 to 1749 sold for £35,000 ($87,500). In the same sale was a collection of 40 letters from Charles Jennens to Edward Holdsworth and 71 from Holdsworth to Jennens. This fascinating correspondence, which is unpublished, contains many references to Handel and Messiah and perhaps the chief interest of the correspondence lies in Jennens's account of the deterioration of his friendship with Handel. They sold for £10,000 ($25,000).

Jennens refers continually to Messiah and in an enthralling letter written in July 1741 he writes, 'I hope he will lay out his whole genius and skill upon it, that the composition may excell all his former compositions, as the subject excells every other subject. The subject is Messiah.'

The collection was sold by the Earl Howe and its provenance can be traced back through the Howe family to the descendants of Jennens's sister Esther.

BENITO MUSSOLINI:
*Progetto per la Roma
Imperiale nella
restaurazione del Campo
Marzio da Lui ideato da
Armando Brasini redatto*
Sold 28.6.73 for £2000
($5000)

Project for a new Rome

Armando Brasini (1879–1965) first projected a plan for Rome in 1916 inspired by D'Annunzio, and apparently no less devastating than the 'Project for Imperial Rome' conceived by and authorized to be completed with all speed by Mussolini on 14th April 1924, only a year after his March on Rome. Its objectives were to isolate antique monuments and churches, open up great streets and piazzas and to erect public buildings in a style distinctive of the Fascist era in the Campo Marzio. The above illustrated 'Building in the Fascist style' was an elaborate model; some proposed buildings were modelled in bronze, and the Teatro Romano in the Villa Borghese was built life-size. The completed project as presented to Mussolini in a monumental binding is dated 'Anno VIII/A.D.MCMXXIX'. Every detail was worked out, nothing left to chance, the most attractive corners of Rome to be demolished being photographed to look as ugly as possible.

A breeze in the book room

CYRIL CONNOLLY

I never thought I should find myself organizing a book sale at Christie's. When asked to become a consultant on modern books I was tempted to refuse as too inexperienced until I suddenly envisaged my disappointment if the job were offered to someone else. After all I have collected modern books all my life and now my own acquisitiveness was beginning to wane. So as well me as another. Now I find it all fascinating, but as my sale approached it became a nightmare. Supposing there were no books? Because there had been such sales in the past it did not follow there would be enough for another one. Modern first editions and presentation copies are getting scarcer. And why should people go on wanting to buy them? They're only boards and paper. I could, of course, put all my own library in to save my honour. Three hundred lots of it. But meanwhile there might be a slump. Or worse could happen. 'Is there any lot you're particularly interested in?' I might say. 'I will open the case for you.'

'Yes – I should like to see the inscribed Yeats' *Mosada* and the Eliot copy of Pound's *A Lume Spento*, and the Joyce *Et tu, Healey.*'

'Of course – the last must be unique. Curiously enough they all come from the same collection.'

'Which happens to be mine.'

'I congratulate you.'

'Perhaps you would rather congratulate my colleague, Mr Connolly. He is from the Fraud Squad.'

Luckily we had a reprieve of ten days and in that time everything happened. When the 4th April came round – not with a purse-loosening burst of spring sunshine but in a drizzle – I found myself for the first time on the other side of the rostrum with the buyers in front of me in a friendly haze and a few of my clients with pencil poised above their catalogues. Sir Henry D'Avigdor-Goldsmid, disposer of a clutch of Verlaines, sat beside me, and opposite sat Mrs Barbara Bagenal, octogenarian owner of forty Virginia Woolf and sixty Leonard Woolf letters; John Carter who had been at school with me, was invigilating from up the road, and representatives from Rota's and Quaritch from whom I had myself bought books with Mr Sims from Reading,

Sick-call to Oscar Wilde. over

Mr Robert Ross.

Reform Club.

Can I see one of the fathers about a very urgent case or can I hear of a priest elsewhere who can talk English to administer the sacraments to a dying man?

ROBERT ROSS: His visiting card, asking for a priest to perform the Last Rites for Oscar Wilde. From a collection of letters, manuscripts, etc., relating to the death of Oscar Wilde
Sold 4.4.73 for £650 ($1560)
From the collection of Rupert Croft-Cooke, Esq

Mr Lucas from the Bow Windows, Lewes, and even the fabulous M. Berès over from Paris, and some old friends like Tom Driberg, Jimmy Stern and Patrick Kinross. The youthful auctioneer, like Theseus come to rescue Ariadne, parachuted on to the rostrum. Bidding opened with Beckett's *Echo's Bones*; the property of Stephen Spender (Pickering, £60 [$150]); suddenly I found myself bidding for a Basil Bunting. A director passed a note to me 'It's going like a summer's day'. A set of *Horizon* was the first lot to reach three figures – £220 ($550) – (about twice what it used to fetch three years ago) and M. Berès carried off a corrected proof copy of Victor Hugo's *Hernani* for £480 ($1200). The beauty of an auction is that the seller has the fairest chance of getting the best value for his possessions in open competition, the buyer the opportunity to pick up the occasional plum. The system of reserves protects the seller from exploitation. But the fixing of reserves requires a very nice judgement of conditions in a fluctuating market. I shall look forward to the day when the sale of manuscripts by younger authors will create a bigger demand. After all there are many books but only one manuscript, the work of the artist's hand. And such hands are of great beauty as in the manuscripts of Virginia Woolf or great characters as in Auden or Evelyn Waugh. I shall try again and hope the libraries will step in next time where the collectors fear to tread.

The letters were a different matter. A fascinating Wilde collection amassed by the priest who took his last confession, though lacking in anything in Oscar's own hand, went for £650 ($1560) to Cortez (see above). Stout fellow. And last of all came the Virginia and Leonard Woolf correspondence with Bloomsbury's 'Ancient Mariner', Saxon Sidney-Turner's record of a life time's friendship which I had taken so much trouble to advertise and catalogue (see illustration opposite). This time the bidding sailed

VIRGINIA WOOLF: A series of 41 A.Ls.S. from her
to Saxon Sydney-Turner, 14 letters from her brother
Adrian Stephen and 2 from her older brother Thoby
Stephen to the same
Sold 4.4.73 for £2800 ($6720)
From the collection of Mrs Barbara Bagenal

away: £1800 ($4500) to McAlpine for Leonard Woolf, £2,800 ($6720) to Quaritch for Virginia and Mrs Bagenal was busy being congratulated. It had all been worth it.

Still the fact remains that the total of £24,000 ($60,000) realized by 300 lots including many manuscripts, letters, presentation copies, rare and beautiful books could be reached by one Victorian painting, a gold box or a piece of French furniture.

I remember, after the war, when English Georgian silver was the Cinderella

JOHN BRAINE: *Room at the Top*
Original manuscript
Sold 4.4.73 for £650 ($1560)
From the collection of John Braine, Esq

(Victorian hardly counted) that one could buy candlesticks, tea and coffee pots, écuelles, tureens and covered cups, unless by Lamerie, for well under three figures. Perhaps one day in a more civilized climate the absurdly low prices for early editions of Yeats, Joyce, Eliot, or the productions of the Hogarth, Nonsuch and other private presses, or authors' manuscripts and typescripts over which they have long laboured and despaired, will seem of more interest than a Regency moustache-cup. In my first sale I detected a flutter of breeze in the prices not entirely due to the work put into it by the organization. May it reach gale force by the next one.

PORCELAIN
AND
GLASS

Top left:
Rare English Royalist blue and white charger painted with a portrait of Queen Catherine of Braganza
14¼ in. (36 cm.) diam.
Sold 18.12.72 for 850 gns. ($2142)

Bottom left:
Rare Brislington dated charger
13¼ in. (34 cm.) diam.
Sold 21.5.73 for 1700 gns. ($4462)
From the collection of the Earl Bathurst

Below:
Important early English tin-glazed group of a man and woman
4¾ in. (12 cm.) high
c. 1670, excavated in Greek Street, Soho, 1929
Sold 21.5.73 for 380 gns. ($997)

Top: Fine Chelsea oblong
octagonal dish
12½ in. (31.5 cm.) wide, raised
anchor period
Sold 13.11.72 for 420 gns.
($1058)

Centre left: Rare Worcester
(Dr Wall) peach-shaped
wine-taster
4 in. (10 cm.) wide
Sold 13.11.72 for 1100 gns.
($2772)

Centre right: Rare Longton Hall
figure of a toper
5 in. (12.5 cm.) high
Sold 13.11.72 for 500 gns.
($1260)

Bottom: Rare Worcester
(Dr Wall) finger-bowl and stand
The bowl 3 in. (7.5 cm.) high,
the stand 5¾ in. (14.5 cm.)
diam., the decoration possibly
by James Rogers
Sold 13.11.72 for 580 gns.
($1460)

Important pair of
Worcester (Dr Wall)
white figures of a
sportsman and
companion
$7\frac{1}{4}$ in. (18.5 cm.) high
Sold 30.10.72 for
5000 gns. ($12,600)

Record-breaking Worcester

CHRISTOPHER ELWES

Two new record prices were established this season for Worcester, a factory renowned for commanding high prices for its rarer productions. The pair of white figures illustrated opposite, of a sportsman and companion, came under the hammer first, in October. All Worcester figures are scarce and their existence was not even known until about 1949 – however the sportsman and companion are considered amongst the rarest of these figure models. Only two other pairs, one white and one coloured, and two single figures are recorded. The £5250 ($12,600) which they realized created a new record for a lot of Worcester. Although a high price, it was predictable since a single figure of a sportsman had realized £2000 ($5600) in 1968.

The second record-breaking lot was the bowl illustrated overleaf. This came from James Giles's studio in London where large quantities of Worcester as well as other English and Continental porcelains were decorated. There has always been great interest in the work of his studio and several different and distinctive hands have been identified. Although as yet the names of these artists still elude researchers they have been named according to their styles of painting. This exceptional bowl shows the combined work of three of the best-known Giles artists, having panels of exotic birds by the 'Cut-fruit painter', a figure in a landscape by the 'Painter of the Teniers figures', and flowers in blue monochrome by the 'Dry-blue painter', reserved on a turquoise ground peculiar to Giles's studio.

Only two plates with similar decoration are recorded, both in museum collections. These were considered to have been traveller's specimens showing the work of the different studio painters to potential buyers; however, the discovery of this bowl indicates the possibility that a complete harlequin service was made of this pattern, but unless other examples come to light, the purpose of these unusual and lavishly decorated wares will remain obscure.

The bowl was sold in January for £9450 ($22,680) breaking the recently established record for Worcester porcelain as well as creating a new record for any piece of English porcelain.

Important and
unrecorded Worcester
(Dr Wall) bowl
decorated in the
atelier of James Giles
6½ in. (16.5 cm.)
diam., blue crossed
swords and No. 6
mark
Sold 29.1.73 for
9000 gns. ($22,680)
Record price for a
piece of English
porcelain

Chelsea melon-tureen and cover
7 in. (18 cm.) wide, the cover and base with red
anchor and number 4 marks
Sold 14.5.73 for 1700 gns. ($4462)

Very rare Chelsea octagonal teapot and cover of 'The Lady
in Pavilion' pattern
6¾ in. (17 cm.) wide, raised anchor period
Sold 13.11.72 for 2400 gns. ($6048)
From the collection of Mrs M. L. Redfern

Rare pair of Chelsea finger-
bowls and stands painted in
colours in the manner of
James Rogers
The stands 6¼ in. (16 cm.)
diam., red anchor marks
Sold 14.5.73 for 1000 gns.
($2625)

Very rare fairing: *To Epsom*
Sold 30.4.73 for 900 gns. ($2268)
From the collection of Mrs J. G. Links

Equestrian figure of Sir Robert Peel
13 in. (33 cm.) high
Sold 22.1.73 for 1600 gns. ($4032)

Rare pair of Staffordshire boxing figures of Cribb and Molyneux
9 in. (23 cm.) high
Sold 5.3.73 for
1900 gns. ($4788)

Derby cylindrical
coffee-cup and saucer, the
cup finely painted by
George Complin
Puce marks and pattern
no. 262
Sold 9.7.73 for 600 gns.
($1575)

Oval teapot and cover from a
documentary Paris porcelain part
tea-service decorated at Torksey, by
William Billingsley
Sold 9.7.73 for 520 gns. ($1352)

Rare Bristol blue and white and
manganese bowl
9 in. (23 cm.) diam.
Sold 21.5.73 for 420 gns. ($1102)

Pair of Wedgwood and Bentley blue and white jasper
oval plaques modelled in white relief with *The Marriage
of Cupid and Psyche* and with *The Sacrifice to Peace*
3¼ in. (8.5 cm.) wide
Sold 21.5.73 for 980 gns. ($2572)
From the collection of the late Cicely, Marchioness
of Zetland

Royal Worcester two-handled vase
By George Owen
6½ in. (16.5 cm.) high
Sold 12.3.73 for 280 gns. ($706)

Extremely rare pair of Bow figures of pugilists
7 in. (18 cm.) high
Sold 13.11.72 for 900 gns. ($2268)

Rare pair of Plymouth white figures
11 in. (28 cm.) high
Sold 14.5.73 for 680 gns. ($1785)

Massive Sèvres-pattern ormolu-mounted vase and cover
55½ in. (141 cm.) high
Sold 5.2.73 for 3600 gns. ($10,072)

Berlin porcelain
rectangular plaque painted
after Murillo's painting in
the Alte Pinakothek
Munich
16 × 12¼ in. (40.5 × 31 cm.)
Sold 11.6.73 for 2100 gns.
($5512)
From the collection of the
late Mrs M. A. Thorne

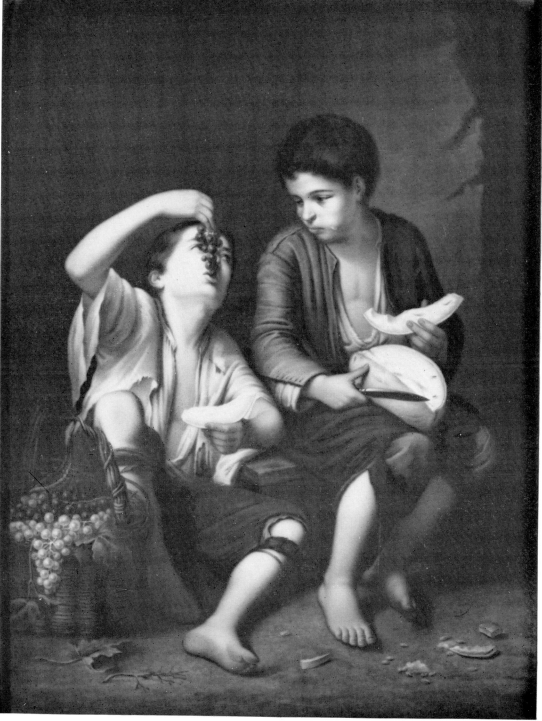

Opposite : Massive Vienna
circular plaque
Signed H. Stadler
23½ in. (59.5 cm.) diam.
Sold 2.4.73 for 2200 gns.
($5544)

Continental porcelain

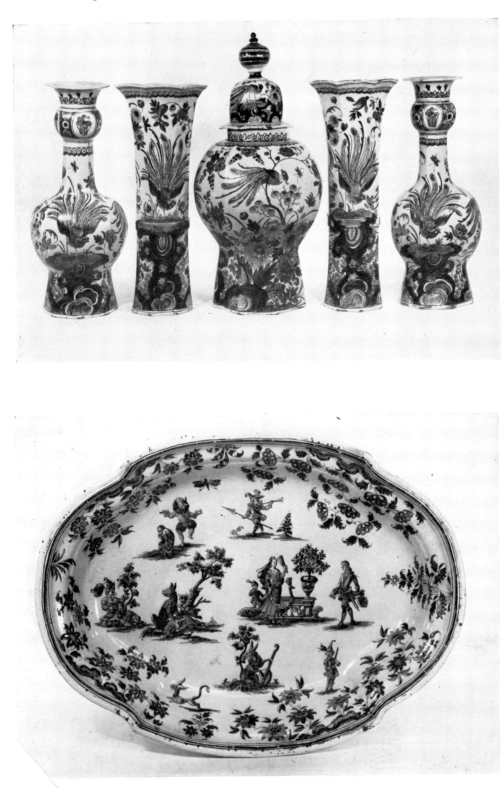

Dutch Delft polychrome
garniture de cheminée
Central baluster vase and cover
24½ in. (62 cm.) high, green B
marks
Sold 16.4.73 for 1600 gns
($4032)

Fine faience Moustiers shaped
oval deep dish
16¼ in. (41 cm.) wide, mark of
Olerys in green
Sold 16.7.73 for 1000 gns.
($2520)

Very rare Ansbach fishing group
6¼ in. (16 cm.) high
Sold 16.10.72 for 2000 gns. ($5040)

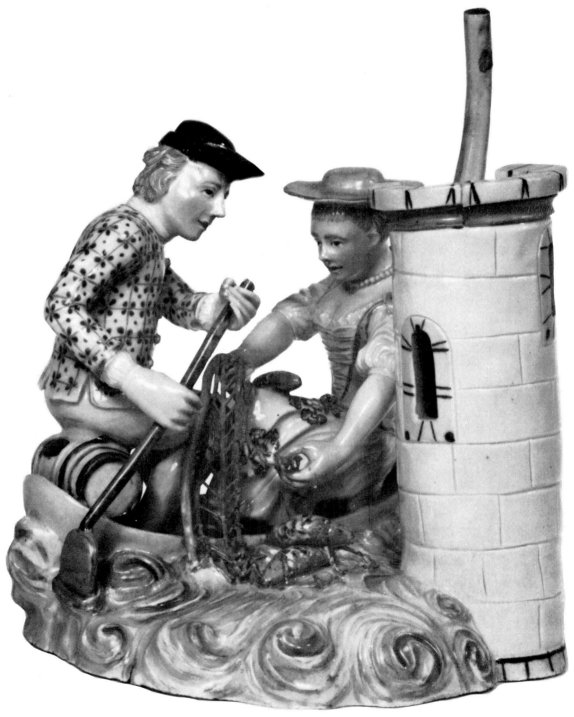

Meissen porcelain

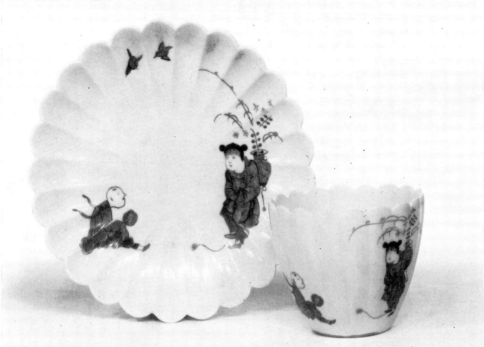

Early Meissen kakiemon fluted teabowl and saucer
Painted after a Japanese original
Blue enamel crossed swords mark
Sold 7.5.73 for 1100 gns. ($2887)

Rare early Meissen chinoiserie candlestick
Modelled by J. G. Kirchner and decorated in the Herold
workshop
9 in. (23 cm.) high
Sold 7.5.73 for 1300 gns. ($3412)

Fine Meissen
'Fabeltiere' yellow-
ground dish painted
by A. F. von
Löwenfinck
9½ in. (24 cm.) diam.
Blue crossed swords
mark
Sold 16.10.72
together with a
Meissen 'Fabeltiere'
yellow-ground ecuelle
and cover for
4000 gns. ($10,080)

Below: Very rare
pair of Meissen
butter-dishes and
covers
5¼ in. (13 cm.) diam.
Blue crossed swords
mark
Sold 16.10.72 for
2400 gns. ($6048)
From the collection of
Sir David Ogilvy, BT

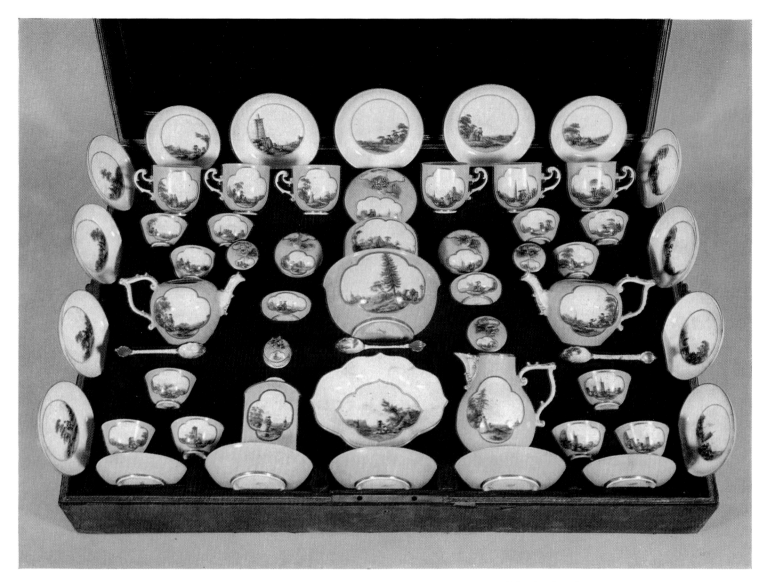

Superb Meissen yellow-ground travelling tea and coffee service painted in the manner of C. F. Herold
Blue crossed swords and gilt D marks on the majority of pieces
Sold 16.10.72 for 10,000 gns. ($25,200)

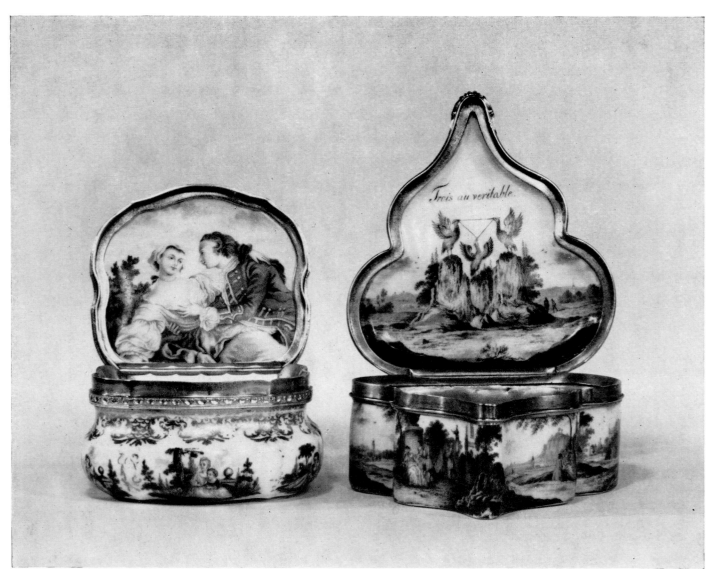

Meissen gold-mounted bombé snuff-box
2¾ in. (7 cm.) wide
Sold 7.5.73 for 2800 gns. ($7475)

Rare Meissen gold-mounted leaf-shaped snuff-box
3¼ in. (8 cm.) wide
Sold 7.5.73 for 1900 gns. ($4987)

Italian porcelain

Naples (Ferdinand IV) figure of a lady
7⅛ in. (18 cm.) high
Sold 12.6.73 at the Salone Margherita, Rome, for
£980 (L. 1,500,000)

Rare Naples (Ferdinand IV) inkstand set
Sold 12.6.73 at the Salone Margherita, Rome, for £1633 (L. 2,500,000)

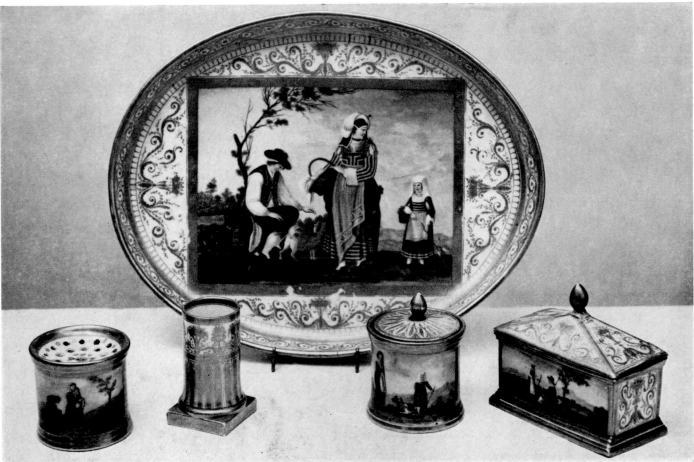

Remarkable pair of Capodimonte (Carlo III) beakers and saucers
Blue fleur-de-lys marks
Sold 12.6.73 at the Salone Margherita, Rome, for £3694 (L. 5,500,000)

Remarkable Faenza Nativity group
Last quarter of 15th century
$23\frac{5}{8} \times 15$ in. $(60 \times 38$ cm.$)$
Sold 12.6.73 at the Salone
Margherita, Rome, for
£4248 (L. 6,500,000)

Faenza portrait tondino
c. 1520
9¼ in. (23.5 cm.) diam.
Sold 12.6.73 at the Salone
Margherita, Rome, for
£2614 (L. 4,000,000)

Pair of Casteldurante
wet-drug jars
c. 1530
8¼ in. (21 cm.) high
Sold 12.6.73 at the
Salone Margherita,
Rome, for £2614
(L. 4,000,000)

Casa Pirota dish
c. 1525
10¼ in. (26 cm.) diam.
Sold 12.6.73 at the Salone Margherita, Rome, for £4248 (L. 6,500,000)

Urbino Istoriato dish painted with the battle of the Lapiths and Centaurs
Workshop of Orazio Fontana, c. 1545
11¼ in. (28.5 cm.) diam.
Sold 12.6.73 at the Salone Margherita, Rome, for £2287 (L. 3,500,000)

The market in glass paperweights

HUGO MORLEY-FLETCHER

On 27th November we offered a collection of paperweights of unusual distinction because of its small size and select quality. Recent years have seen a trend to rather compendious collections with many weights of average type and quality. Formed by the late Mrs V. Hutton-Croft between about 1953 and her death in the late 1960s, the collection consisted of only 52 lots. Since a large proportion of these lots were acquired at auction it is possible to establish in most cases the price change that has taken place. From this some interesting conclusions arise.

The undoubted star of the collection, the Baccarat crown imperial weight (see illustration opposite, top right), had last appeared in the great C. J. Carroll sale of 1958 when it cost £370. By 1972 its price had risen 8½ times to £3150 ($7560), a sum which reflects the attractiveness and technical perfection of the piece. Also from the Carroll sale was a cornucopia weight which rose from £140 in 1958 to £550 ($1320) in 1972.

Butterfly and flower weights have always been in demand, the price normally being dictated by the rarity and quality of the flower. This point was neatly illustrated in this sale by a weight with a rare wheat flower (bottom left, opposite) which fetched £2205 ($5292), more than three times the £630 ($1512) paid for a butterfly above a mere clematis.

In the 1950s and 1960s snake weights had already become very popular and relatively high prices were being paid for them. Two examples in the November sale show the considerable increase since that period: a rare Baccarat red snake weight (bottom right, page 326) which cost £1350 in 1965 fetched £1575 ($3780), an increase of 15%, and a Baccarat green snake weight (top left, page 326) which in 1957 sold for £450 made £1365 ($3276).

Among the rarest objects of the whole collection was a Clichy pear weight. The Clichy factory had a far less varied repertoire than, say, Baccarat, and fruit weights from this source are few and far between. Thus it was hardly surprising when this weight, which in 1958 cost £240 now sold for £1365 ($3276). Similar proportional increases were also to be seen among other fruit and flower weights, such as the Baccarat strawberry weight which cost £150 in 1956 and £630

324

Fine Baccarat rose weight
$3\frac{1}{8}$ in. (8 cm.) diam.
Sold 27.11.72 for 1350 gns. ($3402)

Very rare Baccarat crown imperial
weight
$3\frac{1}{8}$ in. (8 cm.) diam.
Sold 27.11.72 for 3000 gns. ($7560)

Rare Baccarat butterfly and wheatflower
weight
3 in. (7.5 cm.) diam.
Sold 27.11.72 for 2100 gns. ($5292)

Very rare Baccarat flat tricolour bouquet
weight
3 in. (7.5 cm.) diam.
Sold 27.11.72 for 1200 gns. ($3024)

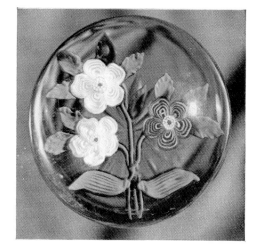

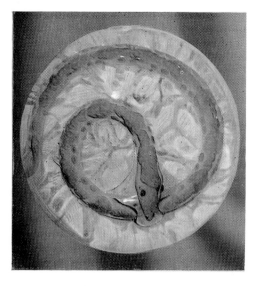

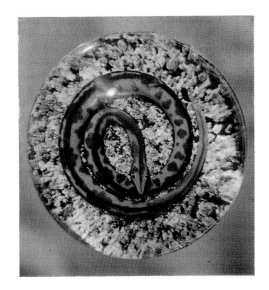

Above: Very rare Baccarat snake
weight
$3\frac{1}{8}$ in. (8 cm.) diam.
Sold 27.11.72 for 1300 gns. ($3276)

Top right: Fine Baccarat green snake
weight
$3\frac{1}{4}$ in. (8.5 cm.) diam.
Sold 27.11.72 for 1200 gns. ($3024)

Right: Fine and rare Baccarat red
snake weight
3 in. (7.5 cm.) diam.
Sold 27.11.72 for 1500 gns. ($3780)

($1512) in 1972; a rose weight (top left, opposite) from the same factory made £175
in 1959 and sold for £1417 ($3402), while another smaller rose weight fetched £90 in
1956 and now sold for £577 ($1385). From the St Louis factory came an upright
bouquet weight which in 1953 sold for £49. It now brought £504 ($1210).

Not all paperweights depict specific motifs such as flowers and snakes. Many are
composed purely of patterns. This aspect of paperweight collecting was also well

represented in the sale. The most remarkable example was a St Louis magnum crown weight, once the property of that *doyen* of collectors, Mr Paul Jokelson, in whose sale in 1963 it realized £400. Ten years later it brought £1417 ($3401). Another weight of similar proportions was a concentric millefiori weight. As is essential in examples of this type, the canes were arranged in perfect symmetry around the central motif. In 1958 this weight cost £165 – it now sold for £714 ($1714).

Also of this type was a Clichy turquoise overlay weight bought from Lord Dunboyne's collection in June 1956 for £320. This fetched £1102 ($2645), a high price when it is remembered that all the gilding with which the overlay was originally decorated had disappeared. A Baccarat weight of this type, but with translucent ruby overlay, had cost £200 in May 1958 to realize £840 ($2016) in 1972.

Naturally, most of the more staggering increases in the value of glass paperweights have taken place over a period of more than ten years. There are also many more current types which have not made such progress, increasing generally under 100%. Where, however, as in this case, the collector has bought fine and rare pieces with discrimination, the market will always greet with enthusiasm their pieces when they reappear.

Extremely rare Baccarat yellow and blue clematis weight
2½ in. (6.5 cm.) diam.
Sold 27.11.72 for 900 gns. ($2268)

Left: One of a fine pair of baluster airtwist candlesticks. 7 in. (18 cm.) high Sold 30.1.73 for 1200 gns. ($3276)

Below: Webb cameo overlay vase The base impressed 'Laburnum' 14½ in. (37 cm.) high Sold 12.3.73 for 2100 gns. ($5290) From the collection of Mr Amedeo Guidastri

Below: Early sealed wine-bottle of dark green metal. Inscribed R.E.W. and dated 1699. 5 in. (12.5 cm.) high Sold 30.1.73 for 280 gns. ($706)

Left: Engraved and faceted table-service comprising: a pair of decanters and stoppers (one shown) 11 in. (28 cm.) high, three goblets, twelve wine-glasses similar six ale-flutes Sold 30.1.73 for 420 gns. ($1058) From the collection of Brigadier P. H. C. Hayward, CBE

CHINESE CERAMICS
AND
WORKS OF ART

Left: Rare small early glazed pottery figure of a standing hound
Han dynasty
5½ in. (14 cm.) high
Sold 23.7.73 for 8000 gns. ($21,000)

Bottom left: Honan globular jar
Sung dynasty
10 in. (25.5 cm.) diam., 8¼ in. (21 cm.) high
Sold 23.7.73 for 14,000 gns. ($36,750)
From the collection of Madame Prunier

Bottom right: Fine early glazed buff pottery pear-shaped vase
Han dynasty
14 in. (35.5 cm.) high
Sold 23.7.73 for 4200 gns. ($11,025)

Rare early Chinese gilt bronze travelling shrine
Northern Wei dynasty
5 in. (12 cm.) high
Sold 5.6.73 for 20,000 gns. ($52,500)

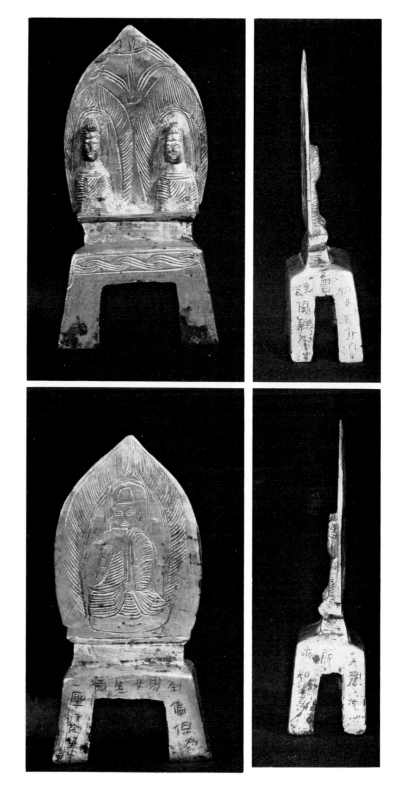

Superbly carved Ting Yao bowl
8½ in. (21.5 cm.) diam.
Northern Sung dynasty
Sold 20.11.72 for 17,000 gns. ($42,840)

Early Ming blue and
white small dish
Yung Lo
$10\frac{3}{4}$ in. (27.5 cm.)
diam.
Sold 4.6.73 for
15,000 gns.
($39,375)

Rare parcel-gilt wine-cup
3 in. (7.5 cm.) high
T'ang dynasty
Sold 20.11.72 for 6500 gns. ($16,380)

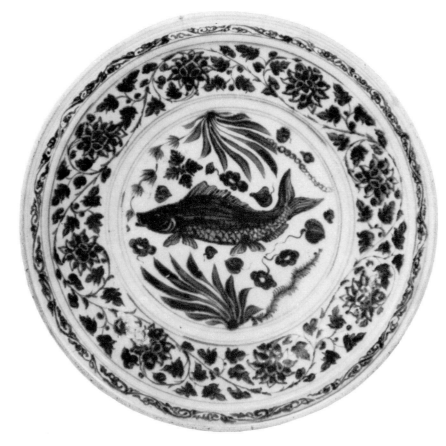

Annamese blue and white shallow
circular dish
15 in. (38 cm.) diam.
14th century
Sold 23.7.73 for 2200 gns. ($5775)

Superb glazed figure
of a mounted
drummer
T'ang dynasty
16¼ in. (41 cm.)
high, 14¾ in.
(37.5 cm.) long
Sold 4.6.73 for
45,000 gns.
($118,125)

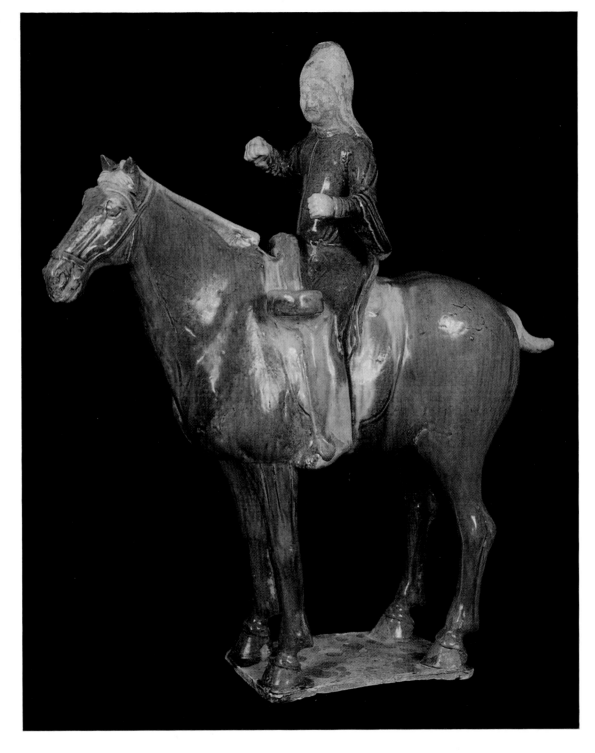

Renewed interest in Chinese art

JAMES SPENCER

Since the discovery of China by Europeans, interest in Chinese art and ceramics has rarely been negligible here, but it has had its peaks and troughs. For instance, it is doubtful if the extraordinary £5900 paid in 1905 for a K'ang Hsi blue and white 'hawthorn' jar would be exceeded today. However, the last few years have seen new levels of interest and price throughout the entire field of Chinese art. In spite of many cautious predictions, this season saw the pace of competition accelerate. The 45,000 guineas ($118,125) paid for a T'ang dynasty mounted drummer (see illustration page 335) on 4th June was partly attributable to the brilliance of its green and ochre glazes and perhaps the popularity of a drummer but it does reflect a greater appreciation of T'ang funerary pottery in general.

The greater knowledge of Ming porcelain which has been gained this century has engendered a particular keeness for it. The fact that China alone knew the 'secret' of porcelain manufacture at this time is in itself stimulating and the same sale saw 65,000 guineas ($170,625) paid for a 15th-century blue and white mei p'ing (blossom vase, see illustration page 338) and 70,000 guineas ($183,750) for a square jar decorated in colours with dragons (see illustration opposite) and bearing the reign mark of Chia Ching (1522–66). An early Ming (Yung Lo period 1403–24) blue and white saucer dish painted with lotus (see illustration page 333) brought 15,000 guineas ($39,375) but perhaps more surprising was the 3800 guineas ($9975) paid for a Ch'ien Lung (1736–95) yellow ground dish painted with a copy of this lotus design. This latter dish was part of the Lorant Goldschlager collection from Monte Carlo. This collection, mostly Ch'ing dynasty (1644–1912) monochromes, emphasized that appreciation of the rather restrained and formal wares of the Ch'ing era has recovered from its overshadowing by the freer and more original products of the Ming period.

No lesser increase in activity was seen in Chinese Export wares for the European market. On 26th February a pair of cocker spaniels fetched 4800 guineas ($12,000) and on 11th June a smaller, but particularly attractive pair of dogs (see illustration page 342) brought 7000 guineas ($18,375). Whereas much of the activity in earlier ceramics can be ascribed to worldwide interest, particularly in Japan and America, the demand for Export porcelain still comes mainly from Europe and both pairs of dogs were bought by an English dealer.

336

Rare Ming Wu
Ts'ai square
baluster jar
Chia Ching six
character mark
within a rough
double square, and
of the period
$7\frac{1}{2}$ in. (19 cm.) high
Sold 4.6.73 for
70,000 gns.
($183,750)

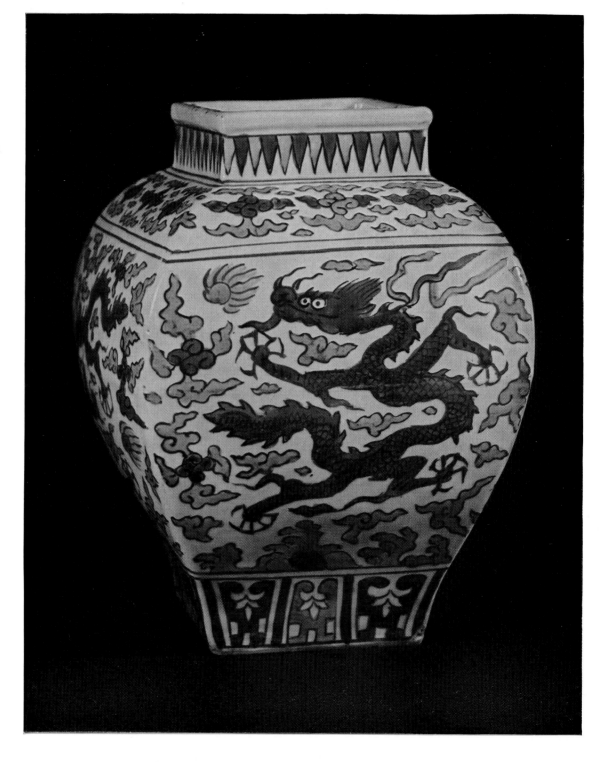

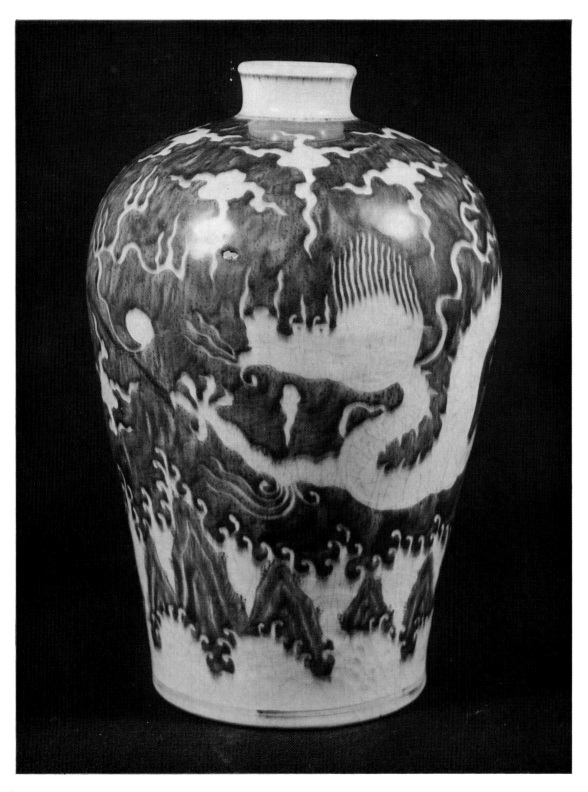

Important 15th
century mei p'ing
Hung Chih
14¾ in. (37.5 cm.)
high
Sold 4.6.73 for
65,000 gns.
($170,625)

From the collection of Mr Lorant Goldschlager of Monte Carlo

Left: Rare lemon yellow bowl
Ch'ien Lung seal mark in blue and of the period
$4\frac{5}{8}$ in. (11.75 cm.) diam.
Sold 4.6.73 for 4200 gns. ($11,025)

Centre: One of a pair of imperial yellow saucer-dishes
Yung Chêng six character marks in blue within double circles and of the period
$6\frac{1}{8}$ in. (15 cm.) diam.
Sold 4.6.73 for 7500 gns. ($19,687)

Right: One of a pair of circular bowls
Ch'ien Lung seal marks in blue and of the period
$5\frac{1}{4}$ in. (13 cm.) diam.
Sold 4.6.73 for 3000 gns. ($7875)

The upsurge of interest in all things Chinese has extended right down to the most common-or-garden objects. Much 19th-century blue and white porcelain and famille rose which was unsaleable three years ago is now in demand. Perhaps this high level of interest is due to the warmer diplomatic relations with China which have allowed the Chinese exhibition to come to London this autumn, but more fundamentally it is a widening of horizons in what has traditionally been a small world of collectors.

Important pair of
massive famille rose
hexagonal beaker vases
Chia Ch'ing
62 in. (157.5 cm.) high
Sold 11.6.73 for
15,000 gns. ($39,375)

Pair of blue and white triple-
gourd shaped vases
K'ang Hsi
29 in. (73.5 cm.) high
Sold 16.7.73 for 9500 gns.
($24,937)
From the collection of the
Duke of Buccleuch, KT

Pair of small brown Compagnie des
Indes figures of hounds
Ch'ien Lung
6¼ in. (16 cm.) high
Sold 11.6.73 for 7000 gns. ($18,375)
From the collection of the late
Mrs Kitchener

Large rectangular cloisonné enamel panel
16 × 24 in. (41 × 61 cm.)
17th century
Sold 26.3.73 for 4000 gns. ($10,080)

Early Ming blue and white
shallow circular dice bowl
11 in. (28 cm.) diam.
Hsüan Tê six character mark
Sold 20.11.72 for 15,000 gns.
($37,800)

Centre: One of a pair of small
famille rose bowls
5 in. (13 cm.) diam.
Yung Chêng six character
mark
Sold 26.2.73 for 5000 gns.
($12,600)

Bottom right and left:
Pair of fine small saucer-dishes covered in
pale aubergine glazes
Yung Chêng six character mark
4½ in. (11.5 cm.) diam.
Sold 4.6.73 for 10,000 gns. ($26,250)

Bottom centre:
Rare circular bowl covered in a pale
café-au-lait glaze
Yung Chêng six character mark
4¾ in. (12 cm.) diam.
Sold 4.6.73 for 2600 gns. ($6825)

From the collection of Mr Lorant
Goldschlager of Monte Carlo

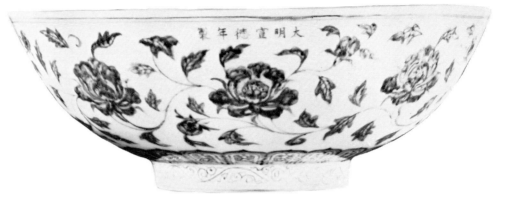

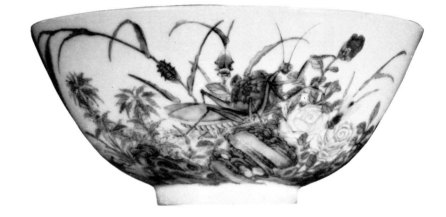

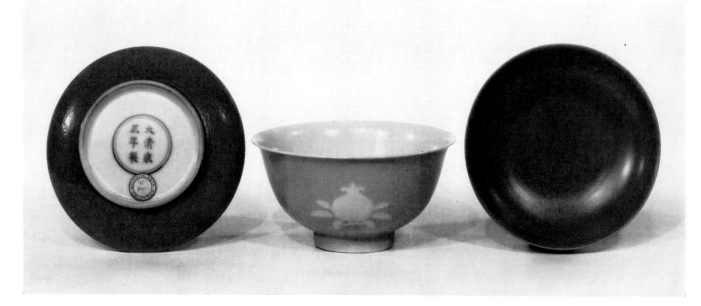

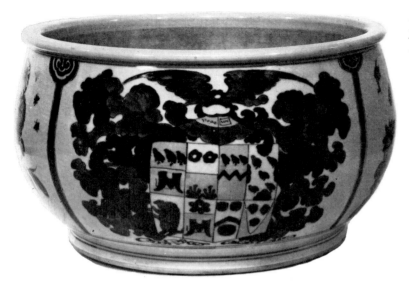

Left: One of a pair of large blue and white armorial jardinières from what is believed to be the earliest armorial service for the British market
K'ang Hsi, c. 1693–98
13½ in. (34.5 cm.) diam.
Sold 16.7.73 for 1800 gns. ($4725)
From the collection of the Duke of Buccleuch, KT

Below: Pair of rare shell sauce tureens, covers and stands with matching spoons
The stands 9 in. (23 cm.) wide
Ch'ien Lung
Sold 26.2.73 for 4200 gns. ($10,584)

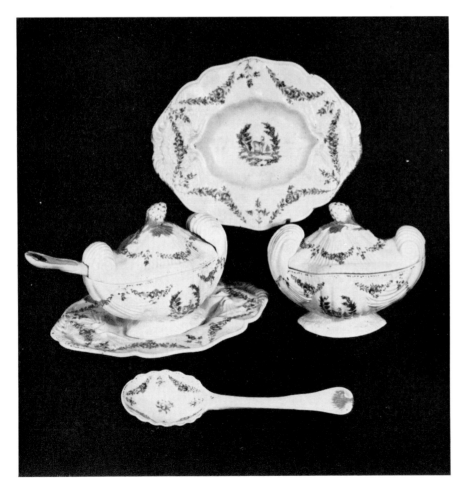

Opposite:

Top left: Pale celadon jade cylindrical brush-pot
5½ in. (14 cm.) high, 5¼ in. (13.5 cm.) diam.
Sold 16.4.73 for 6000 gns. ($15,120)

Top right: Spinach green jade rectangular table screen
K'ang Hsi
7½ in. (19 cm.) wide, 10 in. (25.5 cm.) high
Sold 4.6.73 for 6800 gns. ($17,850)

Bottom: Pale celadon jade shallow circular bowl
7½ in. (19 cm.) diam.
Ch'ien Lung
Sold 7.2.73 for 7000 gns. ($17,640)

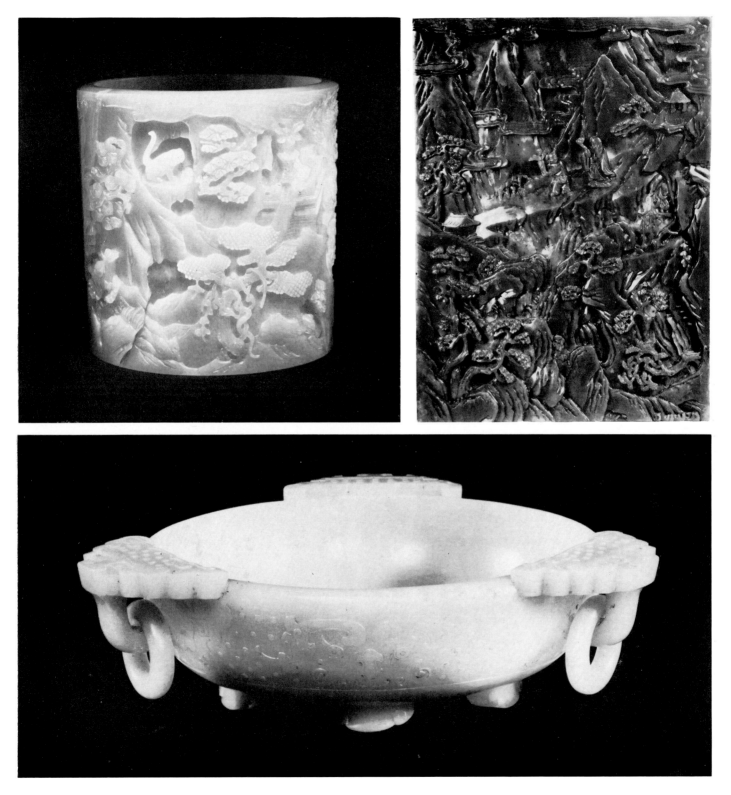

Chinese snuff bottles and brush pot

Centre: Opaque white
glass brush pot
3½ in. (8.5 cm.) high
Incised on the base with
a Ch'ien Lung mark
Sold 7.2.73 for 6200 gns.
($15,624)

JAPANESE, INDIAN,
NEPALESE, TIBETAN
AND MIDDLE
EASTERN WORKS
OF ART

Japanese works of art

Fine wood netsuke
carved as a rat
Signed Ikkan
Sold 8.5.73 for
1050 gns. ($2756)

Finely carved netsuke of
a seated rat eating a nut
Signed Tadakuni
Mid-19th century
Sold 10.10.72 for
500 gns. ($1260)

Wood netsuke carved
as a sleeping shojo
Signed Tadakuni
Sold 8.5.73 for
480 gns. ($1260)

Wood netsuke carved
as an owl
Signed Ikkyu
Sold 8.5.73 for
1500 gns. ($3937)

Below left:
Unusual two-case inro shaped as Mt. Fuji
Sold 9.4.73 for 2400 gns. ($6048)

Below right:
Three-case inro shaped as a water jar
Signed on the base Kajikawa, c. 1756 with an
ivory netsuke signed Kosaku
Sold 9.4.73 for 1300 gns. ($3276)

Below left: Three-case inro
Signed Koma Kyoryu, late 18th century with ivory
netsuke signed Homin
Sold 8.5.73 for 880 gns. ($2310)

Below right: Three-case inro
Signed Kwanshosai, with ivory netsuke signed
Gyokuzan
Sold 8.5.73 for 650 gns. ($1706)

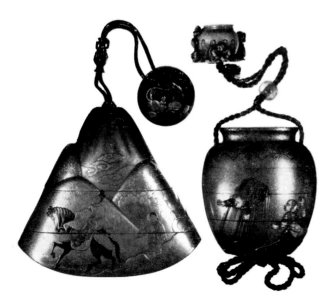

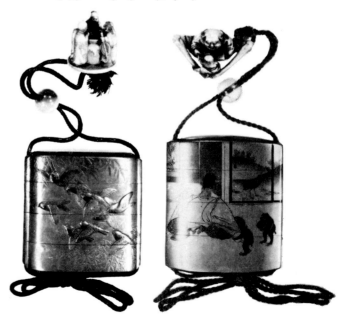

Rectangular cabinet
19th century
$4\frac{3}{4} \times 3\frac{1}{4} \times 4$ in. ($12 \times 8.5 \times 10$ cm.)
Sold 8.5.73 for 2300 gns. ($6037)

Fine two-leaf screen painted in colours
on a gold ground, unsigned, early
Ukiyo-e School, Genroku period
Each leaf $42\frac{1}{2} \times 37$ in. (108×94 cm.)
Sold 30.1.73 for 4000 gns. ($10,010)

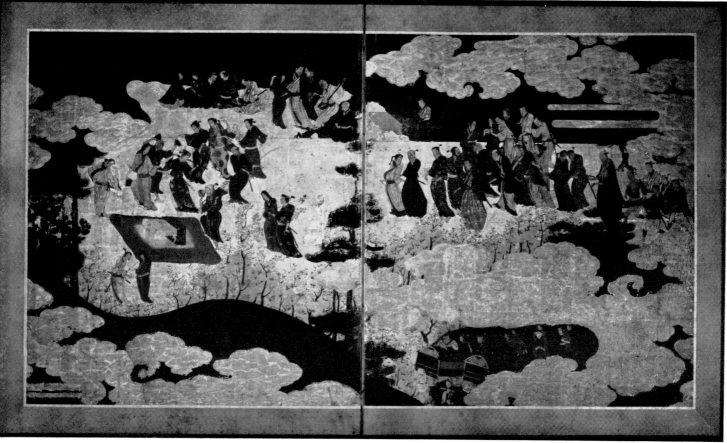

349

Fine kabuto
Signed Satome Iyenaga, 17th century
Sold 9.4.73 for 780 gns. ($1966)

Namban-kabuto
Unsigned, the morion c. 1580
The Japanese mounting later, probably Haruta work
Sold 10.10.72 for 650 gns. ($1638)

Fine shakudo kozuka enamelled in colours and inlaid in metals with the moon rising from behind Mount Fuji
Unsigned, Hirata School
Sold 9.4.73 for 1200 gns. ($3024)

Important lacquer
chest of arrows
$39 \times 14 \times 10\frac{1}{2}$ in.
$(99 \times 35.5 \times 26.5$ cm.)
Sold 13.3.73 for
2800 gns. ($7056)
From the late
Raymond Johnes
Collection

Superb set of
sword-fittings
comprising tsuba,
kogai and lozuka
Signed Ishiguro
Masayoshi (Ishiguro
School 1781–1851)
Sold 9.4.73 for
2600 gns. ($7552)

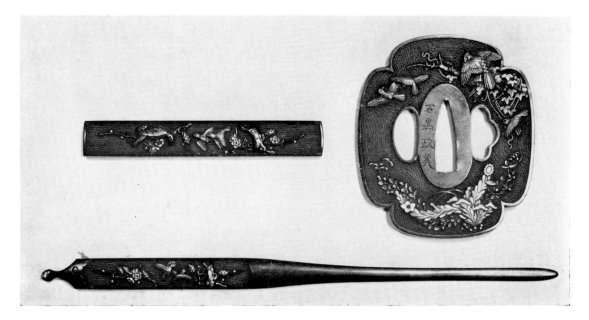

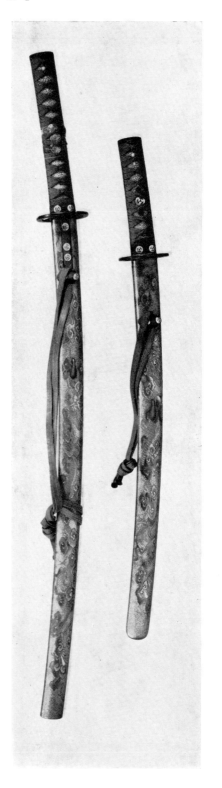

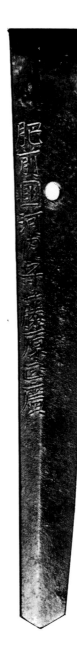

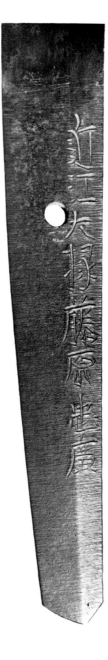

Very fine daisho, the katana blade signed Hizen Kuni Kawachi no kami
Fujiwara Masahiro, mid-17th century
27¾ in. (70.5 cm.) long
The wakizashi blade signed Omi no daijo Fujiwara Tadahiro and dated
Tenwa ninen (1682)
20½ in. (52 cm.) long
Sold 9.4.73 for 8000 gns. ($20,160)

Near right: Arita baluster
jar decorated in
polychrome enamels and
underglaze blue
17th century
16 in. (40.5 cm.) high
Sold 27.2.73 for
2200 gns. ($5544)

Far right: Arita pear-
shaped vase
Late 17th century
18½ in. (47 cm.) high
Sold 25.6.73 for
1300 gns. ($3412)

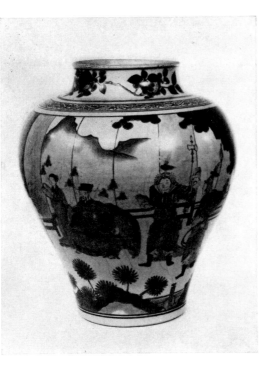

Near right: One of a pair
of large Imari circular
dishes
Late 17th century
22 in. (56 cm.) diam.
Sold 25.6.73 for
1900 gns. ($4987)

Far right: One of a pair
of octagonal Imari jars
and domed covers
Late 17th century
28 in. (71 cm.) high
Sold 25.6.73 for
3600 gns. ($9450)
From the collection of
A. Shawyer, Esq

Left: Arita pear-shaped vase enamelled in the
Kakiemon style
17th century
8½ in. (21.5 cm.) high
Sold 25.6.73 for 8200 gns. ($21,525)

The use of enamelled colours on Japanese porcelain was
first introduced in the middle of the 17th century by the
Kakiemon family. The distinctive palette of clear turquoise
blue, yellow, orange, red and sometimes aubergine, was
delicately applied in the manner of watercolours on a white
body in simple free designs identifiable by their use of space.
Perhaps Kakiemon porcelain had more influence on 18th-
century European porcelain than any other Oriental ceramic
group. The famous designs of 'quail and millett' and 'Hob-
in-the-Well' were freely employed by Meissen, Chelsea, Bow
and many other factories all over Europe

Right: Important Tibetan
mandala
Inscribed on the reverse
19th century
$56\frac{3}{4} \times 37\frac{1}{2}$ in. (144 × 95 cm.)
Sold 19.6.73 for 3600 gns.
($9450)
From the collection of John
Dugger, Esq and David
Medalla, Esq

Opposite bottom:
Left: Kakiemon octagonal dish
17th century
$9\frac{1}{2}$ in. (24 cm.) diam.
Sold 25.6.73 for 4000 gns.
($10,500)

Centre: Kakiemon cylindrical
incense-burner and cover
17th century
$4\frac{1}{2}$ in. (11.5 cm.) high
Sold 25.6.73 for 1600 gns.
($4200)

Right: Kakiemon octagonal
dish
17th century
$9\frac{1}{2}$ in. (24 cm.) diam.
Sold 25.6.73 for 2800 gns.
($7350)

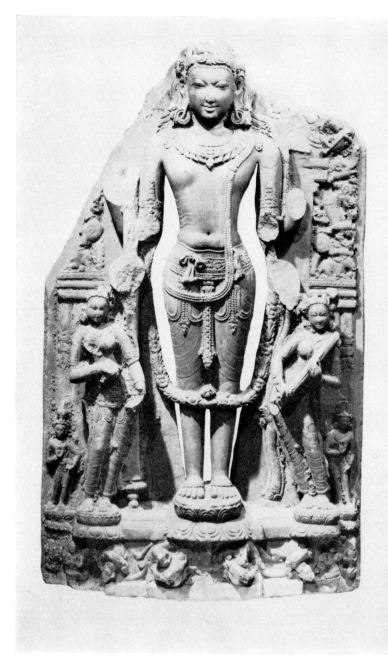

Black stone stele carved with a central figure of Visnu
10th century
41½ in. (105.5 cm.) high
Sold 19.3.73 for 2000 gns. ($5040)

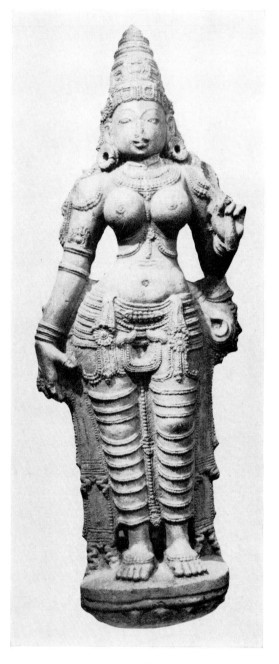

Grey granite figure of a Devi
13th century
48 in. (122 cm.) high
Sold 19.3.73 for 2200 gns. ($5544)

Important Nepalese
gilt copper figure of
Gautama
14th century
23 in. (58.5 cm.) high
Sold 19.6.73 for
24,000 gns. ($63,000)

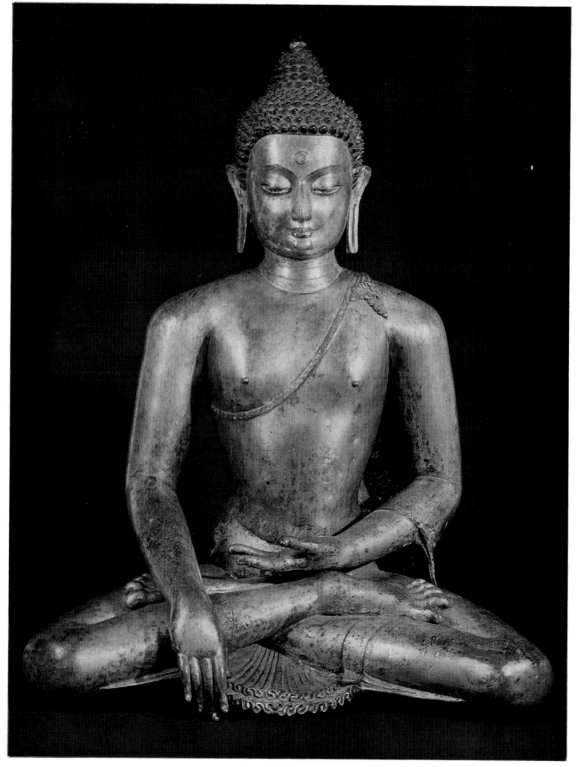

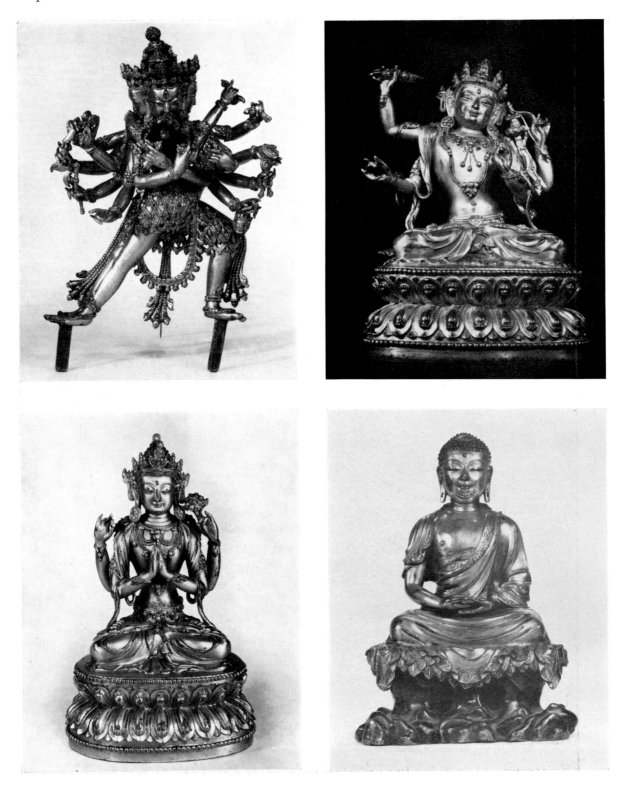

Opposite:
Top left: Nepalese gilt bronze group of Samvara
15th century
11 in. (28 cm.) high
Sold 19.6.73 for
4200 gns. ($10,775)
From the collection of
Madame M. de Huberty

Top right: Chinese gilt bronze figure of Vajranangamanjughosa with a Yung Lo six character mark and of the period 1403–1424
5¾ in. (14.5 cm.) high
Sold 19.6.73 for
3600 gns. ($9450)

Bottom left: Fine Chinese gilt bronze figure of Sadaksari
With Yung Lo six character mark and of the period 1403–1424
6 in. (15 cm.) high
Sold 31.10.72 for
2600 gns. ($7552)
From the collection of Monsieur and Madame Raymond Ducas

Bottom right: Important Chinese gilt bronze figure of Gautama
14th century
8 in. (20 cm.) high
Sold 31.10.72 for
6800 gns. ($17,136)
From the collection of Monsieur and Madame Raymond Ducas

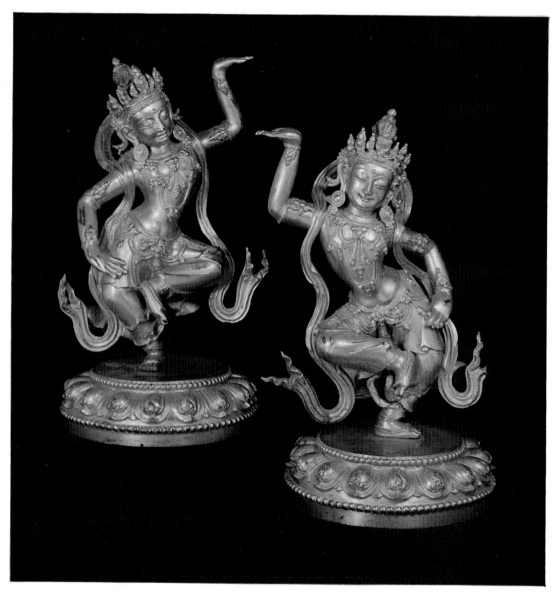

Important pair of Chinese gilt bronze figures of Bodhisattvas
10½ in. (26.5 cm.) high
Incised with six character dedicatory Hsüan Tê marks, early 15th century
Sold 13.10.72 for 6200 gns. ($15,624)
Fom the collection of Monsieur and Madame Raymond Ducas

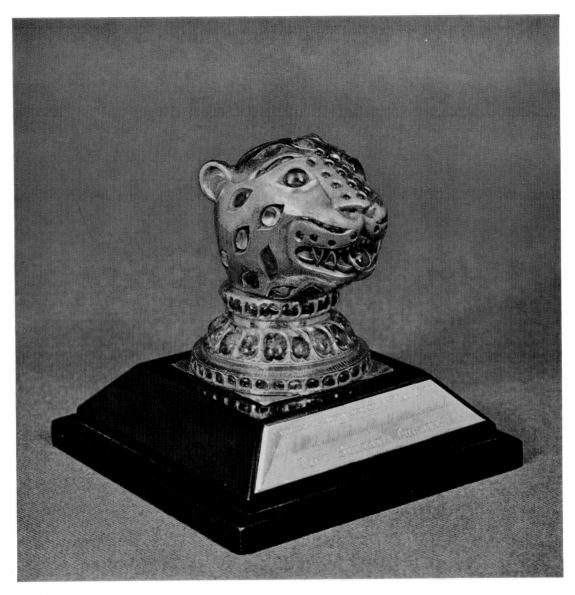

Gold head of a tiger from the throne of Tipu Sultan
Inset with rubies, emeralds and diamonds
$2\frac{5}{8}$ in. (6.7 cm.) high
1786
Sold 19.3.73 for 14,000 gns. ($35,280)
From the collection of Alex Bowlby, Esq

The golden tiger head of Tipu Sultan

Tipu, the eccentric ruler of Mysore in the late 18th century, and sworn enemy of the British, was obsessed by tigers. His throne was mounted with eight magnificent gold-and-jewel-encrusted tiger heads, all his weapons and clothing bore the striped markings of the tiger and the name Tipu is Canarese for Tiger. Like his famous father, Haidar Ali, he was constantly at war with the British, and he was eventually killed by the British at the fall of Seringapatam in 1799, but not before he had created a lasting monument to his eccentricity. Haidar Ali's chief adversary was Brigadier General Sir Hector Munro. After Tipu succeeded his father as Sultan, by chance Munro's son was serving as an officer in the British army nearby. One day, when on a picnic with a fellow officer, a tiger suddenly leapt out of the bushes, carried off the young Munro and killed him, much to Tipu's delight. To mark the event Tipu had an organ constructed (it is now in the Victoria & Albert Museum) in the form of a tiger devouring an army officer. When the organ handle is turned, it screams and growls. After the fall of Seringapatam, Tipu's palace was ransacked and his throne hacked to pieces. The fragments were to have been auctioned, but were saved from this fate by Lord Wellesley. He sent one tiger head to George III, one to his wife, and one to the wife of the Foreign Secretary. Another was acquired, together with a pair of gold-mounted tiger-decorated pistols, by Surgeon-Major Pultney Mein. They passed by descent to Mr Alex Bowlby, who sold both these rare and fascinating Tipu relics—at auction (see illustrations opposite and page 448).

Faces of the Masters

OLIVER HOARE

Portraiture is not an art-form which is generally associated with the Himalayas, and yet over the last year several bronzes have passed through our rooms which suggest that not enough attention has been given to this aspect. In those regions, the human form itself was often treated with extreme liberty in the representation of deities, proliferating heads, arms and legs, but it must be remembered that it was in these strange canons of proportion that it was possible, in human terms, to encode another reality beyond our own, to be experienced only with specialized meditative practices. To try and make an actual portrait of a divinity would be a contradiction in terms, but besides representing the 500 or so deities of Northern Buddhism, the Tibetan craftsmen also sought to portray people who had really lived; great saints who had progressed far along the path to Liberation.

As a general rule, one finds that the more important the historical figure, the less real his portrait, as if his proximity to divinity has erased the human element from his face as well as from his soul. This is understandable in the case of Buddha's immediate disciples, or of Nagarjuna, the great Buddhist philosopher of the 2nd century, or even of Padmasambhava, the Great Magician who formulated Lamaism in the 8th century, because their facial features are impenetrably shrouded in the mists of time. It is also true of Atisa, the Hindu priest who came to Tibet in 1040, of Milarepa, author of the 100,000 songs who lived in the 12th century, and of Tsong-kha-pa the great Reformer of the 14th century, who founded the Yellow Hat Sect, all within easy historical reach. Thus, to find portraits one must not look among the first rank of historical personages, but rather among the groups of monks, Lamas and ascetics, whose lesser achievement allowed them to retain their human identity. Among these groups one noticeable feature is that each group generally tends to have a certain physiognomical type, so that, for example, most Lamas will manifest a family resemblance to each other. Some bronzes, however, stand apart, and the three shown here are all examples.

The first (see illustration opposite) shows a Siddha (Master) whose name, Gom-ka, we know thanks to the inscription around the base. By the 6th century A.D. Buddhism had stagnated due to the institutionalization of its practice, and a reaction

362

Tibetan five-metal bronze portrait of the Siddha
Gom-ka
14th century
5⅛ in. (13 cm.) high
Sold 19.6.73 for 1800 gns. ($4725)

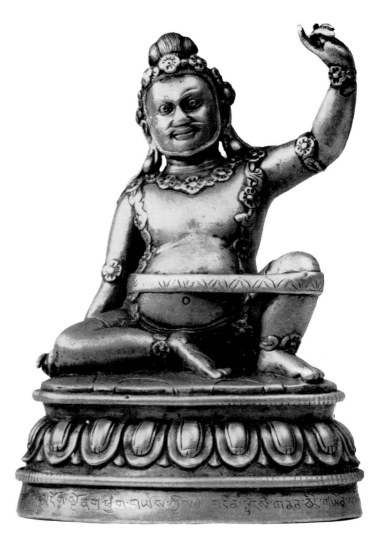

developed whereby individuals asserted that what counted was the experience, not ritual and dogma. In Japan this gave rise to Zen, and in Tibet it was the Siddhas who set the example. The 84 most celebrated of them were called the Mahasiddhas (Great Masters) living between the 8th and the 12th centuries whose deeds are recorded in texts. The most incredible powers were attributed to them, quite unacceptable to our 'reasonable' minds, but these stories were not intended either for belief or disbelief, because their meanings are on another level, carefully guarded symbols of inner experience. Gom-ka was not one of the 84 Mahasiddhas; in fact very little is known about him, and therefore one might speculate that the bronze, though not necessarily a contemporary portrait, was not made too long after his lifetime, before his fame diminished. If one looks into his face, there is the impression

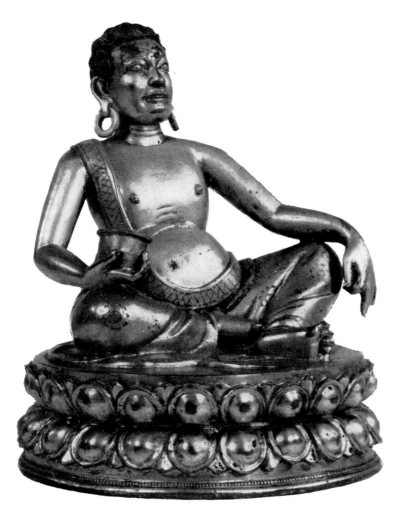

Important Tibetan gilt copper figure of a
Mahasiddha
5 in. (12.5 cm.) high
14th century
Sold 31.10.72 for 3000 gns. ($7560)
From the collection of Monsieur and Madame
Raymond Ducas

of a real human being, but it is difficult to distinguish under the disguise effected by
the conventions often used to portray Siddhas: the moustache and beard, and the
staring eyes, here dramatically intensified by silver inlay. Other features which are
typical of Siddhas are the long hair falling in tresses, the big belly symbolizing power
and especially the meditation strap used to maintain an exact pose during prolonged
meditations, and here relating his knee to his body in a sort of planetary simile.

The second remarkable bronze (above), from the Ducas Collection, is of an
unidentified Siddha showing many of Gom-ka's features – the powerful frame, the
meditation strap, this time slung over his shoulder; his face is undisguised, a clear
portrait of an individual, his almost negroid features exactly drawn, full of intelligence
and power. Even so, there is a certain idealization which speaks more of the man's
ideals than of the man himself.

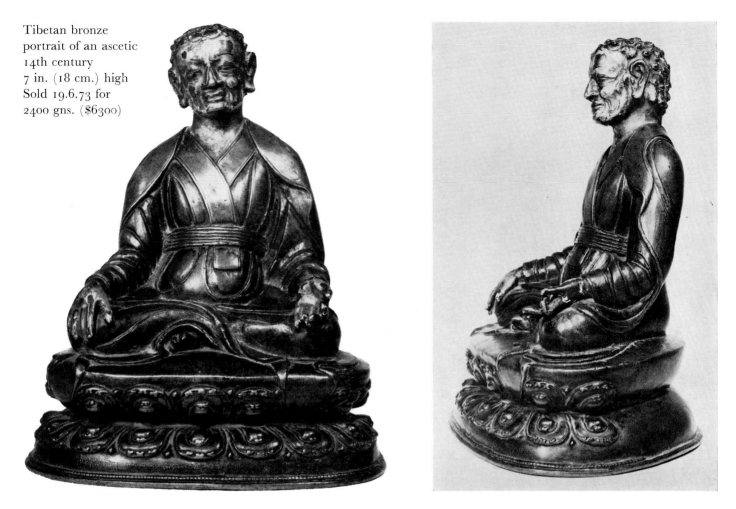

Tibetan bronze
portrait of an ascetic
14th century
7 in. (18 cm.) high
Sold 19.6.73 for
2400 gns. ($6300)

Perhaps no Tibetan bronze has ever portrayed more successfully the hardships and pains of perfecting the self than the third bronze shown here. The expression of this unknown ascetic is full of such indescribable sadness when seen from the front, while from the side a half-smile can be seen creasing his sunken cheeks. It is difficult to see how so much could be expressed unless it was taken from life. His face tells us as much as a complete documented life-history.

> May the sun, the moon and the multitude
> of stars fall on the ground,
> But I shall not die as I am now, an ordinary
> being.
>
> (Lalitavistara)

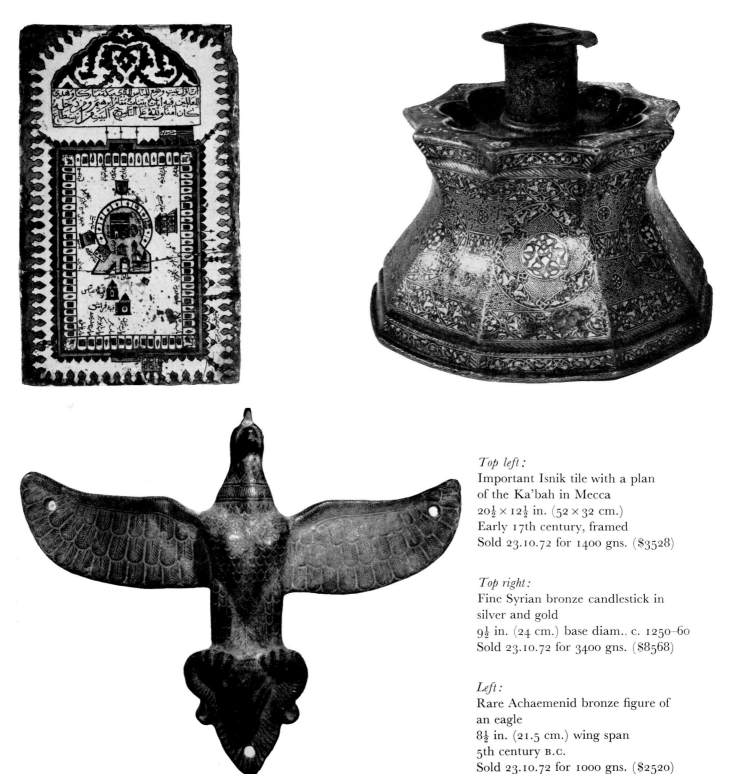

Top left:
Important Isnik tile with a plan
of the Ka'bah in Mecca
$20\frac{1}{2} \times 12\frac{1}{2}$ in. (52×32 cm.)
Early 17th century, framed
Sold 23.10.72 for 1400 gns. ($3528)

Top right:
Fine Syrian bronze candlestick in
silver and gold
$9\frac{1}{2}$ in. (24 cm.) base diam.. c. 1250–60
Sold 23.10.72 for 3400 gns. ($8568)

Left:
Rare Achaemenid bronze figure of
an eagle
$8\frac{1}{2}$ in. (21.5 cm.) wing span
5th century B.C.
Sold 23.10.72 for 1000 gns. ($2520)

FURNITURE,
WORKS OF ART,
TAPESTRIES, RUGS,
SCULPTURE,
MUSICAL INSTRUMENTS,
CLOCKS AND WATCHES

Rare George I
labelled bachelor's
chest by William Old
and John Ody at the
Castle in St Paul's
Churchyard
31 in. (79 cm.) wide
Sold 28.6.73 for
3600 gns. ($9450)

Late George III mahogany library-table
35¾ in. (91 cm.) wide
Sold 23.11.72 for 2300 gns. ($5796)

Mid-Georgian mahogany serpentine commode
in the style of Thomas Chippendale
41¼ in. (105 cm.) wide
Sold 10.5.73 for 7500 gns. ($19,687)

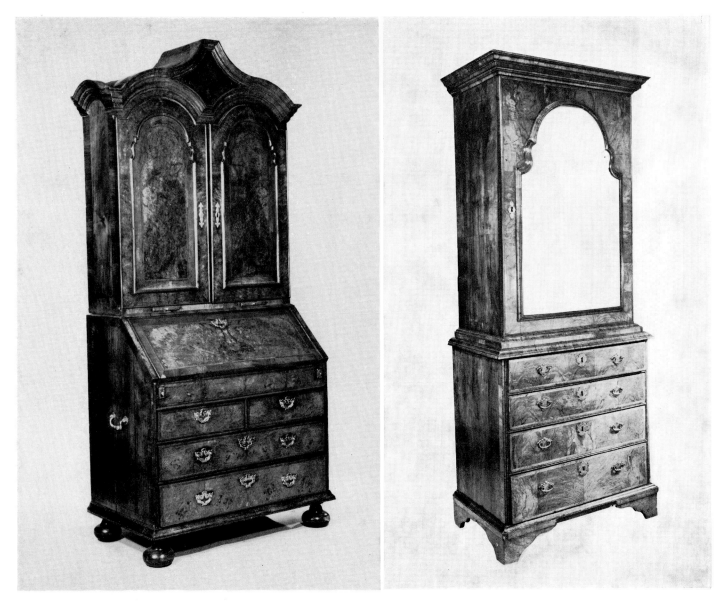

George I burr walnut bureau-cabinet
46 in. (117 cm.) wide, 96½ in. (245 cm.) high
Sold 23.11.72 for 3400 gns. ($8568)
From the collection of Mrs E. K. M. Bradley

George I walnut secretaire-chest in two parts
79 in. (200.5 cm.) high, 32¼ in. (82 cm.) wide
Sold 10.5.73 for 3500 gns. ($9187)
From the collection of the late Mrs C. J. Oldham

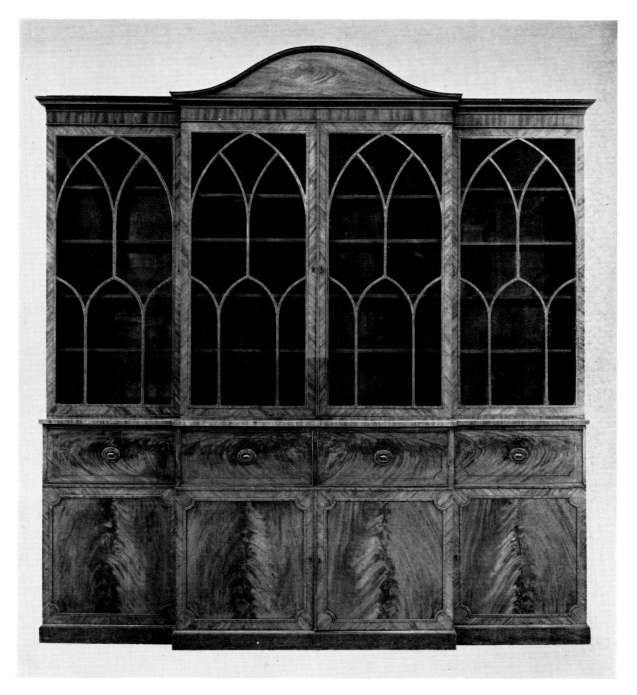

George III mahogany breakfront library bookcase
103½ in. (263 cm.) wide, 111 in. (282 cm.) high
Sold 5.10.72 for 5000 gns. ($12,600)

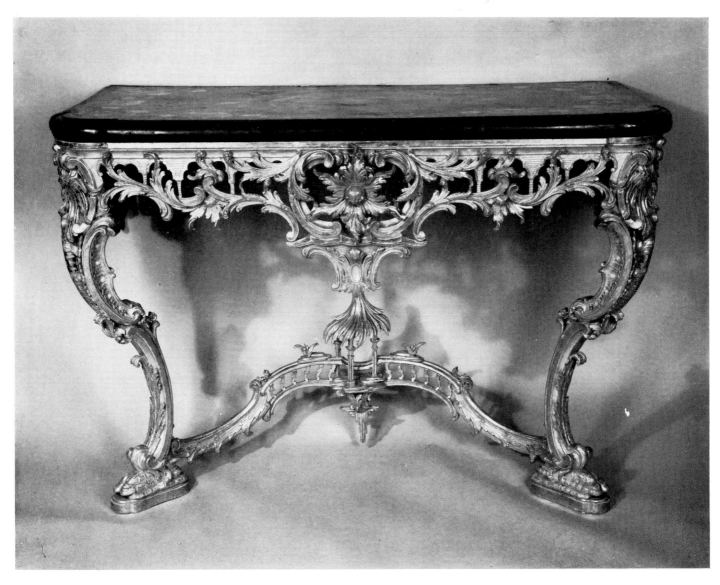

One of an important pair of late George II giltwood console tables with scagliola tops by Don Petro Belloni
54 in. (137.5 cm.) wide
Sold 10.5.73 for 11,000 gns. ($28,875)
Provenance: Ralph Howard, created Baron Clonmore 1776 and Viscount Wicklow 1785
Shelton Abbey, Co. Wicklow, Eire

One of an important pair
of George III giltwood
side tables attributed to
Gordon and Taitt
37¾ in. (96 cm.) wide
Sold 28.6.73 for
12,000 gns. ($31,500)
From the collection of
T. C. Harvey, Esq,
CVO, DSO

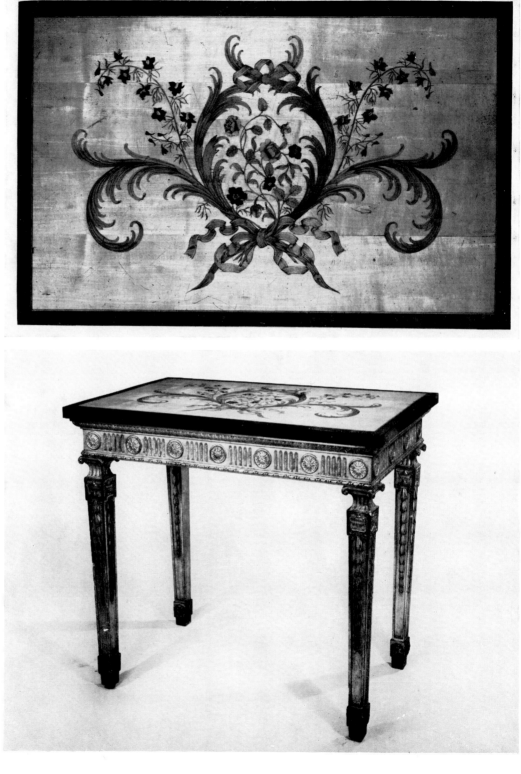

Above:
One of a set of three walnut and marquetry chairs
Anglo-Dutch, early 18th century
Sold 10.5.73 for 1450 gns. ($3806)

Top right: One of a set of eight George III painted armchairs
Sold 23.11.72 for 3600 gns. ($9072)
From the collection of Mrs David Constable Maxwell

Right: One of a set of eight George III mahogany armchairs
Sold 5.4.73 for 4200 gns. ($10,584)
From the collection of the late R. J. Bacchus-Goldie-Taubman

Queen Anne scarlet lacquer mirror on stand
65¾ in. (166.5 cm.) high, 23 in. (58.5 cm.) wide
Sold 28.6.73 for 8000 gns. ($21,000)
From the collection of The Lady Vansittart

Important William III giltwood pier glass in the
manner of John Pelletier
103 × 47 in. (262 × 119 cm.)
Sold 10.5.73 for 2400 gns. ($6300)
From the collection of Winnafreda, Countess
of Portarlington

Rococo classicism

As is often the case with English 18th-century furniture, the table (illustrated opposite) which was sold from the collection of Major A. F. Clarke-Jervoise entirely lacks documentation; it is only by tentative deduction from the evidence of provenance and style that a picture of its origins emerges.

The attribution to Thomas Chippendale, as has been underlined in a recent article (E. T. Joy and B. S. Kern, 'A Side Table by Thomas Chippendale', *The Antique Collector*, April/May 1973), rests on the striking congruity of style between this piece and a group of furniture which includes the celebrated 'Antique' commode supplied by Chippendale to Sir Rowland Winn of Nostell Priory in 1770. This group, which also includes a pair of side tables very similar to but smaller than the Clarke-Jervoise example (sold in 1968 from the Wrottesley Collection), shares a number of features, most obviously the type of marquetry: finely drawn flower sprays on a golden-coloured ground with narrow sinuous flowering branch borders, all four executed on similarly shaped tops. The Clarke-Jervoise table interestingly incorporates in the centre of the top a marquetry bird perched in a tree; this, it seems, is taken from a drawing in George Edwards, *The Natural History of Uncommon Birds*, 1743–51, a work used both by Samuel Dixon, maker of embossed bird pictures (see illustration page 395) and the Chelsea porcelain factory.

The gilt-metal angle and side mounts and, most strikingly, the unusual entrelac and cabochon border mounts are further common links in this group of sophisticated rococo furniture, but the pendant foliage mounts on the front of the Clarke-Jervoise table, one bearing an as yet unidentified cloverleaf (presumably maker's mark), strike a rather different note, giving this table its rather 'advanced' Neo-classical look. The introduction of Neo-classical or 'Antique' motifs is found on other pieces (for example the commode at Nostell mentioned above) made during this period when Chippendale was experimenting with a new style of design and decoration shortly to be mastered in his work at Harewood House in the mid-1770s.

Research into the provenance of this table (published by Joy and Kern, *op. cit.*) suggests a further tentative connection with the firm of Chippendale and provides a possible date of manufacture: the mason contractor working at the Clarke-Jervoise

Opposite: Important George III marquetry side-table Attributed to Thomas Chippendale 55 in. (140 cm.) wide, the top $52\frac{1}{2} \times 25\frac{1}{2}$ in. (133×65 cm.) Sold 23.11.72 for 16,500 gns. ($41,580) From the collection of Major A. F. Clarke-Jervoise, DL, JP

376

London house in Hanover Square in the early 1770s was the same John Devall employed by Sir Rowland Winn at Nostell Priory. That this table, as seems likely, should have been made to form part of the new decorations of a fashionable London house of the 1770s appears entirely apposite, and if so must be regarded as one of Chippendale's earliest ventures and grandest essays in the newly fashionable Neo-classic taste.

'Superb and Elegant Produce'

HUGH ROBERTS

The documentation of English 18th-century objects of art and furniture, by contrast with that of France, is astonishingly meagre, so it was an occasion of more than ordinary interest when the set of candelabra illustrated opposite, the property of the late 5th Duke of Sutherland, came to light in our sale of 23rd November. These candelabra, designed to burn incense in the central reservoirs, were ordered by the 2nd Earl Gower, father of the 1st Duke of Sutherland, on 28th March 1777, as a letter of 23rd April 1777 in the Boulton archives from John Hodges, Clerk of the Soho Manufactory, to Matthew Boulton records. The same letter indicates that Lord Gower was in a hurry: 'They must be sent in six weeks or sooner.' But despite this injunction, it was nearly seven months before they were delivered, on 23rd October, with a bill for £181 1s. 6d. and an endearingly guileless note declaring that the firm found themselves 'quite at a loss how to apologise for the length of time taken in compleating [sic] these vases'.

Several tripods of similar or identical design are in existence, the best known being the pair from Spencer House, dated c. 1760, recently exhibited in *The Age of Neo-Classicism* (Cat. no. 1657) at the Victoria & Albert Museum. Others were supplied to Kedleston Hall (c. 1759/60) and Wentworth Woodhouse.

The original designs have traditionally been attributed, mainly on the basis of drawings in the Soane Museum, to Robert Adam, and their manufacture, for want of an alternative, to Matthew Boulton. It is clear from a recent article (N. Goodison, 'Mr Stuart's Tripod', *Burlington Magazine*, October 1972) that the design must originate with James 'Athenian' Stuart, one of the earliest practitioners of the Neo-classical style, using as a basis his drawings of the Choragic Monument of Lysicrates, later to be incorporated in the first volume of Stuart and Revett's *Antiquities of Athens* (1762). Equally, it is clear that the group of tripods dating from the 1760s (e.g. at Kedleston and Spencer House) cannot have been made by Boulton, since the Boulton factory was not in a position to make this kind of object at least until 1768–9. Mr. Goodison suggests that the metal-worker Diederich Nicolaus Anderson (d. 1767) made the Curzon, Spencer and Rockingham tripods and that after his death Boulton acquired, probably from Anderson's widow, either the designs or an

One of an important set of four
documented ormolu combined
incense-burners and candelabra
by Matthew Boulton after a
design by James Stuart
26¾ in. (68 cm.) high
Sold 23.11.72 for 3800 gns. ($9576)
From the collection of the late
The Fifth Duke of Sutherland

actual tripod from which copies were made. These differ from Anderson's in some
details of construction and design as well as in the chasing (less crisp) and the gilding
(richer). The earliest mention of Boulton's own tripods seems to be in the sale of
'Superb and Elegant Produce of Mess. Boulton and Fothergill's Ormolu Manufactory'
held at Christie's on 11th April 1771 and two days following, where four are listed
and described as 'after a design of Mr Stuart's'. These were probably of the same
design as those long-awaited 'vases', ordered by Lord Gower six years later.

Marquetry cabinet-on-stand
Probably designed by Ernest
Gimson for Kenton & Co
39¾ in. (100 cm.) wide
Sold 14.12.72 for 1900 gns.
($4788)

Oak folding-top table
36 in. (91.5 cm.) wide
Second quarter 17th century
Sold 22.2.73 for 1550 gns. ($3906)
From the collection of The Hon Mrs E. V. Rhys

Northern Dutch oak cupboard in three parts
69 in. (175 cm.) wide, 87 in. (221 cm.) high
Mid-17th century
Sold 22.2.73 for 2000 gns. ($5040)

Dutch walnut and
marquetry armoire
104½ in. (265.5 cm.)
high, 78 in. (198 cm.)
wide, 18th century
Sold 5.7.73 for
4000 gns. ($10,500)
From the collection of
Mrs A. P. Drew

South German marquetry and
parquetry bureau-cabinet
58 in. (147 cm.) wide
86 in. (218 cm.) high
c. 1750
Sold 16.11.72 for
5600 gns. ($14,112)

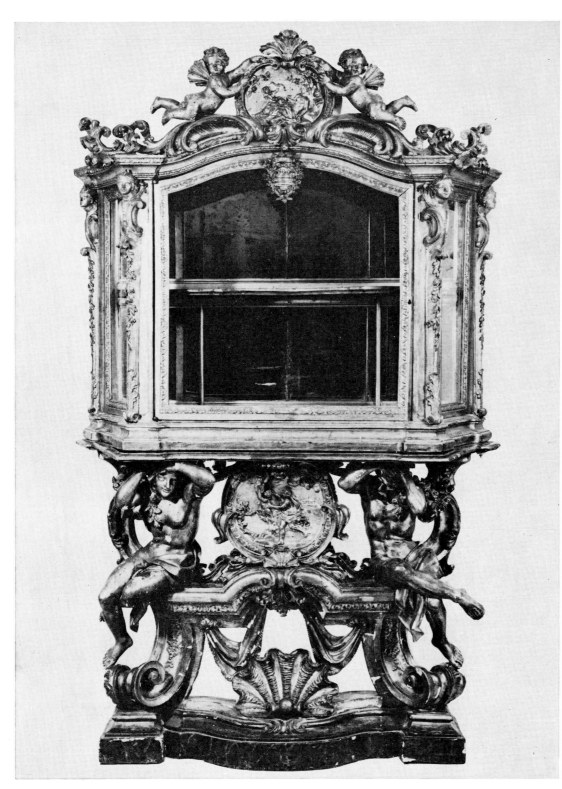

Important Roman
baroque giltwood
vitrine, second half
of 17th century
Sold 12.6.73 at the
Salone Margherita,
Rome, for £2614
(L. 4,000,000)

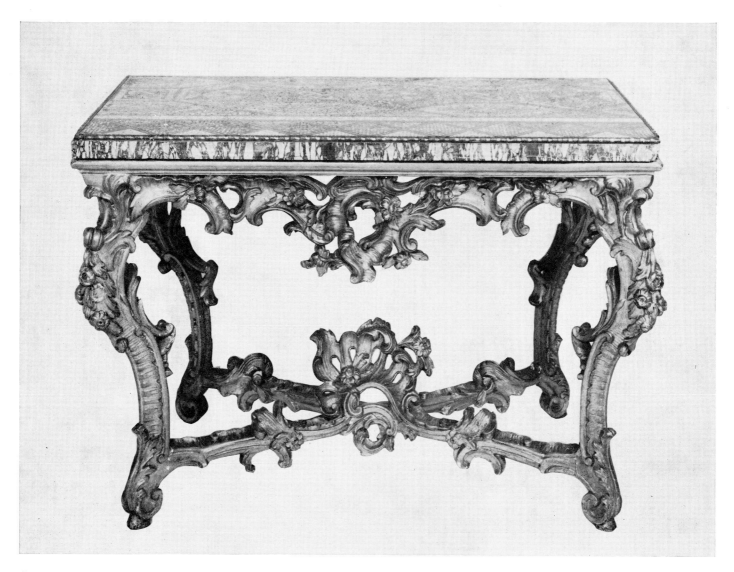

Important Roman giltwood console table, c. 1740, the mosaic 2nd/3rd century A.D.
Sold 12.6.73 at the Salone Margherita, Rome, for £2614 (L. 4,000,000)
From the collection of the Duchessa della Grazia

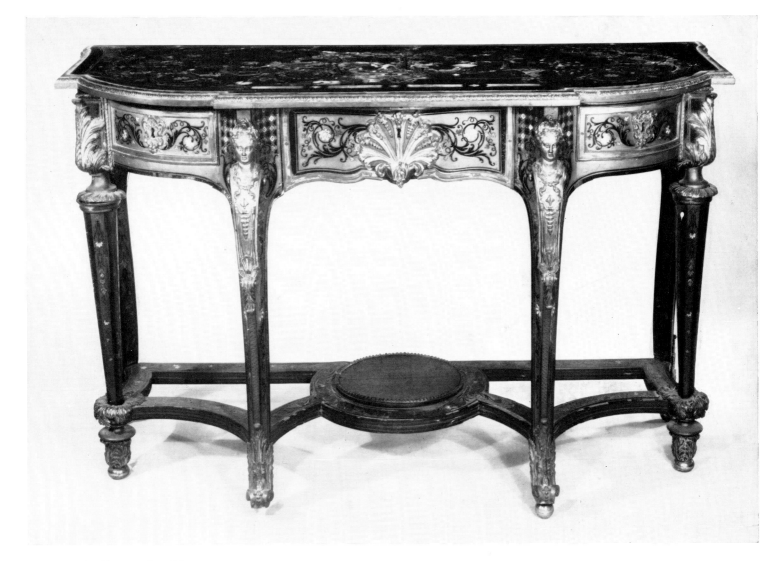

Régence Boulle console-table
52 in. (132 cm.) wide
Sold 30.11.72 for 16,000 gns. ($40,320)
From the collection of the Hon Lady Salmond

Important Louis XV
ormolu mounted black and gold
lacquer commode
By Jacques Dubois
44½ in. (113 cm.) wide
Stamped I. Dubois
Sold 12.4.73 for 23,000 gns.
($57,960)

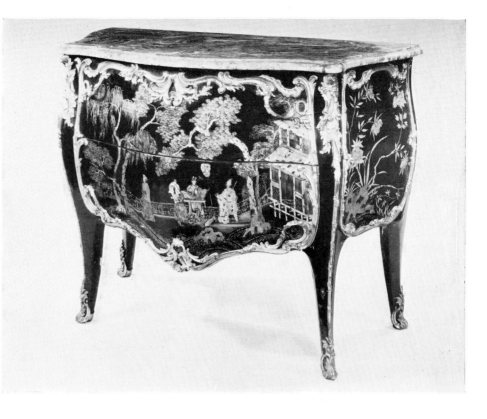

Early Louis XV kingwood
commode
63½ in. (161 cm.) wide
Sold 12.4.73 for 8000 gns.
($20,160)

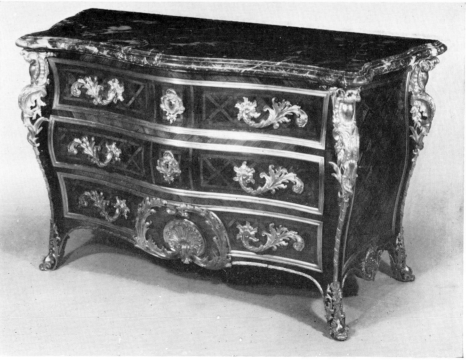

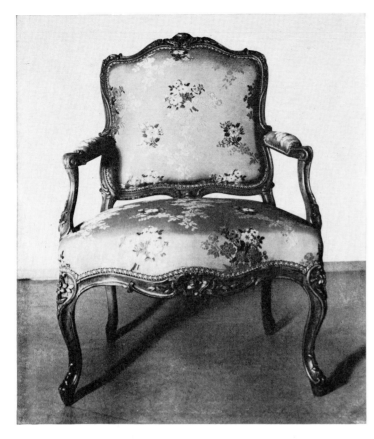

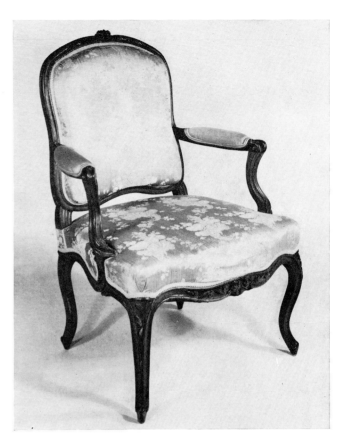

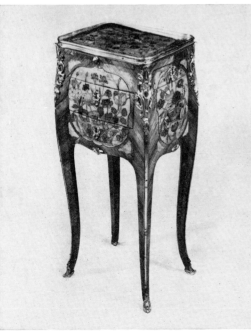

Top left:
One of an important set of six Louis XV beechwood fauteuils
à la reine and a canapé
By J. Gourdin, stamped I. Gourdin
The canapé 85 in. (216 cm.) wide
Sold 8.5.73 at the Hôtel Richemond, Geneva, for £13,750
(Sw. fr. 110,000)

Top right:
One of a Louis XV walnut suite by F. Geny, comprising twelve
fauteuils and a canapé
The canapé 78¾ in. (200 cm.) wide, each chair stamped F. Geny
Sold 5.7.73 for 6000 gns. ($15,750)

Left: Louis XV marquetry chiffonier
11¾ in. (30 cm.) wide
Sold 30.11.72 for 5200 gns. ($13,104)

Important Louis XVI
marquetry bonheur du jour
in the style of R.V.L.C.
26 in. (56 cm.) wide, 39½ in.
(100.5 cm.) high
Sold 8.5.73 at the Hôtel
Richemond, Geneva, for
£9375 (Sw. fr. 75,000)

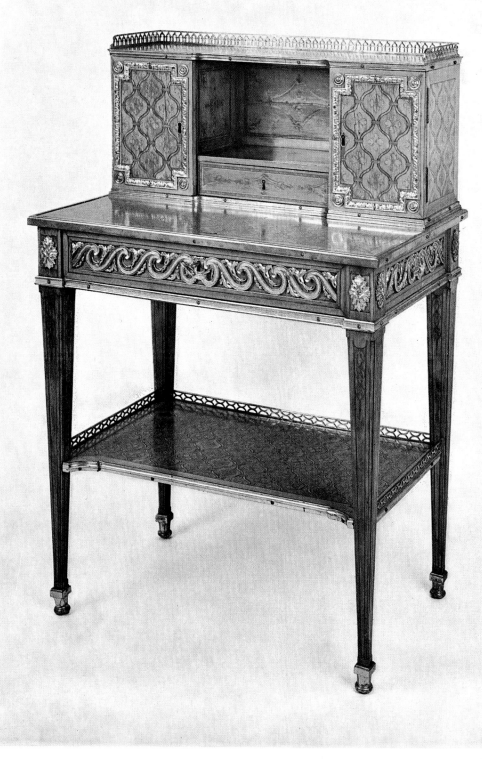

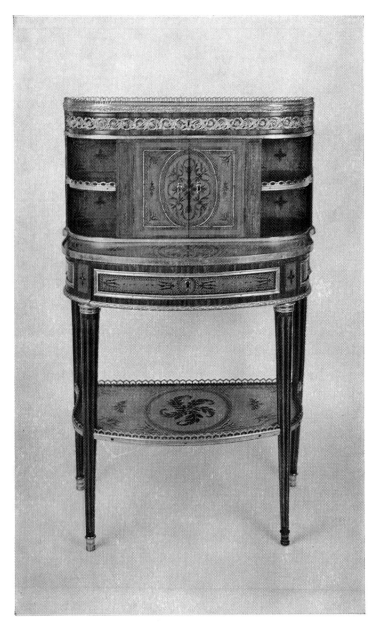

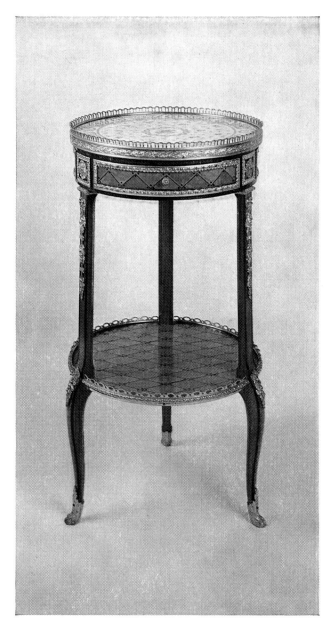

Important Louis XVI marquetry bonheur du jour
By R.V.L.C. from the Palace of Pavlovsk
27 in. (68.5 cm.) wide, 42½ in. (108 cm.) high, stamped
R. Lacroix JME
Sold 8.5.73 at the Hôtel Richemond, Geneva, for £25,000
(Sw. fr. 200,000)

Highly important ormolu and Sèvres-mounted
guéridon
By M. Carlin from the Palace of Pavlovsk
14¾ in. (37.5 cm.) diam., 29½ in. (75 cm.) high
Stamped M. Carlin JME
Sold 8.5.73 at the Hôtel Richemond, Geneva, for
£37,500 (Sw. fr. 300,000)

Above:
One of a set of four Louis XVI ormolu wall lights
28¾ in. (73 cm.) high
Sold 8.5.73 at the Hôtel Richemond, Geneva, for
£6000 (Sw. fr. 48,000)

Top right:
One of a pair of Louis XVI ormolu wall lights
28 in. (71 cm.) high
Sold 8.5.73 at the Hôtel Richemond, Geneva, for
£2875 (Sw. fr. 23,000)

Right:
Important pair of ormolu-mounted Chinese porcelain
vases, decorated in famille rose enamels
47 in. (119.5 cm.) high, the porcelain Tao Kuang, the
ormolu second quarter 19th century
Sold 5.7.73 for 3200 gns. ($8400)
From the collection of the Duke of Buccleuch, KT

Augsburg ebony house altar of architectural form
24½ in. (62.2 cm.) high, c. 1600
Sold 10.7.73 for 14,000 gns. ($36,750)

Large Italian bronze brazier
26 in. (66 cm.) diam., probably Venetian, late 16th/
early 17th century
Sold 8.5.73 at the Hôtel Richemond, Geneva, for £2000
(Sw. fr. 16,000)

Important Limoges enamel plate
By Jean Courtois, 1553
9⅛ in. (23 cm.) diam., inscribed in the
centre Par I. Covrtois Limoges 1553
Sold 10.7.73 for 1600 gns. ($4200)

Below:
Florentine polychrome stucco relief of the
Virgin and Child, after Benedetto da Majano
The relief 25 × 16¾ in. (63.5 × 42.5 cm.), the
case 39 in. (99 cm.) wide when open
Sold 10.7.73 for 1700 gns. ($4462)

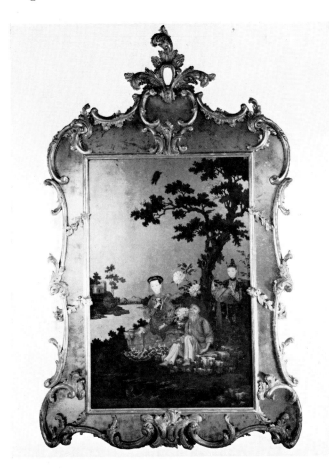

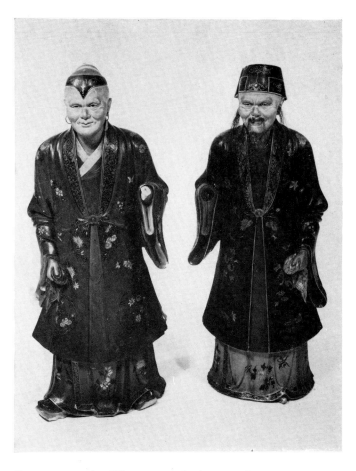

Early George III giltwood mirror
59½ × 38 in. (151 × 96.5 cm.)
Sold 23.11.72 for 9800 gns. ($24,696)
From the collection of Major Dermot Daly
Removed from Little Compton Manor,
Moreton-in-Marsh

Important pair of Regency polychrome plaster
chinoiserie figures
28 in. (71 cm.) high
Sold 28.6.73 for 2500 gns. ($6562)
From the collection of the Duke of Buccleuch, KT

Above: White marble profile portrait of Sir John Everett Millais as a young man by Alexander Munro
$26 \times 21\frac{3}{4}$ in. $(66 \times 55.5$ cm.$)$
Signed with a monogram
Sold 14.6.73 for 1600 gns. ($4200)
From the collection of Sir Ralph Millais, Bt.

Embossed bird and flower pictures by Samuel Dixon

Top left: Polyanthus, sweet peas and convolvulus
$9 \times 7\frac{1}{4}$ in. $(23 \times 18.5$ cm.$)$
Sold 10.5.73 for 1300 gns. ($3412)

Bottom left: Black-headed Indian icterus
$10\frac{1}{4} \times 9$ in. $(27.5 \times 23$ cm.$)$, labelled
Sold 10.5.73 for 1300 gns. ($3412)
From the collection of the late Cicely, Marchioness of Zetland

395

One of an important set of four Beauvais tapestries
By Besnier and J. B. Oudry after cartoons by Boucher
137 × 120 in. (349 × 304 cm.)
Sold 8.5.73 at the Hôtel Richemond, Geneva, for £12,500 (Sw. fr. 100,000)

One of a set of three
Gobelins tapestries
from the Portières
des Dieux series
By Jacques Neilson
after the designs of
Claude Audran, 1776
Approx. 140 × 108 in.
(356 × 274 cm.)
Signed and dated
Sold 8.5.73 at the
Hôtel Richemond,
Geneva, for £15,000
(Sw. fr. 120,000)

One of a pair of fine Kashan silk rugs
80 × 51 in. (203 × 130 cm.)
Sold 28.6.73 for 4500 gns. ($11,812)

Antique Kashan silk rug
83 × 51 in. (210 × 130 cm.)
Sold 5.7.73 for 3000 gns. ($7875)
From the collection of Major E. R. W. Robinson

Fine antique Samarkand saph
177 × 44 in. (450 × 112 cm.)
Sold 30.11.72 for 2500 gns. ($7300)

Rare dragon silk kilim somac
148 × 76 in. (376 × 193 cm.)
Sold 5.7.73 for 3800 gns. ($9975)

Earthly treasure

The sale of the mediaeval gilt-bronze figure of St John (see illustration opposite) at £36,750 ($88,200) established a record price for a bronze statuette, bringing unexpected fame and fortune to its owner, Mr Arthur Davey, a farm worker of Rattlesden, Suffolk. He had dug it up not long before while hoeing sugar beet and for several months it had been a plaything for his small son who at one stage almost 'swapped' it for a toy car. Later the statuette was handed over to Col. John Freeman, a local landowner who also owned an antique furniture business in Chelsea, to bring to London for an opinion. It was one of those rare moments an auctioneer dreams of when Col. Freeman rather diffidently produced the small parcel containing the statuette one afternoon. The bronze, which depicts St John in an attitude of mourning, achieves an extraordinary intensity of expression in its height of less than four inches and shows in that achievement the highest technical skills. It would originally have formed part of a crucifix, being placed on a subsidiary arm of the Cross and balanced by a figure of the Virgin centred on the figure of Christ crucified. The fact that the village of Rattlesden is only 12 miles from Bury St Edmunds would point to a link with the great Abbey there, and it is tempting to imagine a thief in a procession of pilgrims wrenching the figure off, and perhaps discarding it later on realizing it was not gold, or through fear of discovery. Whether this theory is anywhere near the truth or not, anyone considering a visit to Rattlesden with a metal detector to search for the remaining parts of the crucifix can be saved the trouble; it was done well before the sale.

Gilt bronze figure of St John the Evangelist
c. 1200
$3\frac{3}{4}$ in. (9·5 cm.) high
Sold 5.12.72 for 35,000 gns. ($88,200)

Walnut group of the Virgin and Child
33½ in. (85 cm.) high
Probably lower Rhine, late 15th century
Sold 21.3.73 for 2400 gns. ($6048)
From the collection of
Boleyn Investments Ltd

Important French limestone female head supported by an angel
Bourbonnais, last quarter 15th century
10½ × 11 in. (26.6 × 28 cm.)
Sold 10.7.73 for 3000 gns. ($7875)

Copper-gilt statuette
of David
Germano-Italian,
c. 1600
7¾ in. (19.8 cm.) high
Sold 10.7.73 for
3600 gns. ($9450)

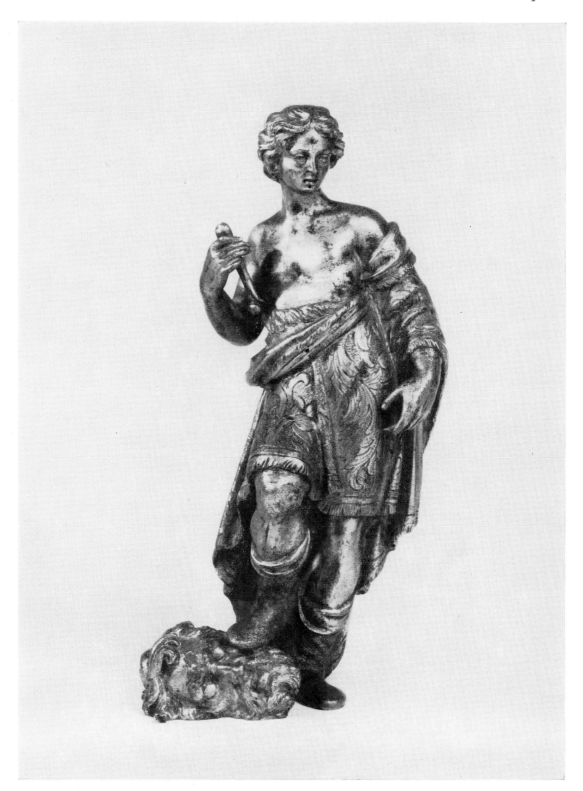

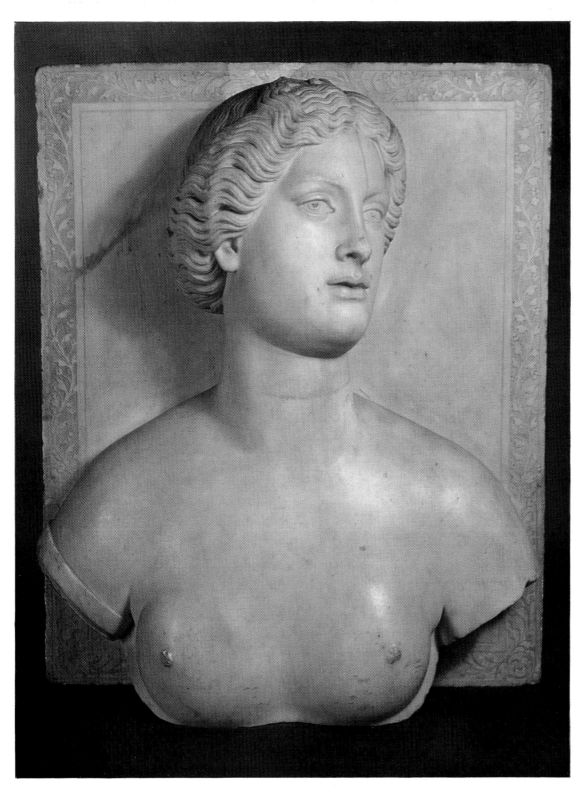

TULLIO LOMBARDO:
White marble
bust of a
young woman
$17\frac{3}{4} \times 14\frac{3}{4}$ in.
(45 × 37.5 cm.)
Sold 5.12.72 for
19,000 gns. ($47,880)
From The Weininger
Collection

The Weininger Collection

PAUL WHITFIELD

On 5th December 1972 we offered for sale one of the most interesting and valuable groups of bronzes, woodcarvings and other small sculpture to have been seen on the market in recent years. The sale consisted of only 40 lots which sold for a total of £288,393 ($548,143).

Apart from the extraordinary mediaeval statuette of St John the Evangelist, which is discussed on page 400, the 'star' piece of the sale was the bronze satyr by the Paduan artist Andrea Riccio (see illustration page 407). In this bronze of great beauty, Riccio is shown as perhaps the most accomplished exponent that the small bronze has ever known, and its quite exceptional condition and colour were factors which contributed to the outstanding price of £26,250 ($85,680).

Another bronze ascribed to Riccio which came from The Weininger Collection of New York, was the strange aeolipile or fire-blower (see illustration page 406) which sold for £19,800 ($47,880). When published in 1927 by the German authority Planiscig in his monograph on Riccio, it was erroneously described as a type of flask, but its real function, discovered in the course of cataloguing at Christie's, is to blow a fire by expelling a powerful thin jet of steam and air at the fire when the vessel, which is filled with water, is heated. This principle has been used extensively in Asian mountainous areas such as the Himalayas, but is rarely seen put into practice in European metalwork, although the principle was mentioned by Leonardo in his notebooks.

The magnificent bronze of Hercules (page 408), from a Netherlandish workshop of c. 1600 was also from the Weininger collection and at £16,800 ($40,320) was one of the four works of art from that collection which fetched in excess of £15,000.

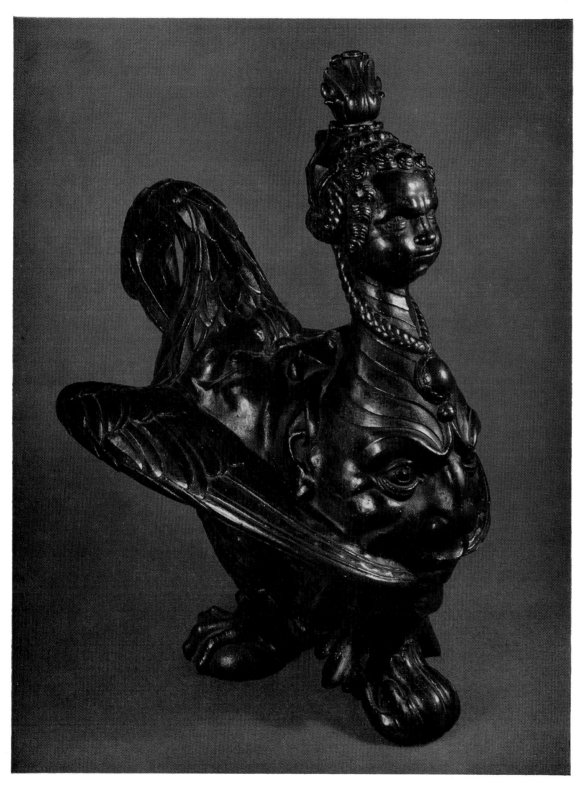

ANDREA
BRIOSCO (RICCIO):
Bronze aeolipile
or fire-blower
$15\frac{3}{4}$ in. (40 cm.) high,
12 in. (30.5 cm.) long
Sold 5.12.72 for
19,000 gns. ($47,880)
From The Weininger
Collection

ANDREA
BRIOSCO (RICCIO):
Bronze figure of a satyr
8⅝ in. (21.9 cm.) high
Sold 5.12.72 for
25,000 gns. ($85,680)
From The Weininger
Collection

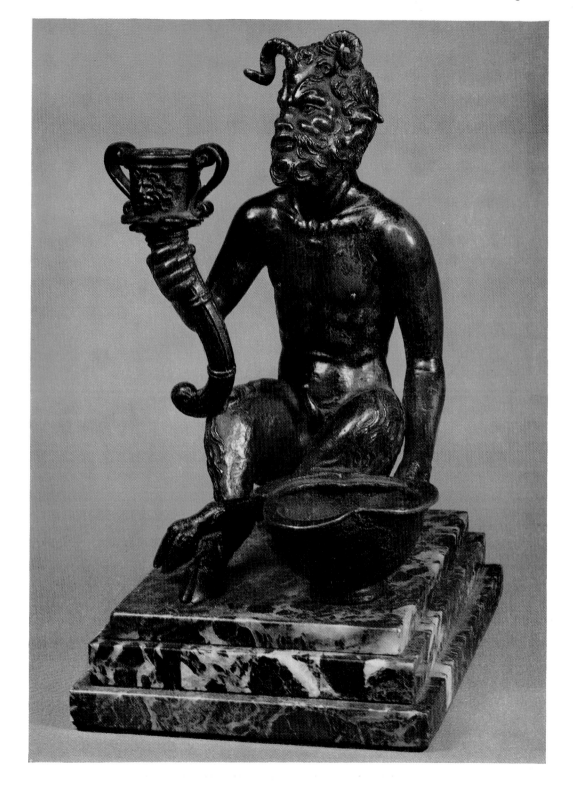

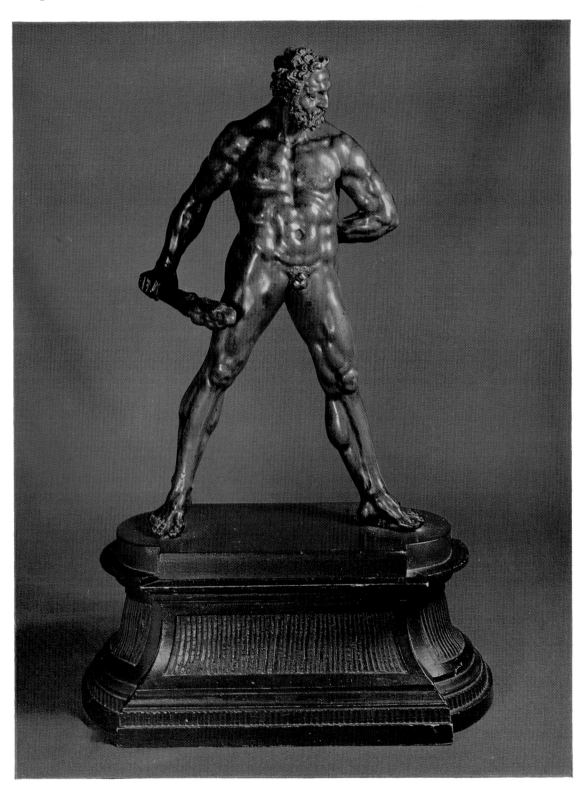

Bronze statuette
of Hercules
Netherlands, early
17th century
15¾ in. (39 cm.) high
Sold 5.12.72 for
16,000 gns. ($40,320)
From The Weininger
Collection

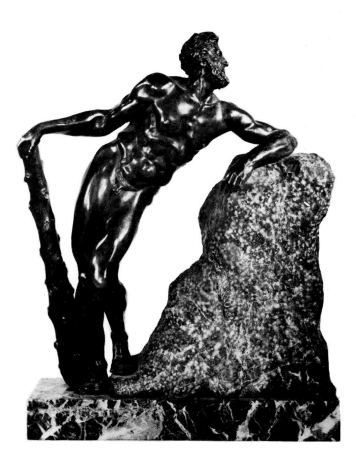

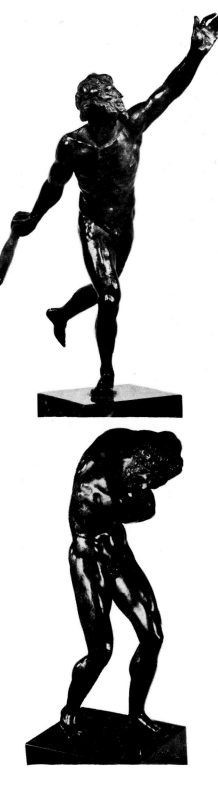

Above: ADRIAEN DE VRIES:
Bronze statuette of Hercules
11¾ in. (29.8 cm.) high
Sold 5.12.72 for 3800 gns. ($9576)
From The Weininger Collection

Top right: VITTOR CAMELIO (GAMBELLO):
Bronze statuette of Hercules
13¾ in. (35 cm.) high
Sold 5.12.72 for 3000 gns. ($7560)
From The Weininger Collection

Right: Ascribed to VINCENZO DE'ROSSI:
Bronze statuette of Atlas
9⅞ in. (25 cm.) high
Sold 5.12.72 for 4600 gns. ($11,572)
From The Weininger Collection

FERDINAND DIETZ: Pair of white-painted limewood bozzetti
$11\frac{1}{2}$ in. (29.2 cm.) and $12\frac{3}{8}$ in. (30.5 cm.) high
Sold 5.12.72 for 4500 gns. ($11,320)
From the collection of Lady Makins

Large Goanese ivory statuette of
St Michael
$33\frac{1}{2}$ in. (85 cm.) high, excluding spear
18th century
Sold 21.3.73 for 2800 gns. ($7056)

Specialized musical sales

Christie's have been selling high quality musical instruments for many years. In 1857 we auctioned the James Goding collection which included as many as seven Stradivaris. This was only eclipsed by the massive Joseph Gillot collection in 1872— 153 lots including eight Stradivaris. Although private collections are rarely this large today, recent sales reflect an increasing demand for instruments of all sorts. The violin bow, for instance, by François Tourte, formerly the property of Rodolphe Kreutzer, the friend of Beethoven, fetched £6 in 1857, but when auctioned again by us in 1969 went for £1680 ($4704). Some unusual instruments also command high prices. An example is a glass flute (see illustration below) which fetched £577 ($1385) on 29th March 1973, whereas a similar example fetched £241 ($674) in 1969. One reason for this uplift in prices is the revival of playing baroque music on original instruments.

Last season we decided to hold specialized sales of musical instruments and appointed Mr Edward Croft-Murray, who retired recently from the British Museum, as consultant in view of his long interest in this field. David Murdoch is responsible for the cataloguing of musical instruments sales.

Rare glass flute
By Claude Laurent
Signed Laurent à
Paris, 1814
26 in. (66 cm.) long
Sold 29.3.73 for
550 gns. ($1385)

The Remenyi Vuillaume

DAVID MURDOCH

Professional violinists understand only too well the frustrations of some of their colleagues in obtaining an ideal instrument. Financial considerations apart, there is considerable difficulty in finding an available instrument of suitable tonal qualities. However, during the 19th century the most eminent musicians had nothing but praise for the violins and other musical instruments of Jean Baptiste Vuillaume. One of them was Eduard Hoffman.

Eduard Hoffman (1830–98), born in Hungary of German extraction but who Magyarized his name to Remenyi (which means 'Hope' as does Hoffman), was one of the leading virtuosi of the 19th century. By the time he came to Paris for the first time in 1865, he was at the height of his career and had been enjoying royal patronage both under the Habsburgs and Queen Victoria. Similarly, Vuillaume was also at his zenith as the most outstanding maker and dealer in Paris. Apart from his successful dealing in the Italian Old Master instruments, his new instruments were appreciated by the leading musicians, including Paganini. Vuillaume had also made a few violins for the nobility with coats-of-arms to order; this was not a novelty as Andrea Amati had made a number of instruments for Charles IX of France decorated with the royal insignia. Remenyi may have requested the Royal Hungarian arms (as opposed to the Habsburg arms) not only to show off his royal patronage, but also to publicize his separatist sympathies, for in 1848 he was forced to flee from Hungary, being a wanted man after his part in that abortive insurrection. Like other Hungarian refugees, he was warmly welcomed in England and only returned to Hungary after the amnesty.

Vuillaume's new instruments were modelled after the Italian Old Masters, Stradivari being the most popular. Far from just following the pattern, he attempted to imitate their age by picking off part of the varnish on the back, thus giving a worn appearance. In 1855 Vuillaume acquired the famous 'Le Messie' Stradivari violin from Luigi Tarisio's heirs, together with a large collection of other important Italian instruments. This instrument was his pride and joy and he made several copies of it. Remenyi's was one of these and they differ from the others in that Vuillaume did not attempt to 'age' the varnish (see illustration opposite); this is in keeping with

412

Vuillaume's ideas of a true copy as the 'Le Messie's' varnish was quite intact.

Some years later Remenyi probably dropped the violin and, finding no use for it in its damaged state, sold it to David Laurie the well-known Glaswegian dealer. William Henley mentions it in his dictionary of violin makers as being in the possession of a Mr Hilton of Matlock Bridge in 1895.

Nothing more was heard until the violin was sold in our rooms for 1800 guineas ($4536), a good price in view of its damaged condition. It is now to be hoped that its playing powers are being fully exercised once again, after a 'sleep' of nearly 77 years.

The Remenyi Vuillaume, a French violin by J. B. Vuillaume
Stradivari model, labelled Jean Baptiste Vuillaume à Paris
3 Rue Demours-Ternes, No. 2599
Length of body 14 in. (35.6 cm.), c. 1865
Sold 16.11.72 for 1800 gns. ($4536)

Italian violin, by Nicolas
Gagliano
Labelled Nicolaus Gagliano
fecit, Neap, 1762
Length of body 14 in.
(35.6 cm.)
Sold 16.11.72 for 4400 gns.
($10,880)

English brass slide-trumpet
Signed Henry Smith, Maker, Wolverhampton
22½ in. (57.2 cm.) long
c. 1840
Sold 29.3.73 for 500 gns. ($1260)
From the collection of T. W. Harford, Esq

Italian violin, by Giovanni
Francesco Pressenda
Labelled Joannes
Franciscus Pressenda q.
Raphael fecit Taurini
anno Domini 1844
Length of body 14 in.
(35.6 cm.)
Sold 4.7.73 for
7400 gns. ($19,425)
From the collection of the
late Mrs Odette Kupfer

Flemish spinet, attributed to Anton Dulcken
Signed with initials A.D. and dated 1750
6 ft. (182.9 cm.) wide
Sold 4.7.73 for 2300 gns. ($6037)
From the collection of Mrs James Currie

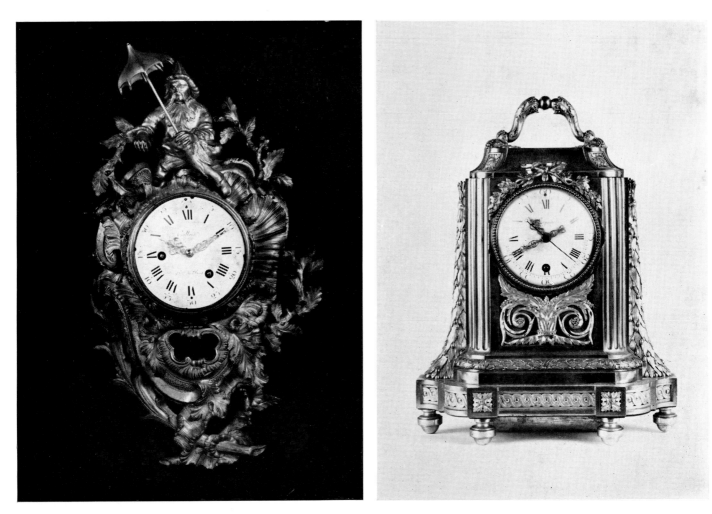

Louis XV ormolu cartel clock
By Gaillois, Hger. du Roy
22 in. (56 cm.) high, stamped with the crowned C poinçon
Sold 8.5.73 at the Hôtel Richemond, Geneva, for £3000
(Sw. fr. 24,000)

Louis XVI ormolu mantel clock signed Lepaute
17 in. (43 cm.) high
Sold 8.5.73 at the Hôtel Richemond, Geneva, for
£3250 (Sw. fr. 26,000)

Important Louis XV
bronze and ormolu
mantel clock, the
striking movement
signed on the enamel
face and backplate
Etienne Le Noir à
Paris
22 in. (56 cm.) high,
17¾ in (45 cm.) wide
Sold 5.7.73 for
8500 gns. ($22,312)

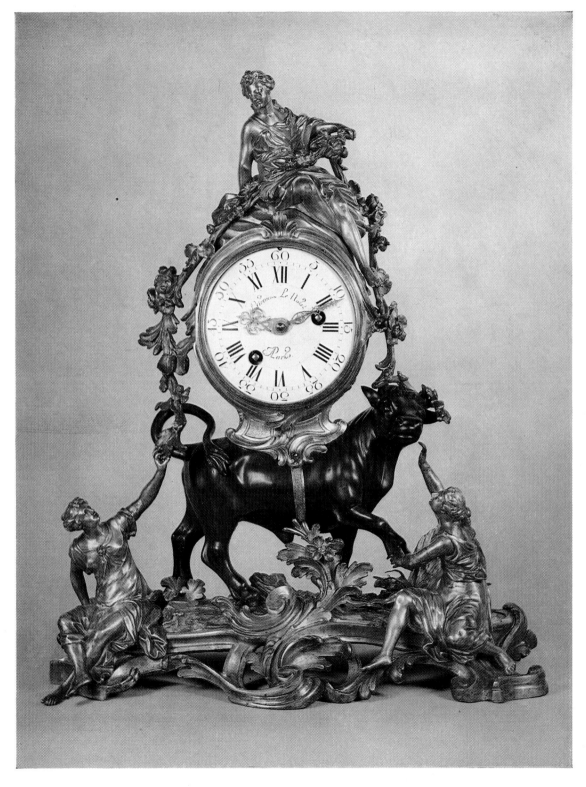

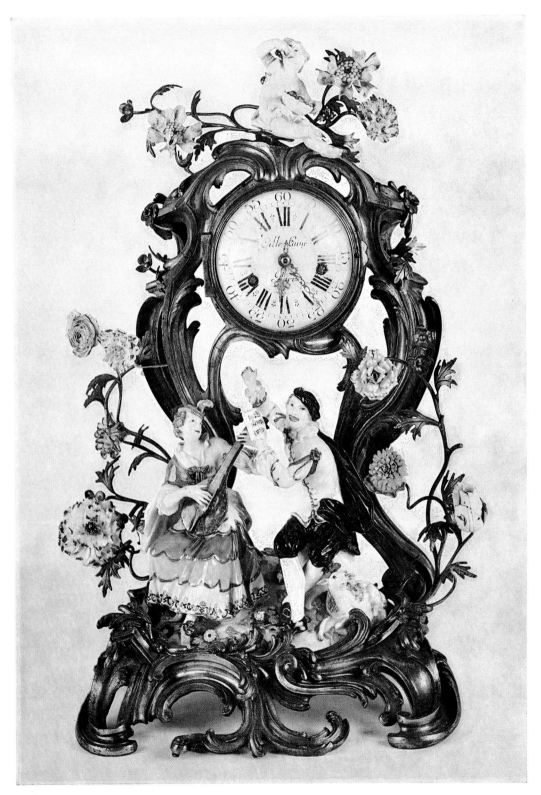

Louis XV ormolu and
porcelain mantel clock
By Gille L'Aîné, Paris
21¼ in. (54 cm.) high
Sold 8.5.73 at the Hôtel
Richemond, Geneva,
for £5000 (Sw. fr. 40,000)

Right: Fine and rare French gilt-metal pendule de table, signed Pierre Amy A. St Malo
9½ in. (24 cm.) high, late 18th century
Sold 28.3.73 for 3400 gns. ($8568)

Bottom right: French Empire mechanical planetarium clock
Signed Lepaute de Belle Fontaine, Elementa Suis Proprus Armis Victa
Early 19th century
24½ in. (62 cm.) overall height including dome
Sold 28.3.73 for 4200 gns. ($10,608)

Below: French Empire mechanical orrery clock with calendar
5½ in. (14 cm.) height of orrery, 21 in. (53 cm.) overall height of clock
Early 19th century
Sold 28.3.73 for 4400 gns. ($11,088)

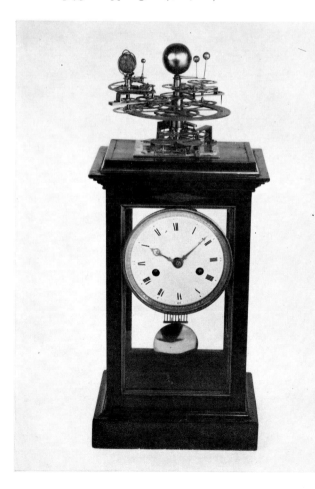

Important ebony night clock
Traditionally, made for
Catherine of Braganza by Edward East,
London
34 in. (86 cm.) high, 9¼ in. (23.5 cm.) width
of movement, c. 1670
Sold 8.11.72 for 9500 gns. ($23,940)

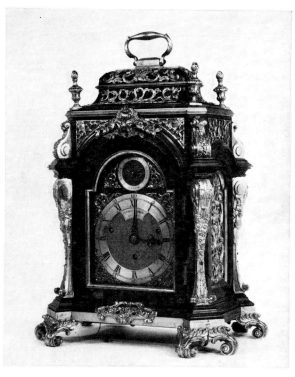

Top right: Fine George III ormolu-mounted tortoiseshell musical bracket-clock
By Francis Perigal, London
13½ in. (34 cm.) high
Sold 12.12.72 for 6000 gns.
($15,120)

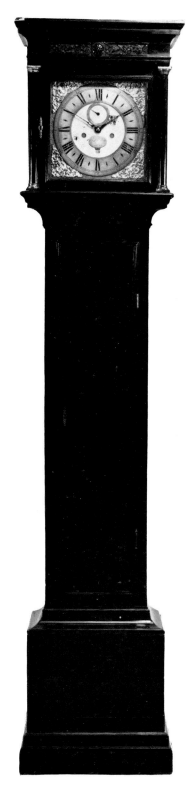

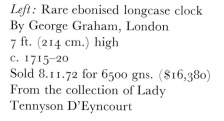

Left: Rare ebonised longcase clock
By George Graham, London
7 ft. (214 cm.) high
c. 1715–20
Sold 8.11.72 for 6500 gns. ($16,380)
From the collection of Lady
Tennyson D'Eyncourt

Bottom right:
Small walnut-veneered bracket clock
By Joseph Knibb, London
11¼ in. (28.5 cm.) high, c. 1680
Sold 28.3.73 for 6000 gns.
($15,120)

Charles Clay—clockmaker extraordinary

SIMON BULL

Charles Clay was born in Flockton, Yorkshire at the end of the 17th century. He came to London, after an unsuccessful fight with Daniel Quare to obtain a patent on a musical repeating watch and took a shop near St Mary-le-Strand Church in 1720. From about 1723 until his death in 1740 he held the official position of Clockmaker to His Majesty's Board of Works, and although few examples of his works in this capacity remain, the survival of a number of extraordinary musical and organ clocks of both monumental and complicated construction have established his importance.

Indeed, the clock sold at Christie's in November (see illustration opposite) indicates that Clay's fame was widespread in his own lifetime. He was able to enlist the collaboration of several of the most eminent artists of his time. The dial painting, an allegory of Apollo, Mars, Pegasus and The Muses on Mount Parnassus is by Jacopo Amigoni, an associate of Canelletto, who came to London in 1729 and stayed for a period of ten years, contributing to several of Clay's clocks. The group of silver figures representing the Liberal Arts at the base of the dial are by John Rysbrack, working in England from 1720 until his death in 1770, while the superbly cast ormolu side frets and the design for the case may well have been the work of Louis François Roubiliac. The cupola-top contains a substantial organ mechanism with music composed by Handel, who is known to have written various pieces especially for Clay's clocks, and the adaptation of the music for the clock may have been undertaken by Francesco Geminiani.

The provenance associated with the clock is also of considerable interest. It was originally in the collection of Gerret Braamcamp, born in 1699 as the eldest son of Jan Braamcamp and Hendrina van Beeck. He had three brothers, Rutger, born 1706, Herman, born 1709, and Dirk (Rodrigo). The family was extremely successful in Amsterdam where Gerret owned a shipping line trading in commodities with Portugal and a timber business, for a time in partnership with Rutger. Herman founded a branch of the family in Portugal, and received many honours as Minister to the King of Prussia. Dirk became a partner in a Dutch firm (Cremer & Braamcamp) in Lisbon.

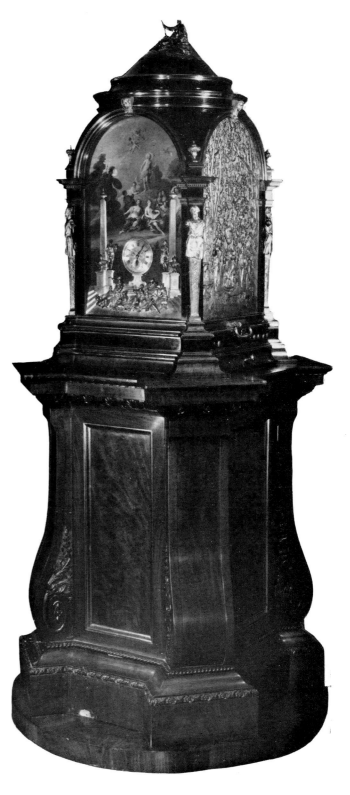

Highly important George II organ clock
By Charles Clay
99 in. (252 cm.) overall height, 44 × 22 in. (112 × 54 cm.)
dimensions of cupola
Sold 8.11.72 for 10,000 gns. ($25,200)
From the collection of Senhor Pedro Felner da Costa

Gerret Braamcamp's collection, started c. 1735, was certainly one of the most famous in 18th-century Europe. Jacob Bicker Raye, the chronicler of Amsterdam, wrote of him, 'he was famous all over the world for his beautiful collection of paintings and other works of art'. He probably obtained the clock soon after it was completed, and he kept it at Sweedenryck, outside Amsterdam, until his death on 17th June, 1771. The collection was sold on 13th July, 1771, and the clock bought by Rutger Braamcamp for Fl. 3700. It was then passed to the nephews in Portugal, probably the sons of Herma's marriage to D. Maria Ignacia de Almeyda Castello Branco, who were born between 1752 and 1773, and who also inherited Gerret's fortune. The clock was subsequently in the collection of the Infanta Donna Maria Isabel, sister of the King of Portugal, Dom Miguel, who kept it at the Palace of S. Domingos de Benfica in Lisbon. After the Infant's death on 22nd April, 1876, the clock was purchased by the Portuguese collector Carvalho Monteiro. From there it has passed through various hands before returning to England for sale.

The years 1650–1750 are perhaps rightly known as the Golden Age of English Clockmaking, and although the names of such makers as Thomas Tompion and Daniel Quare are almost household words, the extraordinary creations of Charles Clay have largely escaped the attention due to them. In a working life spanning little more than twenty years, Clay produced perhaps ten major pieces along with a number of more usual bracket clocks and watches. His obituary appeared in *The Gentleman's Magazine* headed 'The ingenious Mr. Clay, Maker of several Musical Clocks', and continued 'three days before he dy'd he order'd a Musical Machine, which had cost him about 20 years Time, and upwards of 2000L to bring to Perfection, to be beat to Pieces, and entirely destroyed, to prevent further Expence of the Time and Money of anyone who should attempt to finish it after his Death'.

Left: Rare and early French striking globe-watch
Probably by Jacques De La Garde
3⅛ in. (8 cm.) high, c. 1560
Sold 12.12.72 for 8000 gns. ($20,160)

Bottom left: English circular brass combined azimuth
and astronomical dial
Signed Rob. Davenport fecit, first half 17th century
6 in. (15.2 cm.) diam.
Sold 12.12.72 for 2600 gns. ($7552)

Below. Important English silver pair-cased Verge
clock-watch, the movement signed Robert Seignior
London, traditionally a gift from
King Charles II to Nell Gwyn
4½ in. (11.5 cm.) diam., c. 1680
Sold 28.3.73 for 9200 gns. ($2318)

Breguet No. 4270. Fine grande-sonnerie repeating gold watch signed on the cuvette Breguet, Horger de la Marine Royal, No. 4270
2¾ in. (6 cm.) diam.
Sold 28.3.73 for 3200 gns. ($8064)

Very fine gold keyless one-minute chronometer tourbillon watch, signed Paul Ditisheim
2⅜ in. (6 cm.) diam.
Sold 28.3.73 for 6800 gns. ($17,136)

Fine gold hunter-cased perpetual calendar minute-repeating keyless lever chronograph
2¼ in. (5.6 cm.) diam.
Sold 28.3.73 for 2100 gns. ($5292)

Gold perpetual calendar minute-repeating keyless lever chronograph, signed Chas. Frodsham, 84, Strand, London, No. 06206, A.D. Fmsz
2⅜ in. (6 cm.) diam.
Sold 26.6.73 for 2600 gns. ($6825)
From the collection of Mrs V. Silberman

Right: Magnificent Swiss gold, enamel and diamond-set minute-repeating clock watch
2⅜ in. (6 cm.) diam.
Sold 8.11.72 for 4800 gns. ($12,096)

Bottom right:
Fine oval gold, enamel and diamond-set duplex watch, for the Chinese market
Signed on the gilt-metal cuvette William Anthony, London, No. 2043
3½ in. (9.2 cm.) long, c. 1800
Sold 26.6.73 for 6500 gns. ($17,062)

Below:
Fine gold repoussé pair-cased verge watch and chatelaine, the movement signed Chr. Fennymore London (hallmarked London 1747)
3¼ in. (8.5 cm.) overall length
Sold 26.6.73 for 2800 gns. ($7350)
From the collection of E. A. Beausire, Esq

Collection of
gold, silver and
enamel form watches
Sold 28.3.73 for a
total of £3801
($9122)

STAMPS,
VETERAN AND
VINTAGE CARS,
STEAM LOCOMOTIVES
AND MODELS

Postage stamps and postal history

ROBSON LOWE

The outstanding features of the season were the dearth of rarities worth over £5000 ($12,500) and the many sensational increases in value in stamps in the range under £500 ($1250). Although the number of people selling has shown a considerable increase, there was an even greater increase in the number of buyers.

Collections of Great Britain accounted for a turnover of £169,547 ($423,867), almost exactly twice the turnover of two years ago. A selection of notable prices included: £2300 ($5750) for a proof in blue-black from the small plate of three impressions of the 1840 1d.; £1100 ($2750) for a slightly defective used block of eight 1840 2d. blue; £525 ($1312) for an 1858 piece bearing the 2d. blue with the Pearson Hill 'opera-glass' cancellation (see illustration below), and £2200 ($5500) for a sheet of twenty of the 1929 Postal Union Congress £1.

The best G.B. collection disposed of during the season was sold on behalf of Dr G. B. Thrift, of Dublin, and realized over £27,000 ($67,500).

Sales of British Empire stamps in London brought £199,784 ($499,460) and included the late E. M. Erikson's collection of Jamaica which contained a fine mint

The so-called 'opera-glass' cancellation
Sold 13.3.73 for £525 ($1312)
Without the cancellation the stamp would be worth 50p ($1.25)

3 Sicily stamps, used on the first
day of issue from Messina
Sold 19.10.72 for £8125
(Sw. fr. 65,000)

example of the 1920 1/- with centre inverted which fetched £1750 ($4375). The same price was paid for a used example of the 1892 1d. maroon included in John Sacher's incomparable collection of embossed Gambia. The 1912 £1 Rhodesia error of colour realized £1250 ($3125) and an unused example of the Mauritius 1848 2d. Post Paid went for £3500 ($8750). A fine mint block of twenty-four St Lucia 1860 6d. made £2700 ($6750) and a mint Johore 1922 $500 brought £3000 ($7500). A splendid mint block of eighteen St Vincent 1881 ½d. on half 6d. fetched £1700 ($4250), a surprising figure for what is little more than a ten-pound stamp in a single. In the sale of R. A. Baldwin's Pacific Islands, an imperforate between pair of the Solomon Islands 2d. made £800 ($2000).

There were fewer Overseas collections sold during this season as the turnover under this heading was only £160,241 ($400,602). This fall was caused by the decrease in the number of European collections on the market. Among the exciting properties sold was the Henrik Thrap-Meyer collection of Norwegian ship cancellations, the top price, £1700 ($4250), being paid for a strip of six 1854 4sk. from Bergen.

Other outstanding rarities in this group included £3700 ($9250) for blocks of six of the Italian Somaliland 1928 Parcel Post 1 lira and 2 lire, £2200 ($5500) for the United States 1901 4c. with inverted centre and £1150 ($2875) for a dossier of Israeli proofs relating to the production of the 1953 Maimonidos commemorative.

Among the named collections sold were A. C. Waterfall's Tibet, the late Mrs Isa Stuart's Netherlands and R. W. Gibson's U.S.A.

The four Postal History auctions brought £95,610 ($239,025) and included £375 ($937) for a *tête-bêche* pair of the Lake Lefroy Goldfields Cycle Mail 6d. used in Western Australia in 1897. A cover from Saigon to Mauritius in 1869 bearing four Straits stamps fetched £340 ($850) and another envelope from Bassein in Burma to England bearing a British 1d. and Indian 2as. and 4as. made £320 ($800). These sales included Mrs Sybil Morgan's Welsh and Ernest Trory's 'Postal History of Brighton'.

The general auctions held in our Bournemouth salerooms were as popular as ever and added £335,985 ($839,962) to the total sales. Several collections realized over £1000 ($2500) each and a specialized study of Falkland Islands made £3250 ($8125). Typical of the wide appeal of these sales are these lots: Great Britain 1877 £5 telegraph stamp, proof in gold £145 ($362), New Zealand 1903 Scott Expedition cover £70 ($175) and 1911 'Deutschland' Sud Polar Expedition postcard £150 ($375). Among the properties sold during the season were the collections formed by Dr J. F. D. Frazer, Capt E. J. S. Marples, Desmond Eagar, Dr G. W. Hall-Smith and R. K. Haselden. Collections sold for executors included those of the late E. I. Abell, Col W. D. Crewson, G. P. L. James, J. L. Hoult and D. W. Carpenter.

The multi-lingual auctions in Basle continued to attract many European buyers, bringing a total of £361,799 ($904,497). The best collection was one of Sicily which

1879 telegram envelope containing a telegram to Mauritius sent from Suez by ship before the cable had been completed
Sold 14.3.73 for £210 ($525)

came from the estate of a deceased collector who had lived in Palermo. The realizations greatly exceeded the estimates and Sw. fr. 65,000 (£8125) was paid for a letter from Messina, posted on 1st January 1859 bearing a 2gr. and a pair of ½gr. (see illustration page 431). This was the highest price of the season for one individual item. A mint block of four of the French 1877 1c. Peace and Commerce printed on Prussian blue paper made Sw. fr. 25,000 (£3125) and a block of nine Uruguay 1858 240c. with the centre space blank made Sw. fr. 6500 (£812).

In the Louis Frank collection of Malta, a French 1870 40c. cancelled MALTHE with two Italian postage due stamps on an envelope made Sw. fr. 7500 (£937) and a 1/- embossed Great Britain used on an 1855 envelope cancelled with the Malta grid made Sw. fr. 6000 (£750).

Perhaps the most surprising feature was the continued success of the sales of United States stamps in Basle, for in many instances, prices were above those expected in New York. The fall in the value of the dollar put the European buyer on more-than-level terms with the American competition. The top prices paid in this section were for a corner copy of the 1855 5c. on a letter which went for Sw. fr. 15,000 (£1875) and a set of 1875 reprints of the 1865 issue fetched the same price. An 1855 letter posted in San Francisco bearing the current 3c. cancelled by the penny post and used with an uncancelled example of the Californian Penny Post 5c. made Sw. fr. 6400 (£800).

Among other spectacular collections that were sold in Basle was the Egypt formed by Georges Gougas of New York. Letters written nearly two thousand years ago were sold, and Sw. fr. 5500 (£687) was paid for a bisected 2 piastres stamp on a letter from Gedda in 1875.

Throughout all these sales, the astounding accumulation formed by the late Fred W. Ackerman, of California, added some £40,000 ($100,000). This property weighed over 2000 lbs and arrived by air. A great deal of this collection remains to be offered next season.

There was the usual sprinkling of original finds which always stimulate interest among the true collectors. Of these, perhaps the most exciting was the 1840 letter posted in Edinburgh to Glasgow and which bore two strips of four 1d. blacks. On arrival in Glasgow, the letter was returned to the sender and a strip of eight blacks was used. This letter turned up in office files and in spite of a number of faults, sold for £600 ($1500), the owner donating the realization to the 'Save the Children' Fund.

The total auction turnover for the season was £1,310,000 ($3,275,000).

The Hon Patrick Lindsay taking the sale of Veteran and Vintage Motorcars at Beaulieu on 12.7.73 which totalled £295,508 ($738,770). Motorcar sales are held in association with Lord Montagu of Beaulieu

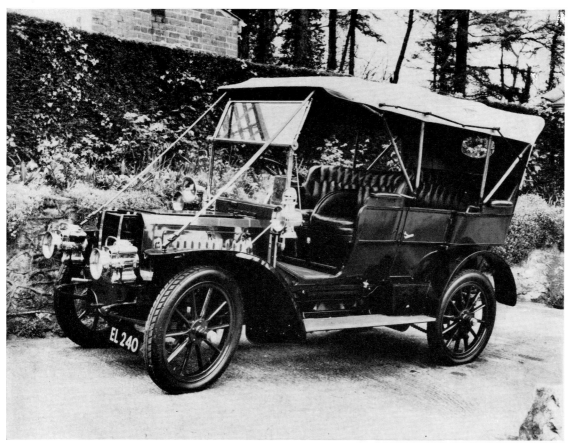

1904 Gladiator 14 h.p.
side-entrance tonneau
Sold 12.7.73 at
Beaulieu for £12,000
($30,000)
From the collection
of A. J. Boyce Esq

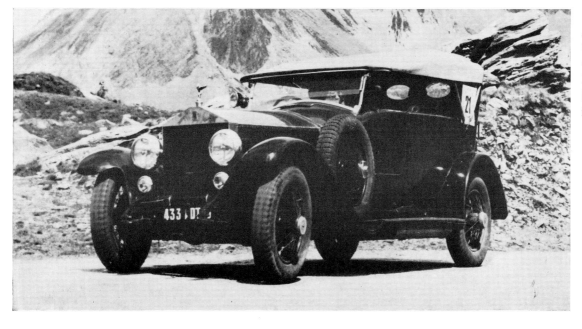

1924 Rolls-Royce
40–50 h.p. 'Silver
Ghost' Sports Tourer
Coachwork by
Million-Guiet, Paris
Sold 22.3.73 in Geneva
for £17,391 (Sw. fr.
140,000)

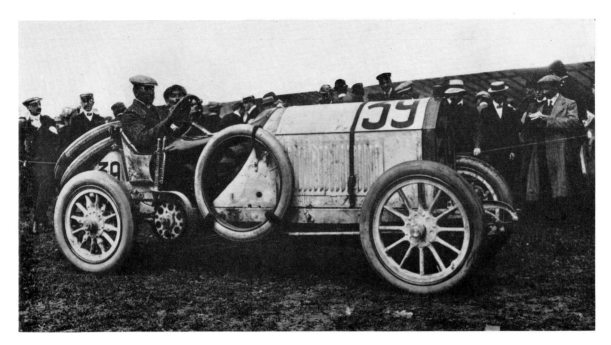

1908 Benz 120 h.p. Grand Prix racing two-seater
Sold 22.3.73 in Geneva for £34,783 (Sw. fr. 280,000)

1930 Mercedes-Benz 38–250 h.p. 'SSK' competition two-seater
Sold 22.3.73 in Geneva for £29,814 (Sw. fr. 240,000)

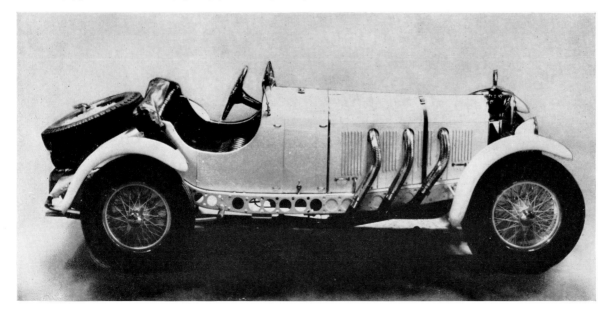

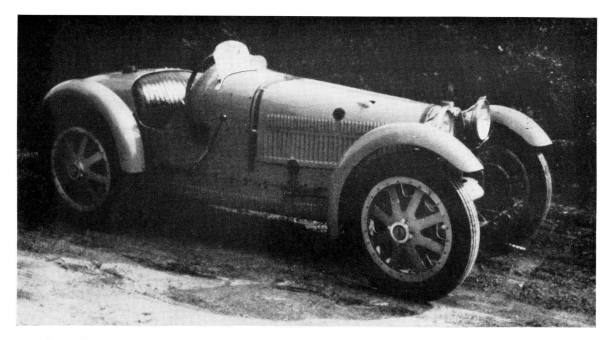

1930 Bugatti 1500 c.c. supercharged Grand Prix two-seater
Sold 12.7.73 at Beaulieu for £17,000 ($42,500)

1937 Mercedes-Benz type 540K foursome drophead coupé
Coachwork by Offord
Sold 12.7.73 at Beaulieu for £15,000 ($37,500)

TERENCE CUNEO: *Steam and diesel of the Great Western Railway with the Brunel Saltash Bridge in the background*
Signed
33 × 30 in. (84 × 76 cm.)
Sold 14.3.73 for 2600 gns. ($7552)

7 mm. fine scale model of the London and North Western Railway 'Problem' class 2–2–2 locomotive No. 531 'Lady of the Lake' as designed by John Ramsbottom
Sold 14.3.73 for 2500 gns. ($7300)

3½ in. gauge model of the Great Eastern Railway super Claud Hamilton 4–4–0 locomotive and tender No. 1813
10¼ in. high × 40 in. long (26 × 102 cm.)
Sold 14.3.73 for 1100 gns. ($2772)

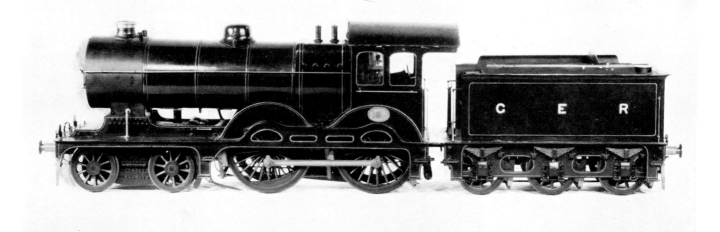

Above: Builder's model of the 479 gross ton steam yacht *Rannoch* built in 1902 by Ramage & Ferguson of Leith
23 × 58 in. (58 × 147 cm.)
Sold 14.3.73 for 3500 gns. ($8820)

Left: Early 19th-century fully rigged bone model of an 86 gun man-o'-war built by French prisoners
17 × 20 in. (43 × 51 cm.)
Sold 14.3.73 for 2800 gns. ($7056)

ARMS AND ARMOUR

Above: German sporting crossbow and cranequin
Early 17th century
25 in. (63.5 cm.)
Sold 4.12.72 for 1300 gns. ($3276)

Top right: Rare Italian Gothic chanfron, struck twice
on the top right with a mark, an orb containing a
Gothic A
Late 15th century
18½ in. (47 cm.)
Sold 4.12.72 for 1400 gns. ($3528)

Right:
Saxon thrusting sword (tuck)
Mid-16th century
53 in. (134.6 cm.) blade
Sold 27.6.73 for 1600 gns. ($4200)
From the J. F. R. Winsbury Collection

442

Composite German 16th-century half-armour,
the helmet probably by Anton Peffenhauser of
Augsburg
Sold 4.12.72 for 2800 gns. ($7056)

German cuirassier armour
c. 1620–30
Sold 30.4.73 for 1600 gns. ($4032)

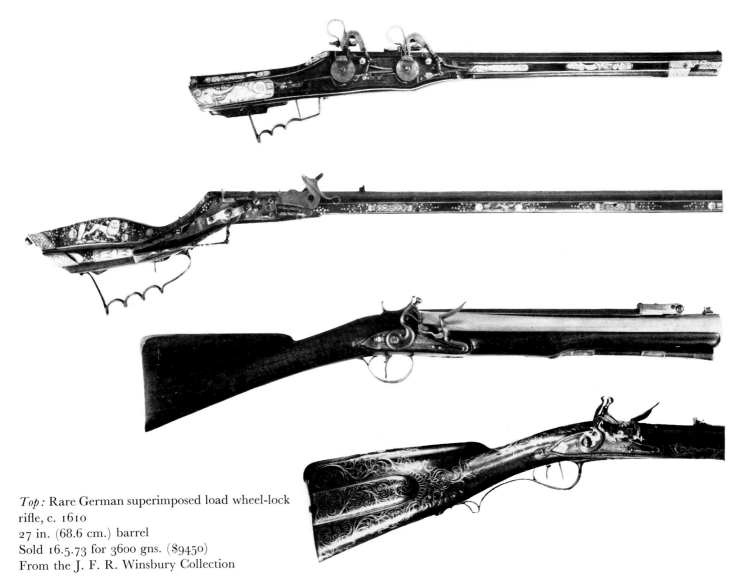

Top: Rare German superimposed load wheel-lock rifle, c. 1610
27 in. (68.6 cm.) barrel
Sold 16.5.73 for 3600 gns. ($9450)
From the J. F. R. Winsbury Collection

Second: Silesian wheel-lock birding rifle (Tschinke), struck with barrelsmith's mark TR at the breech, first half of the 17th century
37 in. (94 cm.) barrel
Sold 7.3.73 for 1700 gns. ($4284)
Sold by the Tower of London Armouries

Third: Flintlock blunderbuss, by H. W. Mortimer, London, c. 1780
32 in. (81.3 cm.) overall
Sold 7.3.73 for 1000 gns. ($2520)

Bottom: Detail of Russian flintlock sporting rifle, the lock inscribed St Petersburg, c. 1780
22 in. (55.8 cm.) barrel
Sold 20.12.72 for 1900 gns. ($4788)

Pair of German flintlock pistols
By Johann Jacob
Kuchenreuter, Regensburg
c. 1760–70
18¾ in. (47.6 cm.)
Sold 27.6.73 for 3600 gns.
($9450)
From the J. F. R. Winsbury
Collection

Double-barrelled flintlock fowling-piece
By John Manton & Son, Dover Street, London, no 6558 for 1818
30 in. (76.3 cm.) barrels
Sold 18.7.73 for 1400 gns. ($3675)

Detail of rare four-barrel percussion turn-over rifle with gilt mounts
and spare stock
By Charles Lancaster, London, no 4190, c. 1868
26¾ in. (68 cm.) barrels
Sold 4.6.73 for 2400 gns. ($6300)

A true collector

John Francis Reuben Winsbury was the oldest arms and armour collector in the country at the time of his death last Christmas Eve. Born in 1884, he was the last of a line of London scale makers, the family business being established in 1793. Like his father and grandfather before him John Winsbury duly entered the business and eventually took charge. His interests in arms and armour, however, began when he was a small boy – he was given his first specimen in 1895, and he made his first purchase in 1896.

A far cry from the investment buyers of today, Winsbury was, unfortunately, never to enjoy the advantages of a large income, but he was a true and tireless collector and by diligent and increasing searches among the small antique dealers, the dirty gas-lit junkshops which then thronged the back streets of the Metropolis – even old clothes shops – he continued to unearth treasures at bargain prices. Between the wars he was able to buy for shillings, and during World War II, when prices in the auction rooms were low, he had a chance to acquire pieces of pedigree from the great collections.

After the war his work took him to all parts of London and the Home Counties, and his soberly dressed rather Victorian figure – only recently did he abandon the stiff wing-collars of his youth – became a familiar sight plodding its way round the shops in all winds and weather, still picking up the 'sleeper' that others had missed. He was always a practical man with a discerning eye, rather than a scholar, and he had an extensive workshop at his disposal.

Winsbury took great pleasure in his collection and was always prepared to lend his pieces for exhibition or to talk about them. Kept always in the back rooms of his small Victorian terrace house they were, however, known by few. He went on collecting to the end despite a succession of serious illnesses, his last purchase being made only two months before he died. It was typical of the man that after a few bequests to friends and museums, he should order his collection to be sold by auction so that other collectors could 'have a go'.

No doubt he would have been amused to see it make over £180,000 ($450,000), a total of 614 lots, most appearing on the market for the first time, sufficient for two morning and afternoon sales. A tribute to an extraordinary lifetime of collecting.

446

Flemish swept-hilt rapier
The blade probably by
Sandrino Scacchi, c. 1630
47½ in. (120.6 cm.) blade
Sold 16.5.73 for 2000 gns.
($5250)
From the J. F. R. Winsbury
Collection

English hunting-sword
Second quarter of 17th century
25¼ in. (64 cm.) blade
Sold 16.5.73 for 820 gns.
($2152)
From the J. F. R. Winsbury
Collection

Silver-mounted combined
hunting-sword and flintlock
pistol
By Vandebaise, London
Early 18th century
27½ in. (69.8 cm.)
Sold 16.5.73 for 1550 gns.
($4068)
From the J. F. R. Winsbury
Collection

French silver-mounted
combined hunting-sword and
flintlock pistol
Paris silver mark for 1771
With discharge mark of
Julien Alaterre
23 in. (58.3 cm.) blade
Sold 27.6.73 for 3600 gns.
($9450)
From the J. F. R. Winsbury
Collection

Top: Saxon wheel-lock holster pistol, struck with the mark
of Abraham or Anton Dressler of Dresden, dated 1577
24¼ in. (61.6 cm.)
Sold 25.10.72 for 2300 gns. ($5796)

Third: One of a pair of gold-mounted Indian flintlock
holster pistols, late 18th century
From the armoury of Tipu Sultan, ruler of Mysore
14½ in. (36.8 cm.)
Sold 7.3.73 for 2200 gns. ($5544)
From the collection of Alex Bowlby, Esq

Second: Fine flintlock holster pistol
By Bleiberg, London, c. 1690
19 in. (48.3 cm.)
Sold 27.6.73 for 4800 gns. ($12,600)
From the J. F. R. Winsbury Collection

Bottom: One of a pair of English long flintlock holster
pistols, the locks signed John Cozens, the barrels stamped
RS at the breech, c. 1670
21½ in. (54.5 cm.)
Sold 16.5.73 for 3600 gns. ($9450)
From the J. F. R. Winsbury Collection

Pair of percussion target pistols with
gilt mounts
By Charles Lancaster, 151 New Bond
Street, London, nos 2991 and 2992
c. 1855–60
16 in. (40.7 cm.)
Sold 18.7.73 for 3100 gns ($8137)

Pair of French presentation flintlock
target pistols, by Prelat, Paris
14½ in. (36.8 cm.)
Sold 7.3.73 for 4800 gns. ($12,096)
From the collection of Colonel and
Mrs Fitzgerald-Lombard

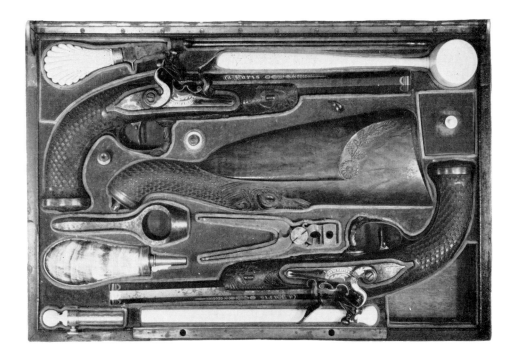

The above pistols were presented by Charles X, King of France, to Major Taylor of the Royal Artillery in 1825, in
recognition of gallant conduct during the rescue of a crew of French sailors from shipwreck off Dover Castle where his
regiment was quartered

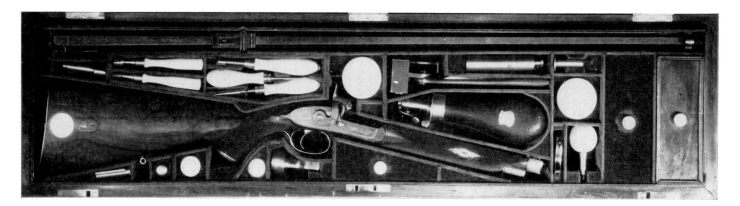

Presentation percussion target rifle (and detail, below)
By Joseph Harkom, 32 Princes Street, Edinburgh, no 700
London proof marks, Edinburgh silver hallmarks for 1861 with maker's mark JH
36 in. (91.4 cm.) barrel
Sold 18.6.73 for 3400 gns. ($8925)

Inscription reads: Presented to Edward Ross Esq.r by a number of his Fellow Countrymen now resident in Australia in testimony of their admiration of the skill he exhibited in carrying off the Prize as the Champion Shot of Great Britain at Wimbledon in 1860

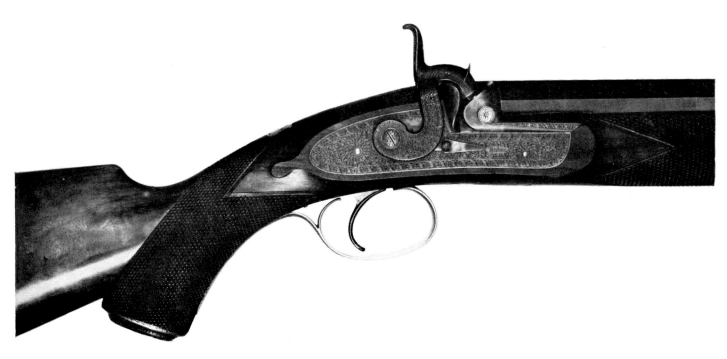

Modern sporting guns

CHRISTOPHER BRUNKER

12-bore over-and-
under sidelock
ejector gun
By Boss, built in 1936
Sold 28.2.73 for
4600 gns. ($12,075)

Proposals for more severe legal restrictions on the private ownership of firearms are under consideration by the Home Office as our 1972/73 season ends. If implemented in anything like their present form, these proposals could seriously affect the home market for sporting guns and would virtually eliminate the burgeoning interest of collectors in vintage breech-loading firearms. For the sake of all those who enjoy owning and using firearms in a responsible manner for legitimate sporting, historical and investment purposes, we hope that next year it will be possible to report that our fears did not materialize.

Proceeds from the sale of modern firearms in 1972/73 were 150% up on last season. This reflects both a rise in prices and a further improvement in the standard of entries. A similar situation in the field of antique arms has enabled us to separate the sale of the two categories in 1973. Of five sales including modern arms this season, the last three have been devoted exclusively to modern sporting guns and vintage breech-loading firearms. To the best of our knowledge, Christie's are the only auctioneers in this country holding regular specialized sales of this type, which may well have contributed to the 50% rise in the number of sporting shotguns entered for sale here this season.

As always, exceptional quality, condition and scarcity have produced record prices for specific items, but during the year there has been an above-average rise in value for most types of firearm, especially double-rifles and pairs of shotguns.

Overleaf are a few examples from sales in the 1972/73 season that, viewed as a whole, indicate the level of prices. All these shotguns were hammerless, double-barrelled and nitro-proof, and most were in good condition. Barrel and chamber lengths are shown in inches: '28/2½ in.' for example.

Sidelock Ejector Guns	GUINEAS	DOLLARS
ATKIN (H) 16-bore self-opener, No. 3303, $26\frac{3}{4}/2\frac{1}{2}$ in.	2000	5250
BOSS 12-bore over-and-under, No. 8375, single-trigger, $27/2\frac{1}{2}$ in.	4600	12,075
DICKSON (J) 20-bore round-action, No. 6184, single-trigger, $27/2\frac{1}{2}$ in.	1500	3938
HOLLAND & HOLLAND 12-bore 'Royal' self-opener, No. 33504, $28/2\frac{1}{2}$ in.	1900	4988
LANG (J) 12-bore, No. 15426, single-trigger, $28/2\frac{1}{2}$ in.	1200	3150
PURDEY (J) 12-bore, No. 22644, cast-on, $30/2\frac{1}{2}$ in.	1700	4463
PURDEY (J) 12-bore, No. 14860, rebarrelled, $28/2\frac{1}{2}$ in.	1700	4463
PURDEY (J) 20-bore, No. 22948, $29/2\frac{1}{2}$ in.	2200	5775
PURDEY (J) 28-bore, No. 25983, $28/2\frac{3}{4}$ in.	2800	7350
PURDEY (J) 28-bore, No. 14351, $28\frac{1}{2}/2\frac{1}{2}$ in.	1700	4463
WOODWARD (J) 16-bore, No. 6153, single-trigger, rebarrelled by Purdey, $29/2\frac{1}{2}$ in.	2000	5250
WOODWARD (J) 16-bore under-and-over, No. 7063, $28/2\frac{1}{2}$ in.	4500	11,813

Pairs of Sidelock Ejector Guns		
ATKIN (H) 12-bore, Nos. 1674/5, rebarrelled, $28/2\frac{1}{2}$ in.	2500	6563
BOSS 12-bore self-openers, Nos. 8111/2, $28/2\frac{1}{2}$ in.	5500	14,438
BOSS 12-bore, Nos. 8051/2, $29/2\frac{1}{2}$ in.	4800	12,600
CHURCHILL (EJ) 12-bore 'Imperial XXV', Nos. 6209/10, $25/2\frac{1}{2}$ in.	3200	8400
GRANT (S) 12-bore, Nos. 7778/9, with extra barrels by Boss, $28/2\frac{1}{2}$ in.	3400	8925
LANG (J) 12-bore, Nos. 16044/5, $29/2\frac{1}{2}$ in.	2500	6563
LANG & HUSSEY 12-bore 'Imperial', Nos. 13024/5, $28/2\frac{1}{2}$ in.	2800	7350
PURDEY (J) 12-bore, Nos. 22144 & 23345, $28/2\frac{1}{2}$ in.	3700	9713
PURDEY (J) 12-bore, Nos. 18117/8, $30/2\frac{1}{2}$ in.	3600	9450
PURDEY (J) 12-bore, Nos. 15389/90, $30/2\frac{1}{2}$ in.	3400	8925
WOODWARD (J) 12-bore, Nos. 5487 & 5871, $29/2\frac{1}{2}$ in.	3000	7875
WOODWARD (J) 16-bore, Nos. 6090/1, single-triggers, rebarrelled by Purdey, $29/2\frac{1}{2}$ in.	3600	9450

Boxlock Ejector Guns		
CHURCHILL (EJ) 12-bore 'Regal XXV', No. 8253, $25/2\frac{3}{4}$ in.	520	1364
CHURCHILL (EJ) 12-bore 'Utility XXV', No. 4342, $25/2\frac{1}{2}$ in.	380	998
CHURCHILL (EJ) .410 'Crown XXV', No. 4471, $25/3$ in.	280	735
GREENER (WW) 12-bore, No. 51915, Grade G.60, $30/2\frac{1}{2}$ in.	400	1050
HELLIS (C) 12-bore, No. 4294, $26/2\frac{1}{2}$ in.	450	1181
WEBLEY & SCOTT 20-bore Model 701, No. 141087, $28/2\frac{3}{4}$ in.	400	1050
WESTLEY RICHARDS 12-bore 'Gold Name', No. 6708, rebarrelled, $27/2\frac{3}{4}$ in.	420	1103

Pairs of Boxlock Ejector Guns		
CHURCHILL (EJ) 12-bore 'Utility XXV', Nos. 3406/7, $25/2\frac{1}{2}$ in.	1050	2756
WATSON BROS & DICKSON (J) 12-bore, Nos. 7569 and 13061, matched, $28/2\frac{1}{2}$ in.	800	2100
WESTLEY RICHARDS 12-bore, Nos. 17877/8, detachable locks, $28/2\frac{1}{2}$ in.	1000	2625

WINE

Wine sales hit new peaks

MICHAEL BROADBENT, MW

The 1972–3 season of wine sales has been far and away the most successful in the company's history. Despite slightly fewer, though larger, sales our turnover has virtually doubled and for the first time ever the total value of wine to come under the Christie hammer has exceeded £1,000,000 ($2,500,000).

We propose to leave the main body of statistics to the end, but just to illustrate the nature of the increase, the following figures put the position in quick perspective:

Seasonal totals: October 1966 to July 1967 £382,905 ($1,072,134)
 October 1971 to July 1972 £695,567 * ($1,669,360)
 October 1972 to July 1973 £1,254,525 ($3,135,637)

*excluding the two annual sales conducted in the U.S.A. (see page 460)

We are now by far and away the largest sellers of fine and rare wines in the world.

The market

What factors are responsible for this tremendous increase? First of all, the world demand for fine wine is immense and supply limited. For the past five or six years American interest in wine has been increasing and its importations of foreign wines have been increasing at a high rate; Europe is prosperous, and now even Japan, flush with funds and ripe for new fields of interest, has, for the first time, taken an interest in wine. We might as well state right away that Japan's influence on the market has been more psychological than anything else. For example, recently published statistics show Bordeaux exports to Japan are only between 0·67% and 1% of the total. Buying has to date been confined to wines bought on expense accounts and we doubt if the taste for wine will develop as powerfully as in the U.S.A. Nevertheless Japanese purchasing power is frighteningly high.

Speculation has added greatly to the demand for top class Bordeaux wines which have suffered, or enjoyed (depending on whose side one is on), the greatest inflation. A build-up of speculative interest, encouraged by rather superficial newspaper articles and by clever commodity investors searching for new fields, has undoubtedly made wine fashionable as a hedge against inflation. However, this 'second' market

454

Large bottles sold 28.6.73
Left to right: Jeroboam Ch.
Haut-Brion 1924, £220
($550); Double-magnum Ch.
Mouton-Rothschild 1924
£230 ($575); Magnum Ch.
Lafite 1870, £200 ($500)

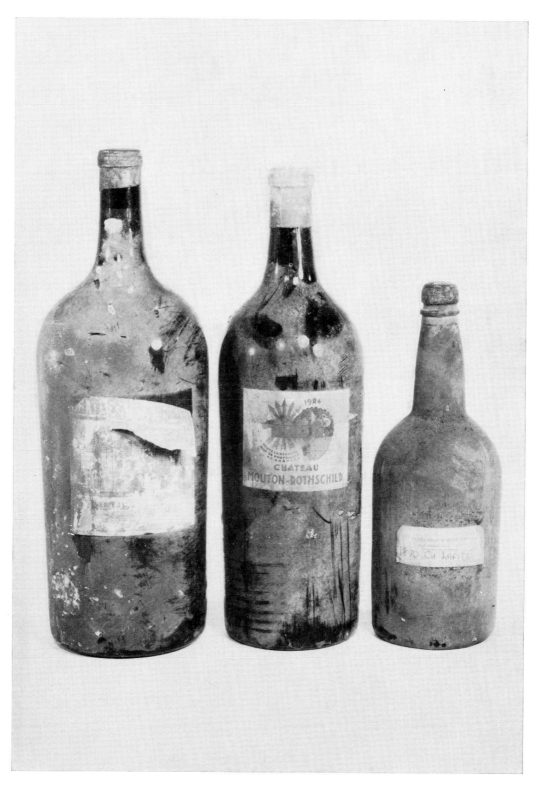

(the first is the market for the wine trade to buy and sell to the consumer through normal distribution channels) has encouraged growers in Bordeaux to stick out for such high prices that the margin for future speculative profits must be small. Although, by and large, the saleroom does not come into the picture at this stage, the relevance is twofold; firstly, the high price of very young wine sends the trade and private buyer scurrying back on the market for older, more mature wines which in comparison look cheap; secondly, the level of future prices could be affected by short-term speculators losing interest or taking fright and getting out of their wines prematurely, in both senses of the word.

One section of the market has taken on a new look: vintage port. Demand is growing visibly and we are now a long way out of the doldrums of two to five years ago when prices for young vintage port, particularly 1963s, were somewhat sluggish. Even the not too scarce Warre '63 commanded £47 ($117) per dozen this July. 1955s are now in the £70 ($175) to £110 ($275) per dozen bracket, and old wines – 1935s, 1927s and 1908s, for example – now match first growth claret in price.

There is no doubt that the current demand and high prices have enticed back on to the market great quantities of wine, a high proportion of which had originally been bought for drinking and not for profit. But drinking at £8 to £30 ($20 to $75) per bottle is clearly an extravagance and many former drinkers of first and second growth wines are cashing in, enabling them to buy many more bottles of younger and less illustrious wines for the price of one. We believe that it is this simple profit taking which has done as much as anything to fill our saleroom with fine wines.

Rarities

As long as there are civilized men with enquiring minds there will be a healthy demand for what we class as rarities. Our sale of 28th June 1973 certainly bore this out. It contained perhaps the widest range of old claret vintages ever presented in one catalogue. Not only rare vintages but rare châteaux, some of which are no more, like Châteaux Brown in the Graves district, one of several vineyards engulfed by the urban spread of Bordeaux.

The oldest dated claret we have sold this season was an 1848 Batailley (which realized a modest £31 ($77) per bottle. However, every great vintage of the 'golden' pre-phylloxera period, 1858 to 1878, has appeared at Christie's. Here are some of the more outstanding clarets, with prices per bottle, Lafite 1865 £56 ($140), 1871 £80 ($200), 1874 £52.50 ($131), 1870 £44 ($110); Latour 1870 £68 ($170), 1874 £52.50 ($131), 1878 £40 ($100); Montrose 1869 £41 ($102); Léoville-Polyferré 1865 £31 ($77); Ausone 1869 £76 ($190).

A trio of pre-phylloxera vintages from the cellars of Lafite – 1858, 1869, and 1878 –

Wine trade relics and collectors' pieces sold 30.11.72
Top left: George III silver gilt fox's mask snuff box belonging to Baron James Forrester of Oporto £350 ($875)
Centre: Rare George II swizel stick £210 ($525)
Bottom right: French silver tastevin dated 1834, £68 ($170)

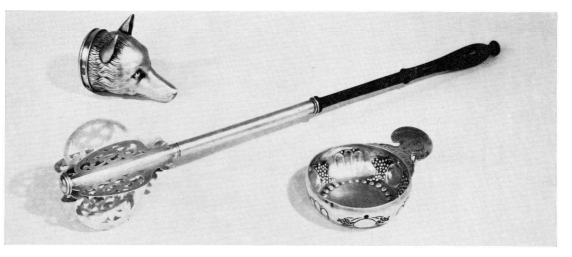

commanded over £1000 ($2500) for the three bottles, which made some of the larger bottles look comparatively cheap, for example, a magnum of 1870 Lafite which realized £200 ($500) (see illustration page 455).

Amongst the large bottles of more recent vintages these were outstanding: Château Mouton Rothschild 1929, magnum £155 ($387); Haut Brion 1924, jeroboam (page 455) £220 ($550); Mouton 1924, double magnum (page 455) £230 ($575), and Latour 1945 double magnum £240 ($600). Perhaps the biggest surprise of all was a rare three-bottle magnum of Sandeman 1935 vintage port at £280 ($700).

Old cognac and Tokay Essence continued steadily with a rare 1789 cognac fetching £125 ($312), and 1811 'Napoleon' brandy £130 ($325) and the same vintage Tokay Essence £110 ($275) for a half litre.

V.A.T.

The introduction of Value Added Tax in April this year has added in no small way to the complications of compiling wine catalogues and administering wine sales. More importantly it has added immediately to the cost of much fine wine, and in the long term will affect adversely the price of all but the cheapest wine.

In addition it adds to the expense of selling wine, as V.A.T. is added to our commission. Admittedly, 10% tax on a 15% or smaller commission is no great burden for the vendor. What is perhaps overlooked is the disproportionate cost of collecting and, in effect, handing it over to H.M. Customs and Excise.

The addition of 10% to the sale price is altogether another thing and we have yet to see what sort of deterrent it is for the English buyer (overseas buyers, in effect, do not pay V.A.T. – which puts them at an advantage). At the moment not *all* wine sold is subject to V.A.T. For example, wines from private cellars are not subject to this tax, though most trade stock is. Furthermore, *all* wine imported from overseas is

subject not only to duty but has 10% V.A.T. added to the *total* cost of importation, i.e. upon the auction sale price, the duty, and all freight and other handling charges. Again this is both immensely complicated to explain away and costly to administer.

At our 28th June Finest and Rarest sale, much of the stock had been imported from cellars in France, some being offered lying at Christie's and subject to V.A.T., some offered in bond only, the onus of payment of duty and V.A.T. being laid fair and square on the English buyer. None of these complications seemed to affect the keen interest or deter high bidding. However, we have no doubt that, once the air has cleared, V.A.T. will be seen – in respect of fine and rare wine—an expensive and possibly an off-putting nuisance.

Christie's Wine Review, 1973

The first edition of our entirely new publication, devoted partly to wine prices and partly to a review of the wine market and related subjects, appeared to hit exactly the right note when it came out last year. We were encouraged to produce another edition this spring along similar lines but augmented by a greater range of wines and prices as well as by more information. This has also been well received and we see our *Wine Review* turning into a hardy annual.

Once again, the price index section clearly demonstrates the difference between wine, which is a commodity produced in quantity, and works of art, which are generally individually created. Not even sets of period chairs, glasses or pieces of porcelain are in the same category. Perhaps the production of postage stamps is the nearest to wine; and like stamps, wines now have a fairly firm and predictable market value. However, unlike stamp catalogues which give notional retail values, our price index lists the prices actually paid for individual wines and vintages over a given season.

To be as comprehensive as possible, we quote other saleroom prices whenever appropriate, particularly when a wine has been sold that has never appeared in our own salerooms. As leaders in the wine auction field, the highest proportion of prices quoted quite naturally arise out of our own sale activities.

Wine trade relics and collectors' pieces

This is another market we have developed over the past year or two which is now quite clearly here to stay. Certainly the two relics sales held during the season being reviewed have confirmed the tremendous interest in the bygones and artifacts which have long been associated with wine. Of course silver wine labels, decanters and such-like have been seriously collected for many years, but now, quite suddenly, lesser objects like bin labels, corkscrews, old decanting machines and cellar equipment are attracting the attention of buyers.

Corkscrews and wine labels
sold 25.4.73

Top row left to right: Early
Farrow & Jackson corkscrew,
£68 ($170); Dowlers patent,
£72 ($180); Hickman tap,
£16 ($40)

Bottom left: Patent corkscrew,
£58 ($145)

Bottom right: Patent corkscrew
chased copper barrel, £125
($312), record price

Wine labels:
Brandy, £64 ($160)
Mountain, £22 ($55)
Sherry, £20 ($50)

Corkscrews in particular have been, deservedly, a great success. There seems to be no end to the ingenuity, craftsmanship, utility and beauty of the early pieces which not unnaturally results in prices which are now frequently, and for the first time, running into three figures. Several specimens are illustrated above.

Wine

Type and place of sale	No. of Sales	No. of Lots	Sale totals
Sales at Christie's Great Rooms			
Fine Wine, Finest & Rarest and Relics & Collectors' Pieces 2[i]	7	2938	£332,662 ($831,655)
Claret & White Bordeaux	7	2912	£384,769 ($961,922)
Vintage Port, Sherry & Cognac	3	1140	£128,636 ($321,590)
End of Bin, wines & spirits	7	2976	£112,856 ($282,140)
Sale of Wine Lying Overseas	2[ii]	1157	£109,023 ($272,557)
Christie-Restell City sales			
Cadenhead stock	1	1542	£140,278 ($350,695)
Miscellaneous wines & spirits	1	473	£21,862 ($54,655)
Christie wine sales in Europe			
Christie's in Düsseldorf equivalent value in £ sterling	1	247	DM 171,000 £24,439 ($610,975)
Christie Wine Sales—TOTAL	29	13,385	£1,254,525 ($3,135,637)
Sales conducted by Christie's in U.S.A.			
for Heublein's, Atlanta (May 1973)	1	589	$273,500 (£109,400)
for Sakowitz, Texas (November 1972)	1	262	$63,380 (£25,352)
	2	851	$336,880 (£134,752)

Note (i): forming the afternoon session of Fine Wine sales
(ii): plus a special afternoon section of the End of Season sale

ART NOUVEAU, ART DECO, PHOTOGRAPHICA, TEXTILES, COSTUMES AND DOLLS

Above:
Martinbird tobacco jar group
Incised R. W. Martin & Bros., London &
Southall, 14.5.1907
11½ in. (29 cm.) high
Sold 18.6.73 for 780 gns. ($2047)

Left:
De Morgan tile panel of 66 tiles designed by
William Morris
c. 1873
66 × 36 in. (85 × 91 cm.)
Sold 18.6.73 for 800 gns. ($2100)

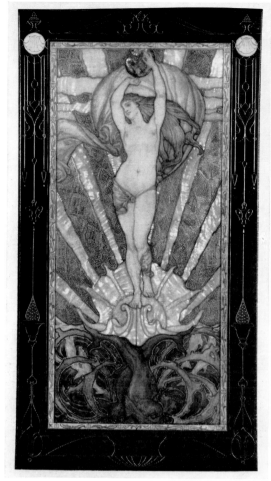

One of a remarkable pair of Art Nouveau
vellum and leather panels by H. Granville-Fell
of Venus and Diana
Signed
22 × 12 in. (56 × 30.5 cm.)
Sold 11.12.72 for 800 gns. ($2016)

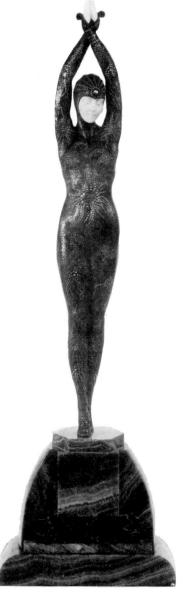

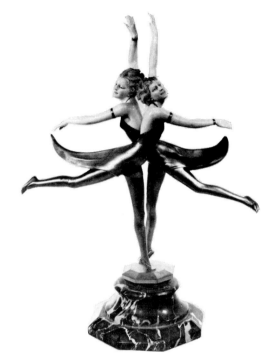

Art Deco bronze and ivory group of
female dancers
By Prof. Poertzel
Signed
15½ in. (39.5 cm.) high
Sold 11.12.72 for 305 gns. ($769)

Fine Art Deco bronze and ivory figure
of an exotic dancer by D. H. Chiparus
Signed
29¼ in. (74.5 cm.) high
Sold 11.12.72 for 650 gns. ($1638)

Photographic sales

CHRISTOPHER WOOD

This season, Christie's held two photographic sales, the first totalling £5091 ($12,219) and the second £13,721 ($34,304). The figures alone are evidence of the increasing interest which this new market is attracting. More and more photographic objects of all kinds – cameras, equipment, lanterns, slides, daguerrotypes, albums, books, catalogues and prints by early photographers – are being brought in for sale. At the last auction in July, the saleroom was packed more than ever before with enthusiastic dealers and collectors, mostly English, but also from many other countries.

Probably the most remarkable development of the season has been the growth of sales of old cameras and equipment. At our sale in July last season, the highest price for a camera was £110 ($264) for a half-plate studio camera by James Sinclair & Co. This season the record was more than doubled twice – a remarkable feat. In December an early wet plate sliding box camera of about 1865 made £294 ($706). Then in June this year a wet plate stereo camera by Morley of London, c. 1860 (see top illustration opposite), made £840 ($2100). In the same sale a Marion Academy Camera, c. 1883, made £651 ($1628); a very early Kodak £441 ($1102); and a Luzo early roll film camera £252 ($630). There were also such curiosities as a Rotoscope, a Kromskop, a Graphoscope, a Kinora, and a Walter Tylers Helioscopic Lantern, all at much more modest prices.

In the world of photographic prints the highest prices went as usual to the familiar favourites – Julia Margaret Cameron, Frank Meadow Sutcliffe, and Francis Frith. A view of Whitby by Sutcliffe made £115 ($277), his highest so far, and *The water rats*, a photograph of naked boys paddling which shocked the Victorians (see illustration page 466), made £99 ($239). A number of Camerons were sold for average prices, as there already seems to be a shortage of good photographs by the great Julia Margaret. Less of photographic interest, but more historically interesting, was the photograph of the house party at Tranby Croft in 1890, scene of the notorious Baccarat Scandal (page 466). All the characters in the drama were there, from the Prince of Wales and Mrs Wilson in the front row, to the enigmatic Sir William Gordon-Cumming in the doorway at the back. Sent in for sale by the daughter of a laundrymaid at Tranby Croft, it was carried off by a collector for £126 ($315).

464

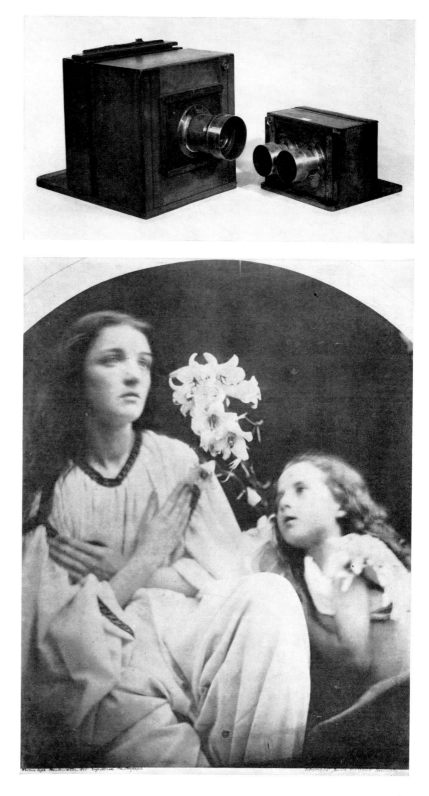

Left:
9 × 7 (approx.) wet plate sliding
box camera
c. 1852
Sold 14.6.73 for 420 gns. ($1102)
From the collection of
A. P. Jenkins, Esq

Right:
Wet plate stereo camera
By Morley of London, c. 1860
Sold 14.6.73 for 800 gns. ($2100)
From the collection of
A. P. Jenkins, Esq

JULIA MARGARET CAMERON:
The Annunciation
Signed and inscribed, arched top
$13\frac{1}{2} \times 10\frac{1}{2}$ in. (34.2 × 26.6 cm.)
Sold 14.6.73 for 200 gns. ($525)

Photographs

FRANK MEADOW SUTCLIFFE:
The water rats
9 × 11 in. (22.8 × 27.9 cm.)
Sold 14.12.72 for 95 gns. ($239)

Tranby Croft, September 8–9, 1890
7½ × 9 in. (19 × 22.8 cm.)
Sold 14.6.73 for 120 gns. ($315)
From the collection of Miss R. Harrison

Pair of velvet and cloth pictures
of a postman delivering a letter
and an old woman of Eridge
By G. Smart of Frant, near
Tunbridge Wells, 'Artist in
Cloth and velvet figures to
H.R.H. the Duke of Sussex'
10½ in. (27 cm.) high
c. 1820
Sold 18.7.73 for 160 gns. ($420)

The Old Tyne Bridge.

Hand-driven Berliner gramophone
Base 12 in. (30.5 cm.) long, turntable 5 in. (12.5 cm.) diam.,
horn 11 × 6 in. (28 × 15 cm.) c. 1894
Sold 12.3.73 for 700 gns. ($1764)
From the collection of H. L. Trudgill, Esq

The Old Tyne Bridge
(47, STG 144) Stevengraph
Sold 12.3.73 for 280 gns. ($706)
From the collection of
Miss Margaret Alice Jones

An important and rare early mantua of snuff coloured silk, c. 1707-9

This form of dress, evolved in the late 17th century as a loose gown for informal wear, had the added advantage of showing off the large 'bizarre' patterns of the silks and embroideries. It was originally made from a long T-shaped length of silk but was soon made with separate sleeves for a better fit. The mantua in the Clive House Museum, 1708–9, is of the earlier type and this mantua is the earliest-known example with separate sleeves. Later in the century, as with most forms of dress, the mantua became more formal, culminating in the splendid Court mantuas of the 1740s, such as the one sold at Christie's in 1969.

This mantua is cut with great ingenuity and very little of the damask is wasted, for although this dress looks plain, the silk was extremely expensive and would not have been used extravagantly. It would have been for someone with quiet but opulent taste. An added interest is that silks of that colour rarely survive.

Important mantua of snuff coloured damask
The damask 18 in. (46 cm.) wide, the repeat also 18 in. (46 cm.). Possibly Dutch c. 1707–1709
Sold 12.3.73 for 550 gns. ($1385)
From the collection of Miss M. R. Bridewell

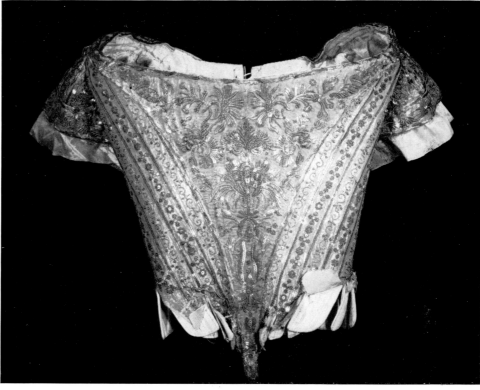

Boned court bodice of cloth of gold, 1761
Sold 18.7.73 for 320 gns. ($840)
From the collection of Lt-Commander C. J. O. Malcolm, RN, Retd
Believed to have been worn by Lady Mary Douglas in 1761 as assistant train bearer
to the Queen at George III's Coronation and sold with a note informing her of her
appointment. She was the daughter of the 14th Earl of Morton, PRS, and later
wife of the 5th Earl of Aboyne

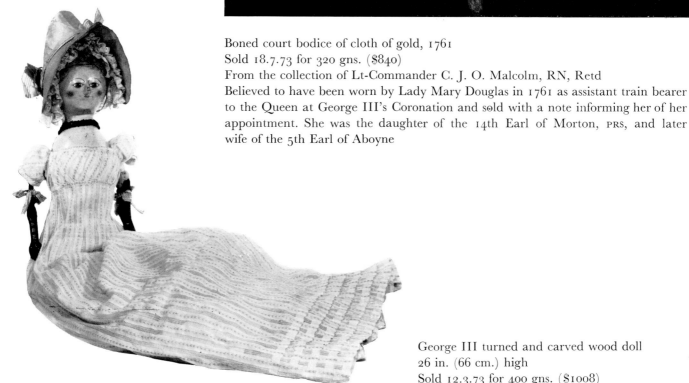

George III turned and carved wood doll
26 in. (66 cm.) high
Sold 12.3.73 for 400 gns. ($1008)

Important collection of drawings of dresses worn by the family of the Rev. Robert Augustus Johnson, Rector of Wistastowe, Salop, and their friends
Sold 18.7.73 for £399 ($997)
From the collection of W. J. Blois Johnson, Esq

Mannequins

In the 18th century, before the coming of the fashion magazine, a country lady was not completely cut off from the centres of fashion. She may not have got to London often but if she had seen the latest fashions on the backs of her neighbours, she could ask her London dressmaker to send her designs for her choice. These designs were called Mannequins but on account of their ephemeral nature few have survived. Three from the trousseau of Miss Pulleine were sold at Christie's from Old Battersea House and are now at Cannon Hall Museum. Apart from these only the forty made for the Johnson family are known. They date from the last quarter of the 18th century and include a débutante's wardrobe of 1787 and dresses made for friends and neighbours, many bearing dates and annotations (see illustration above).

Highly important and probably unique album in which Miss
Barbara Johnson put 122 samples of the material from which
she had dresses made between the years 1746 and 1823
Sold 18.7.73 for 2200 gns. ($5775)
From the collection of W. J. Blois Johnson, Esq

Miss Johnson's wardrobe

This album is probably unique for it consists of 122 samples of materials from which
Miss Barbara Johnson, a rich parson's daughter, had dresses made from 1746 to 1823.
The samples are annotated with name of the material, colours, month of purchase,
yardage and cost and from them costume historians will be able to trace the 'dress
history' from Miss Johnson's childhood to old age. Not only will they know what the
more obscure materials were, but they will be able to find when a woman bought
her summer wardrobe, what materials she used for each form of dress, the quantities
and how much she paid.

Although weavers' and mercers' pattern books survive, no other English 18th-
century 'wearer's dress diary' is known and it is pleasing that this should include
dated samples of the lesser materials like plain cottons, stuff, tabby, poplin, camblet,
fustian, bombazeene, lutestring, Manchester Brunswick, calico, Stormont cotton,
gingham and muslin, dresses of which no longer survive.

Table of picture prices paid at auction over £250,000

(The dollar conversions have been made at the rate in effect at the time of each sale)

27.XI.70	Velazquez	*Juan de Pareja* ($5,544,000)	£2,310,000	Christie's
25.VI.71	Titian	*Death of Actaeon* ($4,065,600)	£1,680,000	Christie's
16.XI.61	Rembrandt	*Aristotle contemplating the bust of Homer* ($2,300,000)	£821,400	Parke-Bernet
19.III.65	Rembrandt	*Portrait of Titus* ($2,234,400)	£798,000	Christie's
9.X.68	Renoir	*Le Pont des Arts* ($1,550,000)	£645,833	Parke-Bernet
29.VI.73	Cuyp	*Woody river landscape* ($1,522,500)	£609,000	Christie's
1.XII.67	Monet	*La terrasse à Ste Adresse* ($1,411,200)	£588,000	Christie's
2.V.73	Manet	*Nature morte aux poissons* ($1,400,000)	£560,000	Parke-Bernet
2.V.73	Cézanne	*Vase of flowers* ($1,400,000)	£560,000	Parke-Bernet
25.II.70	Van Gogh	*Le cyprès et l'arbre en fleur* ($1,300,000)	£541,667	Parke-Bernet
5.V.71	Van Gogh	*L'Hôpital de St Paul à St Rémy* ($1,200,000)	£500,000	Parke-Bernet
11.VII.73	Mantegna	*Christ's Descent into Limbo* ($1,225,000)	£490,000	Sotheby's
27.VI.69	Rembrandt	*Self portrait* ($1,159,000)	£483,000	Christie's
6.VII.71	Renoir	*Le pêcheur à la ligne* ($1,104,000)	£483,000	Christie's
30.VI.70	Seurat	*Les poseuses* (small version) ($1,033,000)	£430,500	Christie's
25.VI.71	Van Dyck	*Four negro heads* ($1,016,400)	£420,000	Christie's
25.VI.71	Boucher	*The fountain of love* and *The bird catchers* (a pair) ($1,016,400)	£420,000	Christie's
27.VI.69	Tiepolo	*Allegory of Venus entrusting Eros to Chronos* ($982,000)	£409,500	Christie's
8.XII.72	de La Tour	*The beggars' brawl* ($957,600)	£399,000	Christie's
25.II.70	Van Gogh	*Le laboureur, Arles* ($875,000)	£364,000	Parke-Bernet
3.XII.69	Rubens	*The rape of the Sabines* (a pair) ($840,000)	£350,000	Sotheby's
8.XII.71	Fragonard	*Anne François D'Harcourt, Duc de Beurson* ($850,000)	£340,000	Sotheby's
25.VI.71	Rembrandt	*Portrait of the artist's father* ($720,000)	£315,000	Christie's
6.VII.71	Renoir	*Mademoiselle Georgette Charpentier* ($720,000)	£315,000	Christie's
26.XI.71	Bellotto	*Ponte delle Navi, Verona* ($719,000)	£315,000	Christie's
16.XI.61	Fragonard	*La liseuse* ($750,000)	£312,500	Parke-Bernet
2.V.73	Degas	*Répétition de ballet* ($780,000)	£312,000	Parke-Bernet
21.X.71	Rousseau (Le Douanier)	*Paysage exotique* ($775,000)	£299,000	Parke-Bernet
14.X.66	Cézanne	*Maisons à l'Estaque* ($800,000)	£285,000	Parke-Bernet
19.VII.72	Gainsborough	*The Gravenor Family* ($700,000)	£280,000	Sotheby's
24.VI.59	Rubens	*Adoration of the Magi* ($775,500)	£275,000	Sotheby's
5.XII.69	Bassano	*Flight into Egypt* ($655,200)	£273,000	Christie's
3.VII.73	Picasso	*Le mort* ($675,000)	£270,000	Sotheby's
7.VII.72	Guariente	*Polyptych* ($617,400)	£257,280	Christie's
30.VI.70	Monet	*Bords de la Seine, Argenteuil* ($605,000)	£252,000	Christie's

Christie, Manson & Woods

LONDON 8 King Street, St James's, SW1Y 6QT
Telephone 01–839 9060 *Telegrams* Christiart London SW1 *Telex* 916429

Our Companies and Agents Overseas

UNITED STATES Perry T. Rathbone, Christopher Burge, David Hall
Christie, Manson & Woods (USA)
867 Madison Avenue, New York 10021, NY
Telephone (212) 744 4017 *Cables* Chriswoods, New York *Telex* New York 620721
LOS ANGELES: Mrs Barbara Roberts
450 North Roxbury Drive, Beverly Hills, California 90210 *Telephone* (213) 273 0550 *Telex* Beverly Hills 674 858

CANADA Mrs Laurie Lerew
Christie, Manson & Woods (Canada) Ltd
1115 Sherbrooke Street West, Montreal, 110 P.Q.
Telephone (514) 842 1527 *Cables* Chriscan, Montreal

SWITZERLAND Anthony du Boulay, Dr Geza von Habsburg, Hans Nadelhoffer
Christie, Manson & Woods (International), SA
8 Place de la Taconnerie, 1204 Geneva
Telephone Geneva 24 33 44 *Cables* Chrisauction, Genève *Telex* Geneva 23634

GERMANY Dr Geza von Habsburg, Michael Voggenauer, Jörg Bertz, Baroness Olga von Fürstenberg
Christie, Manson & Woods KG
Alt Pempelfort 11a, 4 Düsseldorf
Telephone 36 42 12 *Cables* Chriskunst Düsseldorf *Telex* Düsseldorf 7599

AUSTRIA Baron Martin von Koblitz
c/o Christie's Geneva Office, (private address) Burgelsteinstrasse 4, 5020 Salzburg
Telephone Salzburg 23 3 44

ITALY Natalie Narischkine
Christie, Manson & Woods (Internazionale) SA
Via Margutta 54, Rome 00187 *Telephone* 679 2289
FLORENCE: Dr Louisa Nicholson
Via Laura 70, Florence *Telephone* 26 02 74

FRANCE Princesse Jeanne-Marie de Broglie
68 Rue de l'Université, 75 Paris VIIe *Telephone* 544 16 30

SPAIN François Curiel, Richard de Willermin, Isabel Pintado
 Christie's B.V. Sucursal en España
 Montalbán 9, Madrid 14

HOLLAND Drs Andries Baart
 Christie, Manson & Woods
 91 Rokin, Amsterdam

SWEDEN Mrs Lillemor Malmström
 Hildingavägen 19, 18262 Djursholm, Stockholm
 Telephone 7555733

AUSTRALIA SYDNEY: John Henshaw
 Christie, Manson & Woods (Australia)
 298 New South Head Road, Double Bay, Sydney 2028
 Telephone 36–7268 *Cables* Christiart, Sydney
 MELBOURNE: T. D. H. Kendrew
 Christie, Manson & Woods (Australia)
 The Joshua McClelland Print Room, 81 Collins Street, Melbourne, Victoria 3000
 Telephone 63–2631 *Cables* Christiart, Melbourne

JAPAN Sir John Figgess, KBE, CMG, Toshihiko Hatanaka
 Christie, Manson & Woods (Japan)
 113 Fuji Building, 2–3, 3-Chome, Marunouchi, Chiyoda-ku, Tokyo
 Telephone (03) 211 7507/8 *Cables* Christiart, Japan *Telex* Tokyo 28635

SCOTLAND Michael Clayton
 48 Melville Street, Edinburgh EH3 7HH
 Telephone (031) 225 4757
 Sir Ilay Campbell, BT
 Cumlodden Estate Office, Furnace by Inverary, Argyll
 Telephone Furnace 206

WEST COUNTRY R. L. Harrington Esq
 Pencuil, Polvarth Road, St Mawes, Cornwall
 Telephone St Mawes 582

474

Acknowledgements

Christie's are indebted to the following who have allowed their names to be published as purchasers of works of art illustrated on the preceding pages. The figures refer to the page numbers on which the illustrations appear

M. Abram, 215 (centre), 216

Adlam Burnett, 415

Thos. Agnew & Sons Ltd, 15, 28, 29, 30 (bottom), 34, 44, 53, 55 (top), 92 (top), 101 (right), 103 (bottom), 106, 108 (top), 110 (bottom right), 166 (left)

Roy Aitken Esq, 462 (right)

Albany Gallery, 105 (top)

Aldbury Antiques, 307 (top centre)

Mr & Mrs James W. Alsdorf, 402 (left)

Albert Amor Ltd, 301 (top), 304

Appleby Bros Ltd, 109 (top)

J. H. Appleby Esq, 54 (top)

The Armouries, H.M. Tower of London, 447 (centre right), 450

Asprey & Co Ltd, 246 (bottom left), 419 (bottom right), 426 (top left and right), 427 (bottom left)

Azizollahoff & Co, 398 (left)

H. Baer, 246 (top left and right), 392 (left), 403, 410 (left), 442 (top left)

Mr David Balogh, 200

J. Barrett Esq, 444 (second from top)

H. C. Baxter & Sons, 369 (top)

Robert C. B. Beardsley Esq, 395 (top and bottom left)

Beauchamp Galleries, 305 (bottom), 317

Dr Alexander Best, 271 (top)

Herbert Bier, 247 (bottom), 291

P. Blond Esq, 440 (top)

N. Bloom & Sons Ltd, 237 (left), 239 (left)

Bluett & Sons Ltd, 331, 345 (top left)

Bradford City Library, 298

Martin Breslauer & Otto Haas (A. & M. Rosenthal), 292

Simon Brett, 381 (top)

Brod Gallery, 31, 72

Tan Bunzl, 73

H. Calman Esq, 71, 79 (bottom)

The Trustees of the Chatsworth Settlement, 2, 281, 282, 284

Chichester Antiques Ltd, 374 (bottom right), 389

Mr J. G. Cluff, 286 (right)

Mr Roy G. Cole, 351 (top)

P. & D. Colnaghi & Co Ltd, 33 (right), 55 (bottom), 62 (right), 76 (top), 81, 84, 85, 93 (bottom), 100 (top), 102 (bottom), 104, 108 (bottom), 116 (left), 129

Richard Courtney, 368

Crane Kalman Gallery, 170

MMes Croisier & Gillioz, 366 (top left)

Crummells, 221 (right)

F. Cura Esq, 382

G. A. Dando Esq, 439 (bottom)

William Darby, 107 (left), 162

The C. L. David Collection, Copenhagen, 366 (top right)

Mrs Davidson, 419 (bottom left)

Cecil Davis Ltd, 328 (top left)

de Havilland Antiques, 223 (top), 225 (top)

Baron F. E. de Louville, 463 (bottom)

Delomosne & Son Ltd, 328 (bottom left)

Mrs M. Christina de Mello, 141

MM J. & S. de Young Inc, 190 (top left), 192, 200 (top left), 205 (centre left)

Anthony d'Offay, 168 (top)

D. Drager, 246 (centre left)

J. D. Dwek, 409 (top right)

Francis Edwards Ltd, 289 (top)

Dr Eisenbeiss, 33 (left), 144, 402 (right)

Eskenazi Ltd, 348 (centre left, bottom left, and bottom centre left)

D. Factor Esq, 355

E. Fairclough (Arms) Ltd, 444 (bottom), 447 (second from left), 448 (top)

F. L. Fenyres, 411

The Fine Art Society Ltd, 95 (bottom), 111 (top), 163, 462 (left)

Firestone and Parson, 220 (top), 235

Fischer Fine Art Ltd, 32 (bottom), 121 (bottom), 124, 131 (top), 151

Acknowledgements

I. Freeman & Son, 239 (right)

Frost & Reed Ltd, 59 (top and bottom)

Michael Garvin Esq, 132

The J. Paul Getty Museum, 37, 43

Christopher Gibbs Ltd, 109 (bottom)

Glaisher & Nash Ltd, 374 (top right)

Mrs Helen Glatz, 335, 338, 339, 342 (top), 343 (centre), 345 (bottom)

Richard Green, 22, 49, 52, 54 (bottom), 58 (top and bottom), 64, 65 (bottom), 66 (bottom), 171 (top)

Messrs Andrew Grima, 190 (bottom), 203 (bottom left)

A. V. Gumuchian Inc, 190 (top right)

Stephen Hahn Gallery, 137

Messrs M. Hakim, 256 (top)

John Hall, 306 (top left)

Frank Hammond, 288 (bottom), 289 (top)

S. H. Harris & Sons (London) Ltd, 205 (top left)

Hartnoll & Eyre Ltd, 62 (left), 63, 112 (bottom)

Hazlitt, Gooden & Fox Ltd, 91 (top)

M. Henderson Gallery, 94 (bottom)

The Lord Hesketh, 285 (left), 436 (bottom)

Hotspur Ltd, 377

Houston Gallery, 166 (right)

How of Edinburgh, 220 (bottom right), 222 (right), 223 (bottom), 225 (bottom), 229

Cyril Humphris Ltd, 24–25, 401, 408, 409 (bottom right)

Henry Jacobs Fine Paintings, 65

Geoffrey P. Jenkinson, Lausanne, Switzerland, 442 (top right), 443 (left)

E. Joseph, 283

Henri A. Kamer, 276 (right)

W. Keith Neal Esq, 445 (centre)

P. W. Kemp Esq, 307 (bottom right)

D. R. Kirch Esq, 220 (bottom left)

E. & C. T. Koopman & Sons Ltd, 218, 257 (bottom)

D. S. Lavender, 246 (bottom right), 250 (top left and right)

Ronald Lee, 349 (top), 391 (bottom)

R. A. Lee, 375 (left), 421 (bottom right)

The Leger Galleries Ltd, 39, 51 (top), 57, 93 (top), 98 (top and bottom), 99, 111 (bottom)

Leggatt Brothers, 27, 46, 50

Mr E. Lim, 34

Miss L. Lowe, 80 (top)

Thomas Lumley Ltd, 221 (left), 226 (top), 237 (right)

Michael McAleer, 224 (right)

W. H. McAlpine, 439 (top)

Ian MacNicol, 158

Maggs Bros Ltd, 290

Mrs S. Maison, 88 (top)

Mallett at Bourdon House Ltd, 440 (bottom)

Mallett & Son Ltd, 375 (right)

Manning Galleries Ltd, 90 (bottom), 102 (top), 103 (top)

S. Marchant & Son, 343 (bottom centre), 353 (bottom right), 354 (bottom left)

Marlborough Fine Art, 153, 156 (left)

J. & J. May, 307 (top right)

Roy Miles Fine Paintings, London, 42, 47, 51 (bottom)

Max Moller, 414 (left)

The Lord Montagu of Beaulieu, 436 (top)

Mrs G. Montgomery, 259 (top)

Piers R. Morris Esq, 271 (bottom right)

H. Moss, 332, 333, 334 (top and bottom), 337, 342 (bottom), 344 (top), 345 (top right), 346 (top left and right and centre), 399 (left)

Sydney L. Moss Ltd, 330 (bottom left)

The Munnings Trust, Dedham, 164

Meyrick Neilson of Tetbury Ltd, 421 (left and top right)

Newhouse Galleries Inc, 41

Noble Antiques, 311

Nogatch, 388 (bottom left)

O'Hana Gallery, 134

Royal Ontario Museum, 468

S. Ovsievsky, 185, 358 (bottom left), 407

M. G. Panchaud, 199 (centre), 258 (bottom right)

Acknowledgements

Frank Partridge & Sons Ltd, 74, 75 (right), 150, 372, 374 (top left), 387 (top), 423
Howard Phillips, 328 (centre)
S. J. Phillips Ltd, 204 (above and below left), 213 (centre), 214 (centre), 227, 242 (left), 254 (top), 255 (top)
Piccadilly Gallery, 60, 61
Ian A. Pout Esq, 466 (top)
Preus Foto As., 465 (top left and right)
Bernard Quaritch Ltd, 297
Redburn (Antiques), 377
Howard Ricketts Esq, 444 (top), 448 (third from top), 449 (top)
James Robinson Inc, 236
Dr Robert Rosenbaum, 414 (centre)
Royal Scottish Museum, 425 (bottom left)
Rubens's House, Antwerp, 17
Paul W. Russell, Amsterdam, 78 (bottom right)
Barry Sainsbury Antiques, 353 (top right)
Sanders of Oxford Ltd, 466 (bottom)
José M. E. Santo Silva, 199 (bottom left), 224 (left), 231, 238
Hermann Scheiner, 426 (bottom right)
A. Scott Esq, 308 (top)
Mr and Mrs Peter A. Silverman, Toronto, Canada, 219
M. R. Soames Esq, 425 (bottom right)
John Sparks Ltd, 340
Edward Speelman Ltd, 19, 21, 40
Spink & Sons, 83 (right), 97, 226 (bottom), 247 (top), 248 (centre), 249 (top left), 272 (right), 325 (top left and right and bottom left), 327, 348 (top left)
Marshall Spink Ltd, 165
Mr L. Steinhardt, 420
R. Stern Esq, 241
Oliver Sutton Antiques, 300 (bottom right), 306 (right and bottom left)
R. J. Symes Esq, 272 (left), 273 (top and bottom)
Christopher Taylor Esq, 271 (centre)

H. Terry-Engell, 135
C. Thomas Esq, 157
Thorpe & Foster Ltd, 370 (right)
Tilley & Co (Antiques) Ltd, 300 (top), 305 (top right), 308 (bottom)
Alan Tillman Antiques, 310, 328 (right)
Arthur Tooth & Sons, 139, 160
Dr A. Torré, 256 (bottom)
Charles Traylen Ltd, 285 (right), 288 (top)
M. Turpin Ltd, 373
C. J. Vander Ltd, 232
M. Pierre Vander Elst, 261, 264
José Luis Varez Fisa, 20
J. von der Becke, 469 (bottom)
Leslie Waddington Prints Ltd, 126 (right), 127
Wartski, 222 (left), 254 (centre), 258 (top and bottom left)
Lawrence Weinberg, 154
B. Weinreb Ltd, 289 (bottom)
H. S. Wellby Ltd, 243
R. F. Wenger Esq, 307 (bottom left and centre)
N. A. Whitley Esq, 442 (bottom), 447 (left)
G. R. Whyte Esq, 275
Winifred Williams, 301 (centre left), 313, 314 (right and left, 315 (bottom), 316
Mr Joseph Wolpe, 128
Miss Cynthia Wood, 148
Ian Woodner, 70
H. Woods Wilson, 353 (bottom left)
Douglas J. K. Wright Ltd, 343 (bottom left and right and top), 348 (top and centre right), 353 (top left), 356 (left), 357, 360, 365
Zeitlin & Verbrugge, 296
Peter E. Zervudachi, Galerie du Lac, Vevey, Switzerland, 198, 199 (top), 253, 254 (bottom), 255 (centre and bottom)
Gérard Zuber, 391 (top right)

Index

happened — a visit from Clive, very portly & prosperous, a visit from Lydia, who rode a bicycle against Maynard's wish, & so very rightly fell off & cut her knee, a visit from Angus: but nothing said' half so clever, I daresay, as what you said to Wittgenstein — The fame of that interview has gone round the world. how you talked without ceasing, some say in an obscure Austrian dialect, of the soul, & matter, till W. was moved to offer himself to you as bootboy at Mozart's Hotel, in order to hear you still talk.

I have always been one of those who maintained that the flowering of the aloe, once in a hundred years, was worth waiting for. I have compared it to snow falling by moonlight. The extreme rarity, I have said of the loveliest things is part of their charm. And this had reference to you.

But then, too, I have always liked the frozen water & the closed buds. In fact, if I had to write an obituary of any young